THE WORKBENCH GUIDE TO

Jewelry
Techniques

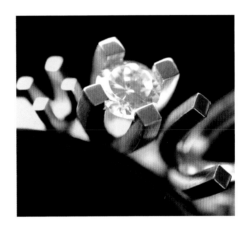

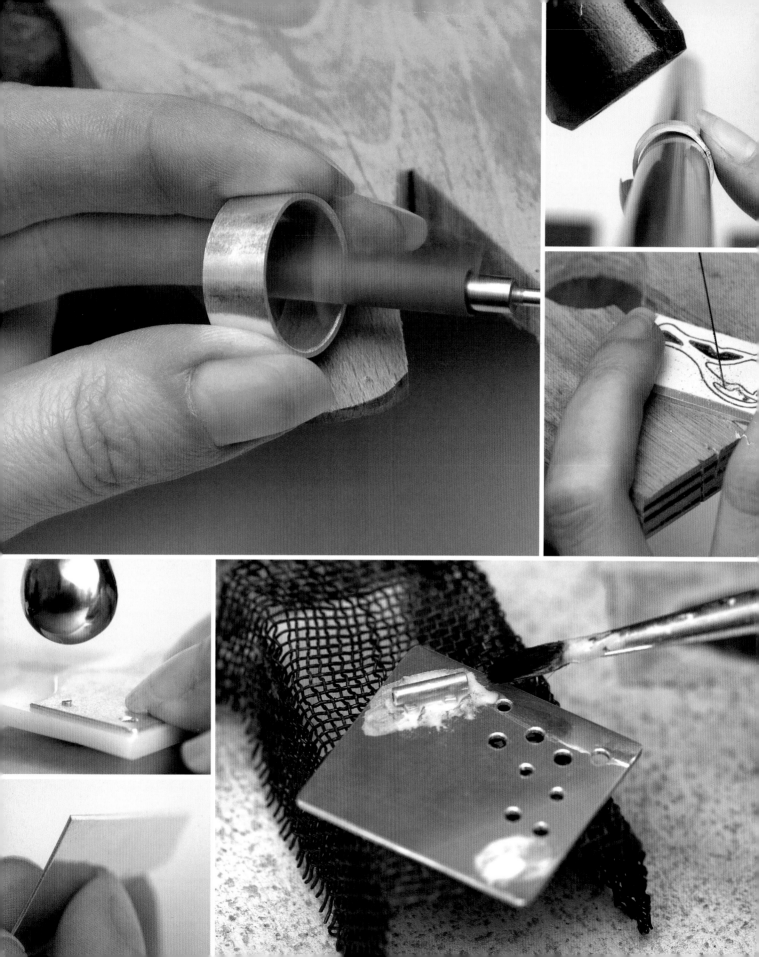

THE WORKBENCH GUIDE TO

Jewelry
Techniques

Anastasia Young

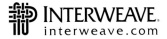

INTERWEAVE.
interweave.com

A QUARTO BOOK

Copyright © 2010 Quarto Inc

Published in North America by

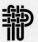

Interweave Press LLC
201 East Fourth Street
Loveland, CO 80537-5655
interweave.com

Conceived, designed, and produced by
Quarto Publishing plc
The Old Brewery
6 Blundell Street
London N7 9BH

QUAR.BJB

Senior Editor: Lindsay Kaubi
Art Editor and Designer: Louise Clements
Art Director: Caroline Guest
Copy Editor: Liz Dalby
Photographer: Phil Wilkins
Illustrator: Kuo Kang Chen
Picture Researcher: Sarah Bell
Creative Director: Moira Clinch
Publisher: Paul Carslake

Color separation in Singapore by PICA
Digital Pte Ltd
Printed in Singapore by Star Standard
Industries (PTE) Ltd

Library of Congress Cataloging-in-Publication
Data

Young, Anastasia.
 The workbench guide to jewelry techniques /
Anastasia Young.
 p. cm.
 Includes bibliographical references and index.
 ISBN 978-1-59668-169-9
 1. Jewelry making--Handbooks, manuals,
etc. I. Title.
 TT212.Y684 2009
 739.27--dc22
 2009041385

10 9 8 7 6 5 4 3

Contents

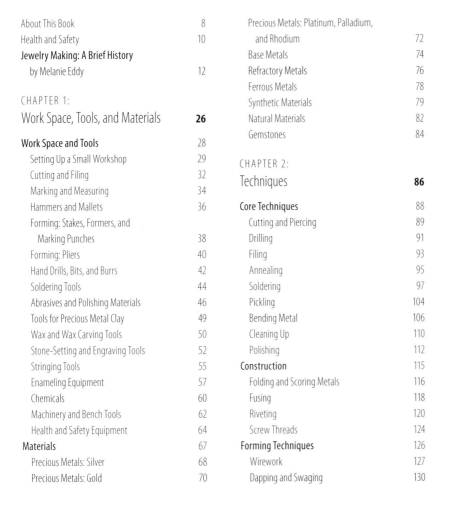

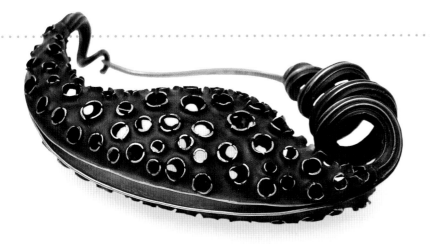

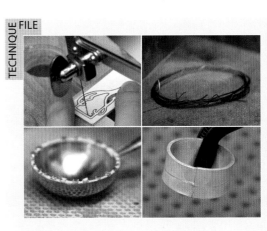

Continued on the next page ⟶

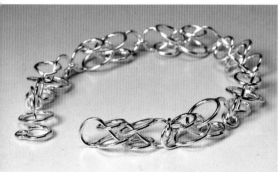

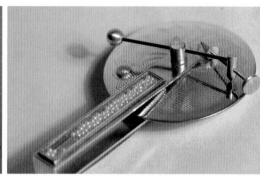

Contents
Continued

The Workbench Guide to Jewelry Techniques is organized into five chapters covering all you need to know about jewelry making, introduced with an exploration of jewelry making throughout history.

Jewelry Making: A Brief History (pages 12–25)

Jewelry Making: A Brief History is a whistlestop tour of jewelry making through history, providing a fascinating insight into and examples of how jewelry making has developed through the ages, from pre-history to the twenty-first century.

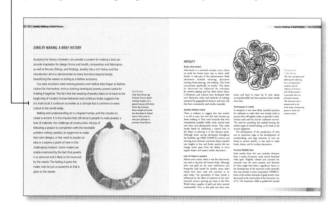

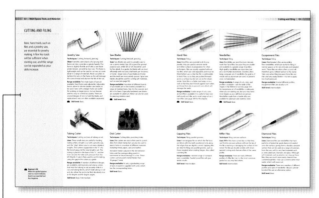

Work Space, Tools, and Materials (pages 26–85)

This chapter begins with a guide to setting up a work space and continues with a truly comprehensive catalog of tools. This exhaustive directory covers everything from simple hand tools to advanced machinery and includes a guide to what to buy for your "Beginner's Kit." This is followed by a detailed exploration of jewelry-making materials from precious metals and gemstones to "smart" plastics, vintage textiles, and found items.

Techniques (pages 86–271)

This comprehensive chapter is organized into nine subsections, from the core skills of piercing, soldering, and polishing to more advanced techniques, such as casting, stone setting, etching, and enameling. There is also a guide to what to consider when outsourcing work to specialist craftspeople.

Each technique covered is listed in the "Technique Finder," an at-a-glance listing of all the broad subject areas included in the techniques chapter and the specific topics within each subsection. "Technique Finders" are included at the beginning of each new subject so that you can place it within the context of the techniques chapter and easily refer back to earlier pages or forward to future ones.

Throughout the techniques chapter, processes are both discussed in context, with examples of finished pieces, and explained step-by-step with clear photography and detailed instructions. Each step-by-step technique included is numbered and can be found directly using the technique file listings on the contents pages (4–7).

Technique finder

Technique file number

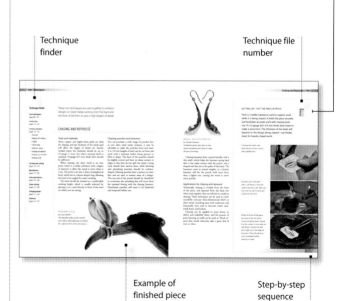

Example of finished piece

Step-by-step sequence

Design (pages 272–283)

This chapter takes you through the entire design process from finding inspiration and using drawing to generate ideas to design realization and the practical implications of developing a design that might be part of a collection or commissioned by a client.

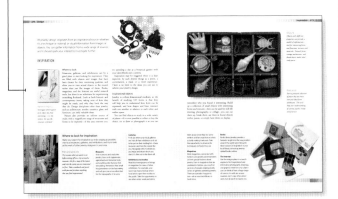

Going Into Business (pages 284–299)

Learn what you need to do to set up professionally, including successfully photographing your work and creating promotional material. Also find out about setting up a website, figuring out what kind of jeweler you are, selling your work, and exhibiting at galleries and trade fairs.

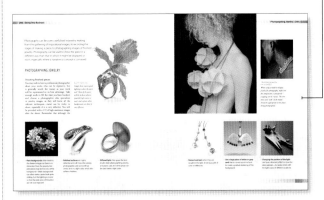

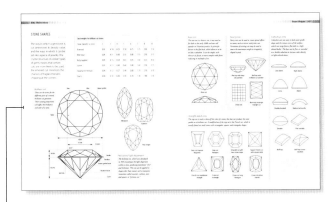

Reference (pages 300–315)

Here you will find a solid base of information to refer to again and again. There is a directory of gemstones, a guide to stone shapes and tool shapes, conversion tables, standard ring sizes and measurements, a glossary, and listings of suppliers, further reading, and useful organizations.

Gallery Pieces

Throughout the book you'll find dozens of examples of the work of contemporary jewelers from around the world. These have been carefully selected not only to demonstrate the possibilities of the many techniques and processes described in the book but also to convey a sense of the sheer variety and diversity of the jewelry that is being made today.

Most health and safety advice for jewelry making is based on common sense, but there are a few basic rules that should be followed, especially if you are working at home.

HEALTH AND SAFETY

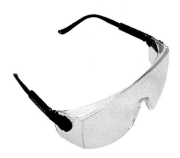

Safety goggles
Always wear safety goggles when using polishing equipment and drills.

Dust mask
Wear a dust mask during any activity that generates dust particles.

Latex gloves
Latex, vinyl, or rubber gloves should be worn when handling chemicals.

Protective equipment

A few key items of protective equipment are a worthwhile investment; more specialized hardware is required for techniques such as enameling or casting and will not be necessary in every workshop.

Wear safety goggles whenever you operate machinery, including flexshaft motors. These goggles are made from shatterproof plastic so that they cannot shatter if impacted by a flying object or particle, and are designed so that they can be worn over spectacles; safety goggles worn while soldering will help keep your eyes from drying out, and can be beneficial to contact lens wearers.

Dust masks should be worn whenever dusty processes are being carried out; any dust particle that enters the lungs is potentially dangerous. Wear a respirator whenever you use chemicals that give off harmful fumes, even if you are out-of-doors—this includes polyester resins and "fuming" and diluted acids.

Rubber, latex, or vinyl gloves should be used as a barrier against corrosive chemicals; leather gloves are used to protect the hands from excessive heat.

These and other items of protective equipment are described in more detail at the end of the tools section, see page 64.

Using machinery safely

Rotary machines, such as polishing motors and drills, can be dangerous if they are not used correctly. Always wear safety goggles when using rotary machines, and tie back loose clothing and hair. Never wear gloves when polishing—if you need finger protection, use leather finger guards.

Always polish chain in a barrel polisher, never on a polishing motor. If a piece catches in the wheel while you are polishing, let it go, switch off the motor, and wait for the machine to stop before retrieving the piece.

Working with heated metal

A few sensible precautions should be followed when heating metal—and always work on a heatproof surface when using a gas torch to protect work surfaces. To prevent gas leaks, turn the gas off at the bottle when you have finished using it; if there is a suspected leak in the rubber hose connecting the torch to the gas bottle,

Leather gloves
Leather gloves should be used to protect your hands from heat.

coat the hose in soap and watch for bubbles to appear when the gas is turned on. When lighting a torch, hold the lighter very close to the torch head and slowly increase the gas; once the torch is lit put the lighter in a safe place so that it does not explode due to heat exposure.

When enameling, wear leather gloves to protect your hands from high temperatures, and do not look directly into the kiln for any length of time—kilns emit harmful infrared rays when hot and glowing.

Wear a leather apron when working with molten metals—this will protect against splashes of liquid metal.

Using and storing chemicals

Acids, salts, solvents, and adhesives are all chemicals with potential health risks associated with them. Always make sure that you ask the supplier for the health and safety data sheet when purchasing chemicals, and follow the manufacturer's advice on use and storage. Certain chemicals require the use of an extraction unit in order to use them safely—polyester resin and nitric acid are among these. Do not attempt to use noxious chemicals at home—it is just not worth the risk. Alternative materials, such as ferric nitrate or epoxy resin, are less toxic and are a viable substitute. Pungent chemicals such as liver of sulfur solution should be used out-of-doors, and away from open windows—take note of the direction of the wind, too.

Ideally, chemicals should be stored in a lockable metal cupboard and should be clearly labeled with the name of the solution and the date it was mixed, if appropriate.

Use glass or plastic containers for chemical solutions, and work on a large plastic tray to protect wooden surfaces, which can absorb chemicals.

When mixing solutions, always add acid to water (not the other way around). That way, the strength of the solution will increase gradually; adding water to acid can cause a dangerous chemical reaction.

Repeated exposure to certain chemicals can cause contact dermatitis, so it is always advisable to wear protective gloves when handling any chemicals. Baking soda can be used to neutralize acid spills. Clean acid up with newspaper before thoroughly washing the area with plenty of water. Don't pour chemicals down drains; many are toxic to aquatic life, and some can corrode pipes.

Hazard Symbols

It is a good idea to familiarize yourself with the commonly used hazard symbols (below) because these are used to warn of hazards in materials and in locations that might occur in a jewelry workshop.

Flammable

Corrosive

Toxic

Oxidizing agent

Harmful

Explosive

General health and safety tips

- Work in a well-ventilated area so that any dust or fumes produced when you are working are quickly dissipated.
- Ensure your work space is well lit; proper lighting will help with accuracy and prevent eye strain.
- Tie back long hair and avoid loose clothing or jewelry, which could get caught on equipment.
- Clean up after yourself—put chemicals, tools, and materials away after use; vibrations made from hammering or other processes can encourage tools to fall off surfaces.
- Keep the floor of the work space clear of items that could cause trips or falls.
- Clean up liquid spills and dust as soon as possible.
- Don't allow children or pets into the work space.
- Have a first-aid kit to hand, in case of minor cuts and burns.

JEWELRY MAKING: A BRIEF HISTORY

Studying the history of jewelry can provide a context for making it and can provide inspiration for design: forms and motifs, composition and fabrication, as well as fixtures, fittings, and findings. Jewelry has a rich history and this introduction aims to demonstrate its many functions beyond simply beautifying the wearer or acting as a fashion accessory.

Our early ancestors were wearing jewelry even before they began to fashion clothes for themselves. And as clothing developed, jewelry proved useful for holding it together. The fact that the wearing of jewelry dates so far back to the beginning of modern human behavior and continues today suggests that it is instinctual. It continues to evolve as a concept but is common to every culture in the world today.

Making and understanding art is uniquely human, and the impulse to create is ancient. It is this impulse that still attracts people to make jewelry: a love of materials, the challenge of construction, the joy of following a project to completion with the inevitable problem-solving needed, an eagerness to make their own designs, or the need to explain an idea or a express a point of view in this challenging medium. Some makers are simply enamored by the fact that jewelry is so personal and is likely to be treasured by the wearer. The feeling it gives the maker may be just as powerful as that it gives to the wearer.

Gold lunula
Lunulae, crescent-shaped neck rings, are a typical ornament of the Early Bronze Age in Europe. Many examples of lunulae have been found in Ireland and to a lesser extent in other parts of Europe, in particular Great Britain.

ANTIQUITY

Body adornment

Adornment is a universal concept; every culture on earth has found some way to adorn itself. Jewelry is only part of this phenomenon. Body adornment includes tattooing, decorative scarring, body-piercing, and makeup. This book concentrates specifically on jewelry. This desire for adornment has influenced the techniques for jewelry making and has often driven them. Civilizations and cultures have developed their own distinctive styles and methods of making, separated by geographical distance and time, but have consistently used similar materials.

Jewelry before metal

There is evidence to suggest that jewelry is as old as man, but how did early humans go about making it? They used materials that were immediately available: shells, seeds, animal teeth and claws, and subsequently, stones. They made simple beads by exploiting a natural hole in the object or piercing it at the thinnest point. Although stone carving developed throughout the Neolithic age (9000–4500 BCE), pottery and weaving were invented, and stone objects reached new heights in line and finish, jewelry did not change much apart from the ability to carve regular shapes and impart surface decoration.

Use of metal in jewelry

Almost every metal, when it was first discovered, was used to decorate the human body. Although silver and gold are the most well-known and frequently used metals for jewelry, many other metals have been used and continue to be used today. Our perception of these metals is influenced by the effect of explorers of the mid-sixteenth century opening up mines in the New World where supplies of gold and silver seemed inexhaustible. Prior to that gold and silver were

scarce and hard to come by. It now seems incomprehensible just how precious these metals once were.

Techniques in metal

In antiquity it was most likely standard practice for craftsmen to make their own simple tools (a practice that still applies today to specialist tools). Various tools used by ancient craftsmen survive. The need for annealing was realized during the earliest stages of metalworking, as far back as the ancient Egyptians.

The development of the production of wire was an important stage in the development of metalworking, and large amounts of wire are found in ancient jewelry; it was used to make beads, chains, and for surface decoration.

Ancient Middle East

Early jewelry from this area includes elements from a variety of sources, some several hundred miles apart. Brightly colored and unusual raw materials were the most popular and demand for these might have been a significant factor in the development of the extensive trade networks that were already in place long before 5000 BCE. Some of the earliest examples of gold jewelry were discovered in the royal tombs of the Sumerian city of Ur. The Sumerians' skills as

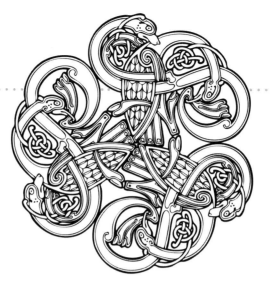

Ornamental Celtic design

The Celtic style galvanized following the combining of an existing jewelry tradition with the influence of Germanic and Viking ornament, in particular their use of animal ornament. This distinctive style is demonstrated in this tattoo design incorporating geometric motifs and animal interlace.

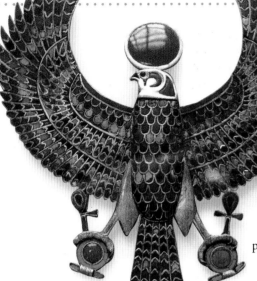

Egyptian pectoral jewel

A gold pectoral jewel, inlaid with semi-precious stones, faience (a glazed ceramic composite material), and glass from the treasure of Tutankhamun (c. 1325 BCE). Depicted is Horus the falcon-headed god crowned with a sun disk, the symbol for Aten—the life-giving force of light. An ankh—the symbol of life—is attached to each claw.

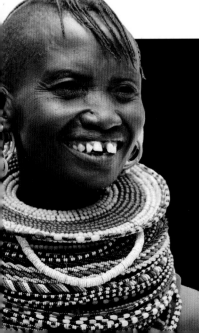

Turkana tribeswoman

The Turkana are nomadic pastoralists in Kenya. A Turkana woman's social status determines how much jewelry and what kind of jewelry to wear. To the trained eye, one glance is enough to know her standing in the society.

goldsmiths spread over Western Asia and north to areas of Turkey and southern Greece.

By 1900 BCE, jewelry was playing an important role in Egyptian culture. An incredible amount was preserved, as jewelry was extremely important in rituals surrounding death, with jewelry being specifically made for the dead. Gold was the metal of choice for the Egyptians and they were fortunate as they could rely on their own sources as well as gold from lands farther to the south.

Dynastic Egyptian jewelry is characterized by a colorful polychrome effect with its underlying symbolism. The broad collar, *wesekh*, was one of the most typical forms and incorporated bands of cylindrical beads arranged by size and color between two semicircular or falcons' head terminals. The scarab beetle was a common motif for Pharaonic jewelry; others included the lotus flower and the eye of the sun-god Horus.

Greece: Bronze Age through Classical period

The Minoans (3650–1100 BCE) flourished on the Greek island of Crete, and excelled in metalwork and jewelry. They successfully mastered the techniques of filigree, granulation, and repoussé. They were also skilled gemstone engravers using materials such as agate, jasper, hematite, chalcedony, and rock crystal. The Mycenaeans invaded and conquered the Minoans and continued many of the existing jewelry traditions, as well as producing complex seals for use in rings and perfecting the use of colorful inlay and simple enamels, and the production of fine chain. Greek craftsman were restricted during the Archaic and Classical periods (600–300 BCE) by their limited supply of gold. The Hellenistic period (330–27 BCE) was rich in gold, it being both mined in Thrace and acquired as booty from Persia by Alexander the Great. The empire expanded over most of Egypt and Western Asia, and this resulted in an increased supply of gemstones and a broadening of jewelry techniques and design influences. The introduction of the polychrome effect—the use of multiple colors

World/traditional jewelry

Much of this introduction focuses on the development of Western traditions in jewelry, but in this section emphasis is placed on non-European, non-Western forms and techniques of jewelry manufacture.

Africa

Jewelry is a universal feature of almost all of the varied cultures of Africa. The use of organic materials—bone, hair, wood, roots, seeds, and so on—is widespread and continues ancient traditions. The effect of the introduction of new materials through trade and colonization, in particular the introduction of colored glass beads and refined metals, is evident. African jewelry is also remarkable for its ingenuity and inventive use of nontraditional materials. Aluminum is acquired by melting down old containers and cooking pots, newspaper is rolled into earplugs by the Masai, and scraps of bathroom tiles are strung into necklaces using lengths of rubber from old inner tubes of tires.

India

India has a heritage of jewelry design that spans at least 5,000 years. Indian jewelry is characterized by its associations with religion, fortune, and health. In addition to the functions to beautify, signify status, confer respectability, act as a store of wealth, and to mark the wearer's

in a single object—greatly transformed the appearance of Greek jewelry. Cut stone panels, glass, and enamel featured. The cameo was also introduced—a popular motif was the Hercules or reef knot. A serpent wrapped around the arm or finger was a popular design for bracelets and rings, animal-head finials characterized hoop earrings, chains, and necklaces.

Etruscan

Early Etruscan jewelry (seventh–fifth century BCE) is characterized by abundance, technical proficiency, and variety. The most distinctive feature of their jewelry is their use of granulation. Late Etruscan jewelry (400–250 BCE) is marked by a shift away from surface decoration as large convex sheets of gold were preferred. Jewelry after this period fell into the Hellenistic style, influenced by the Greek cities of southern Italy.

Roman

While early Roman jewelry was informed by the Hellenistic influence, it eventually developed its own style. Roman jewelry came to be characterized by colored gemstones and simple, heavy settings. Early Roman jewelry is relatively rare, probably due to the continued use of gold to fund military campaigns. Significant quantities of the metal were not available for alternative uses until the Imperial period (27 BCE onward). Intaglios and cameos continued to feature, as did the serpent form. Egyptian

emeralds, garnets, and sapphires from India were popular and amber from the Baltic was highly prized, as well as rough diamond crystals in rings. The Romans developed fine-chiseled openwork, *opus interrasile*, and the use of niello in anticipation of the Byzantine style to follow.

BYZANTIUM AND THE MIDDLE AGES

Byzantium

The Byzantine Empire originated in 330 CE with the founding of Constantinople on the site of the Greek city of Byzantium. The Byzantine Empire survived until Constantinople was taken by the Ottomans in 1453. Constantinople, well placed for trade between East and West, became a center for ivory, precious stones, and pearls. It also benefited from domestic sources of gold in the Balkans, Asia Minor, and Greece. The empire was wealthy and hugely influential. Byzantine society was hierarchical and the wearing of jewelry and the availability of certain types of ornament was strictly regulated through sumptuary laws: every man and woman was entitled to wear a gold ring but the wider use of gold and precious stones was restricted to the court and the church.

The adoption of Christianity led to new forms of jewelry, for example pendant crosses, new iconography, and the development of figural representation to particularly high standards. Roman order and Classical traditions were

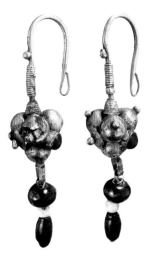

Roman earrings

A pair of gold earrings (third–fourth century CE) incorporating glass cabochons bezel-set into the body of the earring and glass beads.

identity, jewelry served a particular function in ritual ceremonies. For many outside of India it is the Mughal style, with its characteristic precious stones, engraving, carving, and enamels that represents the quintessential image of Indian jewelry. In actual fact, styles are incredibly varied according to region and continue to develop.

The Americas

Civilizations were already flourishing prior to the European

"discovery" of the New World. Personal adornment was an important aspect of all ancient peoples of the Americas, but after the Spanish conquest it was only in areas least affected by Spanish colonization that traditional techniques continued to thrive and develop. Metalworking was already established prior to contact with Europeans. Jade was also prized by the Aztec and Maya, who used it for elaborate relief carvings. Locally available

natural materials were also used, for example feathers, skin, and bone as well as trade goods such as beads, metal, mirrors, and other trinkets.

Native North American jewelry

It is clear that there was an established tradition of jewelry prior to European contact with North America from the vivid descriptions by early travelers of the finery worn by native peoples. Materials were widely distributed, indicating

vast trading networks as early as 5000 BCE. The acquisition of metal for tool-making and the introduction of European goods led to manufacture of jewelry components from natural materials and the creation of modified versions of native prototypes. New materials, such as glass beads, metal wire, and non-native feathers began to feature in jewelry. As silver became more widely available, metalworking flourished among the people of the Plains, in particular the Navajo

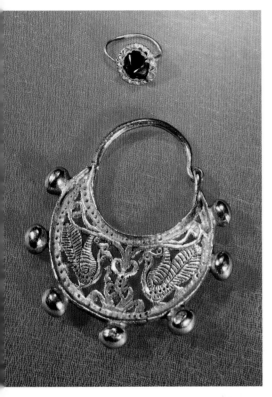

Roman and Byzantine earrings

Top: A Roman gold hoop earring (second–third century CE), with bezel-set cabochon gemstone and openwork periphery. Above: Byzantine gold crescent-shaped earring (sixth–seventh century CE), with pierced and engraved decoration, incorporating the popular Byzantine motif of affronted peacocks.

maintained with the addition of Christian iconography, new styles in polychrome jewelry where the gem was to predominate over the goldwork, and the widespread use of niello to highlight engraving and give a contrast to bright precious metal. Characteristic of Early Byzantine jewelry was fine-chiseled openwork, opus interrasile. Chasing and embossing were popular techniques and were sometimes combined with opus interrasile. The Roman love of colored stones was to remain a constant and to this was added enamel techniques. Gold cloisonné jewelry became a distinctive feature. Carved gems (cameos and intaglios) were also used, along with portrait medallions and coins; some depicting religious scenes such as the Annunciation or Christ blessing a couple.

Early European

The earliest possible date of metalworking technology developing in Europe dates to the Balkans around 4000 BCE, but this knowledge appeared to travel slowly westward as new ore sources were exploited around the Danube Basin. By 2000 BCE, metalworking had been introduced and basic common forms—though differing in style depending on the region—emerged during the Bronze Age (1800–600 BCE). Jewelry in central and northern Europe developed independently of the Mediterranean.

Ireland was rich in alluvial gold and so the craft of goldsmithing developed very early on in the Bronze Age there. Two types of ornament are typical: large disks decorated with central crosses that were sewn onto clothes, and crescent-shaped neck rings called lunulae.

In Central Europe a style of jewelry developed around the use of wire formed into spirals. In Ireland, Britain, and France cruciform strips of wire were twisted into long three-dimensional spirals that were worn around the neck or arm.

Celtic

The Celts dominated Europe during the Iron Age and established a stylistic tradition that persisted in parts of Europe throughout the Roman period and beyond, and still has relevance today. There is evidence that Celtic craftsmen were using enamels and inlay as early as 400 BCE. The item of jewelry most associated with the Celts is the torc; this was a prominent part of battle dress worn by both men and women. Celtic jewelry was essentially functional, used to fasten clothes, and the most universal form was the brooch.

Germanic

The spread of Germanic fashions throughout Europe can be attributed both to the numbers of Germanic mercenaries employed in Roman Imperial service and to the invasions and settlement of Germanic tribes of vast areas in Western Europe in the fourth and fifth centuries. Seminomadic tribes, although known as "barbarians" by the Greeks and Romans, achieved very high levels of craftsmanship and their occupation enabled pre-Roman traditions to thrive. Sophisticated polychrome inlay of garnets and glass is the major feature of Germanic jewelry. Gold was the favored metal, and geometric motifs and zoomorphic decoration were widespread. The pagan custom of burying jewelry with the dead was abandoned in most parts of Europe by the early eighth century, so little jewelry from this later period has survived.

Viking

Vikings, like the Germanic tribes, were never subjected to Roman rule. Similarly to the work of Germanic tribes, animal motifs dominate Viking jewelry and repoussé and filigree are incorporated to enhance basic cast shapes. Uniquely they developed a decorative technique called "chip-cutting" where the surface of the metal was worked with a chisel to create facets that produced a glittering effect. This was an important development and decorative element, as their work did not generally utilize stones. Most Viking jewelry was made in silver, generally woven and braided into torcs and bracelets.

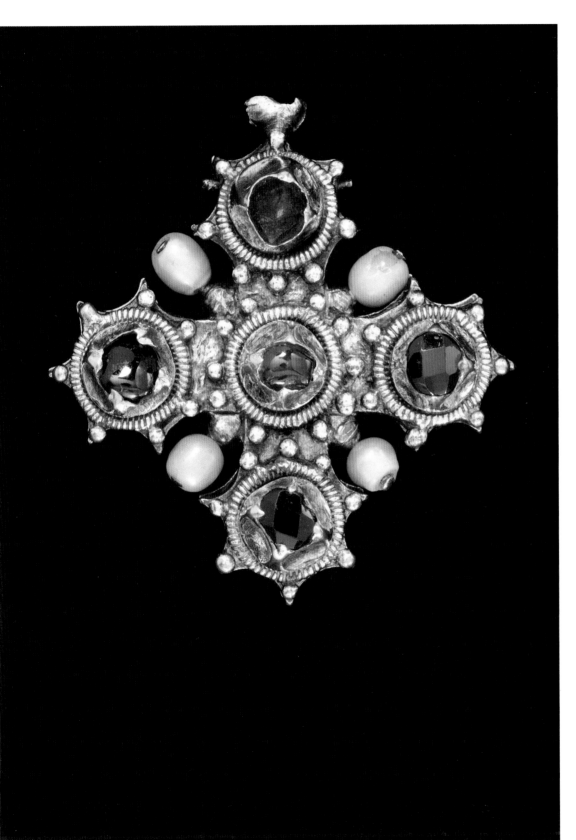

Pendant reliquary cross

Pendant reliquary made from silver, silver gilt, ruby, sapphire, garnet, and pearls, (1400–1500, Germany) and intended to contain a small relic. There are devotional images on its reverse and symbols of the Crucifixion on the lid. The decoration of pendant reliquaries could be secular as well as religious, though they were intended for meditation as well as jewelry.

Medieval jewelry (fifth–fifteenth century), in addition to its varied functions, was beginning to be established as a way of expressing the wearer's place in society and the wearing of it was heavily prescribed through sumptuary laws—heraldic symbols were widely used. The materials used in jewelry were valued for their religious, magical, and medicinal properties above their intrinsic worth. Jewelry bearing an inscription—whether religious invocation, magical formulae, or love mottoes—was popular. The flourishing of the monasteries from the mid-eleventh century meant that devotional jewelry was prominent.

Gothic influence

Jewelry from the thirteenth century onward begins to take on the forms and ornamentation used in Gothic architecture of the medieval period, for example the quatrefoils, trefoils, and vesica piscis that feature in the window tracery of great cathedrals. Jewelry of this period was created by goldsmiths, who also created a variety of objects, including vessels, tableware, and church plates. Although there were both secular and monastic goldsmiths, the majority of production took place in a monastic setting; it wasn't until later that there were specialized workshops. These goldsmiths often incorporated miniature architectural forms into their creations. Clarity of pattern and line superseded dense surface detailing. Brooches remained the most frequently worn type of jewelry, with ring brooches the most popular. Disk brooches and cluster brooches incorporating cameos and intaglios showed the formality of design as gemstones were ordered in patterns and interspersed with tiny gold figures of humans, animals, or dragons. The naturalism of later Gothic brought figurative pieces in enameled gold using the new en ronde bosse technique, in which enamel is applied to shapes in high relief.

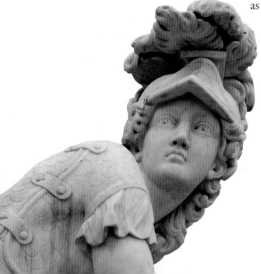

Classical influences

Pieces such as this statue of a Roman warrior were to influence the jewelry of the Renaissance period, which was fascinated by the culture, arts, and architecture of ancient Greece and Rome.

RENAISSANCE TO REVOLUTION

Renaissance

Jewelry of the Renaissance period was influenced by the renewed interest in the culture and arts of ancient Greece and Rome. Classical architecture provided inspiration, with decorative motifs used in jewelry designs of the time. Historical and mythological subjects provided sources for figural pieces, and themes from nature continued to gain popularity, particularly the exotic animals of newly discovered lands. However, Christian imagery remained current, and in addition to biblical scenes other symbols, including animals, were utilized to represent Christian virtues. The most dramatic religious pieces were memento mori jewels, which displayed symbols of death to remind people of their mortality and encourage virtuous living. Maritime exploration inspired jewels shaped as galleons, sea monsters, mermaids, and mermen.

Voyages sponsored by the Spanish and Portuguese at the end of the fifteenth century greatly affected the trade of gemstones and the quantity of precious metals available for jewelry manufacture. Henry VIII introduced the Tudor passion for jewelry and had the greatest treasury of jewelry ever possessed by an English king. Popular Tudor motifs were the monogram device and the knot, which was elaborated to include jewels. The birth of the concept of "crown jewels" occurred in the Renaissance, with the French King Francis I making a distinction between the personal jewelry of a royal family and pieces that were to become heirlooms of the monarchy. Other monarchs soon followed suit.

Renaissance jewelry is characterized by vivid color—enameled gold and precious stones. Cameos and intaglios continued to remain popular and gem engraving reached new heights and became a highly regarded European art form. Jewels of the period are particularly difficult to distinguish by region.

The Thirty Years' War is perhaps the reason for the loss of much Renaissance jewelry. The nations involved, including the jewelry capitals of France, the Netherlands, Italy, and England used any resources they could to further their respective causes.

Baroque

The change of fashion in the seventeenth century to flowing silk fabrics meant that as the stiff tight costumes of the late Renaissance became outmoded, so too did the great display of formal ceremonial jewelry. A softer style emerged, with pearls becoming increasingly popular, even being artificially produced to satisfy the demand. Botany, in particular flowers, was a characteristic motif, as was the bow, which derived from the ribbons used in the Renaissance to secure jewels to garments. These were arranged symmetrically with emphasis on massed gemstones. While goldwork receded to provide merely a framework or setting for stones, new enamel techniques emerged, in particular painted enamels, which lent themselves to the naturalistic depiction of botanical themes and the softer style.

Mementi mori continued to remain current, encouraged by wars and plague. However, they began to commemorate the death of particular individuals. English jewelry in the mid-seventeenth century was much affected by the Civil War and Puritanism. Much commemorative jewelry (worn secretly or discreetly) was made following the execution of Charles I in 1649. Jewelry attracted Puritan hostility and even wedding rings were scorned, although they continued to be worn, defiantly ranging in style from plain gold bands to enameled and gem-set.

Eighteenth century

This century saw the rise of the gemstone and the beginning of distinctions between daytime and evening jewelry. The newly established middle class took their entertainment in the evening and so the demand increased for jewelry that was effective in artificial light. The châtelaine, a decorative belt-hook or clasp worn at the waist with a series of chains suspended and mounted with useful household accessories such as scissors, thimble, watch, keys, and so on, became a widespread and important daytime jewelry item for women. The foiling of stones (placing a foil backing on a stone to enhance its sparkle) was an innovative development. The emergence of the Rococo style and its flowing naturalism also influenced jewelry, with asymmetrical jeweled bouquets, curving lines, leaves, and feathers.

Neoclassical elements begin to emerge as early as the 1760s, coexisting with naturalistic bouquets and ribbons. Cameos and intaglios become a major element of this style, produced in the alternative materials of ceramic and glass or the effect created with painted enamels.

Diamonds

The discovery in 1725 of a new source of diamonds in Brazil was to have a profound effect on jewelry of the eighteenth century. The increased availability of diamonds and the innovations in stone-cutting led to greater prominence for stones, and the mounts of stone-set jewelry became more delicate.

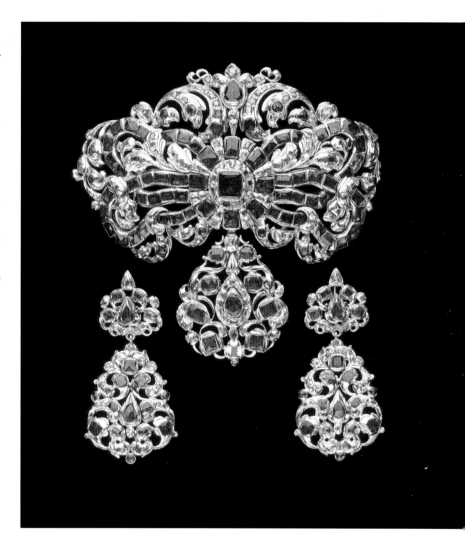

Jeweled bodice ornament with ribbon bow

Diamonds and hessonite garnets set in silver and gold scrolling foliage, with a pendant whose reverse is engraved with flowers (c. 1680–1700, Netherlands). The color of the ribbons is enhanced by placing foils beneath the stones. The great popularity of bow brooches, known later as Sévigne, continued into the eighteenth century and beyond.

Victorian garnet brooch

In the Victorian era (1837–1901) garnets were believed to enrich the blood and provide the wearer with a long, healthy life and to empower the wearer with the qualities of truth, constancy, and faith. During this time garnet jewelry developed its characteristic design of closely packed stones entirely dominating the metal setting.

Jewels were often made with separate elements that dismantled and could be worn in different combinations. In addition, large valuable stones were mounted in removable settings so they could be utilized in more than one piece. The foiling of diamonds to alter the color was also practiced, with soft pastel shades being desirable.

The eighteenth-century workshop

The jewelry industry by this point had become clearly structured and organized. Highly specialized workshops had developed (with apprentices, journeymen, and masters) who supplied retail jewelers, the majority of whom by now no longer made their own stock on the premises.

Nineteenth century

In the nineteenth century jewelry became more accessible than in previous periods, with the advent of machine-made jewelry and the beginnings of mass production. It was a time of great industrial development and social change and jewelry designs of this century were influenced by the expansion of archeological discoveries and nationalism. International exhibitions, like the Great Exhibition in London in 1851, cultivated artistic and technological innovations. By the end of the century, ideas of design reform had led to the founding of two new movements in Britain and Continental Europe: Arts and Crafts and Art Nouveau. America took to the fine jewelry stage as large American luxury houses such as Tiffany gained prominence.

Romanticism and nationalism

Romanticism was a reaction against the order and rationality that typified Classicism in general and the Neoclassicism of the eighteenth century in particular. It was characterized by an appreciation of the beauty of nature and a preoccupation with folk culture, and national and ethnic origins. An important idea of Romanticism was the assertion of nationalism; this was to become a central theme of Romantic art and greatly affected the jewelry of the time. Subsequently there was a revival of whole historic styles, such as Gothic and Renaissance, or elements of styles such as the naturalistic forms of the Baroque and Rococo, as nations tried to establish their identity.

Archeological style

Archeological jewelry was often copied closely from surviving finds, and it is this that distinguishes it from earlier Neoclassical jewelry, which by comparison was uninformed in relation to actual Classical jewelry artifacts. This style of jewelry was particularly favored by intellectuals of the 1860s to 1880s because it provided a counterfoil to the opulent diamond naturalist jewelry. Gold was the principal material, in keeping with the ancient provenance: ancient Etruscan and Greek jewelry was the most influential. Egyptian motifs were popular at the Paris Exhibition of 1897, following excavations undertaken during the digging of the Suez Canal. The Castellani family of goldsmiths/jewelers were well-known leaders of this style and their efforts had a political leaning: they featured Classical items found in Italy from antiquity onward and used this array of jewels to symbolize Italian unity. Eugène Fontenay of Paris had no such political message to convey. He mixed elements from different periods, producing supremely elegant jewels, and even incorporating brilliant-cut diamonds, which would never have occurred on a Classical piece.

America

Until the mid-nineteenth century virtually all Western jewelry was designed and made in Europe. Now America and Australia, precipitated by their gold rushes, joined the fray as European-trained jewelers settled in their major cities.

Mass production

The introduction to the jewelry trade of industrial processes saw the mass production of large quantities of cheap jewelry. Paste jewelry, which had emerged as a phenomenon in the eighteenth century, was to grow into an established costume-jewelry industry. Precious metals did not escape modes of mechanization: gold was

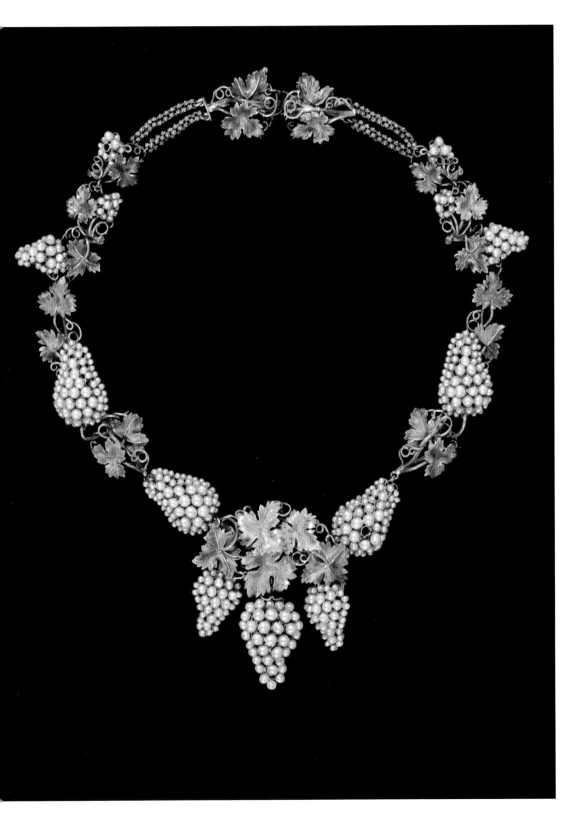

Naturalistic necklace
Colored gold and pearl necklace, dating from 1835–1845; an upmarket version of the fashionable "naturalistic" jewelry, interpreted here with pearls simulating grapes, and green-tinted gold leaves. Closer to nature were examples that imitated its colors with colored enamels, and its forms with chased or matted gold to simulate bark and leaves.

passed through rolling machines to produce large sheets of uniform thickness, which could then be stamped out into component parts for affordable jewelry. Chain-making, a previously labor-intensive technique, was transformed by the use of dedicated machines. The time required for the manufacture of jewelry was generally decreased by two-thirds. However, this development did not gain appeal universally and often fostered greater respect for artistic jewelry design and traditional crafts.

Novelties

The Victorian era spawned a fondness for eccentric and humorous trinkets. Everyday objects, vehicles, and pets were incorporated into designs, as were sporting and hunting themes. The taxidermy craze that took hold of the Victorians was expressed in jewelry with the mounting of exotic birds' heads and exotic and iridescent insects in jewelry pieces. Another feature was moving jewels powered by electricity.

Arts and Crafts

Artistic jewelry was highlighted by the Pre-Raphaelite Brotherhood, who began to have a wide influence by the 1870s. Their appreciation of unusual materials and handcrafted work was to pave the way for the Arts and Crafts movement to take hold in Britain. In jewelry it was a reaction to mechanization and mass production. Long-forgotten techniques were revived and although technology and machine production were tolerated when they proved useful, the craftsman was to reign supreme, and the production of handcrafts was considered to provide creative and satisfying employment. As this movement centered on the individual craftsman there was much variety in terms of style and method of production.

TWENTIETH CENTURY

Twentieth-century jewelry is predominantly characterized by two distinctly different developments; the rise of the luxury jewelry houses and the rise of the individual designer-jeweler/artist-jeweler. This century was also marked by an increase in the use of alternative materials for jewelry, for up until now, mainly precious and semiprecious materials were used.

Art Deco

As a movement, Art Deco originated in Paris, around 1910, prior to the onset of World War I. However, neither did it immediately replace Art Nouveau, nor was it particularly a reaction against it. Many individuals and firms created fine pieces in both periods and styles; Lalique is a prime example. A significant event of this period is the 1925 Exposition Internationale des Arts Décoratifs et Industriels Modernes. The style's name is adopted from a shortened version of this fair's title. The Art Deco style borrowed from the other Modernist movements of the time, such as Bauhaus, Cubism, Empire Neoclassicism, and Futurism.

The return to opulence following the forced austerity of World War I included a radical departure in design. Art Deco jewelry was characterized by linear forms and stylized and abstracted geometric motifs. Technology had a powerful influence in this "machine age," and angular and cylindrical shapes were combined to resemble the inner workings of machines. The industrial white metals of platinum, palladium, and rhodium begin to take center stage as jewelry metals par excellence. Diamonds dominated fine

Art Deco brooch

by Cartier (c.1925, Paris) Jazz-Age jewelry in the abstract Modernist style. The two opposing triangles of this hard-edged geometric bow brooch in Cartier's distinctive mode, create a perfect symmetry. Cartier exploited the use of platinum, whose strength made near-invisible settings possible, allowing maximum visibility for the pavé-set diamonds.

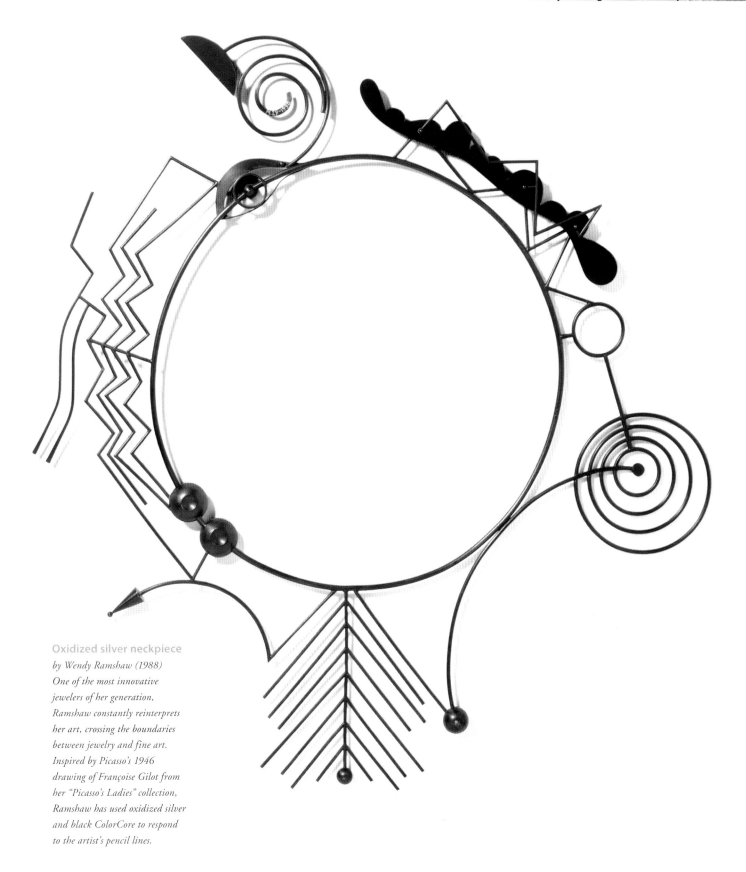

by Wendy Ramshaw (1988)
One of the most innovative
jewelers of her generation,
Ramshaw constantly reinterprets
her art, crossing the boundaries
between jewelry and fine art.
Inspired by Picasso's 1946
drawing of Françoise Gilot from
her "Picasso's Ladies" collection,
Ramshaw has used oxidized silver
and black ColorCore to respond
to the artist's pencil lines.

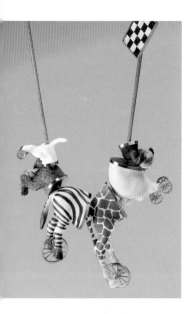

Second peleton

by Felieke van der Leest (2008)
Made from plastic animals, oxidized silver, and glass beads, this necklace teams traditional metalworking skills with plastic toys.

Exhaustion

by Scott Millar (2008)
This set of 61 brooches made from steel exhaust pipes was made into an installation art piece featuring a series of video stills of the artist pinning the brooches to his clothing.

jewelry and discoveries of new diamond sources in Africa expanded the supply. Stones were closely packed in minimal linear forms or geometric patterns and set into delicate platinum or white-gold settings. While fine evening jewelry was almost entirely white, bold color combinations also existed where jewelry of the time was inspired by Indian Mughal jewelry, Chinese design motifs, and "primitive" African art. The civilizations of ancient Egypt and the Aztecs were also to provide inspiration. By establishing an exotic cosmopolitan approach, Cartier and other Parisian firms, such as Van Cleef & Arpels, Boucheron, and the House of Mauboussin, were at the forefront of Art Deco design in jewelry.

Costume jewelry

Although costume jewelry grew out of the desire for the average person to have copies of the fine jewelry that was the preserve of the wealthy, it was to reach new heights in the twentieth century. Even Coco Chanel and Elsa Schiaparelli (whose principal designer was Jean Schlumberger) encouraged their wealthy clients to wear extravagant and theatrical bijoux de fantaisie; exciting and imaginative jewelry not bound by the constrictions of precious stones and materials—essentially jewels of the imagination.

Jewelry since the 1960s

The rise of the individual artist–craftsman, trained at art schools, was to precipitate the dramatic change undertaken in jewelry beginning in the 1960s. Their approach was more oriented toward self-expression than commercial venture, in opposition to the main focus of the major international luxury jewelry houses of the

time. New materials were embraced, expected forms and functions were challenged, and the boundaries between jewelry, sculpture, clothing, and performance art were explored. The materials used included newly developed materials, materials from other disciplines finding an outlet in jewelry, and the use of discarded materials as a form of recycling. For example, paper is hardly a "new" material, but paper jewelry could be considered a new development. This aspect in the development of jewelry is still current and ideas from this time continue to inform the current contemporary jewelry practice.

JEWELRY FOR THE TWENTY-FIRST CENTURY

It is difficult to write with authority on the twenty-first century as it has really only just begun. Projections can be made but there is no telling what this century truly has in store in terms of societal changes, and developments in art and design. What is already clear is the phenomenal surge of creativity across all mediums of art and design disciplines. Older ideas and dogmas galvanized in the twentieth century are being challenged. One of the most visible changes is the return of decoration to the forefront. Advances in computer and manufacturing technologies have led to the introduction of new materials and modes of production. While it is doubtful that the rise of the luxury brands will be stanched completely, there has been a shift in the concept of luxury from the attainment of desired consumer goods and services, spurred by the effects of the Industrial Revolution, to being more experience-based: the luxuries of time, travel, and self-fulfillment.

Following the democratization of "luxury" that occurred later in the twentieth century, what begins to emerge are more complex notions of specialness and exclusivity in relation to physical objects, surrounding a renewed interest in the origin of products, inclusive of materials, the method of manufacture, and the level of craftsmanship involved, whether it be handmade or innovative computer-aided manufacture.

Contemporary jewelry fits happily into these new modes of thought, and since the

1970s has developed in two different directions. There is work that references goldsmithing's traditional craftsmanship, in particular concerned with wearability and incorporating varied interpretations of beauty, and work with a more abstract emphasis; the ability to transmit a message or to analyze form and adapt and relate it to the body. Fashion is now firmly structured around seasonal reinventions of product with the tendency to recycle ideas and inspirations; however change is afoot, cross-pollination is occurring, and figures from the design world with their notions of timelessness, technological innovation, and cultural relevance are being approached for the input of ideas.

Studio jewelry

Studio jewelry has developed and grown since its inception in the 1960s, gaining a wider audience, and has begun to be considered an accessible art form rich in both ideas and possibilities. Function continues to be a concern for many contemporary jewelers but their work now often encompasses performance art and conceptual ideas. It is seen to engage with design, in particular architecture, fine art, and a range of applied art disciplines. A dialog is developing between the embrace of increasingly innovative technology, the return to traditional hand skills, and an organic approach to ornament and form. Issues surrounding the practices of sustainability and recycling are gaining ground and inform the jewelry making of many contemporary practitioners. Themes and subjects are wide-ranging and, in addition to aesthetic concerns, we see ideas expressed pertaining to cultural identity, the psyche and memory, existential thought, and conceptions of value and preciousness.

Moving gold disk ring

by Bernadine Chelvanayagam (c. 2009) A beautifully crafted 18k yellow and white gold dome riveted to a ring shank contains free-moving disks.

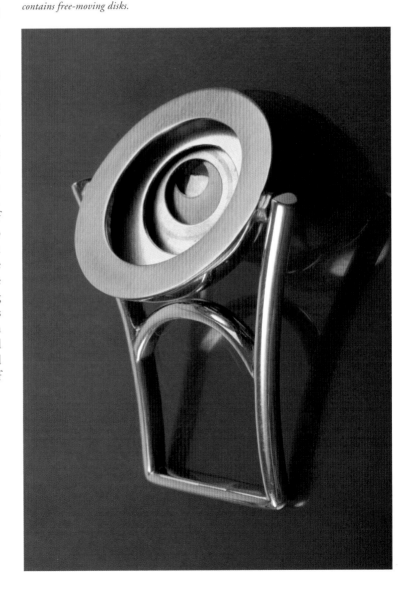

WORK SPACE, TOOLS, AND MATERIALS

WORK SPACE AND TOOLS

The first requirement of a jewelry maker is a solid bench or table to work at, this can take the form of a temporarily commandeered kitchen table or a dedicated, purpose-made jewelry-making workbench. Either way, it's important to put some thought into the arrangement of your work space so that it not only includes all the tools and equipment you need close to hand but is also a safe place to work. There is a vast range of tools that could potentially fill your workshop, subdivided into many categories, and this chapter contains a comprehensive listing of all you might need, from simple hand tools to more complex pieces of machinery.

Beginner's Kit

The equipment that you choose to buy will depend to some degree on the type of work you wish to do; however, there are some items that will be useful for every beginner jeweler, and in the following pages you'll find those tools marked as "Beginner's Kit" with a toolbag icon.

Finding a space to work in is the first step—whether you are starting out on the kitchen table with a clamped-on bench peg, converting the spare room, or renting workshop space. This section describes a few of the basic requirements for a small workshop where you can carry out bench work and soldering.

SETTING UP A SMALL WORKSHOP

Workshop furniture

Many jewelers start out working at the kitchen table, with a bench peg clamped to the table. This is fine for small bench work, but when the range of techniques you want to use increases, you may need more specific equipment and facilities.

In addition to a jeweler's bench, which is described in more detail on the following pages, you will need to allocate space for a soldering and heating area, storage for chemicals and tools, and fixed equipment such as a vise, rolling mill, or bench drill.

It is very useful to have a sink in the same room, and pickle and other chemicals should be used in this area.

Work surfaces can be made from thick, outsized shelves, which are secured to the wall and have supporting legs at the front. It is very important that all workshop furniture is structurally secured, usually by screwing it to the floor or walls. Freestanding surfaces will be subject to vibration during many working practices—this can make the processes noisier, and much less accurate. Vibrations can also cause tools to work their way off the edge of a surface. Place an extra supporting leg under heavy equipment such as rolling mills and vises.

Cut-down tree stumps are very good at absorbing the noise from hammering, and can be adapted so that small stakes can be set into them, but do make sure that they are at a good working height.

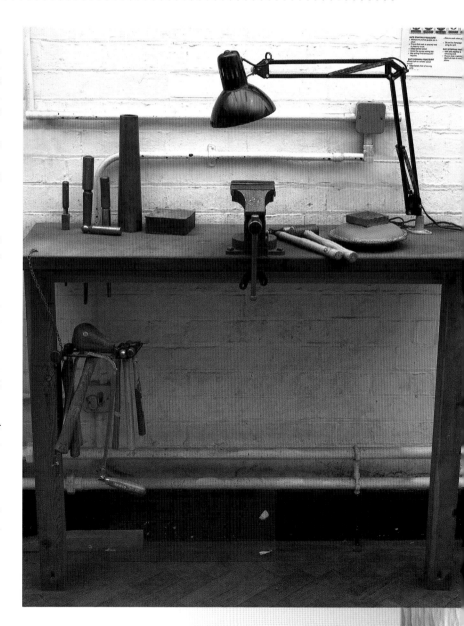

Creating a work space
A general-purpose workbench, with a vise, tool racks, and an angle-poise lamp.

Drill bits and snips
Useful tools and equipment, such as drill bits and snips, can be kept close to hand in small metal drawers or hung from shelving on cup hooks.

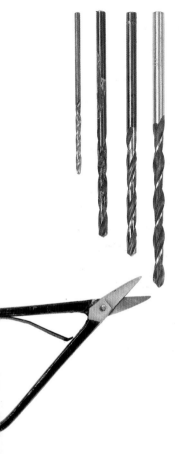

The height of work surfaces is crucial in a workshop—if the surface or equipment is too high or low, it can cause health problems. Adequate ventilation is also important, to dispel dust and low-level chemical fumes. Hazardous chemicals should only be used in an extraction unit, or out-of-doors.

Storage of tools

The setup of a jeweler's workshop will depend on the type of work he or she makes. The types of tools that you use most often will dictate how the scheme is arranged and what you need closest at hand. Metal drawers under the workbench are useful for storing small tools and equipment, such as saw blades, drill bits, emery paper, and sticks. Tools such as pliers, hammers, and mallets can be stored in a rack so that you can easily select them and pick them up. Shelving around the walls can be used for storing books, boxes, and many other things, and also provides a useful place to attach cup hooks from which tools or materials can hang.

Setting up a soldering area

The area that you use for soldering and heating must be adequately insulated to protect the surface underneath. A heatproof mat on the benchtop will insulate sufficiently during small soldering jobs, but it is advisable to create a specific area for heating large work. Use a layer of house bricks under a mat, and build walls using more mats—this will also make it more efficient to heat large pieces, as the heat will be reflected back. Make sure the heating area is ventilated; although drafts can be problematic during soldering and heating, these processes can give off harmful fumes, so an open window is advisable. Regularly vacuum the heating area to remove dust and flux from the heat mats, as well as oxides that have flaked off heated base metals.

The jeweler's bench

The bench is arguably the most important piece of equipment for any jeweler, providing a solid work surface that will allow for accurate working, as well as storage for tools. You can buy flat-packed benches relatively inexpensively, but they will not be of the same quality as handcrafted benches, which are traditionally made from beech and are built to last.

A traditional jeweler's bench is made of solid wood about 2 in (5 cm) thick. The bench is fixed firmly to a wall or stands rigidly on a solid floor. The bench has a large, curved section cut out from the front edge, under which a leather "skin" is hung to catch metal filings and dust. Ideally, the wooden surface should be sealed with a wax polish to keep metal filings from penetrating the surface. This surface can be easily cleaned and maintained with regular rewaxing. A varnished or plastic surface can be used instead; these surfaces are easy to clean, but they do not withstand heat and are therefore unsuitable for use as soldering supports.

The bench surface should be about 3 ft (1 m) high. This is higher than a standard table to allow for easy use of tools, particularly the jeweler's saw, and a clear view of the work. As a guide, when sitting upright at the bench, the work surface should be at about mid-chest level. A typist's chair is ideal to use when working at a bench, especially one with an adjustable seat—certain jobs will require a higher sitting position than others. Ensure that your back is properly supported and that you are sitting at the correct height for a particular task—your shoulders will soon let you know if the chair is set too high or low.

The bench needs to be brightly and directly lit. An adjustable reading lamp clamped to the back, left-hand corner of the bench (for a right-handed person) is ideal.

A flexshaft motor can be set to the right of the bench, either supported on a stand set into the bench, or hanging from a bracket secured to the wall above the bench. Other tools, such as a small

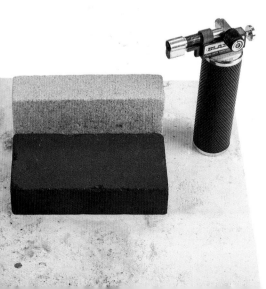

Soldering area
For small soldering jobs, a heatproof mat will be sufficient, but for larger pieces, you will need to set up a soldering area using house bricks and heatproof mats.

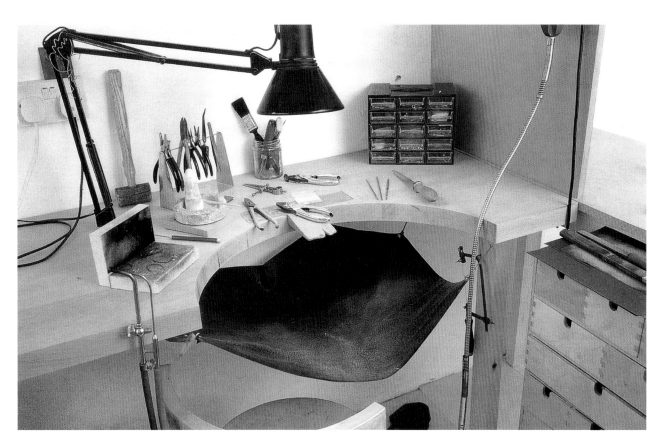

vise, can be attached to the bench to help hold tools or pieces while they are being worked. Files, pliers, and the saw frame are usually kept on or around the bench so they can be easily reached.

Working at the bench

The bench peg is used to steady and support the work, and is located in the center of the curved cut-out section. The peg, which is wedge-shaped, has one sloped side and one flat side; bench pegs are often fitted sloping side up, which is more convenient for filing and cleaning up. The peg can be wedged in place tightly, or secured with a nut so that it can be turned over; many benches have another peg fixed to the left-hand side of the curve (for right-handed people) which is flat, as a flat surface is better when using a jeweler's saw. The bench peg should be adapted to suit your specific needs: cutting a "V" into the center will allow more versatility in the support and holding of pieces while you are working them.

Rest either the work or the hand that is holding it on the bench peg to support and steady it—this allows you to apply more pressure in an accurate way and is a more efficient use of energy than working unsupported.

Put tools away after they have been used and sweep out the bench skin regularly, especially if you are working with different materials. Dusts from different metals should be saved and stored separately; these can be recycled at a refinery along with other scrap metal.

The jeweler's bench

Setting up your bench gives you the chance to arrange everything exactly as you need it.

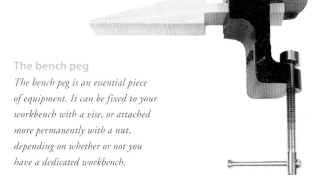

The bench peg

The bench peg is an essential piece of equipment. It can be fixed to your workbench with a vise, or attached more permanently with a nut, depending on whether or not you have a dedicated workbench.

CUTTING AND FILING

Basic hand tools, such as files and a jewelry saw, are essential for jewelry making. A few key tools will be sufficient when starting out, and this range can be expanded as your skills increase.

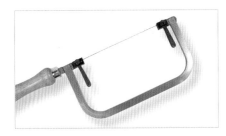

Jewelry Saw

Techniques: Cutting, fretwork, piercing.

Uses: A jewelry saw consists of a sprung steel frame set into a wooden or plastic handle. The frame is slightly flexible and holds a saw blade under tension, secured by two nuts. The frame is lightweight and can be used to cut very accurate detail in a range of materials. Never use pliers to tighten the nuts on the frame as this will damage the screw thread and shorten the life of the nut.

Range available: Two main types of saw are available: fixed frame and adjustable. Adjustable frames allow for shorter broken saw blades to be used. Saws with a deeper frame are useful for working on larger pieces, but are heavier and less easy to control accurately. There are several designs of nuts to hold the blade, and replacement nuts are often available separately.

Skill level: Basic.

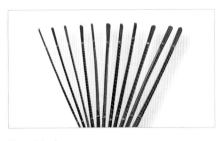

Saw Blades

Techniques: Cutting, fretwork, piercing.

Uses: Saw blades are used in a jewelry saw to cut or pierce metal. Size 2/0 is good for general-purpose uses, while 4/0 or 5/0 should be used for fine detail. As a guide, the blade will cut most efficiently with two and a half teeth per thickness of metal—larger sizes of saw blade are thicker and the teeth are more widely spaced. Spiral saw blades should be used for cutting soft materials, such as wax (see page 90).

Range available: A number of different brands of saw blades are on the market, available in a range of standard sizes. Size 4 is the coarsest and 8/0 is the finest. Especially hardened saw blades are available for platinum; these can also be used for piercing stainless steel.

Skill level: Basic.

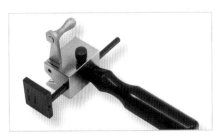

Tubing Cutter

Techniques: Cutting sections of tubing or rod.

Uses: These small vises are useful for holding tubing while a length is cut with a jewelry saw, and the "stop" allows you to cut many identical lengths. The cutter is supported in the "V" of a flat bench peg, and the stop length is set. The tubing is placed in the base of the "V," and the lever secures the tube with pressure from the left thumb. A saw is then used to cut the tubing, using the gap in the cutter as a guide.

Range available: A number of different designs are available: jointing tools and tubing cutters that hold the tubing or rod securely while it is cut; and tubing blocks, which hold tubing or rod and also allow the end to be filed absolutely true at 90-degree and 45-degree angles.

Skill level: Basic/intermediate.

Disk Cutter

Techniques: Cutting disks, punching holes.

Uses: Disk cutters are most often used to punch disks from sheet metal, but can also be used to punch holes in a number of different materials including metal, paper, card, and leather. Annealed metal is placed in the slot between holes and the corresponding punch is hammered or forced through in a vise. These cutters cannot punch metal thicker than 18 gauge (1 mm).

Range available: As sets, a graduating range of sizes of punch is supplied with a die, which has the corresponding holes.

Skill level: Basic.

Beginner's Kit
When this symbol appears next to a tool it indicates that it is an essential tool for a beginner.

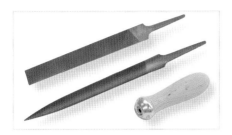

Hand Files

Technique: Filing.

Uses: Hand files are essential tools for any jeweler; they are used to remove metal and refine surfaces in preparation for other techniques. Files are usually supplied without handles, which are sold separately and must be fitted before use so that the file is comfortable to hold. Files cut as they are pushed forward across a surface, but do not cut on the return stroke. Store files in a fabric tool wrap, or in a rack so that they don't knock against each other, and keep them dry to prevent rust, which will damage the teeth.

Range available: A wide range of cuts, sizes, and profiles is available. It is useful to have one half-round cut 0 file, and a small range of cut 2 hand files (see page 309 for file shapes).

Skill level: Basic.

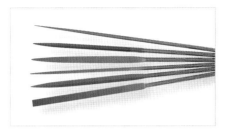

Needlefiles

Technique: Filing.

Uses: Needlefiles are used for more intricate work than hand files, because they are smaller and available in a greater range of profiles. High-quality needlefiles are expensive, but are a worthwhile investment. Jewelers often keep a separate set of needlefiles for gold or, if metals such as aluminum are used, to prevent cross-contamination.

Range available: A range of cuts, sizes, and profiles is available—see the table of file shapes in the Reference section, page 309. An inexpensive set of needlefiles is adequate when you are starting out, but you may need more shapes as your skill level progresses. Needlefiles made from a harder alloy are available for platinum and stainless steel.

Skill level: Basic.

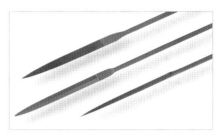

Escapement Files

Technique: Filing.

Uses: Watchmaker's files are incredibly fine needlefiles, which are useful for filing in narrow spaces or for very intricate and detailed work. These files are often a fine cut and will therefore give a refined surface to the metal. Take care when filing because these files are thin and very easily broken—try not to apply too much pressure.

Range available: Several different profiles; escapement files are usually cut 6.

Skill level: Intermediate.

Gapping Files

Technique: Filing parallel grooves.

Uses: A rectangular file on which the flat faces are blind, with the teeth positioned only along the edges that are slightly curved. Gapping files are ideal for filing out parallel grooves, such as those required when making hinges. Also called a jointing file.

Range available: A limited range of standard sizes is available. Parallel round files will give similar results.

Skill level: Intermediate.

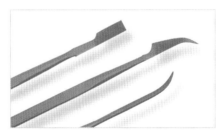

Riffler Files

Technique: Filing concave surfaces.

Uses: Riffler files have curved tips so that they can file into concave surfaces without the tip of the file scratching or damaging the surface of the metal. The files are double-ended, with short, tapered cutting ends that are often of the same profile.

Range available: There are many different profiles of riffler file. Cut 2 is the most common grade, but you may find others.

Skill level: Intermediate.

Diamond Files

Technique: Filing.

Uses: Diamond files are needlefiles that have particles of industrial-grade diamond bonded onto the surface, giving them a durable, abrasive surface that can be used on a range of materials, from the very soft to very hard materials such as steel, platinum, titanium, and glass. Although soft materials such as plastics can clog up these files, they are much more easily cleaned than conventional files—but use a solvent rather than water, which will cause rust.

Range available: There are a number of different profiles and sizes of needlefile. Silicone carbide-bonded files are an alternative option.

Skill level: Basic.

MARKING AND MEASURING

Engineering tools are used by jewelers for accurate marking and measuring. For precision fabrication, the dimensions of component parts are important, otherwise the pieces may not fit together properly, and it is often necessary to know the exact measurements of drill bits and other tools. Devices are also available that make measuring rings, bangles, fingers, and wrists quick and easy.

Steel Ruler

Techniques: Measuring, checking accuracy, a guide for marking tools.

Uses: For the accurate marking of metal, a steel ruler is often used in conjunction with a scribe or dividers, which mark the metal once the correct measurement has been decided. A ruler can also be used as a guide for marking tools in order to draw straight lines.

Range available: Rulers usually have both imperial and metric scales, and are either 6 in (15 cm) or 12 in (30 cm) in length. Some rulers also have useful conversion tables on the reverse.

Skill level: Basic.

Engineer's Square

Techniques: Marking, measuring, checking accuracy.

Uses: Engineered to a high degree of accuracy, an engineer's square can be used with a scribe to mark lines on metal. It is also useful for checking the accuracy of right-angles—place the true edge of a piece of metal against the thick side of the square so that the metal touches the thinner part of the square—if you can see light between your metal and the square, then the angle is not a right-angle.

Range available: Squares are available in several sizes—the scale of the pieces you usually make will determine the size you need.

Skill level: Basic.

Scribe

Technique: Marking.

Uses: Scribes are used in combination with a steel ruler or an engineer's square for very precise marking of measurements—the fine point means that it is accurate. The point of the scribe may need to be reground from time to time in order to keep it sharp. Designs can also be drawn freehand onto metal with a scribe, as preparation for fine piercing work or engraving.

Range available: Scribes are generally found in three types: a straight punch with a flat top, a pointed end, and a textured grip; double-ended with one straight end and one hooked end; or a double-ended combination scribe and burnisher.

Skill level: Basic.

Dividers

Techniques: Marking, dividing, drawing circles on metal.

Uses: Dividers are useful for marking perfect circles, concentric circles, and for finding the centers of circles, including the ends of pieces of rod. Another common use is to make parallel marks by using the side of a metal sheet as a reference. If the dividers are not adjusted after use, then the same measurement can be applied repeatedly. Dividers are also used for marking parallel intervals on wax ring tubes, making accurate cutting easier.

Range available: Dividers come in a range of sizes, and a number of variations can also be sourced—for marking internal spaces, the legs of the dividers are curved outward; pivoted legs allow for accurate marking of vertical surfaces.

Skill level: Basic.

Beginner's Kit
When this symbol appears next to a tool it indicates that it is an essential tool for a beginner.

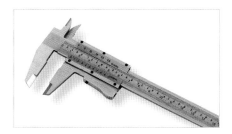

Vernier Gauge

Technique: Accurate measurement of internal and external dimensions.

Uses: Gauges are used for measuring the thickness of metal sheet and the diameter of rod or drill bits. The object being measured is placed between the jaws of the gauge, and the jaws are slid shut so that the object is held tightly. The measurement can then be read from the scale. Internal dimensions can be measured by using the protruding jaws on the top of the gauge.

Range available: Steel gauges are more accurate than plastic, but are also more costly. Several different designs are available: sliding gauge, digital display, and dial. Most gauges have both imperial and metric scales.

Skill level: Basic.

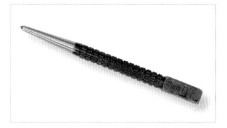

Center Punch

Techniques: Center-punching for drilled holes, applying stamped patterns.

Uses: A center punch should be tapped with a general-purpose metal hammer. This creates a guide mark in the surface of the metal for the drill bit to sit in, and will prevent the bit from slipping. The point of a center punch differs from that of a scribe, in that it is much wider. You can create repeated patterns by hitting the center punch into the metal repeatedly.

Range available: There are two types of center punch—those that need to be hit with a hammer, and spring-loaded automatic center punches that can be adjusted to increase the force with which they work.

Skill level: Basic.

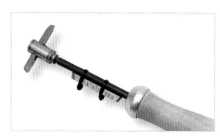

Scoring Tool

Techniques: Scoring metal prior to folding, creating decorative lines.

Uses: To create sharp corners or folds in metal, it is necessary to remove metal from the inside of the fold. This is done with a scoring tool, which carves out a sliver of metal as the tip is dragged along the surface. A steel ruler is often used as a guide, to ensure that a straight cut is made.

Range available: The cutting points are either fixed or interchangeable and are set into a wooden handle. You can make your own scoring tool from an old file with the last ½ in (1 cm) of the tang bent down and ground to a sharp point.

Skill level: Intermediate.

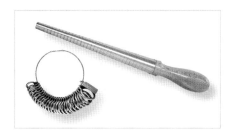

Wheatsheaf Ring Gauges

Technique: Measuring either fingers or rings in order to determine ring size.

Uses: Ring gauges come as a series of rings, in graduated sizes. These rings can be tried on the finger to test the size. The width of a ring will affect the size it needs to be—wide bands should be a larger size to fit over the knuckle. Some ring mandrels have ring sizes marked down the length, so that rings can be put onto the mandrel and the size read off the scale.

Range available: Gauges mimic different styles of ring to give more accurate measurements—so are often D-shaped or a thin shank. They are either strung together on a hoop or boxed as a set of separate rings. Some sets include half sizes. Individual plastic ring sizers and card templates with holes are also available, but these are not as accurate. Mandrels with ring sizes printed on them are made from either steel or aluminum.

Skill level: Basic.

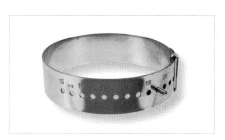

Bangle Sizer

Technique: For measuring hand or bangle size.

Uses: A bangle sizer is a strip of metal with a peg at one end, and a series of holes that allow it to be temporarily fixed at a particular diameter. The sizer is slipped over the hand to test the diameter, and adjusted if necessary. These sizers have a scale of measurements along the length that indicate the circumference of the chosen size. Wooden bangle mandrels are used to measure the size of the bangle, and have sizes marked down the length.

Range available: There are two basic designs of bangle sizer: those for measuring the hand, and those for measuring the bangle.

Skill level: Basic.

Burnisher

Techniques: Smoothing metal, work hardening.

Uses: A polished steel burnisher is a versatile tool, and can be used for a number of different techniques. Because steel is harder than precious metals, the burnisher imparts a shine to areas it is rubbed across and can be used to add contrast to matte finishes by highlighting the edges, especially of pierced work, and to work-harden metal wire, such as earring hooks or brooch pins. In engraving, a curved burnisher is used to burnish over slips of the graver, by pushing a small amount of metal into the scratch, so disguising the error. The burnisher works better when lubricated with oil or wax. A burnisher is also useful for opening fold forms (see page 136).

Range available: Polished steel burnishers are either curved or straight and come in a range of lengths and widths. For hard stone burnishers, see Stone-setting tools, page 52.

Skill level: Basic.

HAMMERS AND MALLETS

There is a bewildering range of hammers available to jewelers. Most basic needs will be catered for with a jobbing hammer and a rawhide mallet, but for more advanced techniques such as forging, chasing, and anticlastic raising, specialist hammers are required.

Jobbing Hammer

Techniques: General purpose hammering and hammer texturing.

Uses: Also called a ball-peen hammer. The flat face of the hammer can be used for hitting other tools such as center punches, pattern punches, and dapping punches when riveting. The face will become marked from use because the steel tools are as hard as the hammer, therefore a cheap hammer can be kept aside for any job where the quality of the face is not crucial. The curved face can be used for a number of different tasks, including sinking and hammered textures.

Range available: Different weights of head can be found; a jobbing hammer head is usually "ball peen" (one flat face and one domed face) but may also be "cross peen" (one flat face and one thin, narrow face).

Skill level: Basic.

Riveting Hammer

Techniques: Riveting, hammered textures.

Uses: Riveting hammers have one flat circular face and a narrow rectangular flat face. The lightweight head can be used for many small tasks in jewelry, including hardening and straightening wire—the flat face will not stretch the metal. Riveting hammers are also used for making flat-headed rivets and tapping pins into hinges.

Range available: Different weights of head are available, but a small riveting hammer is potentially the most useful size to have.

Skill level: Basic.

Raising Hammer

Techniques: Raising, anticlastic raising, forging, hammered textures, caulking.

Uses: A raising hammer has two long, semicylindrical faces, with one face more gently curved than the other. This hammer is used to stretch metal—the cylindrical shape means that the metal is only stretched in one plane, which allows for accurate control during forging. The edge of a form made from sheet can be thickened up, if you hit it end-on with a raising hammer.

Range available: Different weights and alternative shapes of head—some have one horizontally set face and one vertically set face. Necking hammers have longer heads with smaller faces.

Skill level: Intermediate.

Blocking Hammer

Techniques: Blocking, forging, upsetting, hammered textures.

Uses: A blocking hammer has two domed faces and is used to block in sheet metal as part of the raising process. This is carried out either on a sandbag, or in a recess in a wooden stake or stump. The hammer can also be used to "upset" wire or rod when it is secured vertically and hit end-on, thus spreading the end.

Range available: Different weights of head and degrees of curvature on the faces of the hammer can be found.

Skill level: Intermediate.

Beginner's Kit
When this symbol appears next to a tool it indicates that it is an essential tool for a beginner.

Chasing Hammer

Techniques: Chasing, hammered textures, riveting.

Uses: One large circular flat face backed with a small ball distinguishes a chasing hammer; the flat face is used to tap the chasing punch. This hammer also has a distinctively shaped handle that is designed to rock smoothly in the hand when chasing, and the narrow width of the shaft gives the hammer a spring-back after it has hit the chasing punch. The small domed face of the hammer is useful for spreading rivet heads.

Range available: The basic shape of chasing hammers is always the same, but different weights of head are available. Lightweight hammers are used for very fine detail, and heavier hammers have more force.

Skill level: Intermediate.

Planishing Hammer

Techniques: Planishing, forging, work hardening, texturing.

Uses: Planishing hammers are used to remove marks made by other hammers, imparting a subtle, even texture to the surface of the metal. One face of the hammer is completely flat and the other has a gentle curve—both faces should be kept highly polished so that the planished surface of the metal is reflective. The hammer blows should overlap each other for the best effect, and the piece of work needs to be supported on a metal stake, such a ring mandrel or flat steel stake.

Range available: Several sizes, weights, and shapes of hammer are available.

Skill level: Intermediate/advanced.

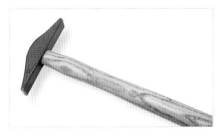

Creasing Hammer

Techniques: Forging, anticlastic raising, hammered textures, raising.

Uses: A creasing hammer has two narrow, semicylindrical faces that will stretch metal in one direction in a similar manner to a raising hammer. The narrow head of a creasing hammer makes it useful for raising small anticlastic forms as it can get inside the form without making contact with other areas of the piece.

Range available: Different weights and variations in the curve of the faces can be found, depending on the manufacturer.

Skill level: Intermediate.

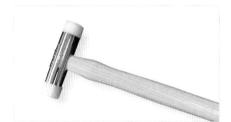

Nylon Mallet

Techniques: Bending and forming, truing forms.

Uses: Mallets will form metal without marking the surface, but can also be used for hitting other tools such as doming punches with less force and noise than a jobbing hammer. The nylon faces will eventually degrade through use, but they can be reground or sanded flat again. Small nylon mallets are useful for shaping thin or small forms, but a heavier mallet may be required for larger work; "dead blow" mallets have sand or lead shot trapped inside the head, so that they give a more forceful blow.

Range available: Different sizes, shapes, and weights of mallets can be found. Replacement heads are available for some brands of mallet, which can be cut and shaped if necessary.

Skill level: Basic.

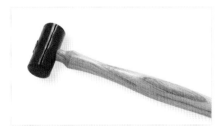

Rawhide Mallet

Techniques: Bending, forming, truing forms, gradual stretching.

Uses: When new, rawhide mallets are hard with little resistance. With use the head will begin to soften, and eventually the shape of the face will become deformed, but can be trimmed down to give a true face again. Mallets are used to shape or flatten metal without marking it—mallet heads are much softer than the metal. A steel stake is used to support the metal while it is being hit with a mallet. Lightweight mallets are suitable for forming rings and other metal forms less than 8 gauge (3 mm) thick; successful bending relies on technique rather than force.

Range available: Several sizes and weights of rawhide mallet are generally available.

Skill level: Basic.

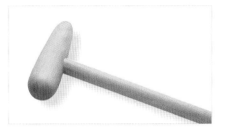

Bossing Mallet

Techniques: Sinking, truing.

Uses: This pear-shaped mallet is most often used in silversmithing techniques. The narrow end is used for the controlled shaping of sheet metal into a depression in a hardwood stake, and the wider end is used for truing the form over a domed stake. The force of the blow is more evenly spread when the wide end is used; the narrow end exerts a more concentrated blow and so will make the metal move more quickly.

Range available: Different weights and sizes are available, but bossing mallets should be made from boxwood, which is dense and hard.

Skill level: Basic/intermediate.

FORMING: STAKES, FORMERS, AND MARKING PUNCHES

Stakes and formers are often used in conjunction with hammers and mallets to bend and shape metal sheet, rod, and wire. Punches are used to add decorative detail to designs, in the form of imprinted designs or relief forms and patterns.

Ring Mandrel

Techniques: Bending, forming, truing forms, sizing.

Uses: Mandrels are most often used for forming a ring with a mallet, truing the form once it has been soldered, and forcing the piece up the mandrel to enlarge it. The mandrel is usually held horizontally in a vise, but can be supported in the "V" of a bench peg while sizing or truing a ring.

Range available: Ring mandrels are available in a wide range of shapes and sizes. The most common profile (cross-section) is round, but oval and square mandrels are also useful. Other styles available include pear-shaped, mandrels with a groove (for sizing or truing stone-set rings), and mandrels marked with ring sizes.

Skill level: Basic.

Bangle Mandrel

Techniques: Bending, forming, truing forms, sizing.

Uses: Oval mandrels are more suitable for forming open cuffs than bangles, and are useful formers when bending thermoplastics such as acrylic. Round mandrels can be used to shape circular bangles or other large curved forms, with the use of a hammer or mallet. Wooden inserts can be used to prevent damage to the mandrel when it is held in a vise.

Range available: Steel bangle mandrels are usually available as round or oval in profile, and in several sizes. Wooden mandrels are a cheaper alternative to those made from steel, but will not have such a long lifespan.

Skill level: Basic/intermediate.

Flat Stake

Techniques: Forging, riveting, truing, hammer texturing, stamping.

Uses: Flat stakes can be used in a vise for forging, on the bench, or on a sandbag to reduce the noise created from hammering. The stake provides a hard resistant surface to support metal while it is being worked, and will prevent sheet metal from distorting as it would if hit on a wooden surface. The surface of the block should be perfectly flat, so it is also useful for checking that pieces are "true." Two flat stakes can be used to straighten annealed wire by rolling it in between them.

Range available: Freestanding flat stakes come in a range of sizes—buy the largest one that you can afford. Some flat stakes are mounted on a stem, and will need to be fixed in a vise before they are used.

Skill level: Basic.

Bench Anvil

Techniques: Forming, bending, truing, riveting.

Uses: Also called a "sparrow hawk." The bench anvil is a supporting stake with a flat area, and two projections of different shapes, which are useful for adjusting awkward shapes, or riveting in a restricted space. It is often used as a rest when performing other techniques such as riveting, and may be used in a vise or free-standing.

Range available: Designs of bench anvils vary slightly, but the form is generally the same.

Skill level: Basic.

Beginner's Kit
When this symbol appears next to a tool it indicates that it is an essential tool for a beginner.

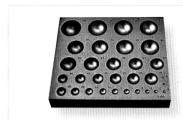

Dapping Block

Technique: Making domes.

Uses: Dapping blocks are used in conjunction with dapping punches (either steel or boxwood) to curve sheet metal forms. The block should be placed on a sandbag to reduce the noise produced when the dapping punch is struck. Dapping blocks can also be used to form heated thermoplastics.

Range available: Dapping blocks and cubes are made of either steel or brass, and have a graduating range of depressions. The most common range is ¹⁄₁₆–1¼ in (2–30 mm) in diameter. Outsize blocks have singular or double depressions and are often sold with the corresponding punch.

Skill level: Basic.

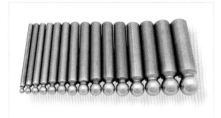

Dapping Punches

Techniques: Making domes, chasing, sinking, raising, truing, riveting, making textures.

Uses: Dapping punches have a polished ball on one end, and are designed to be hit with a mallet or jobbing hammer on the other. They can be used for a variety of techniques: when used with a dapping block, they will force metal to curve. Dapping punches can also be used in the same way as domed stakes for truing or planishing but for smaller scale forms, and can also be used as punches for spreading rivet heads, chasing, and making textures.

Range available: Punches are made from either steel or boxwood, and are sold individually or in sets.

Skill level: Basic.

Swage Block

Techniques: Swaging, forming, making D-section wire.

Uses: Swage blocks are similar to dapping blocks, but curve sheet metal in one plane only. Straight steel punches are used to hammer sheet metal into the "U"-shaped recess. This process can be used to form metal sheet into a curve or, if the sheet is curved in successively smaller channels of the swage block, the ends can be made to meet, and the join soldered to make tubing. Round wire can be hammered into the recesses to flatten the top, making it D-section.

Range available: Swage blocks come in different size ranges, each one having a graduating series of recesses.

Skill level: Basic.

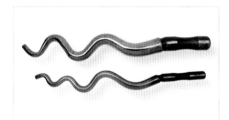

Sinusoidal Stake

Technique: Anticlastic raising.

Uses: Sinusoidal stakes are used almost exclusively for anticlastic raising (see page 140), and the unusual shape of the stake is designed to effect specific changes in the dimensions of sheet metal when hit with a wedge-shaped mallet or hammer. The size of the troughs and peaks of the stake will affect the shape of the form being created and the amount of curvature that can be achieved.

Range available: Large, medium, and small; some stakes have only one size of trough. Sinusoidal stakes are available from specialist suppliers of jewelry tools.

Skill level: Intermediate.

Sandbag

Techniques: Sinking, doming, raising, engraving.

Uses: Sandbags are leather cushions filled with sand that are used to support work or tools, and have the added benefit that they will reduce the noise produced from hammering. In processes such as sinking or raising, the sandbag supports the work while it is shaped, offering a resistant yet malleable medium, which allows the metal to be deformed. It takes time for the leather of new sandbags to become supple and recess properly when sinking. A sandbag is often used to support engraving work mounted on a block of wood; a piece of leather is placed under the wood so that it can be more easily rotated.

Range available: Different diameters of sandbag are available.

Skill level: Basic.

Domed Stakes

Techniques: Forging, raising, planishing.

Uses: More commonly found in the silversmith's workshop, domed stakes are used mounted in a vise. These stakes can be used to exaggerate the action of the hammer when forging, to true raised forms, and for generally shaping smooth curves. For planishing, use a stake that is closest in profile to the existing curve of the form so that it does not distort or stretch too much.

Range available: Different diameters and degrees of curvature are available.

Skill level: Intermediate.

Pitch Bowl

Techniques: Chasing, repoussé.

Uses: A heavy cast-iron bowl with a rounded base that is filled with pitch, and is used as a supporting medium when chasing designs on metal. The bowl needs to be supported on a ring so that its position can be easily adjusted. The pitch is a solid medium, but is slightly elastic and so allows movement of the metal with some resistance. Chasing punches and a chasing hammer are used to emboss the metal while it is secured on the surface of the pitch.

Range available: Different diameters of bowl are available—choose a size that suits the scale of your work. Pitch is sold separately, and needs to be mixed with a number of other ingredients to give it the correct consistency.

Skill level: Basic/intermediate.

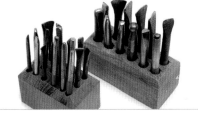

Chasing Punches

Techniques: Chasing, making textures.

Uses: Chasing punches are used in conjunction with a chasing hammer and pitch bowl to apply three-dimensional relief designs to sheet metal. There are four main types of punches: lining tools, which are used to chase outlines; blocking punches, which are cushion-shaped or domed; planishing punches, which are a shallow cushion shape; and matting punches, which are textured and are used to apply a matte finish to areas of the design. It is usual to have a range of sizes of each type of punch so that there is something appropriate for every eventuality.

Range available: You can buy a wide range of chasing punches but, as a number of different tools will be needed, it is worth considering hand-making your own punches from tool steel.

Skill level: Intermediate.

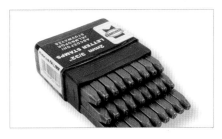

Pattern Punches

Techniques: Decorative textures, chasing.

Uses: Punches are used to strike patterns on metal, and are held vertically and hit with a jobbing hammer, working on a steel surface. Swan-neck punches have a bent section so that they can be used to imprint the inner surfaces of rings. You can make your own punches from tool steel, using etching or carving to make the design, but these will need to be tempered and hardened before they can be used.

Range available: Letter and number punches are sold in sets, either as straight or swan-neck punches. Pattern punches are usually sold individually, with designs such as flowers or textures being common. Steel rod for making punches is available in a variety of diameters.

Skill level: Basic.

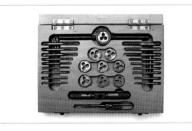

Tap and Die Sets

Techniques: Screw threads, texturing wire and rod.

Uses: Tap and dies are used to cut screw threads, and enable nuts and bolts to be made from precious metals. The tap is a threaded steel rod held in a special vise, and is used to thread holes or tube; the die is held in a wrench and will cut a thread around the outside of the rod or wire being used. The die wrench can also be adjusted to fine-tune the outside diameter of the thread.

Range available: Both imperial and metric taps and dies can be found. It is important to stick with one system, as they aren't interchangeable. Boxed sets usually contain a range of sizes of taps and dies and the wrenches that they need, but the pieces can be purchased separately.

Skill level: Intermediate.

FORMING: PLIERS

A range of pliers is needed to bend, form, and hold metal. The shape of the jaws will directly influence the effect that the pliers have when used. Choose pliers that are a suitable size for the job in hand, and ensure that the pliers have boxed joints, and that the jaws match up well.

Beginner's Kit
When this symbol appears next to a tool it indicates that it is an essential tool for a beginner.

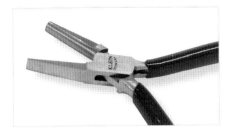

Half-Round Pliers

Techniques: Bending, curving.

Uses: Also called ring pliers, because they can be used to bend sheet or wire into a ring. The curved side of the pliers always sits on the inner surface of the curve that is being formed, and the flat side provides leverage against which the metal can be bent without it being damaged. They are also useful for forming earring hooks.

Range available: Different widths of jaws and degrees of curvature can be found; some half-round pliers are large and slightly curved and some are thin and very curved. Pliers with nylon jaws are also available.

Skill level: Basic.

Round-Nose Pliers

Techniques: Curving, curling, bending.

Uses: Round-nose pliers are used for curving and curling wire, and can make very small diameter turns. They can mark the outer side of curved wire when bending if too much pressure is used—for thicker wires and larger diameter curves use half-round pliers.

Range available: There are many slight variations in the degree of tapering, and the diameter of the jaws of round-nose pliers.

Skill level: Basic.

Flat Pliers

Techniques: Bending, folding, straightening.

Uses: Pliers with two flat-faced jaws are used to bend and fold sheet and wire, or straighten kinks out. Flat pliers are also useful for pulling rivets or pins through holes.

Range available: Different widths of jaw are available and it is a matter of personal preference as to which is the most useful. Most styles of pliers are available plain or sprung, meaning that they will automatically reopen after being closed; sprung pliers are only fractionally more expensive than plain and are easier to use.

Skill level: Basic.

Snipe-Nose (chain) Pliers

Techniques: Bending, adjusting, closing chain links.

Uses: Snipe-nose pliers have tapered jaws that come to a point. The jaws are flat inside and can therefore be used to access awkward spaces, and easily fit inside or around chain links when closing or adjusting them.

Range available: Different sizes and degrees of taper will vary with the brand. Snipe-nose pliers with serrated jaws can also be sourced.

Skill level: Basic.

Parallel Pliers

Techniques: Folding, bending, straightening, holding small work securely.

Uses: Parallel pliers open with a parallel action, unlike other pliers that work with a scissor-action, and can therefore be used to hold work without damaging it. This makes them useful for bending right angles and straightening kinks in wire without marking the metal badly.

Range available: Many different variations of parallel pliers can be found. The most common are flat-faced, but snipe-nose, half-round, and sprung variations are available, as well as parallel-action cutters.

Skill level: Basic.

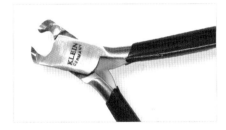

Top Cutters

Technique: Cutting wire.

Uses: Top, or end, cutters can be used to cut wire of less than 17 gauge (1.3 mm) if it is soft, and up to 24 gauge (0.5 mm) if it is hard. For larger diameter wires, use heavy-duty cutters or a jewelry saw. Don't cut steel wire because it will damage the cutters. It is useful to have a cheap pair of cutters that can be abused, and keep a good sharp pair for accurate cutting.

Range available: Several profiles are available; some have one narrow pointed end, and these are useful for getting into small spaces to cut. Side cutters are another alternative, but are not as versatile.

Skill level: Basic.

HAND DRILLS, BITS, AND BURRS

This section illustrates the tools needed for drilling, grinding, and shaping metal and other materials, for techniques such as stone setting, riveting, or carving. Drill bits and burrs can be used with hand drills and pin vises, which are inexpensive and very useful, but can also be used with a flexshaft motor.

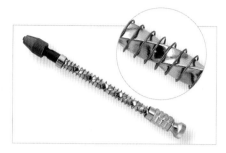

Archimedean Drill

Technique: Drilling.

Uses: This small drilling device has a moveable collet that twists around a shaft, making the head spin as the collet is moved up and down. The drill bit is held in a collet within the head of the drill. Twist drill bits only cut in one direction, and this drill moves the bit both ways, so is not very efficient and its operation requires the use of both hands.

Range available: There are variations on a standard design; some Archimedean drills are spring-loaded to make them easier to use.

Skill level: Basic.

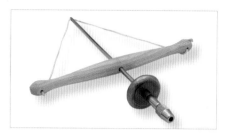

Bow Drill

Technique: Drilling.

Uses: A bow drill is hand-powered, driven by a string that connects the central shaft and wooden handle. The handle is moved up and down and the string twists and untwists around the central shaft, rotating it. It does take practice to get the rhythm going and sustain it, but it is possible to use the drill with one hand and control the pressure and speed of the cutting with accuracy.

Range available: There are variations on the traditional design, and different-sized collets may be supplied with the drill.

Skill level: Basic.

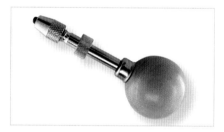

Pin Vise

Techniques: Riveting, drilling, stone setting.

Uses: Pin vises are very useful for holding small tools such as drills and burrs when drilling by hand, or when making fine adjustments to stone settings so that the stone fits perfectly into the setting. A drill bit held in a pin vise can also be used for making reference marks and lining up holes in different layers of materials in preparation for riveting.

Range available: A number of different designs are available: single-ended, double-ended, double-ended with collets held inside, swivel-top, or with a wooden handle.

🧰 **Skill level:** Basic.

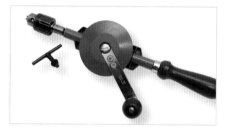

Hand Drill

Techniques: Drilling, twisting wire.

Uses: Because a hand drill requires two hands to be operated, its applications are limited. Older models of drills may have exposed gears, so take care to keep fingers clear of moving parts when the drill is being operated. Hand drills are not suitable for precision work as they are relatively large and heavy, making very accurate control difficult, but they are perfect for making twisted wire, with one end of the wire secured in a vise.

Range available: There are several different designs; you may tighten jaws with a chuck key, or by hand.

Skill level: Basic.

🧰 **Beginner's Kit**
When this symbol appears next to a tool it indicates that it is an essential tool for a beginner.

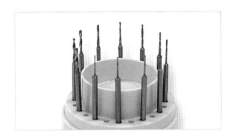

Drill Bits

Technique: Drilling holes.

Uses: Drill bits are used to make holes, which may be decorative or a starting point for other techniques such as piercing or riveting. They are often made from high-speed steel, but may be tungsten carbide, which will not blunt as quickly; lubricants can be used to prolong the life of drill bits.

Range available: Many different sizes, in a range of very small increments from 30 gauge (0.2 mm) to 1 in (25 mm). Usually available individually or in sets of commonly used sizes in jewelry.

Skill level: Basic.

Diamond Drills

Technique: Drilling holes.

Uses: For drilling very hard materials such as glass, porcelain, and semiprecious stones it is necessary to use a drill bit coated with diamond grit. These drill bits should be lubricated with water while cutting, and several different sizes of bits will be needed to drill larger holes in order to work up to the final size. Use diamond burrs or a reamer to chamfer the edge of the drilled hole to prevent chipping.

Range available: There is a range of different diameters available, usually between 20 gauge (0.8 mm) and 12 gauge (2.0 mm).

Skill level: Basic/intermediate.

Pearl Drills

Technique: Drilling holes in pearls.

Uses: These drill bits are specially designed to prevent chipping of the nacre when drilling pearls, and can be used to enlarge predrilled holes as well as to half- or full-drill pearls. Pearls can be held in a pearl vise while drilling so that there is no risk of slipping, or in fingers wrapped with protective tape.

Range available: A variety of diameters of pearl drill bits can be sourced.

Skill level: Intermediate.

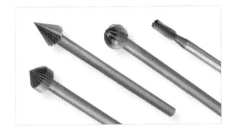

Burrs

Techniques: Shaping, carving, stone setting, countersinking.

Uses: Burrs are most easily used in a flexshaft motor for the fast removal of small areas of metal or other materials, but can also be used in a pin vise to tidy drilled holes or for very slight adjustments to stone settings. For burring out seats for stones, the burr should be the same diameter as the stone. See Reference, page 309, for the different shapes of burr. Burrs should be stored upright in a block or rack with individual holes to keep the burrs from touching, and should always be used with a lubricant to help keep them sharper for longer.

Range available: A wide variety of profiles and sizes of high-speed steel burrs are available.

Skill level: Basic/intermediate.

Diamond Burrs

Techniques: Shaping, carving, countersinking.

Uses: A diamond burr is a steel shank with a shaped head, which has a coating of industrial-grade diamond powder. For grinding glass and other hard materials such as stones, they are used with water as a lubricant, which also keeps the dust in solution; the burr is dipped into a small pot of water at regular intervals to keep the surface of the material wet. Special care must be taken when using water with electrical tools.

Range available: A variety of profiles and sizes can be found. Low-quality diamond burrs are a much cheaper option, because the burrs wear out quickly if used incorrectly.

Skill level: Basic.

Carbide Burrs

Techniques: Grinding, shaping, carving.

Uses: When used in a flexshaft motor, carbide burrs will grind most materials and last longer than high-speed steel burrs. The burrs should be stored in a stand so that they don't become chipped or damaged through contact with each other.

Range available: A variety of profiles are available, mounted on a steel shank. Carborandum stone is available in small blocks or sticks and is often used as a rough abrasive to grind enamel once it has been fired onto metal. Use with water.

Skill level: Basic/intermediate.

SOLDERING TOOLS

Soldering is a crucial technique in jewelry making, and it is essential to have the correct equipment; a hand torch will be adequate for those starting out with small-scale jewelry pieces, but a torch linked up to bottled gas will be necessary for larger scale pieces, or if you plan to do a great deal of soldering.

Hand Torch

Techniques: Annealing, soldering, applying heat patinas.

Uses: Filled with lighter gas (butane), the small flame means that the hand torch is only suitable for small-scale soldering and annealing jobs, because larger pieces of metal will take too long to reach temperature. It is most suitable for soldering chain and other fine work.

Range available: A number of different brands are available, but try to source a torch on which the flame can be adjusted.

 Skill level: Basic.

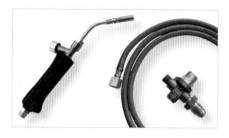

Gas Torch

Techniques: Annealing, soldering, applying heat patinas, fusing, warming pitch.

Uses: Although a sizeable outlay is required, a good-quality gas torch is a necessity if you plan to do much soldering and heating as part of your jewelry making. The gas torch needs to be connected to bottled propane with reinforced rubber hose, and a gas pressure regulator. A range of different-sized heads that can be interchanged on the hand piece are available, and these allow different sizes of flame to be used, appropriate to the work being done.

Range available: Stick to one brand of head and attachments, otherwise the parts will not be compatible. Ask the supplier for advice on setting up the torch to the gas supply, and follow the manufacturer's guidelines.

Skill level: Basic.

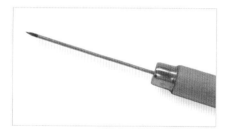

Soldering Probe

Technique: Soldering.

Uses: A probe is used to position or apply solder to a piece while it is being heated, and can also be used to spread molten solder across a surface. The probe itself does not conduct heat well and so even though it is relatively short, it can be held close to the heat source without the other end getting hot.

Range available: They are often made from titanium rod, and mounted in a wooden handle.

 Skill level: Basic.

Binding Wire

Techniques: Soldering, model making, copper plating.

Uses: Binding wire is predominantly used to hold parts of a piece in position while soldering. The diameter of wire used is dependent on the job—thin wire doubled up is suitable for most small-scale work. Metal expands when heated, and if the wire is too tight or too thick it can mark silver deeply. Iron binding wire will copper plate other metals if it is present in the pickling solution; stainless steel binding wire does not have this drawback but is more expensive.

Range available: Soft iron or stainless steel binding wires can be found in a variety of diameters, and are usually sold on a reel.

 Skill level: Basic.

 Beginner's Kit
When this symbol appears next to a tool it indicates that it is an essential tool for a beginner.

Heatproof Mats

Techniques: Soldering, annealing, applying heat patinas, fusing.

Uses: Heatproof blocks and mats are used to protect surfaces from heat, and also to build a wall around the piece being heated—this makes the process more efficient as the heat will be reflected back onto the piece. The mats will not prevent prolonged heating from damaging the surface underneath, so a platform should be built from house bricks to go under the heat mat, or you can use a soldering turntable—always ensure that the area you are using for soldering is adequately protected.

Range available: A variety of shapes and sizes of blocks and mats are available for use as heatproof mats. They are either a solid, fibrous material or a ceramic honeycomb, which is very useful for pinning pieces through the board with binding wire and is also less dusty.

Skill level: Basic.

Charcoal Block

Techniques: Granulation, mokume gane.

Uses: Charcoal blocks are used during certain heating processes, especially when small work requires a high temperature. Charcoal holds heat and prevents it from dissipating, meaning that work will take less time and energy to reach the required temperature. Recesses can be carved in the block, which is relatively soft, also making it suitable for pinning work to. Before use, the block should be tightly tied up with binding wire to keep it from cracking when heated.

Range available: Most blocks from jewelry suppliers are a standard size and are compressed charcoal.

Skill level: Basic.

Soldering Turntable

Techniques: Soldering, annealing, applying heat patinas, fusing.

Uses: Turntables are used to rotate work while it is being heated, and are particularly useful for bringing large pieces of work evenly up to temperature. Heat mats should be used on top of the turntable to protect the surface from the torch flame.

Range available: There are generally two styles of turntable: a circular metal turntable, which is available in different diameters, or a square form with a heatproof block mounted on the surface.

Skill level: Basic.

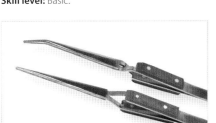

Reverse-Action Tweezers

Technique: Soldering.

Uses: Steel tweezers are used to hold elements of a piece in position while soldering and also to absorb heat out of thinner parts, helping to keep them from becoming overheated. The tweezers should be balanced on a heat brick or mounted in a "third hand" to ensure that parts don't move when heating begins.

Range available: Reverse-action tweezers have either straight or angled jaws and, if made of steel, have insulated handles. Tungsten-tip tweezers should be used when soldering platinum.

Skill level: Basic.

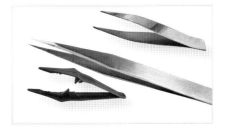

Tweezers

Techniques: Soldering, pickling, etching, patination.

Uses: Tweezers are used for picking up and moving work, usually into and out of chemical solutions. Plastic tweezers are ideal for working with acids and other chemicals as they will not scratch metal, but cannot be used for hot work. Brass tweezers should be used for placing work into pickling solution.

Range available: Tweezers are available in several different materials, including plastic, brass, steel, and titanium.

Skill level: Basic.

Tin Snips

Technique: Cutting.

Uses: Also called shears. Snips are most often used for cutting solder pallions, but also for cutting thin sheet metal and binding wire. The jaws cut most effectively when the metal is placed down into them—the tips of the jaws are much less accurate.

Range available: Tin snips with straight blades are best for cutting pallions, whereas those with curved blades are more suitable for cutting sheet metal. Self-sprung versions are also available.

Skill level: Basic.

ABRASIVES AND POLISHING MATERIALS

Abrasives are used for refining the surface of metal and other materials, either as a preparation for polishing, or as a final finish. A vast choice is available for use by hand or with machines. Polishing materials are applied by hand, with a flexshaft or polishing motor, or with a barrel polisher.

Wire Wool

Techniques: Cleaning up, surface preparation, surface finishes, wax carving.

Uses: Wire wool cleans metal, removing a small portion of the surface. This makes it ideal as a preparatory step for techniques such as patination. Wire wool can also be used as an abrasive for cleaning up wax models for lost wax casting. Use a medium grade to remove file and carving tool marks before polishing the wax with a very fine grade.

Range available: Several grades of wire wool are available, from the very abrasive to grade 0000, which is very fine and will give a subtle, bright finish to metal.

Skill level: Basic.

Pumice Powder

Techniques: Cleaning up, surface preparation, surface finishes.

Uses: Pumice powder is applied to metal surfaces with a bench brush and water, often with liquid detergent. The powdered volcanic rock is an abrasive and will remove a small amount of metal, but more importantly dirt, grease, and traces of pickle. The matte surface produced from cleaning is often used as a final surface on metal.

Range available: Several grades are available, from rough grades to very fine powder.

Skill level: Basic.

Emery Sticks

Technique: Cleaning up.

Uses: Emery sticks can easily be made by using double-sided sticky tape to adhere abrasive paper to a wooden stick or dowel. The stick allows for quick and accurate application of abrasive paper to a surface. It is useful to have several grades of emery sticks, and to have different-shaped wooden sticks, such as round, half-round, and flat, to deal with awkward shapes.

Range available: Emery sticks can be bought, but you can easily make your own—any type of abrasive paper can be used. Self-adhesive abrasive strips that come in several grades are also available.

Skill level: Basic.

Abrasive Papers

Techniques: Cleaning up, rolling mill textures, surface preparation, surface finishes.

Uses: Abrasive papers are used to remove file marks, scratches, and firestain from metal and other materials. A rough grade of paper is used initially, before finer grades are used to refine the surface, often in preparation for polishing. When abrading soft or potentially harmful materials such as plastics, use wet-and-dry paper with water. This will keep any dust in solution and prevent it from becoming airborne.

Range available: There are a number of different types of paper available. The most commonly used are emery paper, which must be used dry; and waterproof silicon carbide paper, otherwise known as wet-and-dry paper, which is available in grades from 180 to 2500. The most commonly used grades are 600–1200.

Skill level: Basic.

Beginner's Kit
When this symbol appears next to a tool it indicates that it is an essential tool for a beginner.

Split Pin

Technique: Cleaning up.

Uses: Also called a split mandrel. This tool is used in a flexshaft motor with abrasive paper inserted into the slit and wrapped around the pin. The paper can be secured with tape at the base to keep it from unwrapping. During use, the worn-out paper can be torn away to reveal fresh paper. Don't apply too much pressure when cleaning up work with a split pin.

Range available: Split pins are either parallel or tapered.

Skill level: Basic.

Steel Shot

Techniques: Polishing metal forms, work hardening.

Uses: Steel shot is used in a barrel polisher with barreling soap, to give a high shine to metal. The polished steel shot knocks into the metal form, and burnishes and work-hardens it. The shot must be kept covered in water and barreling soap, or stored dry, in order to prevent rust from forming.

Range available: Different shapes of shot are available, and are sold individually, or as a mixed lot. It is best to use a mixture of shapes in a barrel polisher.

Skill level: Basic.

Abrasive Cones

Techniques: Cleaning up, applying surface finishes.

Uses: Abrasive media can be used in a barrel polisher to prepare the surface of a piece for polishing, or to give it a matte surface. A small amount of material is removed from the surface of a piece, so that edges and corners will eventually become softened or rounded. This action will be increased if abrasive cones are used together with cutting powder in the barreling unit.

Range available: Cones or chips are either made from ceramic material or grit-impregnated plastic, which is available in different grades.

Skill level: Basic.

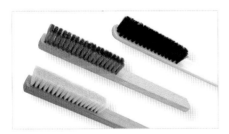

Bench Brushes

Techniques: Cleaning up, surface preparation, surface finishes.

Uses: Brushes are used for washing and cleaning pieces after techniques such as pickling, polishing, or etching, to remove residues. They are also used to clean pieces before the application of patinas, or in any other situation where the metal needs to be clean and degreased, with the application of detergent or pumice powder.

Range available: Brushes are available with bristles made of nylon, hair, brass, or steel set into handles made from wood, plastic, or bone. Old toothbrushes are a cheap alternative.

Skill level: Basic.

Polishing Thread

Technique: Polishing.

Uses: Threads are used to polish holes or slots, such as those in fretwork—this technique is called "thrumming" or "threading." Several threads are put through the hole, and the piece is run up and down the length until it is satisfactorily polished. Apply Tripoli or rouge to the thread before polishing the work.

Range available: Usually supplied as a tied bundle of cotton threads. Abrasive threads and cords are also available and can be used for cleaning up small spaces. Strips of suede can be used in a similar way on larger pieces of work.

Skill level: Basic.

Polishing Cloth

Techniques: Polishing, buffing.

Uses: Polishing cloths are used for a final buffing after polishing, or to remove finger marks or tarnish from work before it is displayed or worn. Patinas on silver can be lightened by buffing the surface with a polishing cloth. Cloths should be stored carefully so that they do not pick up dust or grit, which could scratch work when the cloth is used.

Range available: Cloths impregnated with polish will very quickly remove tarnish from silver. There are also cloths specifically for gold, gemstones, and pearls.

Skill level: Basic.

Liquid Polishes

Techniques: Polishing, tarnish removal.

Uses: Liquid polishes can be applied to a soft cloth or chamois leather for use on plastics and fragile forms that will not withstand being polished on a motor. On metals, they are used to revive tarnished surfaces and are metal-specific, but all can be applied to plastic. For example, Brasso will only work on copper, gilding metal, and brass, while Silvo works best for silver.

Range available: Available as liquids or as impregnated wadding. "Silver dip" does not polish but will remove tarnish effectively from silver.

Skill level: Basic.

Polishing Compounds

Techniques: Polishing, buffing.

Uses: Polishing compounds are applied to mops used with polishing motors and flexshaft motors. The rotary motion from a motor causes abrasion of the surface being polished, removing a small amount of material, but reducing surface defects so that they are not visible to the naked eye. Polishing compounds can also be applied to polishing threads and felt or suede buffing sticks, which are used for hand polishing.

Range available: Tripoli is for the initial polishing of nonferrous metals; rouge is for a high finish. Vonax is for plastics, and there is a polishing compound specifically for steel. There are many compounds available, some with specific applications.

Skill level: Basic.

Polishing Wheels

Technique: Polishing.

Uses: Wheels are screwed onto the spindle of a polishing motor, and rotate at high speed enabling the fast polishing of surfaces, particularly metal. Polishing compound must be applied to the wheel while the motor is running, and wheels should only be used with one type of polish, to avoid cross-contamination and achieve optimum results. Different wheels are appropriate for different tasks—it will depend on the type of metal and the finish required.

Range available: Polishing wheels are available in a number of different materials, from hard—felt, through muslin and cotton—to wool and swansdown, which is very soft.

Skill level: Basic/intermediate.

Brass Points

Techniques: Polishing, surface preparation, surface finishes.

Uses: A small brass brush mounted on a steel shank for use with a flexshaft motor, which can be used to quickly brighten textures, especially in hard-to-reach areas on castings. A small amount of brass may be transferred to the surface of the piece, but this allows base metal patinas to be applied to precious metals—such as verdigris, or oxidization on gold.

Range available: Several different shapes are available, including wheel, cup, and point.

Skill level: Basic.

Polishing Bobs

Technique: Polishing.

Uses: These are small polishing wheels that are used with a flexshaft motor and are very useful for polishing the insides of rings. Apply polishing compound to the bob before starting to polish, and use the same process as for a polishing motor. The small radius of the bob means it will heat up quickly through friction—so polish plastics at a slow speed to avoid friction smears.

Range available: Wheels of cotton, muslin, and wool; felt points come in a variety of profiles, to be applied to different-shaped surfaces.

Skill level: Basic.

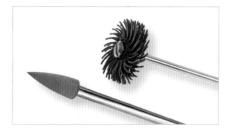

Silicone Points

Techniques: Cleaning up, surface finishes.

Uses: Silicone points are impregnated with grit and mounted on a steel shank, for ease of use in a flexshaft motor. While they are very useful for cleaning up pieces that contain small curved recesses and awkward spaces, they are not a cheap option.

Range available: A variety of shapes are available in different grades. The grade is indicated by the color—different manufacturers may use varying color codes.

Skill level: Basic.

TOOLS FOR PRECIOUS METAL CLAY

The tools used for precious metal clay are very similar to those used for conventional clay-working, but a wide range of tools are also available that have been specifically designed for use with metal clay.

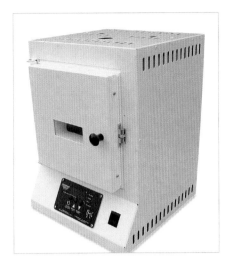

PMC Kiln

Technique: Firing precious metal clay.

Uses: Once formed, precious metal clay must be fired to drive off the organic binder. The type of clay used will determine the firing temperature. Clay can be fired at a high temperature for a short length of time, or a lower temperature for longer.

Range available: Standard kilns with temperatures appropriate for firing PMC. These kilns may not be suitable for some types of enameling.

Skill level: Basic.

Clay-Working Tools

Techniques: Modeling and carving precious metal clay.

Uses: While precious metal clay is damp, these tools can be used to model and sculpt forms, or refine forms made in a mold. When it is dry, fine detail can be carved into the form, and the surface can be smoothed.

Range available: Rubber tips for smoothing and steel points for carving and burnishing. Wax carving or sculptors' tools can also be used with precious metal clay products.

Skill level: Basic.

Silicone for Molds

Technique: Mold making.

Uses: Silicone putty is best used for impression molds of textures, or objects with no undercuts. Equal parts of both compounds are mixed until an even color is obtained and, once mixed, the silicone cures within about ten minutes. The resulting molds can be filled with precious metal clay, or molten wax that can then be cast using the lost wax-casting method. Silicone molds can also be used for casting resin, wax, and plaster.

Range available: These come as a two-part set, which can be used to make impression molds.

Skill level: Basic.

Cutters

Techniques: Cutting shapes from precious metal clay.

Uses: Cutters are used to cut shapes out of precious metal clay while it is damp. When the clay is rolled out thinly on a nonstick mat, precise forms can be cleanly cut out. Most cutters are small, and are designed to be used for making pendant or earring forms.

Range available: Many different shapes and sizes, including circles, diamonds, hearts, and stars.

Skill level: Basic.

Beginner's Kit
When this symbol appears next to a tool it indicates that it is an essential tool for a beginner.

WAX AND WAX CARVING TOOLS

The preparation of wax models for lost wax casting requires a different set of tools to those used for metalworking. Jeweler's wax can be cut, carved, and formed into incredibly detailed forms, which are then cast into metal.

Spiral Saw Blades

Techniques: Cutting and piercing wax, plastics, and other soft materials.

Uses: These specialist saw blades are used in a piercing saw in the same way as a straight blade.

The arrangement of the teeth in a spiral around the length of the blade keeps it from getting stuck, and the teeth throw out the cut material. Straight saw blades can be used for cutting wax, but have a tendency to get stuck because the heat from the friction of the cutting causes the wax to melt and trap the blade.

Range available: Different sizes are available.

Skill level: Basic.

Wax Ring Sizer

Technique: Sizing wax ring blanks.

Uses: Wax ring sizers are used to increase the inside diameter of wax ring blanks. The blade on the sizer gradually shaves wax away from the inside of the ring as it is twisted. The printed gauge on the sizer indicates the size of ring that will be produced.

Range available: One basic design—a tapered wooden rod with a blade along the length, and printed with a ring sizing system, either U.S., U.K., or European (see page 310 for ring size conversions).

Skill level: Basic.

Wax Files

Technique: Wax carving.

Uses: Wax, or rasping, files have widely spaced rough teeth that allow wax to be removed without clogging the file. Once a wax form has been pierced out, wax files are used to refine the form and allow large amounts of wax to be removed quickly before fine detail is added.

Range available: As both hand files and needlefiles, with a range of profiles. Available individually or in sets.

Skill level: Basic.

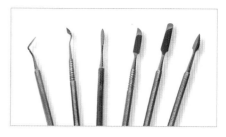

Carving Tools

Techniques: Wax carving and modeling; also for plaster and clay.

Uses: Carving tools are used to remove small amounts of wax in a controlled way, once the basic form has been created. The pointed tools will scratch in fine detail or textures, and can be used to "engrave" wax, plaster, or clay.

Range available: Varied shapes are usually sold in sets. Engraving tools, dental tools, or lino-cutters can also be used to carve detail into wax forms.

Skill level: Basic.

Beginner's Kit
When this symbol appears next to a tool it indicates that it is an essential tool for a beginner.

Scales

Techniques: Weighing waxes before casting, weighing metal.

Uses: Waxes should be weighed before being cast to determine the amount of metal that will be needed for the final piece. Scales are also useful for weighing finished pieces (before stones are set) so that the amount of metal can be determined, which will help when pricing them.

Range available: Inexpensive scales are adequate for most purposes, usually have a limit of 10 oz (300 g) and are accurate to ¼₀₀ oz (0.1 g).

Skill level: Basic.

Spirit Lamp

Technique: Wax modeling.

Uses: Spirit lamps are used with denatured alcohol to give a clean flame, which will not deposit soot on tools or wax. The flame is used to heat wax or tools so that surfaces of component parts can be joined while they are molten. Using a flame to "lick" wax surfaces will create a shiny finish. The wick should be kept short so that it does not burn down too quickly.

Range available: There are a few different brands. Replacement wicks and denatured alcohol are sold separately.

Skill level: Basic.

Wax Tubes

Techniques: Wax carving and modeling for lost wax casting.

Uses: Wax tube is cut into slices and can be easily carved to make rings. The hole can be opened to an appropriate size with a wax ring sizer before the form is carved with wax files and cleaned up with wire wool. The maximum measurements of the piece that will be carved should be considered when cutting the slice from the tube, but wax can be added to, either with soft wax or by heating parts to fuse them.

Range available: A number of different profiles are available—round or D-shaped with a centrally positioned hole, round with an off-center hole, or solid rod with no hole. They also come in blue or green wax.

Skill level: Basic.

Wax Blocks

Techniques: Wax carving and modeling for lost wax casting.

Uses: Wax blocks can be cut to size with a spiral saw blade and carved into intricate three-dimensional forms. Green wax is very hard and a high degree of detail can be carved, but it is quite brittle and so should be used for solid forms. Blue wax is hard and slightly flexible, which allows the wax to be carved very thin without as much risk of it breaking.

Range available: Both blue and green waxes are available in block form, or in slices of assorted thickness.

Skill level: Basic.

Modeling Wax

Techniques: Wax carving and modeling for lost wax casting.

Uses: Modeling wax is used to patch mistakes or stick pieces of harder wax together, as it is too soft to be carved. It can be warmed with the fingers before smoothing it over a join by hand or with a blade. This wax can also be used to make a "wax stick" to pick up and accurately position stones when stone setting.

Range available: Modeling wax is usually red or pink, and sold in tubs or tins.

Skill level: Basic.

Wax Sheet

Techniques: Wax carving and modeling for lost wax casting.

Uses: A dental wax that comes in flat sheets of up to 18-gauge (1 mm) thickness, and has a melting point of 220°F (104°C). It can be cut with a craft knife and modeled to shape in hot water. Wax sheet can be used in conjunction with other forms of jewelry wax to build up pieces, but is itself too soft to carve.

Range available: Standard-sized sheets, sold in boxes of 15 or 32 sheets.

Skill level: Basic.

STONE-SETTING AND ENGRAVING TOOLS

Tools for stone setting fall into three basic types: those for forming the metal settings for stones, devices for holding and securing the settings while the stones are being set, and tools for refining the setting and manipulating the metal around the stone. For engraving, a range of steel cutting tools called gravers are used—a few different shapes will be enough when starting out. Gravers are also used in stone setting.

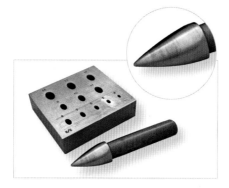

Bezel Block and Punch

Technique: Bezel making.

Uses: Bezels are metal frames that hold stones, and may be formed from tubing or a soldered strip of metal. A bezel block is used to true the angles of the cone-shaped bezel, and will also shrink or stretch the setting if required. It is used in much the same way as a dapping block, the punch being struck with a hammer or mallet to force the setting into shape.

Range available: Bezel blocks have angles of either 17 or 28 degrees; after round, the most common shapes are square, emerald-cut, oval, and pear-shaped. Punches are sold with the blocks.

Skill level: Intermediate.

Triblet

Techniques: Forming and truing bezels.

Uses: Triblets are used for forming and truing bezels and are basically small ring mandrels. The shape of triblet used will depend on the shape of the stone that is being set. The triblet may be held in a vise or the tip may be supported in the bench peg while you are working. Larger bezels may be formed on the tip of a ring mandrel if it is of a suitable diameter.

Range available: Round, oval, square, cushion, and pear-shaped. Usually 9–11 in (22–28 cm) in length, the diameter of the tip of the smallest triblet is ⅛ in (3 mm).

Skill level: Basic.

Bezel Pusher

Technique: Stone setting.

Uses: Bezel pushers are used for rub-over settings on cabochon stones to apply pressure to the bezel that surrounds the stone. This gradually forces the metal against the stone, securing it in the setting. A slightly matte surface on the end of the pusher will help to prevent it from slipping. Bezel pushers usually have square or rectangular faces with slightly rounded edges, or are curved in one plane so that they can rock backward and forward to move the metal around the stone.

Range available: Commercially available pushers are usually of a standard length and made from a steel rod set into a wooden handle.

Skill level: Basic.

Prong Pusher

Technique: Making prong settings.

Uses: Similar to a bezel pusher, but with a groove in the flat face of the tool so that it will push the prongs of a prong setting down without slipping. These tools can be made easily by filing a groove in the end of a piece of steel rod and mounting it in a wooden handle.

Range available: One standard form. Bezel-closing stakes are tools with a concave recess that is placed over the stone and setting, and pushed down to force the prongs over the stone.

Skill level: Intermediate.

Beginner's Kit
When this symbol appears next to a tool it indicates that it is an essential tool for a beginner.

Ring Clamp

Techniques: Holding rings during stone setting, or for holding other items.

Uses: Ring clamps are used to secure work while certain techniques are carried out, and they make it easier to support a ring or hold small work. The jaws of the clamp are lined with leather to protect the ring. Clamps are most often used for holding rings while stones are being set, but are best suited for rings with narrow or parallel shanks. The clamp can be secured in a vise for added stability.

Range available: Several different designs: there are clamps that tighten with a screw or are wedged with a triangular piece of wood around the outside of the ring shank, and there are also ring clamps that grip the ring from the inside. Clamps are made from either plastic or wood.

Skill level: Basic.

Setter's Wax

Techniques: Stone setting, engraving.

Uses: Setter's wax is melted onto the top of thick wooden dowel or a flat block of wood so that the piece can be easily held at the bench or fixed in a vise, and is used for holding small items of work when performing techniques such as stone setting or engraving. The wax is warmed until it is soft enough to sink the piece into the surface and secure it. The piece can be carefully chipped out afterward, or the wax very gently warmed, depending on the item. Wax residue can be removed by soaking the piece in acetone.

Range available: Supplied in sticks or blocks.

Skill level: Basic.

Magnifiers

Techniques: Stone setting and other fine work.

Uses: Eyeglasses and loupes are used to view small work magnified, which will become a necessity as your eyes age, and is important in techniques such as stone setting where accuracy is paramount. Eyeglasses fit neatly around the eye and can be used hands-free while fine work is being carried out. Loupes are handheld, and are used to inspect progress at a higher magnification.

Range available: The degree of magnification of eyeglasses is measured by their focal length, with a short focal length giving a higher magnification. Focal lengths range from 2–4 in (5–10 cm). Loupes are often of a higher magnification: x10 or x20. Binocular headpieces or attachments that can clip onto glasses are also available, as are freestanding magnifying lamps.

Skill level: Basic.

Grain Tools

Techniques: Pavé and grain stone setting, applying decorative textures.

Uses: When a spur is raised with a graver, the grain tool, which has a round depression in the end, is used to push and roll the spur down into a neat ball, or grain. These grains are used to hold stones in position, or can be for purely decorative effect.

Range available: Graduated sizes, available in sets. Grain tools can be interchanged in a wooden handle that is usually supplied as a part of the set.

Skill level: Intermediate/advanced.

Grain Tool Sharpener

Technique: Sharpening grain tools.

Uses: Also called a fion. Grain tools quickly wear down, or the edges become deformed through use, and they will need reshaping and sharpening. A fion is used to open up the end of the grain tool so that it has a truly circular indent in it.

Range available: Linear or circular blocks with different-sized projections that relate to the different sets of grain tools that are available.

Skill level: Intermediate/advanced.

Millgrain Wheel

Techniques: Stone setting, applying decorative textures.

Uses: This tool is a rotating wheel set in a handle that is run along a metal edge to produce the effect of many grains. Traditionally used to decorate the edges of stone settings, and along the borders of pavé pieces to mimic the visual effect of the grains that hold the stones, making the setting appear larger. Each wheel will make one size of grain.

Range available: Millgrain wheels are available in sizes from 1 (smallest) to 15, which is the largest and makes grains of ³⁄₆₄ in (1 mm).

Skill level: Basic.

Hematite Burnisher

Techniques: Stone setting, highlighting edges, applying gold leaf.

Uses: Burnishers can be used for the final rubbing of the metal around the stone without damaging it. Steel or hard-stone burnishers must be kept highly polished so that the surface does not scratch the metal. Hematite burnishers have rounded ends, which makes them more suitable when stone setting—if the tool slips, it will not damage the stone that is being set.

Range available: Other nonmetallic burnishers are made from agate or bone. Plastic burnishers can be made for setting very soft materials such as shell or amber with fine silver bezels.

Skill level: Basic.

Scraper

Techniques: Fabrication, stone setting, engraving.

Uses: A scraper is a triangular blade mounted in a wooden handle that is used to scrape away material from a surface. To de-burr rings or bezels, the scraper is run around the inside edge at a slight angle, with two corners of the triangle touching the ring. The leading edge of the scraper will shave away a small amount of metal as the piece is rotated into the blade. In engraving, scrapers are used to remove slips and areas of engraving that are too deep to be burnished out.

Range available: Several sizes of scrapers are available, and handles are sold separately.

Skill level: Basic.

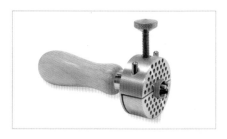

Engraver's Vise

Techniques: Engraving, stone setting.

Uses: An engraver's vise is used to hold flat work securely. Pegs are positioned in the board, the work is placed in between, and then the vise is tightened. The vise is supported against the bench peg while working.

Range available: Several designs of vises are available. Clamps and vises can be made from two pieces of wood laterally drilled and secured with long bolts and wing nuts. These clamps can be adapted for particular jobs.

Skill level: Basic.

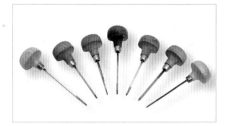

Gravers

Techniques: Engraving, stone setting, applying decorative textures.

Uses: Gravers are used to engrave designs, textures, and lettering on a variety of materials. They are sold without handles, and need to be correctly mounted at the right length for an individual's hand. Specific gravers are suitable for specific tasks: square gravers are used for cutting lines and some lettering, lining tools (also called stitches) will cut multiple lines with one stroke and are used for shading and textures, and bullsticks are used to carve out stone settings. Gravers should be stored carefully so they do not become blunt through contact.

Range available: A wide variety of gravers are available (see page 309 for different graver profiles). For cutting steel and brass, use high-speed steel gravers because they will stay sharper for longer. Handles are sold separately.

Skill level: Basic/intermediate.

Oilstone

Techniques: Sharpening gravers, chisels, and other cutting tools.

Uses: Also called India oilstone. Oilstones are used with machine oil to grind down steel tools and give them a sharp cutting edge. A smooth backward and forward motion is used, usually to create a flat face on tools such as gravers or chisels. The steel dust in solution with the oil creates a finer grinding surface, so don't clean it off.

Range available: Different grades of oilstone can be found, and they are often "combination": double-sided with one rough side and one fine side.

Skill level: Basic.

Arkansas Stone

Techniques: Sharpening gravers, chisels, and other cutting tools.

Uses: A fine natural stone that is used to polish or give a finer surface to ground tools, and will prevent chipping; therefore the tool will need sharpening less often. Arkansas stones are used with machine oil or olive oil, and should be kept oiled to prolong their life.

Range available: A number of different sizes are available, supplied in a wooden box. Buy the largest you can afford.

Skill level: Basic.

STRINGING TOOLS

Semiprecious beads and pearls require special treatment to preserve their natural beauty and display them to their best advantage. Silk or thread is knotted between each bead to prevent abrasion, and the choice of thread and needle used will make a difference to the outcome. Other tools and materials in this section will help with the speed and accuracy of the stringing process.

Silk and Thread

Techniques: Pearl and bead stringing.

Uses: Silks and threads are used for stringing semiprecious beads and pearls, and are usually knotted between items to stop them from knocking against each other and getting damaged. The thread is used doubled up, and fed through the beads with a wire needle. A knotting tool is used to make neat, even knots.

Range available: Different thicknesses, colors, and mixes of material—such as silk, silk and nylon mix, pure nylon, waxed cotton.

Skill level: Basic.

French Wire (gimp)

Techniques: Pearl and bead stringing.

Uses: Gimp is fine coiled wire that is used at the ends of strings of beads and pearls to protect the thread from rubbing thin on the catch fittings. The choice of size of gimp depends on the thickness of the thread being used, and the diameter of the holes in the beads.

Range available: Gimp is supplied gold or silver plated, and in different gauges appropriate to silk and needle diameters.

Skill level: Basic.

Wire Needles

Techniques: Pearl and bead stringing.

Uses: Wire needles are used to easily insert thread through the holes in beads or pearls. They are thin and flexible, with eyes that will flatten and fit through very small holes in beads. Some silks are supplied with needles attached.

Range available: Different gauges of twisted wire needles are available; some have collapsible eyes and are reusable. Straight steel beading needles are also an option.

Skill level: Basic.

Other Stringing Media

Techniques: Bead stringing.

Uses: Any fine linear material can be used to string beads, even incorporating wirework or textile techniques. Enameled copper wire, nylon coated steel cable (tiger-tail), transparent elastic, embroidery silks, hair, leather, and rubber cord are all interesting materials with which to experiment. Depending on the material being used, crimps may be employed to secure the ends and prevent raveling.

Range available: A wide range of materials is available for stringing and making beaded jewelry. Most forms are supplied in several different diameters.

Skill level: Basic.

Beginner's Kit
When this symbol appears next to a tool it indicates that it is an essential tool for a beginner.

Chinese Clippers

Techniques: Pearl and bead stringing.

Uses: Clippers are used to cut silk or thread close to the knot, giving a neat finish with no trace of stray threads. End knots are often sealed with adhesive or clear nail polish before being cut.

Range available: Spring-action clippers are a standard size, but sharp scissors or end cutters are an alternative option.

Skill level: Basic.

Bead Board

Techniques: Pearl and bead stringing.

Uses: Bead boards and sorting trays are used to plan designs by laying out beads, and help to keep the beads in order while the piece is being worked on. They will also keep beads clean and prevent damage, although some stringers prefer to work on a folded towel or piece of fabric.

Range available: A variety of different designs: molded plastic boards, which may be flocked with grooves, rulers, and markings that give a guide to necklace or bracelet length; flat, padded cushions.

Skill level: Basic.

Crimps

Technique: Bead stringing.

Uses: Crimps are used to secure the ends of stringing materials where knots are not possible or to cover knots, making them more secure. Crimping pliers are used to force the crimp tightly around the thread.

Range available: Silver or gold, or plated base metal. Different sizes and styles of crimps are available—choose the smallest crimp possible for the thread used. Small sections of thin-walled tubing can be used in place of bought crimps.

Skill level: Basic.

Diamond Reamer

Technique: Enlarging drilled holes.

Uses: A diamond reamer is a tapered, diamond-coated point that will enlarge drilled holes, especially in glass or semiprecious stones. End beads will need to have larger diameter holes to allow for a double thickness of thread where the ends of the silk are secured. Start with the closest diameter reamer to the original size of the hole, and twist the tool in the hole on both sides; a larger reamer can be used to continue the process.

Range available: Diamond reamers are often supplied as a set of tools that can be interchanged in a handle. Reamers are also available as steel four-sided tapers that come in a set of different diameters.

Skill level: Basic.

Knotting Tool

Technique: Knotting silk and thread.

Uses: A knotting tool allows knots to be pulled tightly against previous beads or pearls on a string and will help form neat, uniform knots, making a tidy string of beads. The thread is looped around the prongs on the tool and when the collar slides up, the knot is tightened as it is released. Silk or nylon will give the best results.

Range available: Different brands.

Skill level: Basic.

Crimping Pliers

Techniques: Fixing crimps.

Uses: Crimping pliers are used to crimp tube into position, permanently securing threads. Some pliers can be used to squash the crimp into sections, which will separate threads, before using the pliers to close the crimp. Crimps are a necessity when using stringing media such as tiger-tail as the ends cannot be easily secured by any other method.

Range available: A few different styles are on the market, and the notches in the jaws relate to sizes of crimps—use small crimping pliers for small crimps.

Skill level: Basic.

ENAMELING EQUIPMENT

Enameling is a technique that requires meticulous processes, and must be carried out in a clean environment. Having the correct equipment is important to ensure good results and also to adhere to health and safety considerations. Many of the tools in this section are only available from specialist enameling suppliers (see Suppliers and services, page 313), which may offer small kits for those starting out.

Beginner's Kit
When this symbol appears next to a tool it indicates that it is an essential tool for a beginner.

Kiln

Techniques: Enameling, thermoforming plastics, applying heat patinas, wax burnout, melting precious metals.

Uses: Enameling kilns are used for firing enamels at temperatures that cause them to melt and fuse to metal surfaces. Modern kilns don't take long to heat up to the high temperatures required for enameling; most will reach 2010°F (1100°C). Work in a well-ventilated area when enameling.

Range available: Kilns are heated either by gas or an electric element. Kilns are expensive, so it is worth discussing your requirements with the supplier. These will include the size of kiln, and the type of insulation and base blocks.

Skill level: Basic/intermediate.

Pestle and Mortar

Techniques: Grinding and washing enamel.

Uses: Made from fully vitrified, acid-proof porcelain, a pestle and mortar is used to grind and wash enamel. Lumps of enamel can be smashed and ground to a suitable size for use, but even powdered enamel will need to be lightly ground and carefully washed before use. Enamel is washed initially with tap water and then with distilled water to remove any impurities or contaminants.

Range available: Several different sizes, stated by the volume held or the diameter of the mortar. The pestle and mortar are sold together, by enameling suppliers.

Skill level: Basic.

Glass Brush

Techniques: Surface preparation, surface finishes.

Uses: Fine glass fibers held together as a brush are used to clean enameled surfaces. The glass brush is used under running water, so that residues and broken glass fibers are washed away, giving a perfectly clean finish to the enamel in preparation for other processes. Wear protective gloves to prevent glass fibers from becoming lodged in your skin.

Range available: Large brushes are bound with string and coated in a rubber sleeve, which is cut to expose the fibers as the brush wears down. Small brushes are retractable and set in a plastic handle. Refills are sold separately.

Skill level: Basic.

Sieve

Technique: Enameling.

Uses: When grinding enamel from lumps into powder, sieves with a fine mesh base are used to sort the size of the enamel grains. It is important that the powdered enamel is all of a similar particle size to ensure even application. Sieves are often 60–80 mesh for general use, but up to 325 mesh is used for painting enamel, which needs to be very fine. Wear a mask when handling dry enamel powders.

Range available: Sieves of different grades are available—80 mesh is commonly used for powdered enamels suitable for wet-packing.

Skill level: Basic.

Powdered Enamels

Technique: Enameling.

Uses: Powdered enamels are bought pre-ground to a suitable grain size and, after washing, are applied to a metal base in a technique known as wet-packing. When the piece is fired in a kiln, the enamel fuses to the metal. Many layers of enamel can be applied to a piece to create stunning effects.

Range available: Enamels are available in three main types: transparent, opaque, and opalescent. Flux is a clear enamel used either as a base or top coat. Enamels are described as hard, medium, and easy, which refers to their melting point. Brands include Schauer, Latham, Soyer, and Ninomija. U.S. legislation dictates that lead-free enamels should be used, but this is not the case in Europe.

Skill level: Basic/intermediate.

Enamel Threads and Lumps

Technique: Enameling.

Uses: Threads and lumps of enamel are used to create special effects when they are fused to an enameled base. Lumps will leave raised areas of color, while threads will flatten and become level with the base plane once they are fired. Elements are dipped in gum to hold them in position during firing.

Range available: Enamel threads and lumps are available in many different colors, and in opaque, transparent, and opalescent finishes. Millefiori glass can also be used.

Skill level: Basic/intermediate.

Painting Enamels

Technique: Enameling; Limoges technique.

Uses: Painting enamels are very finely powdered and can be used to create painterly effects. The fine powder is mixed with water, or an oil-based medium to the consistency of oil paint, and applied onto an enameled base sheet of metal. The painted surface may be fired under a transparent glaze to give the effect of more depth.

Range available: Many different colors and types, along with specific media for thinning. Enameling suppliers will often stock sets of painting enamels.

Skill level: Intermediate.

Quills

Techniques: Wet-packing enamel.

Uses: Quills are the traditional tools used for wet-packing enamel onto a surface. The end of the quill is cut at an oblique angle and can then be used to scoop up wet enamel powder and deposit it on the surface of the metal. Quills are easily cleaned, which prevents contamination of the enamel.

Range available: Goose quills are preferred, but sturdy flight feathers from other birds will suffice, as will paintbrushes. Small, medium, and large sizes of goose quill are stocked by enamel suppliers.

Skill level: Basic.

Gold/Silver Foil

Techniques: Enameling, fusing.

Uses: Pure metal foils can be used under enamel to give a bright shiny finish and color contrasts within a piece. Because the metal is unalloyed, it does not tarnish or discolor when it is fired. The foil, once fired and bonded to the enamel, can be left as a surface effect, or have more layers of enamel applied over it. Foil is also used in a technique called "keum boo," where gold foil is fused onto the surface of sheet silver.

Range available: As single sheets or in booklets. Other products for special effects include precious metal dust in an oil suspension and mother-of-pearl powder, which can be fired under or over enamel. These are stocked by enamel suppliers and bullion dealers.

Skill level: Basic/intermediate.

Inorganic Gum

Techniques: Cloisonné, enameling.

Uses: Inorganic gum is a water-based adhesive that burns away cleanly during the firing process, and is used to hold pieces in position. The gum is used either neat or diluted, depending on the task, but has good adhesion properties, even on curved surfaces. It is often used for holding cloisonné wires in place during the initial firing.

Range available: Specialist inorganic gum is available from enameling suppliers; there are several brands.

Skill level: Basic/intermediate.

Ceramic Fiberboard

Technique: Enameling.

Uses: Ceramic fiberboard is used to support work during firing, and can be used to shield specific areas of a piece from heat. It can be cut and shaped to pack around areas of a piece, and is soft enough to allow earring posts or other findings to be pushed down into it. Wire racks are used to support the board while the piece is being fired.

Range available: A variety of products are available from enameling stockists, including heat mats, paste, and wool.

Skill level: Basic.

Wire Rack

Technique: Enameling.

Uses: Used to support work or ceramic fiberboard prior to and during firing, making it easier to move work, whether hot or cold. Wire racks allow a spatula or firing fork to be placed underneath for easy insertion and removal of a piece from kiln.

Range available: Different gauges of wire mesh, in stainless steel or titanium. Supplied flat or pre-folded.

Skill level: Basic.

Spatula/Firing Fork

Technique: Enameling.

Uses: These tools are used for placing work into and removing it from the kiln. Both spatulas and firing forks have an extended length so that the hand holding them does not get too close to the heat of the kiln—however, you should still wear leather gloves to protect your hands from the high temperatures. The end of the tool is slipped underneath the wire mesh rack or stilt that the work is supported on.

Range available: A number of variations of forks and spatulas can be sourced from enameling suppliers.

Skill level: Basic.

Stilts

Technique: Enameling.

Uses: Stilts are used to support work in the kiln while it is being fired and are made from folded stainless steel sheet. The shape of the piece of work being enameled will make a difference to the way it needs to be supported while the enamel is fired, because it must be carefully balanced and avoid contact with the enamel.

Range available: Several different sizes and varying shapes of stilts are available from enameling suppliers, and they are inexpensive.

Skill level: Basic.

Mica

Technique: Enameling.

Uses: Mica is a mineral that is heat-resistant up to temperatures of 1740°F (950°C) and can be used to support enamel during firing without bonding to it. Mica is used under plique-à-jour enamel during packing and firing to support the enamel and keep it from falling away or moving out of position. Mica sheet can also be used to mask the window of the kiln, preventing the harmful infrared rays from being visible.

Range available: Standard-sized sheet material, from enameling suppliers.

Skill level: Intermediate.

Diagrit

Techniques: Enameling, grinding.

Uses: Diagrit is an abrasive medium that is used to grind down enameled surfaces and to smooth lumps. It is usually supplied as self-adhesive strips of diamond-impregnated fibermesh, which can be cut to shape and adhered to wooden or plastic sticks. Diagrit should be used under running water to prevent harmful dust from enamels or other materials being released into the air. Diagrit pads can also be used for grinding ceramics and glass.

Range available: Several grades of diagrit can be sourced, from 75, which is medium grade, through to 10, which is very fine.

Skill level: Basic.

CHEMICALS

Jewelers use a wide range of chemicals for a number of different techniques, including patination, soldering, and etching. Care must be taken when using chemicals—see page 10 for more health and safety advice. When buying chemicals, ask the supplier for the relevant data sheet, which will have detailed information about the product and how to use it safely.

Patination Chemicals

Technique: Patination.

Uses: Patination chemicals are used to create colorful effects on metal; some are heated, some are applied cold. The chemicals are usually metal-specific—chemicals that work on copper or brass will have no effect on silver or steel. Wear protective goggles, gloves, and a ventilator or mask when working with patination chemicals. Heated solutions give off fumes, so extra care must be taken. Work out-of-doors if necessary. Chemicals should always be stored in a lockable metal cabinet and clearly labeled.

Range available: Patinas are usually sold in liquid form as a premixed solution, but also sometimes as crystals that need to be mixed with water in the correct proportions.

Skill level: Basic.

Solvents

Techniques: Etching, stone setting, engraving.

Uses: Solvents are used to dissolve other media such as stop-out varnish, wax, adhesives, and resin. Wear protective equipment such as gloves and goggles when working with solvents, and work in a well-ventilated area. Solvents need to be stored carefully, as most are highly flammable.

Range available: The most commonly used solvents are acetone, mineral spirits, turpentine, and lighter fluid, and these are available from hardware stores or artists' suppliers.

Skill level: Basic.

Adhesives

Technique: Fixing components in place.

Uses: The choice of adhesive will depend on the materials being joined, and the degree of permanence required. Epoxy resin is suitable for many jobs and provides a strong bond. Superglue is powerful but rather brittle for jewelry. Pearl cement is used to secure half-drilled pearls onto pins within a piece. Gold size is formulated for the application of gold leaf. It is painted thinly over the area that will be leafed and allowed to dry until it is tacky. Oil-based size provides a better bond than acrylic, but acrylic has a quicker drying time. Work in a well-ventilated area when applying adhesives.

Range available: Epoxy resin, cyanoacrylates (superglue), cements, UV-reactive glue (which is transparent), and gold size.

Skill level: Basic.

Lubricants

Techniques: Drilling, sharpening tools, tool maintenance.

Uses: Machine oil is used to lubricate tools or machinery when they are in use; drill bits and burrs will work more efficiently with less resistance, friction, and heat and will therefore stay sharp for longer if a lubricant is applied. Generous amounts of oil are used when sharpening tools on an oilstone to aid the process. Beeswax can be rubbed onto saw blades so that they cut more smoothly. A regular application of oil to tools helps prevent rust, by forming a physical barrier against moisture.

Range available: A number of different lubricants are available: 3-in-1 machine oil, wintergreen oil, mineral oil, organic cutting fluid, and beeswax.

Skill level: Basic.

Beginner's Kit
When this symbol appears next to a tool it indicates that it is an essential tool for a beginner.

Fluxes

Techniques: Soldering, fusing, smelting, casting.

Uses: Fluxes prevent oxides from forming on metal when it is heated. All fluxes have specific working temperatures—Easyflo works best with low-temperature solders such as easy and extra-easy, while the high temperatures required for soldering steel means that most fluxes will burn out before the solder melts—Tenacity 5 works well in this range though. Borax is suitable for most soldering jobs. Work in a well-ventilated area when soldering.

Range available: The most common general-purpose flux used is borax. It is available as a solid cone, or in powdered form. Auroflux works well with gold, and Tenacity 5 is used for steel.

Skill level: Basic.

Barreling Soap

Technique: Barrel polishing.

Uses: A special soft soap that facilitates the polishing action of steel shot in a motorized barrel-polishing unit. The compound also contains a chemical safety pickle powder that prevents the steel from rusting when it is in constant contact with water. Mix a small amount of the powder with warm water before adding it to the barrel. There are no known health and safety issues.

Range available: Usually available in powder form. There are several brands.

Skill level: Basic.

Safety Pickle Powder

Techniques: Pickling metal after annealing, soldering, or casting.

Uses: Pickle solution removes oxides and flux residues from nonferrous metals, and contains sulfuric acid, so take care, and wear gloves and goggles when mixing, according to the manufacturer's instructions. The pickle powder needs to be mixed with warm water in the correct proportions. As the solution is heated it will give off fumes, so use in a well-ventilated area.

Range available: Safety pickle powder, usually supplied in quantity. Some jewelers prefer to use alum solution. Steel must be pickled in a solution called Sparex #5.

Skill level: Basic.

Heat Paste

Techniques: Soldering, annealing.

Uses: Heat paste is used to protect gemstones when soldering, but also to prevent solder seams from remelting upon subsequent heating. It can also protect very thin areas of metal from overheating. Follow the manufacturer's guidelines for use—often the paste needs to be applied in a ⅜ in (1 cm) thick layer, around the area that is being protected. Washes off easily after it has been heated.

Range available: Several different brands of pastes and gels are available. Correction fluid or rouge powder mixed to a paste with water is often used to protect solder joins.

Skill level: Basic.

Acids and Salts

Techniques: Pickling, etching.

Uses: Acids and salts are used to chemically remove metal by dissolving it, and have a variety of applications, including etching and pickling. Ferric chloride and ferric nitrate are technically salts rather than acids, and attack the metal in a different way, but give a similar effect when used for etching. They are less dangerous than acids, but care should still be taken when using them. See page 10 for advice on using chemicals safely.

Range available: Commonly used acids within jewelry making are nitric acid, hydrochloric acid, and sulfuric acid. These are usually sold in liquid form and generally need to be diluted before use. Ferric nitrate and ferric chloride can be found in liquid form, but also as crystals, which are dissolved in warm water.

Skill level: Basic.

Stop-Out Varnish

Technique: Etching.

Uses: Stop-out varnish is painted onto clean, prepared metal surfaces to resist acid etching. The exposed areas of metal are eroded by the acid, while the varnished parts remain unaffected. Designs can be painted onto the metal with a brush, or the whole surface may be coated with varnish and a design scratched through once it is dry. Stop-out is often used in conjunction with sticky-backed plastic as a barrier.

Range available: Various brands of liquids and pens.

Skill level: Basic.

MACHINERY AND BENCH TOOLS

Although many of the tools and machinery in this section are an unnecessary outlay for the beginner jeweler, certain tools are invaluable timesaving devices and a worthwhile investment. A bench vise and flexshaft motor are both versatile tools that can be used to aid a wide range of techniques.

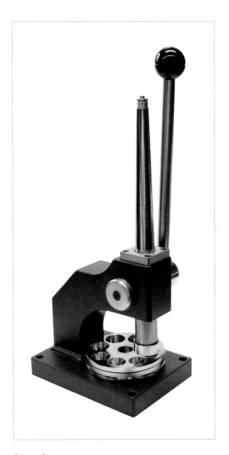

Ring Sizer

Techniques: Stretching and shrinking rings.

Uses: A ring sizer is used to increase or decrease the internal diameter of a ring. The outer edges are compressed by forcing the ring down into a die set on a rotating base. Rings can be stretched on the vertical mandrel of the machine by raising the handle to increase the width of the mandrel, which is often marked with ring sizes.

Range available: Several different designs. Most ring stretchers and reducers are designed specifically for wedding bands, or sizing rings that contain gemstones.

Skill level: Basic.

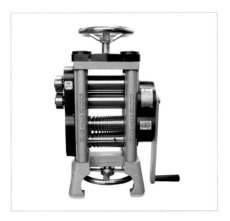

Rolling Mill

Techniques: Thinning metal, tapering rod and wire, imprinting textures.

Uses: Rolling mills have parallel hard steel rollers, which are used to thin metal sheet or wire, by cranking a handle to rotate the rollers. The distance between the rollers can be adjusted using the wheel on top. Mills must be bolted down, either to a very sturdy bench surface, or to a purpose-built stand. Mills must be kept clean and well oiled so that the mechanisms and surfaces of the rollers stay in good working order.

Range available: Full-size mills with both sheet and wire rollers are expensive, but are geared for maximum efficiency in use—with a gear ratio of 7:1. Mini mills are more affordable, but check the gearing ratio as some are direct-drive and require much more effort to operate. Mills with different designs of wire rollers are available.

Skill level: Basic.

Draw Plate

Techniques: Drawing, straightening and work-hardening wire and rod, rivet making.

Uses: Draw plates have a series of graduated holes, which are arranged as lines of numbered holes that decrease in size. Wire or rod is pulled through these holes with some force, gradually reducing its diameter and increasing its length.

Range available: Draw plates for making many different shapes of wire can be found; they are most often circular, but may be D-section, square, rectangular, oval, or star-shaped. Some have a few different shapes on the same plate.

Skill level: Basic.

Beginner's Kit
When this symbol appears next to a tool it indicates that it is an essential tool for a beginner.

Bench Vise

Techniques: Forging, riveting, forming, holding tools.

Uses: Every workshop needs a vise, predominantly to hold tools while working on processes such as forming or forging. Protective pads are often used to protect work from the rough surface of the jaws, and can be made from leather. Vises must be fixed to a bench, either with bolts or an integral clamp on the vise. Vises can also be used to make press forms.

Range available: There are a number of different sizes and designs. Small vises that are fixed to the bench top with a C-clamp are suitable for small-scale work such as riveting, but for smithing techniques such as forging, you will need a large vise to hold tools securely. Reasonable-quality secondhand vises can be found cheaply.

Skill level: Basic.

Bench Drill

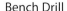

Technique: Drilling.

Uses: Bench drills provide a means for accurate and vertical drilling in a wide range of different materials. The drill should be bolted to the bench top to prevent vibration. Drill vises can be used to securely hold work in position on the drill bed during the drilling process.

Range available: There are many different brands—price is a reasonable gauge to quality. Consider the power, number of variable speeds, and the maximum diameter of drill bit the chuck can hold on a model before buying one.

Skill level: Basic.

Draw Bench

Technique: Wire drawing.

Uses: Draw benches are designed specifically to aid the drawing of wire, and are used in conjunction with draw plates and draw tongs. Most draw benches use a manual winding system to pull the tongs away from the draw plate, which forces the wire through the hole.

Range available: Several different designs can be found, including belt or chain mechanisms, and wall-mounted or electric benches.

Skill level: Basic.

Draw Tongs

Techniques: Drawing, straightening, and work-hardening wire and rod.

Uses: Draw tongs are used to pull wire through a draw plate secured either in a draw bench or in a vise. The tongs have serrated jaws and the end of one leg curved over to form a hook, which will catch the chain or belt of the draw bench, or provide purchase when drawing by hand.

Range available: Several different brands are available. Some tongs can only be used with a particular type of draw bench.

Skill level: Basic.

Pickle Tank

Techniques: Pickling after annealing or soldering metal.

Uses: A pickle tank is used to hold pickle, often with the facility to heat it. Heated pickle works much faster than cold, but this may be a luxury for a small workshop. It is a good idea to have a timer switch on the socket as an extra safety device, and to use a well-ventilated area.

Range available: Specially designed pickle tanks are an expensive investment, but come in different capacities, measured by the amount of liquid held—consider the scale of the work you will be making to determine which size to choose.

Skill level: Basic.

Ultrasonic Cleaner

Technique: Cleaning.

Uses: An ultrasonic cleaner uses high-frequency ultrasonic waves to vibrate dirt from pieces, and is very useful for removing traces of polish from enclosed spaces. A heated solution works most effectively—nontoxic fluids to enhance the speed of cleaning are now used more often than ammonia solutions. Pieces of work that are fragile and contain mixed media, including certain gemstones, should not be cleaned by this method.

Range available: Inexpensive ultrasonic cleaners are available, but are not as effective as more expensive models. When selecting a cleaner, compare volume, wattage, and whether the unit is heated and has a timer.

Skill level: Basic.

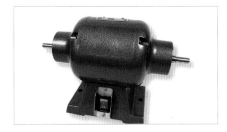

Flexshaft Motor

Techniques: Cleaning up, carving, polishing, applying surface textures, drilling, stone setting.

Uses: A motor that has a long, flexible shaft with a handpiece at the end, allowing a range of attachments to be used. Variable speeds are controlled with a foot pedal. The power of the motor is an important consideration, as is the type of handpiece—some are operated with a chuck key, some work with collets, and others are quick-release at the flick of a lever. It may be suspended from a wall-mounted bracket or from a stand that can be attached to the bench.

Range available: There are many different makes, and several styles of handpiece—stick to one brand to ensure compatibility. Small, handheld motors are a more affordable alternative, but they are not for heavy use.

Skill level: Basic/intermediate.

Polishing Motor

Techniques: Polishing, applying surface finishes.

Uses: For small-scale jewelers, a flexshaft motor and barrel polisher will normally be sufficient for polishing needs. Polishing motors allow many different types of wheel to be used, including fabric, brass, steel, and Scotch-Brite, and enable fast application of surface finishes to a range of materials, giving a superior surface quality compared with flexshaft or barreling motors.

Range available: One- or two-spindle; it should ideally be mounted in an extractor hood, which is sold separately.

Skill level: Basic/intermediate.

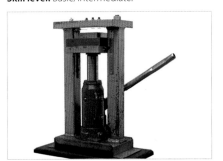

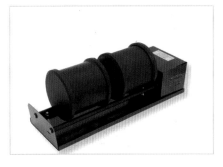

Hydraulic Press

Techniques: Press forming, embossing.

Uses: A hydraulic press is a steel frame with a hydraulic bottle jack secured under a moveable shelf, which is raised by increasing the pressure of the jack, and can be used for a number of forming and embossing techniques on sheet metal.

Range available: From specialist suppliers, you can source 12 or 20 tonne models. As manufactured presses are something of an investment, consider the size of the projects that will be made—a vise may be sufficient for small-scale pieces. Suppliers also stock a range of tooled accessories for press-forming.

Skill level: Basic.

Barrel Polisher

Techniques: Polishing, cleaning up, surface finishes.

Uses: Barrel polishers are used with steel shot to polish work, or with abrasive media such as ceramic cones for giving a matte surface finish. A motorized unit powers a spindle, which causes the barrel containing the work to rotate. This is an ideal method for small workshops as no dust is created. These polishers are used to work-harden precious metal clay pieces once fired, and also for polishing chain safely.

Range available: Tumble polishers are relatively affordable, and have either one or two barrels that run off the same motor. Spare barrels, lids, and seals are available separately.

Skill level: Basic.

HEALTH AND SAFETY EQUIPMENT

It is vital that you take adequate preventive measures when using chemicals, machinery, or processes that could cause damage to your health. Most injuries caused in jewelry making are small cuts and burns, so a first-aid kit in the workshop is advisable.

Beginner's Kit
When this symbol appears next to a tool it indicates that it is an essential tool for a beginner.

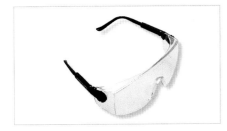

Safety Glasses

Technique: Use of any chemicals or machinery.

Uses: Safety glasses are used to protect the eyes, and should even be worn over glasses. They are made from a shatterproof plastic, which will withstand impacts from flying debris or pieces of work. Safety glasses also provide a physical barrier to chemical splashes.

Range available: Several different designs, including those with adjustable arms. Face shields, which protect the whole face, are recommended when using a flexshaft motor.

Skill level: Basic.

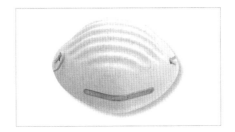

Cup Masks

Techniques: Cleaning up, polishing, working with plastics and wood.

Uses: Cup masks are a barrier prevention against dust, and should be worn when any work that creates dust is done, including using abrasives with a flexshaft motor and filing soft materials such as wood or plastics. The mask should fit closely over the nose and chin and its metal strip can be fitted around the nose to stop dust from being drawn in at the sides of the mask.

Range available: Disposable or reusable, some masks have an exhalation valve in the front, and some will fit the contours of the face better than others.

Skill level: Basic.

Rubber Gloves

Technique: Use of chemicals.

Uses: Protection for the skin against chemicals is very important, even if they are not corrosive, because repeated exposure to certain chemicals can cause contact dermatitis, which is easily aggravated by further exposure, and will make the skin sensitive to other chemicals and prone to eczema. Heavy-duty rubber gloves that cover the forearms are essential when mixing or using corrosive chemicals such as acids.

Range available: Disposable latex gloves are available powdered or non-powdered, but those with a latex allergy should use vinyl or nitrile rubber gloves. Elbow-length cotton-lined nitrile gloves should be used for handling hazardous chemicals, these are reusable.

Skill level: Basic.

Ear Protectors

Techniques: Hammering, forging, raising.

Uses: Used to protect the ears from repetitive loud noises, such as those made when hammering, which will over time affect the hearing. Ear protectors can be used in conjunction with ear plugs for added protection. General precautions to reduce the noise created by certain tasks should be taken as good working practice—place a sandbag under certain tools when hammering so that some of the noise will be absorbed, and use a mallet rather than a hammer wherever possible as the tone is much less sharp.

Range available: Fixed and adjustable headbands; relatively inexpensive.

Skill level: Basic.

Leather Gloves

Techniques: Enameling, thermoforming plastics, casting, other hot work.

Uses: Leather gloves or gauntlets are used to protect hands from heat when performing techniques such as enameling or casting. It is always a good idea to wear thick gloves when handling large pieces of sheet metal as the edges can be very sharp.

Range available: Several different designs: general-purpose leather gloves, or those that have been specially treated for heat. Gauntlets are longer than gloves and cover the forearm.

Skill level: Basic.

Leather Finger Protectors

Technique: Polishing.

Uses: You should NEVER wear gloves when operating rotary machinery such as drills and polishing motors, so if your fingers need to be protected from abrasive media, or the work quickly gets hot when polishing, wear leather finger protectors. If the polishing wheel does catch on the leather protector, it will simply slip off.

Range available: Usually sold as sets of finger protectors in large or small sizes.

Skill level: Basic/intermediate.

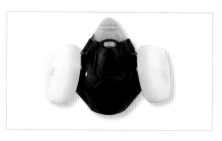

Respirator

Techniques: Use of chemicals, resins, and other substances that emit harmful fumes.

Uses: A close-fitting mask that has a pair of filters attached. The filters remove fumes from the air, protecting the lungs from chemical vapors. The filters will need to be replaced after a period of time—check the manufacturer's guidelines for the correct use of the respirator.

Range available: Several different models—check that the respirator is suitable for the type of chemicals you will be working with. Replacement filters can be bought separately.

Skill level: Intermediate.

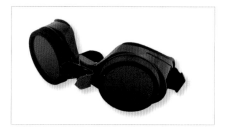

Welding Goggles

Techniques: Welding, enameling.

Uses: Certain processes give off harmful light rays, which can permanently damage the eyes. Goggles should be worn whenever high temperatures are used—enameling kilns emit infrared rays, and precautions should also be taken when handling molten metals. Even safety goggles will make a difference and keep the eyes from drying out too much when heating.

Range available: A few different styles of goggles, eye masks, and face shields are available. Blue-tinted spectacles specifically for use with enameling kilns are also available.

Skill level: Basic.

Protective Finger Tape

Techniques: Cleaning up, drilling pearls.

Uses: Also called "alligator" tape. The tape only sticks to itself, but can be wound around fingertips to protect them from abrasion when cleaning up pieces, and can be used as a preventive measure against cuts. The tape is loosely woven with a texture, and makes it easier to grip small pieces of work while working on them.

Range available: Sold as a roll of tape, and is easily cut to length with scissors.

Skill level: Basic.

Eyewash Station, Fire Extinguisher, First-Aid Kit

Technique: Damage control.

Uses: Hopefully never needed! But nonetheless important to have in the workshop. Eyewash is used to flood the eye in the event that chemicals or particles make contact, and is for one use only. Small fire extinguishers are inexpensive and are a must-have for any workshop.

Range available: Different brands.

Skill level: Basic.

MATERIALS

Although many jewelers work purely in metal, it is useful to have a working knowledge of other types of materials, and it is always interesting exploring the finishes and effects that can be achieved with them, as they often provide a colorful contrast to subtle metallic tones. Some jewelers prefer to work in a particular material and will end up knowing a great deal about its properties and the techniques that are most appropriate to use. Many materials have specific working properties, for example, refractory metals can be anodized but not annealed or soldered, and thermoplastics can be heated and formed while soft. Natural materials such as wood, bone, shell, and leather have been used for body adornment since antiquity, alongside base and precious metals and gemstones. These materials are often combined with more recently developed synthetic products, which are commonly used in contemporary jewelry making—plastics, rubbers, concrete, and magnets have a range of applications including mold making and model making within jewelry practice.

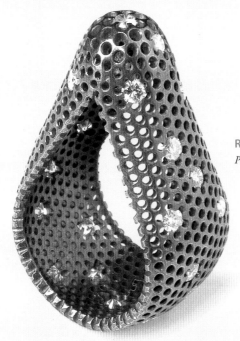

Ring, Grid Collection
Page 73

Silver is a wonderful material to work with—it is malleable and can be stretched and formed to a high degree, while being hard enough to retain structural strength. The most reflective of the precious metals, silver can be polished to a high shine, but does tarnish over time and with exposure to certain chemicals.

PRECIOUS METALS: SILVER

Applications

Silver is an affordable metal, with very good working properties. It is suitable for large- and small-scale work, and will withstand dimensional forming and shaping. Because silver work-hardens relatively quickly, it requires regular annealing to soften the metal before further processes can be performed, but work-hardened pieces constructed from thin gauge sheet or wire may be left in this state so that the form is more durable. Many different techniques can be used on silver as it is malleable and will allow stretching and compression, and can be seamlessly joined to itself using silver solder. Silver does not have enough tensile strength for some applications, such as mechanisms like springs or brooch pins, but is suitable for making jewelry that is worn through piercings.

Fine silver has a limited range of applications because it is so soft, but should be used for setting fragile stones in rub-over settings where not much force can be used. Very thin-gauge fine silver wire is ideal for making pieces that use textile techniques such as knitting or crochet, as it can be easily manipulated. Fine silver is produced when precious metal clay is fired, and this allows different working methods from the other forms of silver; the clay can be pressed into molds or onto textures, used to coat objects, and easily carved before it is fired. Fine silver forms can also be created through electroforming.

Silver electroplating is often used to cover firestain on large pieces of work where cleaning up would take a considerable amount of time, or on pieces that are thin and cannot be sufficiently abraded to remove the discoloration.

Structural brooch
by Victoria Coleman
This brooch was constructed from box structures that were soldered and laser welded together.

Silver properties					
Metal	Alloy composition (parts per thousand)	Color	Melting point		Specific gravity
Fine silver	999 parts silver	Lustrous white	1762°F	961°C	10.5
Britannia silver	958 parts silver 42 parts copper	White	1650°F–1725°F	900°C–940°C	10.4
Sterling silver	925 parts silver 75 parts copper	White	1480°F–1740°F	805°C–950°C	10.3

Availability

Sterling silver can be purchased in a large range of products from bullion dealers (see Suppliers and services, page 313). Products include sheet, wire, rod, solder, casting grains, foil, and tube, as well as chain and prefabricated rings, findings, and stone settings. The form of the product will affect the price per gram because of the manufacturing costs; tube is more expensive than sheet or wire, and casting grains have the lowest production costs. Discounts are often available for quantity purchases, with the price usually dropping at 10 and 50 grams; metal scraps will often be discounted in price.

Silver sheet is usually sold with a protective plastic coating to keep it from being scratched.

Some suppliers will make specific products, such as very thick-gauge sheet or outsize tubing, to order. Many bullion dealers also offer a scrap recycling service, and all forms of precious metals can be recycled, including bench sweepings. The price given for scrap will depend on the form of the metal—clean, hallmark-quality metal will give the highest price, and sweepings the lowest as they will need to be "refined."

Tarnish-resistant forms of silver are also available, but in fewer forms than standard silver. There are a few different alloys on the market in a limited range of products, but the choice should increase with demand. These alloys can be soldered and worked in the same way but are slightly harder to form—the main advantages are the reduced tendency for firestain, and tarnish resistance in air.

Britannia silver is often used for enameling as it is less susceptible to firestain after a few rounds of firing, but is mainly available in sheet form.

Fine silver can be found in a range of gauges in both sheet and wire forms, as well as precious metal clay, which yields fine silver forms once fired and comes in a range of products including clay, sheet, and paste.

Silver

Sterling silver sheet is available in a wide range of gauges.

Silver grain

Casting grain, for use in the lost wax casting process, provides the most economical form of this precious metal.

Silver wire

Sterling, fine, and tarnish-resistant alloys of silver can be found in a variety of wire profiles.

The purity of gold is described in karats—high-karat golds (24 and 22k) are very soft and malleable, and have a rich yellow color. Lower-karat golds are alloyed with greater proportions of other metals, allowing different working properties and colors, such as white, red, or green-gold, to be produced.

PRECIOUS METALS: GOLD

Applications

The high cost of gold compared to silver means that it is often used for contrasting color or accents on silver pieces in order to keep the overall material costs down. The cost of the material influences many of the techniques that are used—it is more usual to engrave gold than to etch it because the dissolved metal in the acid solution is not as easily reclaimed. Gold can be used in thinner gauges than silver as it is not as soft, and sheet can be up to two gauges (0.2 mm) thinner without any loss of integral strength; this also helps to reduce the cost of the metal used in a piece.

White-gold alloys are much harder and stronger than yellow, and for this reason prong and claw settings for valuable stones, as well as mechanisms, are often made from white gold.

Twenty two-karat gold is a very rich yellow color, but too soft for most applications. However, its malleability makes 22-karat gold ideal for bezel-setting very fragile stones. Eighteen-karat gold probably has the best working properties, being a little harder than silver and hard enough

to retain a high polish, making it suitable for most applications; this alloy contains a high percentage of gold, so it is perceived to have a high intrinsic value. Fourteen-karat gold also has good working properties, but is a paler shade of yellow than higher-karat golds; it has the lowest melting point of all the gold alloys.

Nine-karat gold is the palest, hardest, and least expensive alloy of gold, but having such a low percentage of gold in the alloy means that it also has a low intrinsic value.

Availability

Historically, jewelers would make their own alloys of gold, melting metals in the correct proportions in a crucible to cast an ingot that could then be worked into sheet or wire. This is a rare occurrence now, because such a wide range of gold products are available, and with a guaranteed purity. Nine-, 14-, and 18-karat golds are available in a range of gauges of sheet, wire, tubing, findings, chain, and prefabricated products, with the greatest variety of forms available in yellow gold—white, red, and

Gold casting grain
Many different alloys of gold are supplied as casting grain, this is 18k yellow gold.

green golds tend to have a less comprehensive range. "White" gold is available in two alloys: one is dull gray, the other is yellow-gray—for this reason, white gold is often plated with white rhodium to lighten the color.

Different grades of solder are available for each karat and color of alloy, and should be used with a flux suitable for the high temperatures required for gold soldering, such as "auroflux." It is important to use the correct karat solder for the gold being used because of the differences in color and soldering temperatures between gold alloys, and also because using a lower karat solder on a higher karat gold will prevent the piece from being hallmarked at the higher karat.

Twenty two or 24k foil is used for fusing and enameling, and a range of high-karat gold leafs are also available, and can be applied to finished pieces to add color and a luxurious finish. You can also find gold precious metal paint that is designed to be used and fired with precious metal clays.

Gold sheet
Gold sheet is available in a wide range of gauges and alloys.

Gold plating is used as a finish for pieces made from other metals, such as silver or base metals, giving the appearance of a more valuable piece. The color of the plate can be varied by changing the proportions of metals used for the anode; this also determines whether the plate is "soft" or "hard."

The price of gold makes it something of an investment—gold bullion is seen as a safe investment on the stock market; the price fluctuates daily with the rise and fall of the market. This directly affects the price of gold products available from bullion suppliers, as well as the rates given for scrap metal. It is also possible to source ethically mined or recycled gold.

Gold wire
D-section wire is just one of the profiles of gold wire that can be sourced.

Gold properties						
Metal	Alloy composition (parts per thousand)	Color	Melting point		Specific gravity	
24k (fine) gold	999 parts gold	Rich yellow	1945°F	1063°C	19.5	
22k gold	920 parts gold Alloyed with silver and copper	Dark yellow	11769°F–1796°F	965°C–980°C	17.8	
18k gold	760 parts gold Alloyed with proportions of silver, copper, zinc, and palladium	Yellow, red, white, green	1607°F–2399°F	875°C–1315°C	15.2–16.2	
14k gold	585 parts gold Alloyed with silver or palladium, copper, and zinc	Yellow, white	1526°F–2372°F	830°C–1300°C	13–14.5	
9k gold	375 parts gold	Pale yellow, red, white	1616°F–1760°F	880°C–960°C	11.1–11.9	

Platinum, palladium, and rhodium are less easy to work with than silver or gold, as they are hard and have high melting points. Platinum and palladium are ideal for setting valuable gemstones as they are very strong metals. Rhodium is most commonly used in electroplating, and it gives a very durable and bright-white or black finish to pieces.

PRECIOUS METALS: PLATINUM, PALLADIUM, AND RHODIUM

Applications

Platinum is a difficult metal to work because it is so hard, but this makes it good for secure stone settings. Casting is often used to produce pieces in platinum, as they will require little or no forming or soldering. Due to the high cost and high specific gravity of this metal, it is most often used for smaller pieces of jewelry, such as rings and earrings.

Palladium has increased in popularity as a material for jewelry making in recent years, having a good color and reflectivity, and similar working properties to platinum. The main advantages of palladium over platinum are its lighter density, lower soldering temperatures, and cheaper price.

Rhodium is used for electroplating other metals, most commonly white gold and platinum, to improve the color, giving a bright silvery-white finish that does not tarnish. Black rhodium plate is also a choice, and produces a dark gunmetal finish. Rhodium is very hard and can be deposited in thin layers; the plate is only a few microns thick, but will be more durable than other plated finishes.

Sapphire ring
by Erica Sharpe
This ring was fabricated from sheet platinum, and embellished with 22k yellow-gold granules and a blue sapphire.

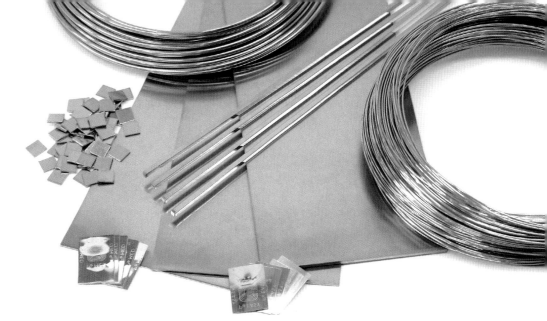

Availability

Platinum products are available in a limited range—because much platinum jewelry is cast, there is no need for a large range of products. Special files, saw blades, and polishing compounds are available for use with platinum as it will quickly blunt normal tools.

Palladium has recently been granted a U.K. hallmark, which sets its place as a precious metal, and will increase public awareness. As interest and demand increases, a greater range of metal products will be available. Palladium is in the same price region as mid-range karat golds.

Many platers will offer white rhodium plating as a service, but fewer offer black. Rhodium plating can be more expensive than other metal plates as the metal itself is very pricey, but not prohibitively so, because such small amounts are being used.

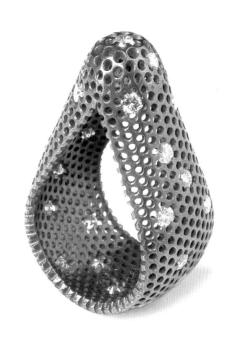

Palladium and platinum
Palladium and platinum are available as sheet, rod, wire, casting squares, and solder panels.

Ring, Grid Collection
by Salima Thakker
Black rhodium plating has been used to color a gold ring, and gives a striking contrast to the diamonds set around the form.

Platinum, palladium, and rhodium properties					
Metal	Alloy composition (parts per thousand)	Color	Melting point		Specific gravity
Fine platinum	999 parts platinum	Gray-white	3227°F	1775°C	21.4
Platinum	955 parts platinum 45 parts copper	Gray-white	3173°F	1745°C	20.6
Palladium	950 parts palladium (gallium, copper)	White	2462°F–2552°F	1340°C–1400°C	11.7
Rhodium	999 parts rhodium	Bright white	3571°F	1966°C	12.5

Nonferrous base metals have a range of useful working properties, and are less expensive and more reactive than precious metals. The reactivity allows a range of chemical patinas, or coloring techniques, to be used with these metals, but also means that surfaces will quickly tarnish in air.

BASE METALS

Applications

This group of base metals has a number of useful applications within jewelry making. With the exception of zinc, these metals can all be soldered with silver solder and borax, to themselves, to each other, and to precious metals to create interesting color combinations, or to construct first-run test pieces and models. However, these metals cannot be hallmarked because they are not precious, and cannot not be used in precious metal pieces that will be hallmarked. Although nickel is also a nonferrous base metal with useful working properties, many people are allergic to this metal so it should not be used in jewelry making.

As gilding metal has a similar malleability and working properties to silver, it can be used to make models or test runs of pieces, or large-scale final pieces that are then electroplated to appear as if they are silver or gold; this will help keep material costs down. Very thinly milled gilding metal leaf is used as a cheap alternative to gold leaf, and can be found in a range of shades in both loose and transfer leaf.

Copper is a good metal for making large pieces that are heavily formed, but too soft for thin, intricate forms, and can be quite tacky to pierce. Although copper is relatively soft, structural forms constructed from copper sheet often have enough integral strength to stay rigid. Copper is a reactive metal and quickly oxidizes in air; this property allows many color variations to be created through heat or chemical patination. Specific chemicals or processes can be used to create verdigris, blue, brown, black, purple, and red effects (see page 211), and the same chemical solutions can be used on brass, gilding metal, and bronze—each metal will give a slightly different result. Any nonferrous metal can be copper plated by wrapping it in binding wire and leaving it in a pickle solution for a time—the copper dissolved in the pickle will be deposited on the piece (use a separate container from your usual pickle tank for this process, to avoid plating other pieces of work!).

Brass is hard and can be brittle—but is a good choice for base metal wire structures as it is very rigid once work-hardened, though it can easily be overworked and requires regular annealing. Air cool brass rather than quenching it, as the shock of a sudden change in temperature may cause excessive internal stresses leading to

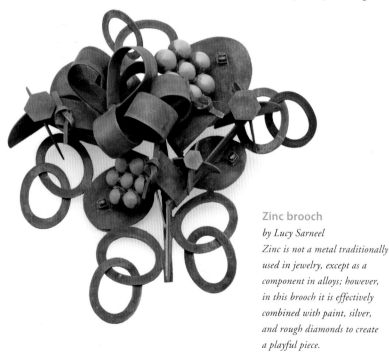

Zinc brooch
by Lucy Sarneel
Zinc is not a metal traditionally used in jewelry, except as a component in alloys; however, in this brooch it is effectively combined with paint, silver, and rough diamonds to create a playful piece.

Base metal properties					
Metal	Alloy composition (parts per thousand)	Color	Melting point		Specific gravity
Copper	999 parts copper	Warm orange	1480°F–1980°F	804°C–1082°C	8.94
Gilding metal	950 parts copper 50 parts zinc	Warm yellow	1650°F–1725°F	899°C–941°C	8.75
Brass	670 parts copper 330 parts zinc	Pale yellow	1690°F–1760°F	921°C–960°C	8.5
Bronze	900 parts copper 100 parts zinc	Yellow-brown	1922°F	1050°C	8.8
Zinc	999 parts zinc	Gray-white	788°F	420°C	7.1

Brass

Copper

Zinc

cracking. Due to its hardness, brass is suitable for making certain types of tools—press-forming tools, simple punches, and pierced templates are most common. The production techniques of brass products will affect the metal's working properties—much brass rod is extruded and this can make it prone to cracking if overworked or overheated.

Bronze is mainly used for casting as it is very hard, and will retain a very high degree of detail; it can also produce a good range of patination colors.

Finestre ring

by Fabrizio Tridenti
Cast bronze and
aluminum provide
contrasting colors in
this sculptural ring.

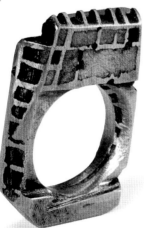

Availability

Base metals can be purchased from specialist base metal suppliers as well as craft and model stores. A range of gauges of sheet, rod, wire, foil, leaf, mesh, and tube can be found.

Castings can be produced in bronze or silicone brass—there are casters who specialize in this area. This can be useful for making models, or "master" patterns in base metal, but as the actual cost of the casting technique and metal is only marginally less than the cost of having a silver piece cast, it is more often the choice of metal that will influence the decision.

Fluctuating metal prices may dictate choice, but compared with many precious metals, base metals are relatively inexpensive.

Copper

Often it is the working properties of a base metal that influence the choice of material, rather than the color. Below: copper.

Also called the "light" metals because of their low specific gravity, this group of metals have quite different working properties from precious or other base metals as they cannot be annealed or soldered, and are less malleable—with the exception of aluminum and tantalum. Stunning refractory colors can be produced when these metals are anodized.

REFRACTORY METALS

Applications

These metals are notable for the coloring techniques that can be applied to them, but have limited applications since they cannot be soldered or annealed under normal conditions. Anodizing is a coloring technique that can be used on titanium, niobium, and tantalum; this process requires specialist equipment, but the effects that can be achieved are worth the trouble of sourcing, hiring, or borrowing equipment. (See page 217 for more information on anodizing.)

Aluminum is the most workable of these metals; being the most malleable, it can be formed and shaped using a number of techniques; it can also be anodized, but requires a different process from the refractory metals. Once anodized to produce a receptive surface, aluminum can be dyed or printed on permanently. Anodized aluminum has a hard skin of oxides on the surface and is not so easily formed. Because aluminum is so light, having a very low specific gravity, thicker gauge sheet can be used that will compensate for its softness, giving pieces greater strength. However, if overworked, the metal is prone to cracking—it is possible to anneal aluminum, but as there is no color change it is very easy to overheat and melt the metal.

Brightly colored powdered aluminum can be applied in a similar way to gold leaf (see page 219). Aluminum (as well as tin, zinc, and lead) is contaminant to precious metals because it has such a low melting point that it will make holes in other metals when they are heated together. Tools used for aluminum should be kept separately, or thoroughly cleaned before they are used on other metals.

The refractory metals—titanium, niobium, and tantalum—are often combined with other metals using cold joining techniques, and are usually anodized to color them, as these metals

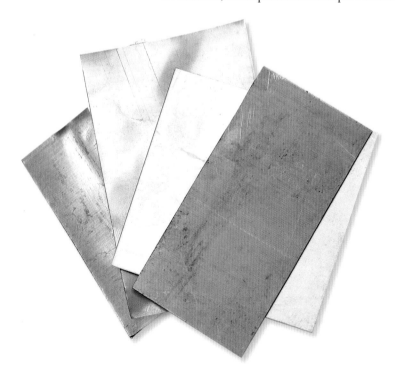

Refractory metals
Refractory metals showing their natural metallic colors. From left to right: tantalum, aluminum, niobium, titanium.

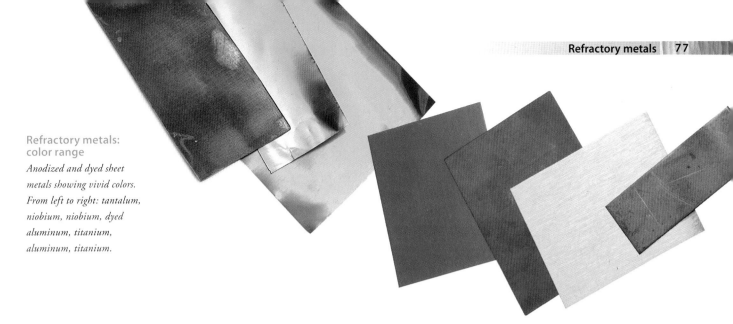

Refractory metals: color range

Anodized and dyed sheet metals showing vivid colors. From left to right: tantalum, niobium, niobium, dyed aluminum, titanium, aluminum, titanium.

do not polish well. Titanium is very hard and does not compress well, so is less suitable for techniques such as stamping; it can blunt tools, so plenty of lubricant must be used when cutting, drilling, or burring the metal. Titanium can fracture when formed because it is brittle, so sheet metal is often used flat. The anodized colors produced on titanium are metallic shades, with etched titanium giving the brightest colors. This metal can also be heat-patinated to produce the same range of colors, although this process is less easy to control and several graduating colors will be present on the piece of metal.

Niobium is the most malleable of the refractory metals, and work-hardens very slowly. It also has a greater range of anodized colors than titanium, and can be cut, pierced, drilled, and burred in the same way.

Tantalum has similar working properties to gold and it can be formed and stone set, as well as being anodized.

Availability

Refractory metals are available from specialist suppliers, in a limited range of products. Sheet, rod, and wire should be easy enough to source, but mesh, tubing, foil, and other forms may be more difficult to find. Look for pre-anodized aluminum if you plan to use dyes; aluminum can be bought ready dyed, but will not be able to be formed in the same way as untreated aluminum because the anodizing process creates a hard skin. There are companies that will anodize and dye formed aluminum pieces to order. You may also find pre-etched titanium for anodizing.

Titanium

Titanium rod and wire can easily be colored by applying heat or anodizing.

Refractory metal properties

Metal	Alloy composition (parts per thousand)	Color	Melting point		Specific gravity
Aluminum	950–999 parts aluminum	Blue-white	1220°F	660°C	2.7
Titanium	999 parts titanium	Gray	3272°F	1800°C	4.5
Niobium	999 parts niobium	Gray	4474°F	2468°C	8.4
Tantalum	999 parts tantalum	Gray	5425°F	2996°C	16.65

Ferrous metals are those that contain iron, such as steel—an indispensable metal in jewelry making, as it is often used to make tools and machinery. Steel can also be used in jewelry pieces, and stainless steel in particular is often used in moving mechanisms such as brooch pins or springs.

FERROUS METALS

Applications
The higher the carbon content, the harder the steel will be; stainless steel is very hard and springy, and ideal for making brooch pins and other structural devices that need to be very strong.

Iron binding wire has little or no carbon content, and is soft enough to securely bind elements of other metals that will be soldered, to hold them in position; it also has a much higher melting point and so will not contaminate other metals when they are heated.

Stainless steel is most easily bent or forged while it is red hot—cleaning up can take time because this metal is very hard and can blunt files. A number of processes can be used with steel, in a similar way to other metals used in jewelry making. Steel can be drilled, pierced, polished, etched, carved, heat-patinated, and allowed to rust. In addition to fabrication processes, tool

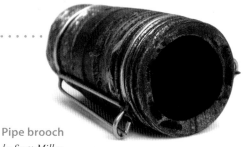

Pipe brooch
by Scott Millar
Laser welding and fabrication techniques have been used to combine a found steel object with a stainless steel brooch pin.

steel (sometimes called silver steel) can be used to make simple tools such as punches and stamps. These tools will need to be hardened and tempered before they can be used.

Steel can be soldered to steel and other metals using silver solder. The main problems arise from the oxidization of the surface that inhibits solder flow, so use a flux with a high working temperature and bring the metal up to soldering temperature very quickly. Steel can also be welded.

Availability
A wide range of steel products are available, but they are mainly stocked by base metal suppliers rather than bullion stockists. Model and craft stores may stock a limited range.

It should be possible to source a range of gauges of sheet, wire, and rod, as well as tube, mesh, and pre-textured sheets for industrial or architectural uses, with a range of different finishes.

Stainless-steel dental wire is very useful because it is supplied fully hardened and in thin gauges.

Ferrous metal properties					
Metal	Alloy composition (parts per thousand)	Color	Melting point		Specific gravity
Stainless steel	800–900 parts iron 100–200 parts chromium	Gray-white	2642°F	1450°C	7.8
Tool steel	850–970 parts iron 30–150 parts carbon	Gray	2192°F –2552°F	1200°C –1400°C	7.8
Mild steel	975–995 parts iron up to 25 parts carbon	Dull gray	2372°F –2732°F	1300°C –1500°C	7.8

This diverse group of materials provides fantastic opportunities for exploring color, texture, and form, and is often combined with precious metals. Many of these materials have specific techniques associated with them, from heat-forming thermoplastics to casting plaster for model making.

SYNTHETIC MATERIALS

Properties

There are two main types of plastics: thermosetting plastics and thermoforming plastics. Thermosetting plastics, such as resin, give off heat as they set from liquid to solid, and are usually cast in simple plastic or silicone molds to create solid forms. Polyester resin is transparent and can be dyed and used to embed objects; it can be brittle and will chip or crack on impact. Epoxy resin is less brittle and is most commonly used as an adhesive. Bioresin is derived from plant oils and has fewer health implications than other forms of resin, but should still be used with care.

Thermoforming plastics, such as acrylic and cellulose acetate, are supplied precast, and can be heated to allow them to be formed. Acrylic is often called by brand names—Plexiglas, Lucite, and Perspex are a few—and it is available in a wide range of colors and effects, including neon, pearl, and mirror. Acrylic has a memory, and if reheated after being formed, will return to its original form; it can be heated many times before its properties are affected.

Nylon and polypropylene are strong, flexible plastics that have a range of useful applications in jewelry making.

Rubber is characterized by its flexibility. Silicone rubbers with differing properties can be found—some are soft

Plastics
A wide range of plastics with differing working properties can be sourced.

and flexible, and others are hard, with little give. Natural latex rubber is a liquid, but once cured it will degrade reasonably quickly. When natural rubber is heated in the presence of sulfur (a process called "vulcanizing"), its properties change and it becomes very durable and long-lasting. Other forms of rubber include neoprene, which is a spongy sheet material, and polyurethane.

Cements must be mixed with water and an aggregate such as sand to give body; the choice of aggregate influences the appearance and properties of the final product. Once the cement has cured, a very hard stonelike substance is produced, and the material takes on the surface properties of the mold into which it was cast. Small objects, such as gemstones, can be included in the mixture to add visual interest.

Glass can be found in nature—obsidian is volcanic glass—but is more usually a manufactured product, valued for its superb

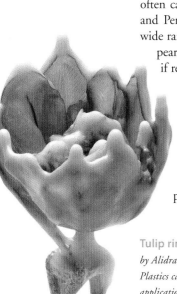

Tulip ring
by Alidra Alic de la Porte
Plastics can be used for a wide range of applications, including experimental techniques to create pieces such as this fragile-looking ring.

Electronic components

Electronic components can be used to create sound or movement in a jewelry piece but will need some kind of power source.

Vintage textiles

Though not always hard wearing, textiles are available in a wide variety of colors, textures, and ranges of flexibility that can be incorporated into jewelry in many different ways.

optical properties. Glass used in jewelry making must be durable, so Pyrex is often used because it is shock and heat resistant.

There are many types of clay that will produce ceramics with specific properties. Porcelain is considered a fine material, being translucent in its white form and very finely textured. It requires specialist equipment in the form of a kiln, as clays must be fired at high temperatures to vitrify them. Clays can be glazed to add color, texture, and a shiny finish.

Textiles and paper are made from a wide range of materials and therefore have a wide range of properties; differing degrees of flexibility, thickness, transparency, and optical effects can be found. The raw materials may be natural or synthetic, and can include metal, plant materials, and plastics.

Electronic components are used to make circuits that have specific functions. Light emitting diodes (LEDs) come in a range of colors and intensities, and other components can be used to effect sound or movement. Components such as resistors, switches, and a power source will need to be incorporated into the circuits, which can be joined with wire or soft-soldered to a circuit board, which may be more appropriate for some applications. The size of the circuit can be kept to a small scale suitable for use in jewelry applications, but the accommodation of an accessible power source will always pose a challenge.

Magnets with a range of strengths, measured in megagauss-oersteds (MGOe), can be sourced in sizes from 3/64 in (1 mm) upward. Neodymium magnets have a high MGOe and the magnetic force is enough to work through two layers of thin metal, meaning that the magnets can be contained in a metal setting or inside pieces.

Applications

There are too many uses within jewelry for these materials to be described here in much detail, but they can provide a source of color, texture, structural form, optical effects, and often create a striking contrast with metal forms or components. As with other materials, synthetic products have their limitations—plastics, for example, are relatively soft and will scratch easily; textiles and paper may be susceptible to water damage; and magnets can be rendered useless when heated

sufficiently. It may be necessary to experiment with each new material to find out what it can and can't do.

Rubber is most commonly used for mold-making and casting, while resins can be cast into solid forms or used to coat or embed objects.

With the exception of some ceramics, it is not possible to solder metal in the presence of these materials, so you will have to use cold joining techniques if they are to be combined with metal; many of these materials also benefit from the structural support and protection of metal parts.

There is a wide range of techniques that can be applied in many cases; for example, glass can be spectacle- or bezel-set, lampworked, blown, silvered, slumped, cast, colored, laminated with foil, engraved, or carved with diamond burrs and may also be used in the form of lenses, dichroic slabs, or beach finds. The lightweight nature of many papers, textiles, and sheet plastics make them ideal for large-scale pieces—and they can be laser-cut to produce intricate designs.

Availability

These materials can be sourced from a wide range of different suppliers: sculpture suppliers, craft or model stores, bookbinding suppliers,

as well as many specialist suppliers that can be found online. Found objects are also a useful source of synthetic materials.

Storage

Chemicals such as liquid resin, latex, and silicone should be stored in a lockable metal cupboard; these products have a limited shelf-life and may be unusable after a certain time. Powdered materials such as cement and plaster, as well as paper and textiles, should be stored in a cool, dry place.

Latex

"Smart" plastic

Synthetic materials
*Synthetic materials can range
from paper to "smart" plastics
with special light properties.*

Paper

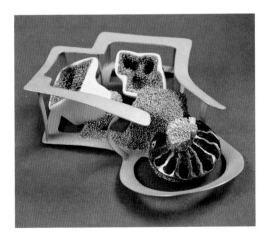

Aquaductus brooch

*by Andrea Wagner
This complex piece combines cast
porcelain elements, pyrite, and polyester
granulate, embedded in synthetic resin,
with a fabricated silver structure that
has been painted.*

Synthetic materials properties		
Material	Composition	Hardness (Mohs' scale value)
Plastics, neoprene	Synthetic polymers	1
Latex rubber	Natural or synthetic polymers	1
Silicone rubber	Polysiloxane	1
Glass	Silica plus additives	6–7
Ceramics	Phyllosilicate clay with minerals; kaolin	5–7
HAC, cement	Calcium aluminate cement with aggregate	–
Plaster	Gypsum	2
Electronic components	Various materials	–
Paper	Cellulose fibers from softwood pulp plus additives	–
Textiles	Natural or synthetic fibers	–
Magnets	Natural magnetite or nickel-plated neodymium iron boron	5.5–7

Gather charm
by Aiko Machida
Soft leather was cut
and formed to make
this tactile piece.

Many naturally occurring materials can be used in jewelry making. Although much softer than metals, many of these materials can be cut, shaped, and polished in a similar way. Look to other trades and forms of craft, such as bookbinding, furniture making, or millinery for inspiration and techniques.

NATURAL MATERIALS

Natural material properties

Although horn, tortoiseshell, feathers, hair, and quills are all composed of the same basic protein, the structure of these materials greatly affects their working properties. Horn from animals such as cows, buffalo, and sheep ranges in color from black, through brown, to blond. The horn is hollow at the base and this tube material is flattened to produce "pressed" sheet horn. The tips of the horns are solid, and are much harder and denser than pressed horn. The layered structure of horn means that it can be prone to splitting and cracking.

Feathers from a large variety of birds can be put to use in jewelry making, and the function of a feather will determine its form—flight feathers are sturdy and structural whereas those for insulation are small, soft, and fluffy. Hair from horses, humans, and giraffes is typically used for jewelry making, as the lengths are sufficient for a range of weaving and braiding techniques. Quills are hollow tapers with a sharp tip, and are either the central shaft of a feather stripped of its "web," or the spine of a porcupine.

Bone, ivory, and shell are all calcium-based, and have similar working properties. Bone is heavier and more brittle than ivory; shell can fracture in thin layers and varies in hardness. Vegetable "ivory" is a term used for several varieties of nut, which can be worked in a similar way to ivory. Shells come in an amazing range of shapes, sizes, and colors and can be iridescent.

Jet is fossilized wood—it is light, very hard but brittle, and will take a high polish. Black glass (French jet), vulcanite, bog oak, and molded horn have historically been used to imitate jet.

Leather is treated animal hide; the production methods of the leather will affect its properties—some leathers are thick and rigid; others thin and flexible. Exotic leathers are those from ostriches, fish, and stingrays; vellum is dried calfskin.

Wood density varies depending on the type of tree, and the position within the trunk—heartwood is harder and denser than the (outer) sapwood. Coniferous trees, such as pine, produce softwood, and deciduous (hardwood) trees give a wide range of densities. Fruitwoods, such as apple, pear, and cherry, are hard and have an attractive grain. Driftwood, coconut shell, and bamboo are also useful materials.

Applications

None of these materials are suitable for pieces that will receive a great deal of wear, as they are sensitive to heat, moisture, body oils, and chemicals. Precious metal liners, fittings, and findings are often used in conjunction with natural materials to improve their durability and function as jewelry objects. The advantages of using these materials are the contrasts of color and texture they can provide, and many of them are tactile as well as being light, making them comfortable to wear. The harder a material is, the greater the amount of detail that can be applied to it; dense and heavy materials may be more appropriate for smaller-scale pieces so that the weight of the finished piece is not excessive.

These materials cannot be heated to soldering temperatures, so cold joining techniques or adhesives must be employed to secure them in position when combining mixed materials. Many natural materials can be drilled, cut, pierced, carved, dyed, polished, engraved, inlaid, and laser- or water-cut depending on their composition, and some have specific techniques associated with them because of their particular working properties. Horn and tortoiseshell can be worked in a similar way to thermoplastics, being easily cut, cleaned up, and polished, and can even be thermoformed when softened in boiling water. Feathers and quills can be softened and shaped in hot water or steam; leather and vellum can be hardened in boiling water or shaped over a former; shell can be etched with nitric acid.

Hardwoods are more suitable for jewelry making than softwoods, and are also useful for making tools. The hardness, density, and grain of the wood will determine the size of the form and the amount of detail—it is even possible to engrave very hard woods such as box.

Availability

Most of these materials will need to be sourced individually from specialist companies if they are required in any quantity. Many interesting finds can be made when exploring other areas of craft manufacture, such as millinery for feathers,

and carpentry suppliers for wood. Online auction sites and secondhand stores and markets are a good place to look for found objects, or items made from natural materials. However, take care not to break the law when buying materials from a natural source—many plants and animals are endangered, and are protected by CITES (Convention on International Trade in Endangered Species of Wild Flora and Fauna), and suppliers should be able to produce a certificate to prove that the source of the material is farmed and not wild. Trade in ivory and tortoiseshell is illegal except for antique material, but some convincing synthetic alternatives are available.

Storage

Care should be taken with the storage of many natural materials, as they are susceptible to damp and chemical and insect damage—both keratin-based materials (such as feathers and horn) and wood can suffer damage from beetle larvae. Bone, horn, ivory, leather, and wood are all sensitive to changes in humidity and should be stored in a cool, dry place so that they cannot warp through contact with moisture.

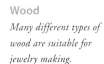

Wood
Many different types of wood are suitable for jewelry making.

Shell and horn
Materials such as horn are completely transformed once cleaned and polished. Shell can be found in vivid dyed colors, as well as in its natural state.

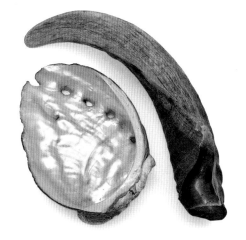

Natural materials properties			
Material	Composition	Hardness (Mohs' scale value)	Specific gravity
Feathers, hair, quills	Keratin	–	–
Horn, tortoiseshell	Keratin	Varying	1.26–1.35
Bone	Calcium phosphate	2.5	2.0
Ivory	Dentine	2–3	1.7–1.93
Shell, mother-of-pearl	Calcium carbonate, chitin, lustrin	3.5	2.7–2.8
Jet	Lignite	2.5–3	2.5
Wood	Cellulose	–	–
Leather	Animal hide	–	–

Gemstones have been used for thousands of years in jewelry making, to decorate, allure, and attract the eye. Many stones were believed to possess magical or talismanic properties that would ward off evil. To this day, gemstones often form the focal point of a piece of jewelry, but can also be used to accent or highlight areas; gems are set, strung, or mounted to give color or sparkle.

GEMSTONES

Composition

The majority of gemstones are mineral in nature, formed underground by pressure, temperature, and other factors in igneous, sedimentary, or metamorphic rock. The way in which mineral crystals form directly affects the properties of the crystal in terms of size, cleavage, and fracture, and the type of optical effects that will be apparent when the stone is cut. Most gems are colored by the presence of elements or minerals; for example, chromium and vanadium give emeralds their characteristic green color.

Gems with similar compositions are grouped into families—quartz is a large group of stones that includes rock crystal, rose quartz, citrine, and amethyst. Many gems are specific to a few geographic locations. A great deal of stones are treated to improve their color and clarity, and this can be achieved through heating, irradiation, and laser drilling to remove inclusions; surface treatments include the application of waxes, oils, or resins to improve the surface of a stone by filling cracks and flaws.

Organic gems such as amber, pearls, jet, and coral are considered precious materials and are produced from plant or animal sources in nature. Pearls are often cultivated, so natural pearls carry a high price. Amber is often reconstituted with synthetic resins, a practice that has been taking place since the mid-nineteenth century. Organic gems are generally much softer than mineral gems, so the range of applications they can be used for is more limited.

Applications

The visual and physical properties of stones vary greatly, and will influence the type of jewelry they can be used for, and how they are secured in position. There are a number of different ways of using metal to "set" stones; in bezel and flush setting, metal is pushed down around the stone to secure it. This method is often used for setting cabochons, but can also be used for faceted stones. Fragile stones should be set with fine silver or gold, as these metals are softer in pure form. Prong or claw settings use shaped wire to form a frame that holds the stone proud of a piece, allowing light to enter around the stone. For more information on types of settings, see pages 237–250.

A setting must be sympathetic to the stone in terms of its hardness, color, and cut; the type of setting may affect the intensity of the color of the stone, and certain types of settings are more suitable for some cuts than others.

Stones can also be used in their rough (uncut) form, and softer stones may be cut and carved.

Beads can be strung on a wide variety of different media, including silk and nylon. The silk is knotted between pearls and semiprecious beads to keep them from rubbing against one another, which would cause damage; it also means that if the string breaks then few, if any, beads will be lost.

Stones may be bought with a specific design in mind, or can provide an inspirational starting point for a piece, but always consider the properties of the stone when deciding on the type of setting.

Freeform ring with stone cluster

by Kelvin J. Birk
This ring features a crushed and reformed amethyst cluster as its focal point.

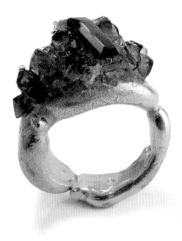

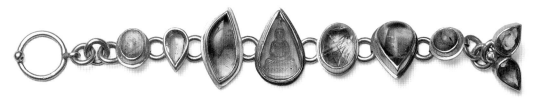

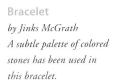

Bracelet
by Jinks McGrath
A subtle palette of colored stones has been used in this bracelet.

Availability

Stones should always be purchased from a reputable dealer, to ensure high quality and fair trade. They will be able to tell you if the stone has been treated or dyed, its origin, and if they have something similar in a different price range. Good dealers should stock a range of each type of stone, so there should be something affordable, even if it is lower quality or a bit pale. Price is always an important consideration, as stones generally increase in value exponentially with size. Most stones can be found in a range of faceted cuts, cabochons, and beads.

When choosing faceted stones, check for color, symmetry, clarity, and cut, and ensure you get a proper receipt, stating the origin, carat weight and type of material—not least so that you can inform customers when they buy your finished pieces, but this is also useful if you want to buy the same type of stone again.

Storage

Stones should be carefully stored so that one stone cannot be damaged by another. Don't allow stones of different hardness values to come into contact—it is best to store gems separately, either in transparent plastic cases, sealable bags, or tissue paper wraps.

Once set in jewelry, gems will be more protected from bumps and knocks, but some are sensitive to chemicals, so remove rings when washing your hands, and never allow the stone to come into contact with chemical cleaners, whether household or jewelry-specific. Most set stones can be cleaned in warm, soapy water with a soft brush.

Gemstone properties		
Stone	Hardness (Mohs' scale value)	Specific gravity
Amber	2.5	1
Amethyst	7	2.6
Aquamarine	7.5–8	2.7–2.8
Coral	3.5	2.7
Diamond	10	3.4–3.6
Emerald	7.5–8	2.75
Garnet	6.5–7.5	3.5–4.1
Jadeite	6.5–7	3.3
Lapis lazuli	5.5	2.3–3
Malachite	3.5	3.8
Moonstone	6–6.5	2.6
Opal	5–6.5	2–2.5
Pearl	2.5–4	2.7–2.8
Peridot	6.5–7	3.3
Ruby/sapphire	9	4
Topaz	8	3.5
Tourmaline	7–7.5	3–3.2
Turquoise	6	2.8
Zircon	6.5	3.9–4.7

Tourmaline

Apatite

Tourmaline

Orange fire opal

Quartz

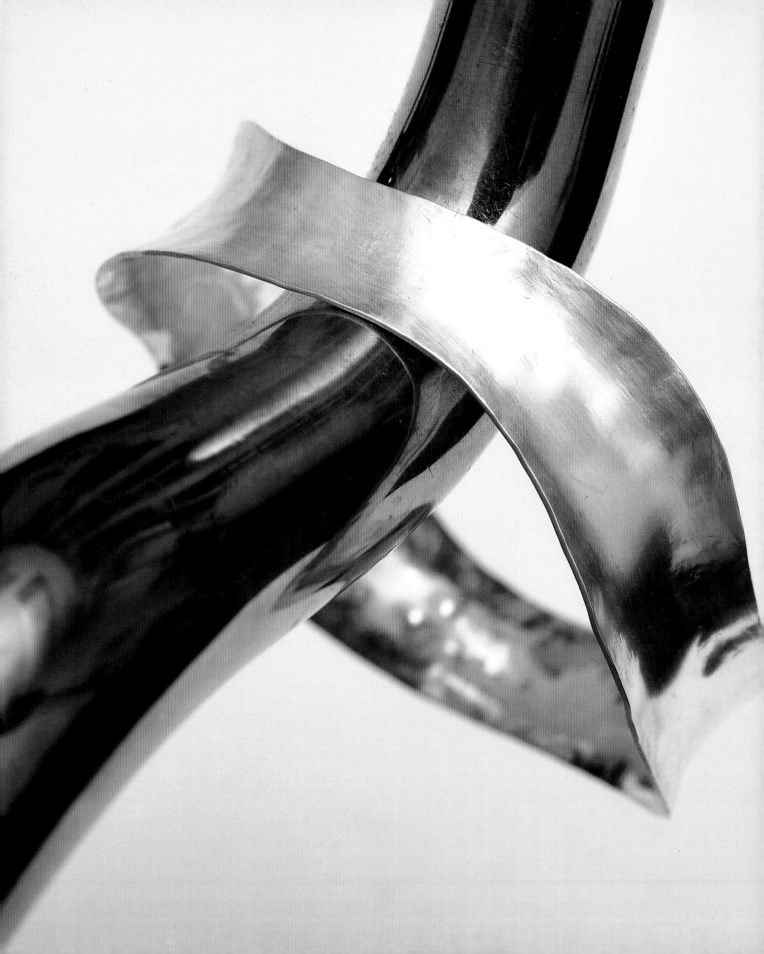

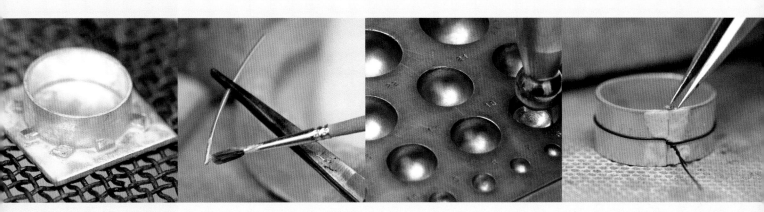

TECHNIQUES

CORE TECHNIQUES

This section covers the range of core techniques, which every jeweler needs to master, from cutting to soldering, bending to polishing. These techniques are essential in jewelry making and will need to be practiced so that accurate results can be achieved—it does take time to get used to working with tools, and to understand their action on the materials being worked. Metal is the most challenging material to work with and should be concentrated on at the beginning; the accuracy that it allows is perfect for the beginner to practice with to gain greater control of skills. Many of these techniques can be applied to materials other than metal, such as plastics and natural materials; any specific tools or practices required for these materials are also described in this section.

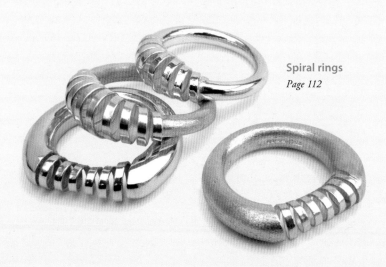

Spiral rings
Page 112

Materials for jewelry making must be cut roughly to size, and then accurately shaped before construction. You can use a range of tools for cutting—a jewelry saw is the most common.

CUTTING AND PIERCING

Cutting sheet metal

Bench shears, guillotines, and tin snips are all used to cut metal down to a more manageable size from stock sheet. These tools are, however, unsuitable for accurate work, because the edge of the metal after cutting is left stretched and distorted. In a small workshop, without access to such equipment, a jewelry saw is an invaluable tool. You can use a saw to accurately cut metal to shape and also to produce fretwork.

Transferring a design to metal

Before you start to pierce (cut), you'll need to transfer your design onto the metal. You can stick a photocopied template onto the metal with double-sided sticky tape, but for more accurate lines it may be preferable to trace the design directly onto the metal.

Rub modeling clay on the back of the design and position the tracing on the metal so that the amount wasted in cutting will be as small as possible. Use a pencil or fine point to trace through, transferring the line to the metal. Then trace over the lines carefully with a scribe, otherwise they will rub away.

Basic technique

The first step is to secure the saw blade in the frame. Sit at your workbench and support the saw frame between the bench peg and your chest, with the handle toward you and the blade clamps uppermost. This leaves both hands free to insert the blade. Clamp the blade at the far end of the frame, with the teeth along the top edge and pointing toward you. Lean gently against the wooden handle, and the steel bow will flex slightly. With the frame flexed, tighten the other wingnut to secure the blade in the frame.

Pluck the blade to test the tension. If it "pings," the tension is correct. A dull "plunk" indicates a slack blade, which will soon break when sawing. To readjust the blade, undo the handle-end clamp, lean on the frame to compress it more, and then retighten the wingnut.

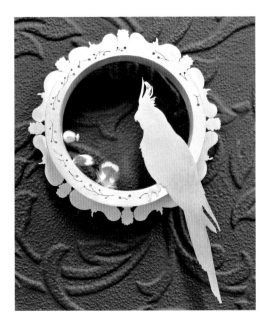

Sticky brooch
by Hannah Louise Lamb
This narrative, mixed-media brooch uses piercing to create both the outline and the decorative detail. A pearl and feathers were added after the piece was constructed.

PIERCING A FRETWORK DESIGN

You can pierce delicate fretwork designs with a jewelry saw, but you'll need to drill holes in any internal spaces before they are pierced.

TECHNIQUE FILE 01

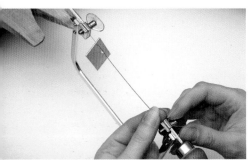
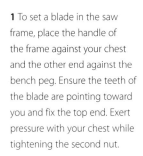

1 To set a blade in the saw frame, place the handle of the frame against your chest and the other end against the bench peg. Ensure the teeth of the blade are pointing toward you and fix the top end. Exert pressure with your chest while tightening the second nut.

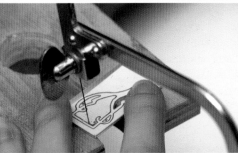

2 Thread the saw blade through a drilled hole before tightening the second nut on the frame if cutting an internal space. To cut a straight line, use slow, even vertical strokes of the blade, and work to one side of the line on the template.

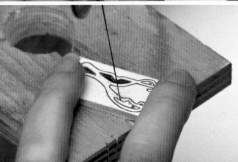

3 You can achieve smooth curves by turning the metal into the path of the saw blade as it cuts. For very tight curves, rotate the saw blade as it moves up and down on the spot, until it is possible to change direction.

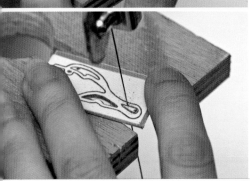

4 For a sharp internal corner, cut along one side of the corner toward the point and then cut down the other side. This will give a much sharper angle than if the saw blade had been turned to change direction in the corner.

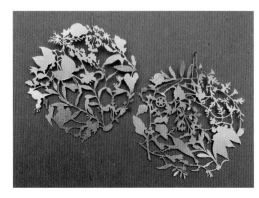

Poison flower earrings
by Rebecca Hannon
Silhouettes of poisonous plants have been pierced into 18-karat gold to create these earrings.

Sit at the workbench and hold the marked material firmly on the bench peg. Aim to cut on the outside edge of the lines rather than inside them—it is better to have too much material rather than too little. Rest the saw blade on the edge of the material and gently draw the blade downward across the edge. (Because the teeth point toward the handle, the blade cuts on the downstroke.) The blade should begin to cut. If the blade sticks, lubricate it with oil or beeswax. It's not necessary to apply great pressure—if you draw the full length of the blade slowly up and down, cutting should be easy.

To saw straight lines, align the frame with the mark on the metal and keep the blade vertical as you cut. To saw around curves, keep the blade upright. To turn corners, raise and lower the blade, gradually turning the frame until the blade faces in the new direction, then continue to saw. When you are piercing fretwork, pierce internal areas first so that the piece remains comfortable to hold. Once all of the fretwork has been completed, you can finish cutting the outline of the piece.

Cutting other materials

When cutting wax, plastics, and soft natural materials such as wood, it is often necessary to use a saw blade with the teeth arranged in a spiral. These blades allow the cut material to be thrown out by the blade. This keeps it from getting jammed, and it will cut the material much more quickly than a straight saw blade, though less accurately.

Holes made by drilling can be functional—to provide access for the jewelry saw for instance, or they may be decorative and arranged in a pattern. Many different materials can be drilled, including metals, plastics, and most natural materials.

DRILLING

Types of drill

The use of manual drills has decreased over recent years, as motorized drills have become more affordable, but the manual drilling of certain jobs is still a necessity. Where work is fragile or access to the area to be drilled is awkward, a drill bit secured in a pin vise will perform the task adequately. Other examples of hand drills are the Archimedian drill, which has a sliding cuff that powers the bit, and the bow drill.

Pillar drills are bench-mounted motorized units that allow you to drill incredibly accurate vertical holes. A flexshaft motor is also a useful device for drilling, but is less easily controlled, unless the handpiece is mounted in a special clamp that allows it to be used as if it were a pillar drill.

Drill bits and chucks

The chuck is the part of the drill that holds the drill bit, and is often made up of three or four jaws that are either retractable, or secured by a collar. The drill bit is the cutting part of the drill, and bits are available in many sizes. For jewelers, bits between 22 gauge (0.6 mm) and 8 gauge (3.3 mm) are most useful. It's a good idea to have a selection of sizes in stock. Most drill bits are made from high-speed steel and are suitable for drilling most metals and many other materials such as plastics and hardwoods. These bits have a spiral recess that allows the drilled material (swarf) to clear easily. Semiprecious stones and glass are so hard that they must be drilled with diamond-coated drill bits, which are lubricated with water. There are special drill bits for pearls, designed so that they will not chip the edge of the drilled hole.

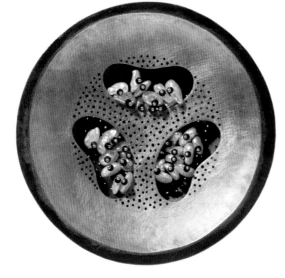

Bacca brooch

by Barbara Paganin
In this brooch, small drilled
holes in gold sheet are used
as a decorative device.

DRILLING HOLES WITH A PILLAR DRILL

Drilled holes are a useful starting point for other techniques such as piercing or riveting, but they can also be used for purely decorative purposes.

TECHNIQUE FILE

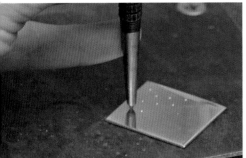

1 Place the tip of a center punch in the exact position you want to drill the hole. Tap the punch with a mallet or hammer—you don't need to hit hard. This will make a registration mark for the drill bit to start cutting into, and help prevent it from breaking. Work on a steel surface.

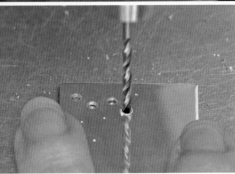

2 Hold the piece firmly, and position the center-punched mark directly under the drill bit. Gently lower the drill so that the bit makes contact with the metal—apply a little pressure, but not too much—allow the drill bit to cut the metal. You will feel the difference when the bit exits the underside of the metal.

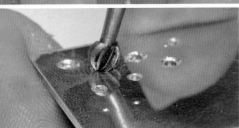

3 Any sharp edges can be removed using a ball burr in a pin vise or, if you require a true edge, you can use a needlefile across the surface to remove the swarf.

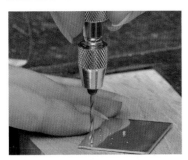

Drilling with a pin vise
Hold the handle of the pin vise in your palm and use your index finger and thumb to rotate the mid section. This rotates the drill bit, and can be used to easily "open up" or increase the size of existing holes.

Drilling metal
Before drilling, you must make a registration mark in the metal so that the drill bit does not skid around the surface, which can cause it to break. Working on a steel block, tap a center punch with a mallet into the metal sheet to make a slight depression. Wearing safety glasses, secure the drill bit in the chuck of the drill and ensure it is set straight. Place the work on a piece of wood, in position under the drill bit, and turn on the power.

Slowly bring down the handle to lower the drill bit and, holding the metal very securely, start drilling the metal. Lubricating oil will make cutting easier and will also keep the drill a bit sharper for longer. Don't apply too much pressure—if the drill bit gets stuck, it will break. Wood dust from the supporting block will start to appear on the metal when the hole has been drilled right though—when this happens, gently release the handle to bring the drill bit up, and turn off the power. Clear the swarf from around the drill bit with a brush.

When drilling holes in cylindrical metal forms, it is often useful to file a small area flat so that the center punch and drill don't skid down the side of the cylinder. Large or thick materials can be clamped to the drill bed with a G-clamp, or set into a drill vise that will hold the work securely and allow both hands to be free to operate the drill.

Drilling other materials
Plastics and natural materials such as wood, bone, horn, and shells don't need to be center-punched before drilling, because the material is soft enough to readily accept the drill bit. Clear the swarf regularly and drill slowly, otherwise friction from the rotation of the bit can cause scorching or, in the case of plastics, the swarf will melt onto the bit, rendering it useless.

Files are used to refine or shape materials gradually, and come in a variety of shapes, sizes, and grades of roughness. Accurate filing is used to even out surfaces, remove unwanted marks, and smooth edges.

FILING

Files

Hand files are available in a range of grades, from the very rough (cut 00) to the very smooth (cut 4). It is generally useful to have a cut 0 half-round file, and a range of cut 2 files of various profiles. The files will need to have a wooden handle fitted so that they can be used comfortably. A set of 12 cut 2 needlefiles is also very useful.

How to file

Files cut on the forward stroke, so this is when you should apply slight pressure. Use the backward stroke to reposition the file. Support the piece of work against the bench peg to make the filing more accurate and effective. The whole width of the file should make contact with the piece, unless you are intending to file a groove.

If you need to remove a large amount of material, start filing with a cut 0 hand file and adjust the basic shape, before moving onto a finer file to refine the surface. Always match the profile of the file to the shape of the surface that is being filed—flat files for straight edges and convex curves, and half-round or round files for concave curves, depending on the degree of curvature. When filing curves, move the file along the curve as it you push it forward to help

Indian bangles
by Meghan O'Rourke
These saw-pierced steel bangles required careful shaping with needlefiles to true the edges.

FILING A METAL RING

TECHNIQUE FILE 03

Filing is used to clean up solder joins and shape or refine metal forms, in the case of a ring, for example. A ring file has one curved side and one flat side—it is also known as a half-round file.

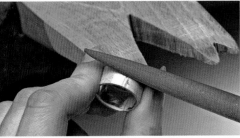

1 Once you have trued the ring on a mandrel, you can file the solder seam. File off any excess solder using a rough file (cut 0), then file across the join to make it level.

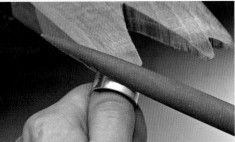

2 Use the flat side of a cut 2 ring file to remove the rough file marks and even up the surface of the ring, keeping the curve of the ring—do not file flat angles.

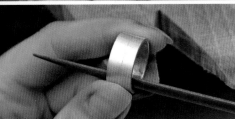

3 For the inside of the band ring, use the curved side of the ring file. Take care not to make the ring too thin where you are filing over the join and don't forget to turn the ring around so that you file from the other side as well.

Tip

Use needlefiles to reduce the file marks over the join, and refine any surfaces that have become scratched or marked. They are especially useful for tidying up pierced fretwork as they can more easily be applied to small spaces.

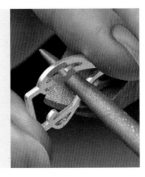

Deconstruction brooch
by Michelle Xianon Ni
The clean lines of this silver and pearl brooch have been created through accurate cutting and filing.

keep the form smooth. As a general rule, only file the areas that need it, otherwise the cleaning up process will take much longer than necessary.

Needlefiles are ideal for tidying up pierced work and other intricate forms that hand files are too large to access. Match the profile of the file to the area that is being filed, and smooth the edges of the form. If a space is too small to allow access for a file, file the very edge of the space so that the hole looks accurately filed from the front, even if it is not.

Filing other materials

Plastics and natural materials can be filed in the same way as metals, but it is advisable to wear a dust mask when you do so, because the dust created by filing these materials is much more readily airborne than metal dust. These materials may also clog up fine files, so it is worth keeping a small selection of files separately for this purpose.

Metals quickly become work-hardened through manipulation. Annealing is the process used to soften, relax, and make them malleable again. Many techniques will require that the metal is annealed at various stages throughout.

ANNEALING

When to anneal

It is necessary to soften metal before bending it—this makes the task much easier and there is less risk of damaging the metal through the use of excessive force. Techniques such as forging, where the metal is being physically deformed, will quickly work-harden it and so regular annealing is necessary. Metal becomes harder due to internal stresses, and heating it to a prescribed temperature relieves these stresses and softens the metal. The annealing process can be carried out many times on a piece of metal.

How to anneal

Metal sheet, wire, and rod are most easily annealed using a gas torch. Place the metal

Annealing temperatures for different metals			
Metal	Annealing temperature	Annealing color	Method of cooling
Copper	750–1200°F 400–650°C	Dark red	Quench in cold water
Brass	840–1350°F 450–730°C	Dull red	Allow to air cool
Gilding metal	840–1300°F 450–700°C	Dull red	Quench in cold water
Steel	1500–1650°F 800–900°C	Cherry red	Quench in cold water
Sterling silver	1200°F 650°C	Dull red	Quench in cold water when metal has cooled to black heat
Yellow gold	1200–1300°F 650–700°C	Dull red	Quench in cold water when metal has cooled to black heat
White gold	1400°F 750°C	Dull red	Quench in cold water when metal has cooled to black heat
Red gold	1200°F 650°C	Dull red	Quench above 930°F / 500°C
Platinum	1850°F 1000°C	Orange-yellow	Allow to air cool
Palladium	1500–1650°F 800–900°C	Yellow-orange	Quench in cold water when metal has cooled to black heat

ANNEALING METAL

Annealing is the process used to soften metal once it has become work-hardened. These steps show the annealing of metal wire, rod, and sheet.

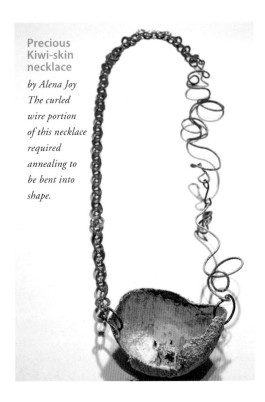

Precious Kiwi-skin necklace
by Alena Joy
The curled wire portion of this necklace required annealing to be bent into shape.

Annealing wire
Lengths of wire should be coiled and loosely bound with binding wire, which will help to prevent overheating any areas. Use a soft, bushy flame to heat the coil evenly.

Annealing thick wire
To anneal thick wire or rod, angle the torch flame along the length of the rod, and start heating at one end. When the end becomes a dull red color, move the flame along the rod, making sure that the whole length or loop has reached annealing temperature.

Annealing sheet metal
Anneal sheet metal with a bushy flame—circulate the flame to bring the whole piece of sheet to a dull red color.

Quenching
Allow silver to cool to black heat before quenching in water. Allow larger pieces of sheet to air cool, which will prevent distortion from rapid cooling.

on a heatproof mat and start heating, using a soft, bushy flame—you will soon see color changes on the surface of the metal, and once the metal starts to glow red (check the chart for particular metals and their annealing color) stop heating. These color changes are most visible in low light levels.

The method you use to cool the metal will affect its temper (hardness)—in order to achieve optimum results, use the recommended method of quenching or cooling for your particular metal.

The annealing process causes a coating of oxides to be formed on most metals, and they will need to be cleaned in an acid solution called pickle (see page 104).

When not to anneal
For certain tasks, such as making earring wires where no soldering is required, it is often desirable to retain the hardness of the metal so that the piece will not easily bend out of shape. The piece will be less easily formed, but will be a more durable structure.

Metals are most often joined together using the soldering process. Solder is a metal alloy with a lower melting point than the metals it is joining; precious metals each have their own solder alloy, but base metals are usually joined with silver solder.

SOLDERING

Materials and tools

Solder is available in different grades—hard silver solder has a melting point just below that of silver, medium has a lower melting point, and easy solder melts at a lower point still. Hard solder is used predominantly, as it color-matches silver better than medium or easy, and flows along seams better, too. Enameling solder has a very high melting point and can be used to join elements that are going to be enameled (see page 231); extra-easy solder should only be used for repair work. Every karat and color of gold has its own solder alloys of hard, medium, and easy.

Flux is used to aid solder flow by preventing the metal from oxidizing when heated. Borax is a good general-purpose flux, and comes either as a solid cone that is mixed with water in a dish to form a thin paste, or as a powder. Soldering gold requires relatively high temperatures, and you may get better results using a flux especially for that purpose, instead of borax. Easy and extra-easy solders, and stainless steel will also perform better with a flux designed for the specific purpose.

Heat-bricks, charcoal blocks, and soldering mats, including ceramic mats that have holes for pinning pieces in position with binding wire, are necessary to protect surfaces from torch flames. Mats can be used on a turntable, which will allow the piece to be rotated while heating takes place.

Small, inexpensive hand torches are useful, but only for small soldering jobs such as chain-making. Torch heads that automatically mix air and bottled propane or butane gas are easy to use, and are a worthwhile investment. You can interchange different sizes of head attachment to give suitable flame sizes for most soldering jobs.

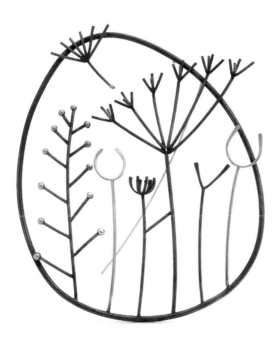

Plant cell brooch
by Laura Baxter
Soldering was used to
combine pierced and
granulated elements for this
silver and gold brooch; the
silver has been oxidized.

PALLION SOLDERING

For this technique you will need a formed band ring. The join should be so neat that when it is held up to the light, you can't see any light through the gap.

1 Use tin snips to cut a fringe at one end of a piece of hard silver solder. Cut across this fringe to produce small chips or "pallions" of solder. Put the pallions in borax solution to keep them clean.

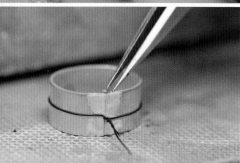

2 Bind the ring with iron binding wire to keep it from opening up when it is heated. Apply borax around the seam with a small brush. Place a solder pallion in position with tweezers or you can use a damp brush.

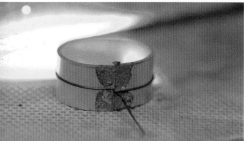

3 Heat the bricks around the ring first, to allow the borax to dry out slowly. Concentrate the flame on the back of the ring and allow it to reach a dull red color.

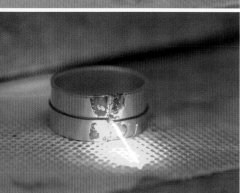

4 Now circulate the flame around the whole ring to bring it all up to temperature at the same time. Watch for the solder melting—it will turn liquid and run down the join. As soon as this happens, take the flame away from the ring.

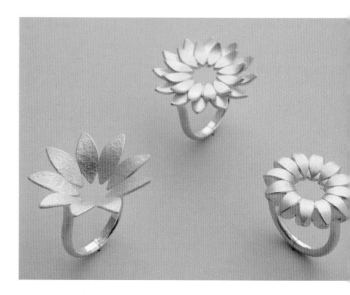

Petal rings
by Rui Kikuchi
For this elegant series of hammer-textured silver rings, cut elements were soldered together and formed before being soldered to a ring shank.

It is also useful to have tweezers, a small brush, binding wire, and a jar of water for quenching pieces of work close to your workstation.

Pallions

Soldering with pallions is probably the most common form of application. A "pallion" is a small chip of solder, which is placed in position on a fluxed join prior to heating. Several pallions may be used along a join. Gauging the amount of solder to be used for each specific join is something best learned from practice—too much solder will leave a messy join that will need much filing, and not enough will mean that the seam will probably have to be resoldered. It is not necessary to pickle pieces if more pallions are added to a seam that is being resoldered.

Start heating the piece and, once the borax has dried out, heat as quickly and efficiently as possible, trying to ensure that all areas reach soldering temperature at the same time. Solder will travel toward heat, so it is possible to draw it along or through a seam using the flame. Stop heating the piece when the solder has melted.

Every time solder reaches its melting point, some of the alloyed zinc evaporates out, effectively giving the solder a higher melting point—so avoid prolonged overheating as this will lead to porous, brittle solder seams.

Stick feeding

The technique of stick feeding solder into a join while it is being heated is used for soldering large pieces together, where it would be very time-consuming to apply sufficient pallions.

Apply borax to the parts that are being joined, and to a cut strip of solder held in insulated tweezers. Heat the metal but don't apply the solder until the pieces are about to reach soldering temperature. Touch one end of the solder to an edge of the metal and heat from the opposite side of the join to draw the solder through. This process can be messy, as blobs of molten solder may get left in unwanted places.

Sweat soldering

Sweat soldering is ideal for hollow forms where it is not possible to place the solder easily, and there is no ledge for the solder to sit on that can be cut away afterward. The solder is melted or "slumped" onto one half first, then the two halves are fluxed and bound together with binding wire, and finally reheated until the solder melts and is

Cellinsula pendant/brooch
by Andrea Wagner
The silver frame of this piece was constructed using thin wires soldered to a thicker base, and hidden prongs secure the porcelain centerpiece.

STICK FEEDING SOLDER

When a large amount of solder will be needed for a join, or pallions would be difficult to place, feeding a stick of solder into a piece while it is being heated may be appropriate.

1 File an angle or chamfer along one edge of the top piece of sheet—this will allow the solder to be drawn in between the two flat sheets of silver.

2 Paint one side of both pieces of sheet with borax, and bind them together. The chamfer on the smaller top sheet is lined up with the edge of the lower sheet. Cut a long strip of solder and coat it in borax—hold the solder in insulated tweezers.

3 Start to heat the piece, making sure that the flame is heating both the top and bottom sheets of silver evenly. When the silver begins to glow dull red, apply the solder to the chamfered edge, and heat the silver from the opposite side to draw the solder through.

4 You should see a line of liquid solder appear along the junction between the sheets. Remove the binding wire and pickle the piece.

SWEAT SOLDERING A HOLLOW FORM

TECHNIQUE FILE 07

Hollow forms can be awkward to solder, as there is often no place for pallions of solder to be placed easily. Sweat soldering allows you to melt solder accurately in position. Here, two domed circles are soldered together to make a spherical form.

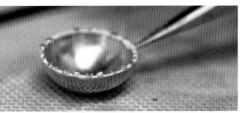

1 Apply borax and plenty of pallions of solder to the flat edge of one dome.

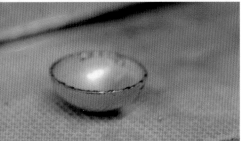

2 Heat the dome until the solder slumps—overheating may cause the solder to run down into the concave surface. Ensure that all of the edge of the dome has solder on.

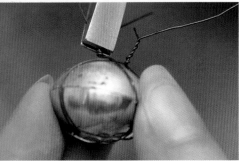

3 Don't pickle the soldered half—but you may lightly rub the soldered surface with emery paper to flatten it if necessary. Flux the two halves and bind them together with binding wire.

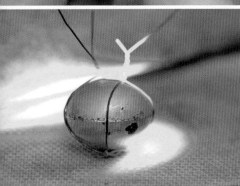

4 Heat the form evenly to bring it all up to temperature at the same time. You will see liquid solder appear along the seam—ensure that this has happened all the way around the seam, and then stop heating the piece.

visible around the edge of the seam. Remember to make an airhole in a hollow form if it is going to be heated again—trapped air can make pieces explode. This technique can also be used to join flat sheets of metal together neatly.

Awkward soldering jobs

Confidence in soldering comes with practice. When things don't go as planned, try to work out why—mistakes can be learned from and the knowledge used to your advantage.

Each soldering job may be slightly different than the last, but a few general points should be taken into consideration.

• Build a wall from soldering mats or bricks around the soldering area, because this will help to reflect heat back onto the piece, which will help it heat up more quickly.

• Time spent setting up pieces is time saved if the elements move when they are being heated and need to be quenched, repositioned, and fluxed again.

• Always try to use gravity to your advantage when balancing pieces—reverse-action tweezers are a great help here, but remember that they will draw heat out of the metal they are holding, and so it will take longer to reach the correct temperature. This fact is useful when you are soldering thin wire onto larger forms—using tweezers will help prevent the wire from overheating.

18-karat gold ring
by Margareth Sandström
The large, hollow form on this 18-karat gold ring was sweat soldered together, and combined with a wire shank.

- Binding wire is incredibly useful for holding pieces in place, but it can cause damage—silver expands more than binding wire when heated, so make sure you use thin enough wire that will not resist expansion.

Multiple joins

While it is possible to use hard solder only to solder multiple joins within one piece, medium and easy solder are often used for the final seams. This means that the piece will not have to be heated to such a high temperature for the solder to melt, and so there is much less risk of the hard solder remelting. In a piece with three solder joins, the first should be made with hard solder, the second with medium, and the final join with easy solder. For pieces with more than three joins, hard solder should be used for as many of the initial joins as necessary, and the joins masked off with rouge powder mixed to a paste with water after they are made. This will help to keep the solder from melting again.

5R1 ring

by Anastasia Young
Many solder joins were used to construct this ring from cast and fabricated component parts.

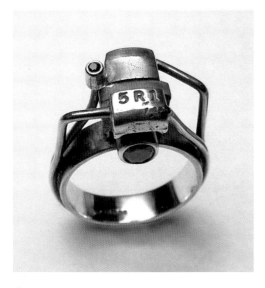

MULTIPLE SOLDER JOINS IN ONE PIECE

This technique demonstrates how to use the three main grades of silver solder—hard, medium, and easy—when soldering a piece that has several different solder joins in it.

1 Form a ring shank from 9-gauge (3 mm) round silver wire (see page 108). Use 26-gauge (0.4 mm) fine silver sheet to make a bezel that fits around a cabochon stone. Solder the ring shank and bezel using hard solder. Pickle and clean up both pieces.

2 True the bezel on a triblet and rub the base on emery paper to ensure it is flat. Place the bezel on a piece of 22-gauge (0.6 mm) silver sheet, flux and place medium solder pallions around the outside of the bezel. Solder on wire mesh, so that the flame can be applied from underneath to avoid overheating the bezel.

3 Pierce out the bezel cup from the surrounding sheet and carefully file the base flush with the sides. Use emery sticks to clean up the outer surfaces. File a flat area on the top of the ring shank, in the same position as the hard solder join. The bezel cup should be a bit larger than the flat surface.

4 Place the bezel cup upside-down on the soldering mat and balance the ring shank in position on top. Support the shank using tweezers. Flux around the join and apply several pallions of easy solder. When soldering, concentrate the heat mainly on the shank. Pickle and clean up the ring. See page 238, for Basic bezel and tube setting, where this project is continued.

SOLDERING AN EARRING STUD

TECHNIQUE FILE **09**

Thin wires soldered onto larger forms, such as pins for earring studs, can be a challenging soldering job. The trick is to avoid overheating the wire. The setup of the pieces is crucial—try to use gravity to your advantage!

1 Hold the rod in place using pins in the soldering mat, and balance the wire in position using insulated tweezers. Apply borax to both parts and place a pallion of hard solder so that it is resting on the rod, and touching the wire, too.

2 Heat the soldering mat first, to allow the borax to dry out slowly. Once you are sure that the solder will not move, start to heat the rod, which is thicker than the wire and will take more time to get up to soldering temperature.

3 As soon as the rod is glowing dark red, allow the flame to "lick" the wire while continuing to heat the rod. Don't allow the wire to get too hot, or the solder will travel up the wire, away from the rod.

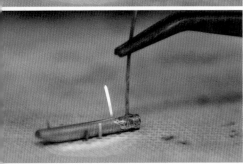

4 When the solder melts and joins the two parts, remove the flame. Quench and pickle the piece.

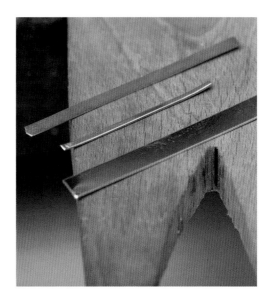

The different types of solder
From the top, easy, medium, and hard solder strips.

Heat-resistant gel can also be used to protect solder seams, thin areas that may be at risk of overheating, and gemstones.

Easy solder should only ever be used for the final solder join in a piece as it can melt holes in silver if it is overheated.

Solder seams can become "dry" from overheating or too much annealing. This can cause pinholes along the seam. Every time solder is heated, some components will burn out of the alloy, which effectively gives the solder a higher melting point and it will require heating to a higher temperature in order to get it to melt. If necessary, run fresh solder along the same seam to reinforce it.

Mixed metals

When soldering gold to silver, it is necessary to use silver solder, regardless of the karat of the gold. This is because silver has a lower melting point than that of gold solder. Take care not to overheat the gold during this process or any subsequent heating because the silver solder can melt pits in the surface of the gold.

Base metals, including steel, can be soldered to silver using borax for the flux and silver solder.

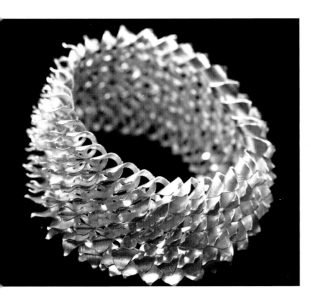

Buckthorn
by Sonja Seidl
This wonderfully tactile bracelet
was made using photoetching
and soldering silver and gold.

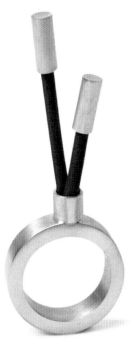

Ping ring
by Gilly Langton
The elements of a piece must
be close-fitting in order for a
solder join to look neat.

SOLDERING MIXED METALS

When soldering mixed metals, always consider the melting points of the component parts, and use a solder and flux suitable for the metal with the lower melting point.

1 Solder an 18-karat yellow-gold wire ring with 18-karat yellow-gold hard solder, using Auroflux. Pickle, clean up the join, and true the form.

2 Use borax to flux the silver base sheet and position the gold ring. Apply hard silver solder pallions around the outside of the gold ring.

3 Place the piece on steel mesh so that the silver can be heated from underneath. The solder will melt when the silver reaches the correct temperature. The gold solder should not be affected.

4 Clean off any excess silver solder with a needlefile and then refine the surface further with emery sticks.

After annealing or soldering metal, the oxides and borax residue need to be removed before further work is carried out on a piece. The solution used for this is called "pickle."

PICKLING

Pickle basics

For silver, gold, and nonferrous base metals, pickle can be made up from safety pickle powder or alum mixed with water, or diluted sulfuric acid (1 part acid to 9 parts water; see Health and safety, page 10). Steel must be cleaned in a special pickling solution called Sparex #1, which is used cold.

Pickle cleans faster when it is heated, but the time it takes to clean metal will also depend on the strength of the solution—ideally the metal should take around five minutes to clean. Pickle pots, which are units designed specially to heat pickle at a constant temperature, are expensive, so many jewelers use a bottle-warmer or a ceramic slow-cooker on a low setting as a substitute. Always make sure that the heater is unplugged after use—a timer on the plug is also a good idea.

When it is heated to soldering temperatures, borax forms a glassy coating on metal that can damage steel tools such as files. For this reason,

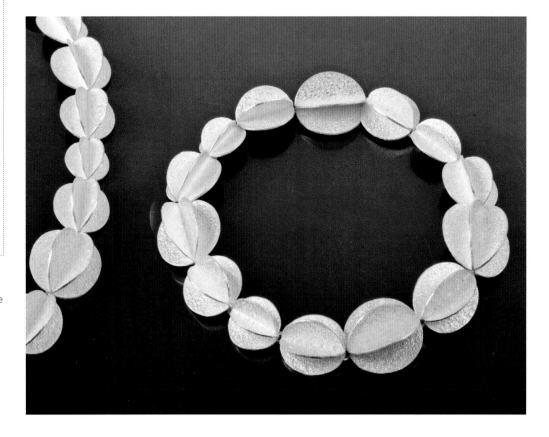

*Geometric neckpiece
by Bernadine
Chelvanayagam
The blanched, textured
surface of the silver is
effectively contrasted with
highly polished edges in
this piece.*

it is important to ensure that no flecks of borax are left on a piece. It may need pickling for longer if you used a lot of flux during soldering.

Avoiding contamination

Always remove binding wire from a piece of work before putting it in the pickle, otherwise a chemical reaction will occur, causing copper to be deposited over the surface of the piece—in effect electroplating it. The solution will only copper-plate when iron is present in it, and copper can be burned off pieces by successive rounds of annealing and pickling, or scrubbing with pumice powder.

Use stainless steel, brass, or plastic tweezers to transfer items to and from the pickle.

Once the metal is clean, rinse well in water and wash with a brush and detergent to remove traces of pickle. Hollow or enclosed forms may be difficult to get pickle out of—use a syringe to inject water to flush out pickle residues. Pieces can also be soaked in a baking soda solution that will neutralize acid traces.

R2 brooch
by Anastasia Young
The blanched surface was left on this silver brooch after pickling, and used as a base color for the patination. To finish the piece a burnisher was used to highlight some areas and create a contrast with the matte surface.

CLEANING METAL USING PICKLE SOLUTION

During annealing or soldering, metal becomes dirty from the oxidization that occurs when it is heated. A chemical solution called "pickle" is used for cleaning. Here, a ring is pickled.

1 Remove the binding wire from the ring. Use pliers to roll off the wire if it has been soldered on. Make sure all of the wire has been removed, otherwise it will cause the silver to become copper-plated in the pickle.

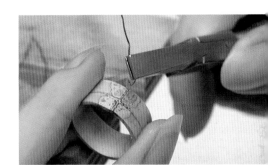

2 Use tweezers to place the ring in the heated pickle solution. Rinse the tweezers in water.

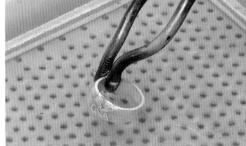

3 Remove the ring when it is clean—it should be matte white. The time a piece takes to pickle will depend on the strength and temperature of the solution, but should be about five minutes. Rinse the piece thoroughly to remove any pickle residue.

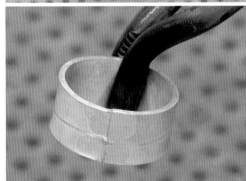

Some of the simplest jewelry forms, such as rings, involve bending metal. Accurate manipulation of the metal is a skilled task, because the tools used to bend the metal can also mark and damage the surface.

BENDING METAL

Using mallets and hammers

Mallets made from nylon or rawhide are most suitable for bending metal without marking it. Most mallets are flat-faced, but others are pear- or wedge-shaped. These are used for forming ring shanks, bangles, and other curved forms with the use of triblets, mandrels, and stakes.

A steel hammer can be used to bend metal in the same way, but as steel is harder than the most commonly used metals such as silver, it will leave marks that will need to be removed, unless a hammered texture is desirable (see page 196). Steel hammers will effect bending much more rapidly than mallets, but the metal will also become stretched and thinner to some degree.

Formers and stakes

Stakes, mandrels, and formers are usually made from steel, but some forms can be made from wood or nylon. Stakes are most commonly used in silversmithing, but a flat steel stake or block is an invaluable tool for the jeweler.

Stakes, formers, and hammers must be kept in good condition so that they do not damage the metals being worked on. Don't let steel hammers hit stakes, as this will mark the stake, and the mark will be transferred to the work. Water or acid will damage steel tools, requiring much repair work; similarly, ensure that metals being worked are regularly and evenly annealed and cleaned—firescale on silver, for example, will cause hard areas that are prone to cracking.

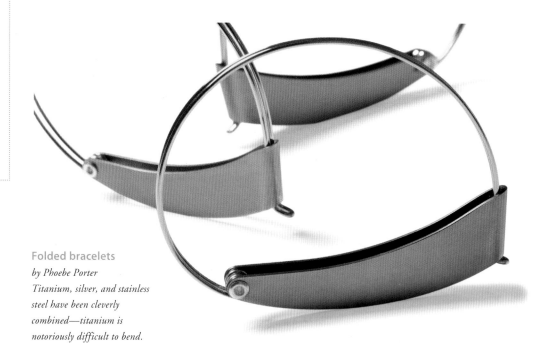

Folded bracelets
by Phoebe Porter
Titanium, silver, and stainless
steel have been cleverly
combined—titanium is
notoriously difficult to bend.

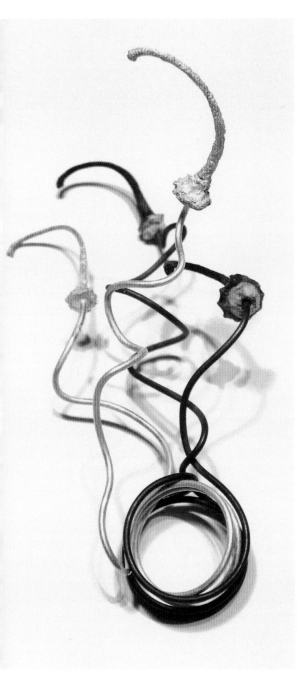

Shadow of the stalks

by Alena Joy

The shank of this ring is formed from coiled and bent wires, combined with cast silver pepper stalks to create a sculptural form.

BENDING SHEET METAL INTO A RING

TECHNIQUE FILE

You will need a strip of annealed silver sheet for this technique—cut it to length before bending. (See the ring size conversion chart, page 310, to find the correct dimensions.)

1 Hold the strip of metal across the mandrel and use a rawhide mallet to tap the end of the sheet to bend it. When about a third of the strip is curved, turn the piece around and tap the curved section again—this is to counter the taper of the mandrel.

2 Curve the other end of the strip in the same way. Close the form with your fingers and push one end underneath the other. Pull the two ends into alignment again.

3 Use a mallet to adjust the join so that it matches well. Cut through the join with a jewelry saw to even it up, before soldering the ring.

4 Once the ring has been soldered and pickled clean, it can be "trued" or made perfectly round. Look down the length of the mandrel to see where the gaps are, and use a rawhide mallet to tap the ring as you slowly rotate it. Take the ring off the mandrel, turn it around, and repeat.

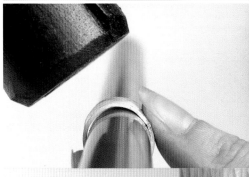

BENDING WIRE INTO A RING

TECHNIQUE FILE

You will need a 3 in (8 cm) piece of 9-gauge (3 mm) round annealed silver wire.

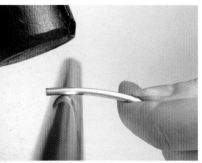

1 Lay the wire on the mandrel with a small amount protruding over one side. Use a rawhide mallet to hit the wire just where it stops making contact with the mandrel—this will make the wire curve. Bend about a third of the length of wire.

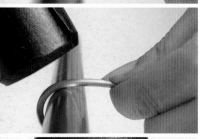

2 Bend the other end of the wire in a similar way. Use your fingers to close the form, ensuring that the two ends can push past one another.

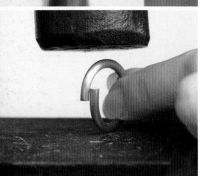

3 Working on a wooden surface so that the ring does not get damaged, tap the top of the ring to push the ends farther past each other and make the ring smaller. (Adjustments to the size can be made by opening the ring up on the mandrel.)

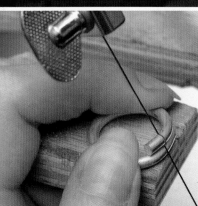

4 Cut through the ring shank where the wire overlaps. The two cut ends should match up neatly, and the ring can be soldered closed.

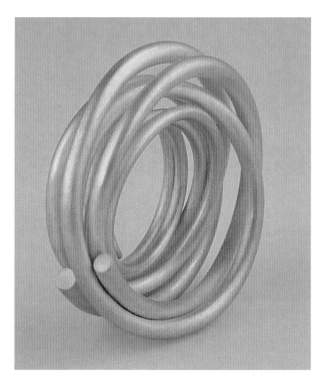

Wire ring
by Susan May
*Forged silver wire was coiled up
and interwoven to form a ring.*

Making a ring shank

You can form wire or band rings using a ring mandrel and a mallet. Secure the mandrel in a vise, and lay the annealed metal horizontally across it about a third of the way up from the narrow end. (You'll start by bending the metal to a smaller diameter than you need to, as it is easier to stretch a circular form larger than it is to decrease the size accurately.) Hit the metal with the mallet just where it stops making contact with the mandrel, which will force the wire to curve. Hitting as the metal is incrementally moved forward across the mandrel, always keeping the straight portion horizontal, will soon form an even curve. Bend a third of the length of the strip, before turning the piece around and bending the other end. You can make adjustments to the form by resting the piece on a wooden surface and tapping with a mallet. It is much easier to make the ring true, or perfectly round, once it has been soldered. Ring shanks can also be bent round using half-round or ring pliers.

Bending metal with pliers

Pliers are used to bend wire, strips of sheet metal, and to hold small pieces that are being worked on. Having a range of pliers of different profiles will save you a lot of time: half-round, round-nose, flat-nose, snipe-nose, and parallel pliers are all useful for particular tasks.

Wire is more neatly formed if it is straight to begin with, and any interruptions in the flow of the line are easily detected by the eye. For graceful curves, it may be more appropriate to bend the wire around a cylindrical former of the correct diameter.

The accurate use of pliers takes practice, as they can easily damage softer metals. This can be minimized by wrapping masking tape around the jaws; pliers with nylon jaws are also available.

Pliers can be used to create a wide range of forms, adjust the shape of areas, or to straighten or increase a curve. Parallel pliers are useful for bending angles and holding small pieces of work, but most pliers will provide leverage when making fine adjustments to forms.

Thick wire is difficult to form using pliers without causing damage, even when it is annealed, and should only be formed with a mallet and former.

Flattening and straightening metal

Metal is a forgiving medium to work in, and if bending doesn't go to plan you can fairly easily rectify mistakes. You should anneal pieces for the most effective flattening. Work on a steel block, and use a rawhide mallet. Protect textured surfaces with masking tape. Place the metal on the block with the convex curve uppermost, and mallet inward from the edges until the sheet is flat. Turn the piece over and repeat if necessary. Severely warped sheet may need to be passed through the rolling mill a few times.

Annealed wire can be rolled between two flat steel plates to straighten it, or tapped with a mallet on a steel plate while it is being rotated. For longer lengths of wire, secure one end in a vise, and pull the other end forcefully with pliers. You can also use draw plates to straighten wire (see page 127).

BENDING METAL USING PLIERS

TECHNIQUE FILE

Careful use of pliers can make the manipulation of metal an effortless process, but you must take care not to damage the metal, which should have been annealed first.

Flat-nose pliers

Flat-nose pliers are used to create angular bends in metal, and also to straighten wire—parallel pliers are particularly useful for straightening and work-hardening earring pin wires.

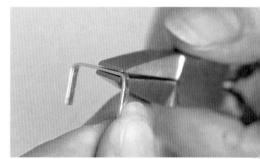

Round-nose pliers

Loops, curves, and spirals can be made using round-nose pliers. Turn the pliers in a circular motion to pull the wire into a curl, taking care not to use too much pressure or the pliers will mark the wire.

Half-round pliers

You can also use half-round pliers to make or adjust curves, and they will not mark metal.

Using steel rod

In order to create long spirals, a steel rod set in a vise so that the wire can be wrapped around it will give the best results. To make jump rings, cut down one side of the spiral with a jewelry saw.

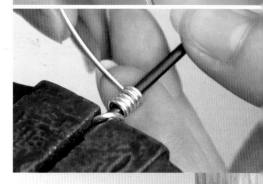

The surface qualities of a finished piece of jewelry are as important as the design or the methods of construction. Abrasive media can be used as a preparation for polishing, or if a matte surface is required, as a final finish.

CLEANING UP

Abrasive media

A wide range of different materials is available to the jeweler to aid the refinement of surfaces. Abrasive papers are a versatile medium as they can be used loose, stuck to wooden sticks of varying profiles, or used with a flexshaft motor. Wet-and-dry paper can be used on most materials and, when used with water, prevents the release of dust particles into the air—particularly important when you are cleaning up plastics.

Silicone rubber blocks and pendant motor attachments are an alternative, and have their uses in certain situations, as do abrasive sponges. These have abrasive particles embedded in them, and come in a range of grades similar to abrasive papers.

Removal of scratches

Any final adjustments to the form should have already been made with files. The abrasive media are only used to remove the file marks. Start with a rough paper such as 600 or 800 wet-and-dry paper—judge the grade by the depth of the scratches that need to be removed—and work the paper over the surface of the metal in one direction only. Any visible firescale on silver should be removed at this stage, until the darker shadows have been completely eliminated. When the metal seems to be evenly sanded, use the next grade of paper across the grain of the last, so that any scratches are easily visible. Continue working through the grades of paper up to 1200, using the cross-grain method. The way in which the abrasive paper is applied to a piece will depend on the shape of the area that is being cleaned—emery sticks will be useful for some surfaces, but for others, a piece of loose paper folded over may be more appropriate.

Wave bangle
*by Laura Jayne Strand
The surface of this fluid silver bangle was carefully cleaned up and prepared before the final finish was applied.*

Wedge ring
by Frieda Munro
Angular forms require careful cleaning up so that the edges remain crisp, as in this three-part ring.

Using a flexshaft motor

Abrasive tools can be used in a flexshaft motor to remove scratches from metal, using the same principles as for removing scratches by hand. The most useful attachment is a split pin, which is a steel rod with a split that is used to hold small cut pieces of emery paper or wet-and-dry paper. This greatly increases the speed at which cleaning up can be carried out, but do take care not to wear away too much metal in any one area in order to maintain an even surface.

Abrasive rubber points and wheels are incredibly useful for cleaning up small spaces and internal surfaces, especially on castings.

Degreasing metal

In preparation for techniques such as enameling and etching, it is necessary to ensure that the surface of the metal is completely free of dirt and grease. In order to prevent the metal from being marked by natural oils present on the skin, wear latex gloves. Apply pumice powder and detergent with a brush and scrub the metal thoroughly. When water is run over the metal, it should form a continuous film without pulling away from the edges—this indicates that all the grease has been removed. You can use a glass fiber brush for this purpose, without detergent.

CLEANING UP WITH ABRASIVE MEDIA

Removing file marks and blemishes from hammering is crucial if you require a fine polished surface on metal. Emery paper and a flexshaft motor are used for this purpose.

1 Emery sticks are useful for cleaning up flat or gently curved surfaces. Work backward and forward in one direction only with the first grade of paper, and then work across the grain with a finer paper.

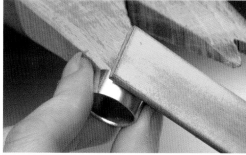

2 The insides of rings are most easily cleaned up using emery paper in a split pin with a flexshaft motor. Hold the ring firmly, and keep the paper moving.

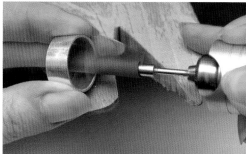

3 Use loose emery or wet-and-dry paper to rub down flat surfaces, and to ensure that no areas of sharp metal remain—make sure that the ring is comfortable to put on and take off.

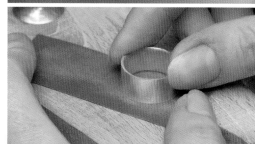

4 A final going over with a very fine grade of paper will remove any uneven marks left by the flexshaft motor, and help to give better results when the ring is polished.

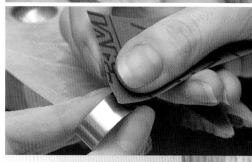

Polished surfaces give an attractive finish to a piece. A brilliant shine will take some time to achieve—ensure that all file marks have been removed and the piece is cleaned up to the finest grade of abrasive paper.

POLISHING

Handpolishing

Small areas of metal can quickly and easily be polished using wooden sticks with suede glued onto them. Keep one stick for the initial polishing with Tripoli, and another for the final buffing with rouge, which will give a high shine. Rub the polish on the suede, and use firm pressure to rub the suede across the metal. In a similar way, cotton strings can be used to polish small internal spaces, such as those in pierced fretwork. This process is called "thrumming."

Polishing cloths that are impregnated with metal polish can be used to give a final once-over to a piece, as well as removing light tarnish from silver jewelry.

Barrel polishing

A barrel polisher consists of a rotating drum that contains steel shot of different shapes, and a soap that aids polishing, as well as compounds to keep the shot from going rusty. The polished steel shot is harder than other metals, so as the barrel rotates the steel burnishes the pieces within. This process also work-hardens pieces and so is ideal for polishing pieces made from precious metal clay, or other items where it would be of benefit to work-harden the metal after construction. The amount of time the polishing takes will depend on the power of the motor—in most cases, an hour should be sufficient.

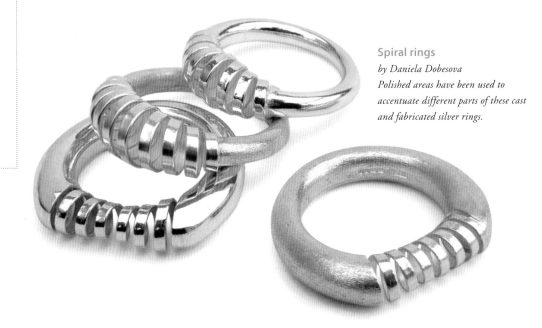

Spiral rings
by Daniela Dobesova
Polished areas have been used to accentuate different parts of these cast and fabricated silver rings.

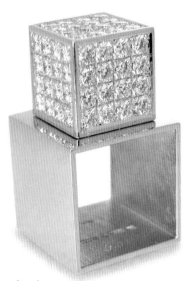

Cube on cube ring
by Peter de Wit
Highly polished gold has been
used to create a reflective surface
on which the pavé-set diamonds
are mirrored.

Fragile work should not be barrel polished, and neither should pieces containing gemstones. Chain, however, should only be polished in a barrel and never on a motor as it can easily get tangled up and cause serious injury to the hands.

Barrel polishing does not remove metal from the piece, and so should not soften any detail or round corners. However, this does mean that any marks or blemishes left after cleaning up will also be visible, and for this reason, barrelled pieces may need further finishing on a polishing motor for a very high-quality finish.

Polishing with a motor

A motorized unit with a polishing wheel fitted to a spindle is the best way to achieve optimum results when polishing. Tripoli compound is used first, as it is slightly abrasive and will polish out fine scratches on the surface of the metal. Apply the polish to the wheel while the motor is running, and polish the piece using the bottom quarter of the wheel only. Keep the piece moving so that it doesn't get too hot to hold, and so that the wheel doesn't wear down any area too much—over-polishing can wear away edges, corners, and details.

POLISHING ON A MOTOR

The best results are achieved when a polishing motor is used, but small polishing wheels used on a flexshaft motor will also give satisfactory results.

1 Switch on the polishing motor and apply the Tripoli compound to the polishing wheel.

2 Hold the ring firmly, but in such a way that you will easily be able to let go if necessary. Apply the ring to the bottom third of the wheel, and keep the piece moving as you use gentle pressure to polish the surface.

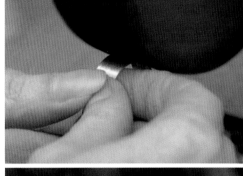

3 Wash the ring well with detergent and a soft brush to remove any polish that is left. Use a separate wheel for the rouge polish, which will give the ring a very highly polished surface.

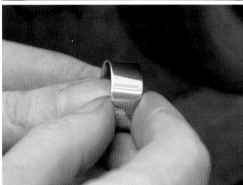

BARREL POLISHING A PIERCED FORM

Items such as chains, pierced work, and castings are polished most easily in a barrel polisher, which effortlessly shines up fine detail without wearing metal away.

TECHNIQUE FILE
17

1 The barrel of the polisher holds water, steel shot, and a soap that contains an antirusting agent. Place the piece into the barrel and ensure that the lid is on tightly.

2 Turn on the barrel polisher. The amount of time the piece should be polished for will depend on the speed of the motor, the type of work being polished, and the amount of work-hardening required.

3 Tip out the contents of the barrel to retrieve the piece, which should then be rinsed in water and dried.

- Wash the piece and your fingers thoroughly to remove all traces of Tripoli using a soft brush and detergent. Ensure that the piece is dry before polishing it with rouge compound on a different polishing wheel.
- Wash the piece again—any trapped polish can be removed with an ultrasonic cleaner.
- Small polishing wheels for the flexshaft motor are very useful, especially for the insides of rings. These are used in the same way as the large wheels with Tripoli first, then rouge.
- Never wear gloves when polishing—if your fingers need protection, use leather finger guards as these will easily slip off if snagged, and gloves will not.

Polishing other metals

Steel is polished using a polishing compound specifically for steel, which is more abrasive than Tripoli. Various specialist polishing compounds are available that will give better results when polishing gold or platinum, but it is only worth investing in these if they will be used often—for most purposes, Tripoli and rouge will give an adequate finish.

Plastics and other materials

When you are polishing plastics and natural materials on a motor, use Vonax, which is a light-colored polishing compound. This is because Tripoli and rouge discolor these materials, and can be permanently absorbed into porous surfaces such as wood. For handpolishing, liquid metal polishes will give satisfactory results when applied with a soft cloth and buffed.

CONSTRUCTION

This section explores construction techniques other than soldering to create layered or three-dimensional forms in metal and other materials. Cold-joining methods are ideal for combining different materials and offer versatile joining solutions, allowing materials that cannot be heated to be combined with each other as well as with metal; this makes them perfect for building forms, and also for adding decorative elements. These methods can be used together with core techniques to create an individual technical vocabulary—each technique increases the amount of applied knowledge, reinforcing what has already been learned and facilitating a greater understanding of material properties, which can only lead to more successful outcomes. Although simplicity is often the key to a well-designed piece of jewelry, careful choices of the range of techniques used will enhance the outcome and make its manufacture a pleasurable process.

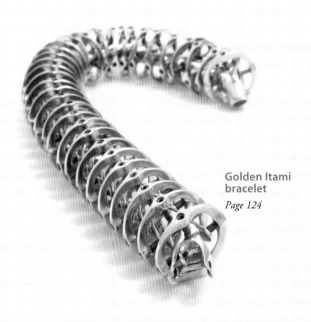

Golden Itami bracelet
Page 124

Accurate folding is often essential for creating geometric forms, especially square or rectangular forms constructed from sheet metal. Removing a portion of metal from the inside of the fold allows you to make a sharp corner.

FOLDING AND SCORING METALS

Tools for scoring and folding
You can buy special scoring tools, but triangular and square needlefiles are good enough for most small folds. You will also need tools to mark out the metal, and a pair of parallel pliers.

Folding sheet metal
Mark a line on the metal exactly where the fold will be, using an engineer's square and a scribe. The line must be at right angles to the edge of the metal or the fold will not be straight. Use a triangular needlefile to establish a groove exactly on the marked line. Then change to a square needlefile, which will give the correct profile of groove to make a right angle. For angles other than 90 degrees, you can use files with different profiles. Remember that the depth of the groove plays a significant role in the amount the sheet will fold—a deeper groove will give a smaller angle once the sheet is bent, for example.

File down to between a third and half of the depth of the metal, checking both edges to ensure that the groove is of an even depth. You can bend along the fold using parallel pliers, but make sure that you fold it correctly the first time, as adjustments may cause the folded metal to split.

For larger pieces of sheet, it is necessary to use a vise or a folding iron, so that you can bend the whole length of the fold at the same time.

Folded neckpiece
by Melanie Eddy
Scored and folded sheet silver
elements were soldered together to
create this architectural neckpiece.

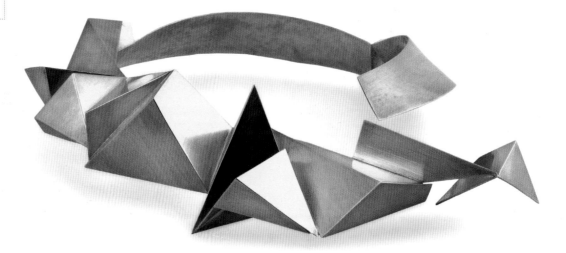

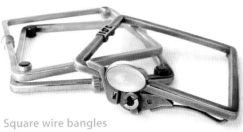

Square wire bangles
by Anastasia Young
Square wire was filed, folded, and soldered
to form these bangles, which have applied
cast elements and bezel-set stones.

You will need to solder folded corners to reinforce them, because the metal will have weakened where it has been thinned and then stretched. Use the stick-feeding soldering method to solder large seams, especially when there is limited access.

Folding rod and wire

Apply the same process to rod or thick wire in order to fold accurate angles. Your filing needs to be even more accurate because the greater thickness of the metal will magnify any error in the angle of filing. File the groove to around half the depth of the diameter of the rod.

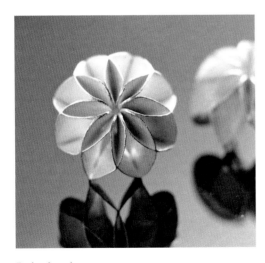

Etched and folded earrings
by Inni Pärnänen
Etching was used to create
grooves in sheet metal before
it was folded into shape.

SCORING AND FOLDING SHEET METAL

In order to make a sharp fold in metal sheet, it is necessary to score or file away metal from the inner surface of the fold. Use 18-gauge (1 mm) sheet metal for this technique.

1 Measure the distance that the fold will be from the end of the piece of silver sheet and use an engineer's square to scribe a perpendicular line across the metal. Leave the protective plastic on the silver to keep it from becoming too scratched.

2 Use a triangular needlefile to make a groove along the marked line. Start carefully filing at one edge, then file in from the other end of the line. It is important to keep the file true to the line, otherwise the silver will fold at an angle.

3 Once you have established the groove, use a square needlefile to continue cutting the groove to a depth of about a third of the thickness of the silver.

4 Line up the groove against the edge of the jaws of a pair of parallel pliers, and fold the metal into a right angle. You can check the angle with the engineer's square, and adjust it with the pliers if necessary.

Fusing is a process in which metal pieces are heated to the point where the surfaces melt and join, creating an attractive, subtly textured surface. Different metals can be fused together for added visual interest within a piece.

FUSING

Fusing different metals

The process of fusing uses heat alone to weld or melt metal components together, without the use of solder. Scrap silver or pierced shapes can be fused to a base sheet, or metals with differing melting points can easily be combined. The process can be unpredictable, as it will be difficult to achieve exactly the same results twice.

"Keum-boo" is a technique of fusing pure gold foil onto a silver base without the use of flux and the best results are achieved by heating the silver from underneath on a heat-plate.

Setting up

All the metal parts should be clean, grease-free, and have no solder on them, because the high temperatures that are used for fusing will cause solder to melt holes in silver or gold.

The base sheet should be around 18 gauge (1 mm), but the materials that are being fused onto

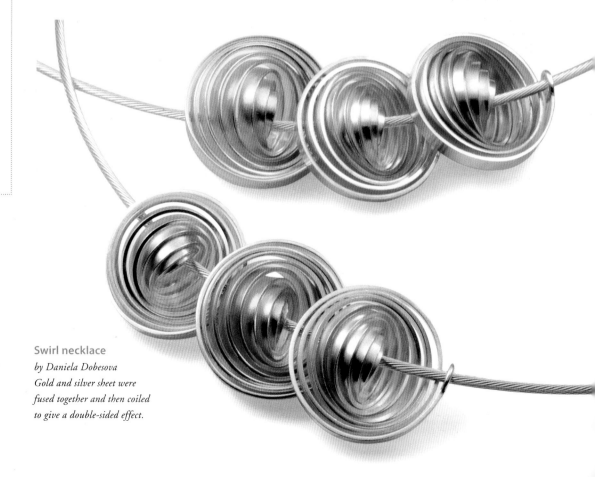

Swirl necklace
by Daniela Dobesova
Gold and silver sheet were
fused together and then coiled
to give a double-sided effect.

Fused gold pendant
by Felicity Peters
Gold foil, granules, and wires
were fused to a textured silver
base to create this pendant.

it can be of any size and thickness, from pieces of dust to rod or thick sheet. Remember to take the amount of time that the different thicknesses of metal will take to heat up into consideration.

Flux and position the elements, setting them down on a heatproof mat or charcoal block. When fusing dust, use plenty of borax so that the torch flame doesn't blow away the dust. Sprinkle the dust onto the borax while it is still wet.

Successful fusing

Start heating the metal with a gas torch, concentrating on the base sheet first. When the silver becomes red hot, watch for darker patches appearing—this is the surface melting. Play the flame around so that the melting occurs all over the surface, to ensure that all the required areas have been fused (not necessarily all at the same time). There is a danger of overheating the base sheet, which will cause the edges to pull in and the surface to reticulate—quickly move the flame off the silver if this starts to happen. Quench the piece, and pickle until clean.

The surface of the silver will be a bit porous, so scrub well with pumice powder and detergent to remove all traces of pickle.

If you are going to form the fused piece of silver further, it will need annealing after it has been fused because the silver will be hard and brittle from prolonged heating.

FUSING SILVER

This project demonstrates the fusing of pierced silver components onto a base sheet—without the use of solder.

1 Place the silver base sheet on a soldering mat or charcoal brick and apply flux. Position the pierced shapes on the base and begin heating.

2 Play the flame over the silver so that all areas heat up at the same rate. Keep heating until dark patches start to appear on the silver's surface—this is the silver melting and areas of both the base sheet and the pierced shapes need to melt in order for the pieces to fuse properly.

3 Pickle the fused form until it is thoroughly clean and use a brush loaded with pumice powder and detergent to scrub the surface.

Fusing gold dust to silver
It is possible to fuse gold dust to silver using the same technique—use plenty of borax so that the dust does not blow away with the force of the torch flame.

Cold-joining techniques are very useful for jewelry that utilizes mixed materials, where soldering is not possible. Rivets are pins or tubes that can be used functionally to join component parts, or they can also form decorative elements.

RIVETING

Tools for riveting

Gather together all the tools that you will need before you start. You'll need a riveting hammer or a small ball-peen hammer, drill bits, ball burrs, a pin vise, a steel block, a flat needlefile, masking tape to protect surfaces, and parallel pliers to straighten wire. And, depending on the type of rivets you're making, a burnisher, a small dapping punch, and a tubing cutter may also be useful. Drilled holes in the materials to be riveted together should be exactly the same diameter as the rivet wire or tube.

Uses for rivets

Rivets are a versatile cold-joining method—as long as a material can be drilled and can withstand hammering it should be suitable. A rivet may be as simple as a wire soldered onto a base plate, onto which another material is secured, or it may

perform complex structural tasks such as holding sheets of material at a prescribed distance apart using spacers made from cut tube. Flexible materials such as leather or rubber may need washers or metal sheet on both sides in order to keep the rivet from slipping out.

You can form simple pivots using rivets—in order to retain looseness in the joint, a piece of paper can be riveted between the metal parts. Once the process has been completed, the paper can either be soaked in water to remove it, or burned out.

Sterling silver, gold, and brass are all ideal materials for making wire rivets. Purchase the metal as half-hard, or work-hardened in a draw plate. This is so the wire does not bend too easily when the rivet head is formed. 18-gauge (1-mm) wire is a good size to start with, but wires of different diameters and of different metals may

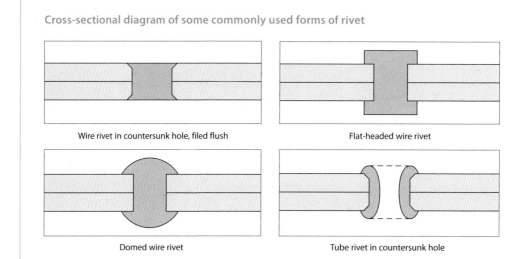

Cross-sectional diagram of some commonly used forms of rivet

Wire rivet in countersunk hole, filed flush

Flat-headed wire rivet

Domed wire rivet

Tube rivet in countersunk hole

be used within the same piece to add visual interest. Anneal and pickle any tubing you use before riveting.

Wire rivets

To form a rivet head on the end of a piece of wire, set it in a vise and file the top flat. This will help to give an even head. Hammer the top of the wire to force it to spread out, and slip it through the drilled holes of the sheet materials that you are joining. Use end cutters to trim the protruding end of the wire. Repeat the process of

Riveted bangles
by Harriete Estel Berman
For these bangles, gold wire rivets
were used to cold-join folded layers
of tin-plated steel, which cannot
be soldered.

Wire rivet joining two metal sheets, with a tube spacer

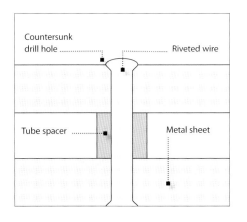

Countersunk drill hole Riveted wire

Tube spacer Metal sheet

RIVETING MIXED MATERIALS WITH WIRE

Wire rivets form a useful method for combining metal with other materials where soldering would not be possible.

1 Secure a length of 18-gauge (1 mm) brass wire in the protective jaws of a vise, with just a small amount protruding. Use a flat needlefile to level the end of the wire.

2 Tap the very end of the wire with a small ball-peen hammer. Start tapping in the center of the wire, and spiral outward—this will force the metal outward, forming a nailhead.

3 Slip the rivet through both component parts of the piece—the drilled hole should be exactly the same diameter as the wire so that it is a snug fit.

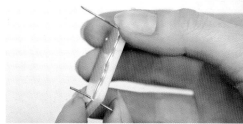

4 Working on a steel block, cut the protruding end of the rivet wire with top-cutters, leaving a small amount. File the top of the wire flat, so that it makes a neat rivet head.

5 Use the hammer to spread the top of the wire, forming a neat domed rivet head. Take care not to hit the silver sheet with the hammer— protect it with masking tape.

TUBE-RIVETING MIXED MATERIALS

As well as joining together component parts, tube rivets can be used to frame drilled holes or to make pivots.

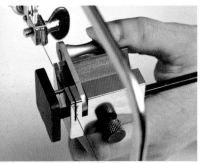

1 Cut the tubing to length using a tubing vise—the pieces need to be longer than the depth of the sheet materials that are being joined.

2 Countersink both sides of the holes that will be riveted so that the tube has room to spread. Anneal and pickle the pieces of tubing. Then, working on a steel block, insert a piece of tubing into the drilled hole and use a scribe or burnisher and a hammer to open up one end of the tube slightly. Turn the piece over and repeat.

3 Once the ends of the tube are sufficiently spread to hold the two pieces of sheet together, use a dapping punch to flatten down the rivet head. Use a small ball burr to neaten up the center of the tube rivet if necessary.

Ab exordio mundi **brooch**
by Ramon Puig Cuyas
Hidden rivets secure the elements of
mixed materials in this brooch.

filing and hammering the rivet on the reverse of the piece to secure the pieces.

You can make small, neat rivet heads using the following method. Secure the rivet wire in a pin vise with only a small amount protruding. File the end flat, and roll the wire on a steel block in a motion that will force the edges to be pushed out, making a rivet head.

Another method of making rivet heads is to place a piece of balled wire (see page 129) in a draw plate and tap the ball flat with a riveting hammer. Use a hole in the draw plate that is the same diameter as the wire.

If the hole through which the rivet is hammered has been countersunk slightly with a ball burr on both sides, then it is possible to file away the rivet head to make it invisible. Protect the sheet material with masking tape so it is not scratched by the file. When you have filed off one head of the rivet, the part of the wire that sits in the countersink should be enough to keep the rivet from slipping out.

Always make sure that the rivet head does not have sharp edges, and is well tapped down.

Tube rivets

Cut annealed tubing to an appropriate length and place it inside the drilled hole in which it will be riveted. It is easiest to spread the tubing evenly in the correct position using a scribe or punch, rather than in a vise. Don't spread the end of the tubing too far—flip the piece over and open up the other end of the tube so that there is an equal amount on both sides, making the rivets look the same size. Work on both sides until the rivet is flattened down completely.

You can also cut and file tubing so that it splits into "petals." This causes the rivet to spread further, and so may be more suitable for holding flexible materials together, such as leather.

Decorative rivets

Decorative rivets come in many forms—they could be pegs soldered onto a pierced shape, or a cast element. These devices often work best when they form color, texture, or material contrasts within a piece. The design must allow for the hammering involved in the technique, and therefore fragile forms are not suitable. Keep textures from becoming flattened by placing a piece of soft leather over the steel block you are working on.

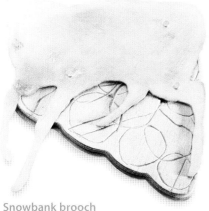

Snowbank brooch
by Nelli Tanner
A pierced silver form is combined with decorated wood to form this brooch.

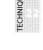

DECORATIVE RIVETS

Patinated elements can be joined using rivets without disrupting the surface. Shapes pierced from textured silver sheet can be used as rivet heads, and will enhance the design of a piece.

1 Solder 18-gauge (1 mm) wire pins onto pierced silver shapes. Use one small pallion of solder for each wire otherwise the rivet head will stand proud from the sheets it is joining.

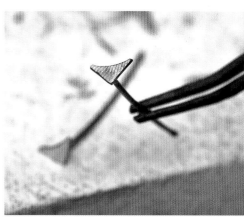

2 Drill 18-gauge (1 mm) holes in the patinated top plate, and countersink enough to compensate for the solder around the base of the pin. Drill holes in the base plate to correspond with the patinated sheet.

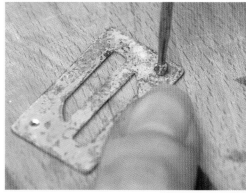

3 Pull the wire through the drilled holes from front to back, and cut, leaving a small amount. File the wire and spread the rivet head, working on a piece of hardwood or a steel block covered with leather. This will prevent the textured surface from being damaged while hammering.

Cutting a screw thread on a metal rod or in a drilled hole or tube allows you to create nuts and bolts. Because they are moveable parts, screws allow for interchangeable elements, but can also be used for permanent fixtures.

SCREW THREADS

Tap and die sets

There are many different standards of tap and die sets; the main distinguishing feature between them is the pitch, which is the distance between the threads on the screw. The ISO metric system is the one most commonly used, and is suitable for cutting small-scale screw threads of the size a jeweler would find useful. BA screw threads have a smaller pitch, and are used in engineering and optical devices such as microscopes. These may be more suitable for softer metals such as silver, in order to prevent the thread from shearing away from overuse.

Uses and suitable materials

Nuts and bolts made from gold, silver, and brass are hard enough to function well, but will not tolerate heavy use in the same way as manufactured steel screws. For this reason, they are best suited to the semipermanent joining of component parts within a piece of jewelry. Screw threads that enable moveable parts to function should be made from a hard alloy of gold—18 karat or lower.

Cutting a screw thread

A taper tap is used to cut a "female" thread on the inside surface of a hole, for a nut or bolt. When cutting a thread into a blind hole (with a base), you need to use several different taps of the same size in order for the thread to reach the bottom of the hole. These are called "bottoming" or "plug" taps and have a reduced taper so that the thread cuts down further.

Dies are used to cut "male" threads on rods. You can vary the diameter of the screw cut by tightening the screws in the die's wrench—for larger screws, tighten the middle screw first, which will force open the die slightly.

When cutting threads, it is very important to keep the tap or die perpendicular to the rod or tube being cut, otherwise the component parts will be a bit wobbly. It's very easy to break fine taps if they are not cutting straight. Use plenty of lubricant to aid the cutting process.

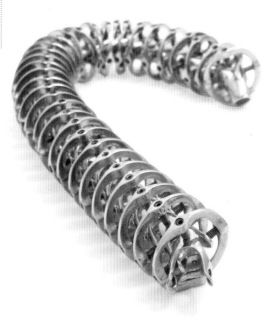

Golden Itami bracelet
by Sean O'Connell
A flexible bracelet has been created using screw threads to form universal joints. The components were cast in 9-karat yellow gold.

Table of rod and hole sizes for
BA and ISO systems

BA thread

Size	Diameter of rod (in)	Diameter of rod (mm)	Diameter of hole (in)	Diameter of hole (mm)
12	0.051	1.3	0.041	1.05
10	0.071	1.8	0.055	1.4
8	0.089	2.25	0.071	1.8
6	0.112	2.85	0.091	2.3
5	0.126	3.2	0.104	2.65
4	0.142	3.6	0.118	3.0
3	0.161	4.1	0.136	3.45
2	0.189	4.8	0.157	4.0
1	0.213	5.4	0.177	4.5
0	0.236	6.0	0.201	5.1

ISO thread

Size	Diameter of rod (in)	Diameter of rod (mm)	Diameter of hole (in)	Diameter of hole (mm)
M1.6	0.065	1.65	0.050	1.26
M1.8	0.073	1.85	0.057	1.45
M2.0	0.081	2.05	0.063	1.6
M2.5	0.102	2.6	0.079	2.0
M3.0	0.122	3.1	0.098	2.5
M3.5	0.142	3.6	0.114	2.9
M4.0	0.161	4.1	0.130	3.3
M4.5	0.181	4.6	0.150	3.8
M5.0	0.201	5.1	0.165	4.2
M6.0	0.240	6.1	0.201	5.1

CUTTING A SCREW THREAD

TECHNIQUE FILE

You will need to select the correct diameter of rod and drilled hole for the size of tap and die you will be using—check the table of tap and die sizes.

1 To cut a screw thread using a die, fix the die into the wrench. Set the silver rod vertically in a vise and place the die (chamfered side down) over the end. Apply some lubricant to the die. Using gentle, even pressure begin to rotate the wrench clockwise.

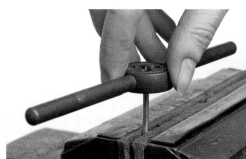

2 For every two clockwise turns, rotate the wrench one turn counterclockwise to clear the swarf, otherwise cutting will become difficult. Keep the wrench level and keep turning until the thread on the rod has been cut to the right length.

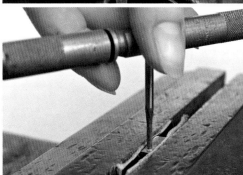

3 Cutting a screw thread for a nut or bolt requires a pre-drilled hole of an appropriate size. Fix the tap in the T-wrench, and the drilled sheet in the vise. Turn the tap clockwise, then counterclockwise to clear the swarf. Keep the tap absolutely vertical, otherwise the nut will be loose.

4 When the two threads have been cut, screw the nut onto the threaded rod to check that the parts work well together. You can then cut the rod down with a piercing saw, file the top flat, and file a groove in the head like a conventional screw.

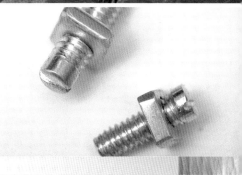

FORMING TECHNIQUES

Dimensionally altering metal can be a challenging process, but this range of techniques provides invaluable ways of creating structural and voluminous forms from wire and sheet metal. Many of the techniques described in this section require the use of formers and hammers to aid the shaping of the metal, and are "organic" requiring the gradual change of dimension in a metal surface, using small incremental steps to achieve the outcome. This can mean that there is more room for error, but these techniques allow so much more freedom of form than basic construction techniques that it is well worth exploring the effects that can be achieved. The way in which these forms "grow" will greatly influence the design of a piece and the subsequent ways in which it is constructed and finished.

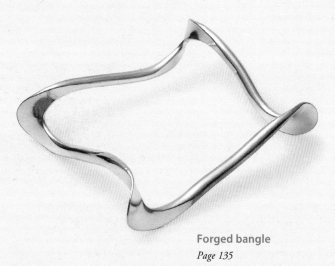

Forged bangle
Page 135

Manipulating and bending wire and changing its diameter or cross-sectional shape are techniques that can be used to add interest to a piece. Fine wire can be manipulated into detailed, structurally strong forms.

WIREWORK

Using a draw bench

You can gradually reduce the diameter of a piece of wire by "drawing" it down. To do this you pull the wire through successively smaller holes in a draw plate and, as the wire gets thinner, it will also get longer. File one end of a piece of annealed wire to a point, and apply a lubricating agent before inserting the pointed end into the chamfered side of the draw plate, using the first hole that the wire does not slip through easily. Set the draw plate in the draw bench and attach the tongs to the protruding wire, wind the handle of the bench to pull the wire through the plate. Work down through the holes in the plate until you reach the desired diameter—the wire will need annealing every three or four holes. It may be necessary to file the point again.

Traditionally, base metal wire is soldered onto the end of gold wire to make the taper, as this will lessen the gold wastage.

DRAWING DOWN WIRE WITH A DRAW PLATE

TECHNIQUE FILE

A draw bench can be used to reduce the diameter of wire, change its "section," and also to work-harden and straighten wire. Draw plates can also be held in the vise and the wire pulled through with sturdy tongs or pliers.

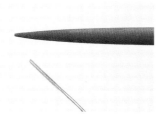

1 File one end of the wire to a taper, so that a portion of the wire will protrude through the front of the draw plate. This needs to be enough for the draw tongs to hold onto.

2 With the draw plate in position, thread the pointed end of the wire through the back of the draw plate and fix the end in the draw tongs. Begin to wind the handle, which will pull the wire through the draw plate.

3 The wire will need annealing after it has passed through two or three holes. Work sequentially down through the holes in the draw plate until the wire is the desired diameter.

FORMING REPEATED WIRE UNITS ON A JIG

You can easily create simple repeated units from wire with the aid of a jig. 18-gauge (1 mm) wire was used for this project.

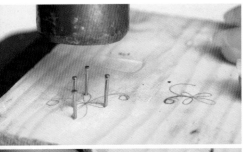

1 Sketch your design onto a piece of wood, and hammer small nails into the wood to correspond to the loops of the design.

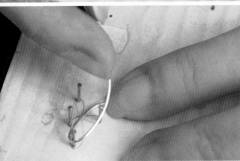

2 Using a longer length of silver wire than you need, so there is enough to hold onto, begin wrapping the wire around the nails.

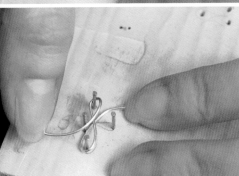

3 Make a note of the sequence of loops if necessary, and continue forming the wire until the design is complete. You can manufacture many identical units quickly in this way.

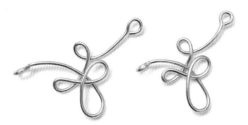

4 By forming loops at each end of the repeated forms with pliers, these simple units can be linked together.

Thinner wire can be drawn with the draw plate secured in a vise, by pulling the wire through with handheld tongs. This process is also very useful for straightening and work-hardening wire, if it is pulled through the same hole several times.

Changing the section of wire

Draw plates come with a variety of shaped holes; the most common is round, but oval, square, and triangular holes (as well as many others) are also available. Round wire can be drawn down so that its shape is changed gradually—in order to take into account the dimensional change, start with a wire that is slightly thicker than the widest part of the final shape. Square wire can be started off in the wire rollers of the rolling mill, and then drawn down to a perfect square section with a draw plate. More dramatic changes in section may call for the wire to be hammered roughly into shape before drawing, otherwise the resulting wire will get very thin before it has been completely altered. For example, round wire may be hammered into a swage block to prepare for a "D" section.

Jigs

Jigs are boards with pegs hammered into them that provide an easy way of wrapping or bending wire into a prescribed form, and can be used to make repeated units. Headless nails hammered into a piece of wood will work best. Match the diameter of the nails to the desired curve of the shape—use larger diameter nails or pegs for larger diameter curves.

Wire forms made in this way can be adapted and modified with pliers and hammers, and soldered closed.

Pliers

Pliers are very useful for bending wire in conjunction with other types of formers (see page 109), and can be used to tidy up the ends of forms to make loops and adjust forms made on a jig in preparation for soldering—manipulating elements so that they are in the right position and making ends meet, for example.

Knitting and weaving

Textile techniques are suitable only for wires thinner than 24 gauge (0.5 mm), and metals such as copper, fine silver, or 18-karat gold should be used, so that they are soft enough to not need annealing during the process. Knitting and crochet both produce interesting structural forms, and the size of the needles or hook will determine the density of the weave. To create a tubular form, crochet a chain spiraling around a former, or use a French knitting dolly made from an old wooden cotton reel with headless nails hammered in around the central hole.

The ends of the wire can be woven back into the form, or secured inside beads to hide them. The final structure is flexible and can be stretched or shrunk, allowing manipulation into a particular shape.

Twisting wire

Strands of wire can be twisted together to create an attractive ropelike linear form. Fold a long length of wire in half, and secure the two loose ends in a vise. Using a hook set into a hand drill, catch the looped end of the wire and turn the handle on the drill—this will begin to twist the wire. Continue until the required twist is achieved. The strand can be folded in half or twisted again, or several strands of wire could be twisted at the same time.

Balled wire

Creating balled wire involves overheating one end of the wire so that it melts and forms a ball—these forms are useful for head pins, rivets, and decorative elements. Be careful to not overheat too far up the wire or it will become brittle. For larger diameter wires, allow the ball to cool slowly by keeping the torch flame nearby so that it doesn't shrink too much.

Fine silver will not need borax or pickling as it does not oxidize during the heating process.

MAKING HEAD PINS

TECHNIQUE FILE 26

By overheating one end of a piece of wire, you will form a droplet of molten silver. When you are balling fine silver wire, you don't need any flux.

1 Hold the wire in insulated tweezers and apply borax to one end. Balance the tweezers of top of a soldering brick so that the wire sits vertically in front of the brick, with the fluxed end at the bottom.

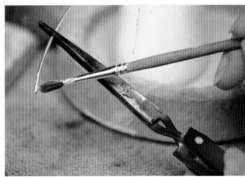

2 Heat the fluxed end of the wire only, positioning the flame so that the wire is just in front of the pale blue cone—this is the hottest part of the flame. Pickle, rinse, and buff the resulting head pin.

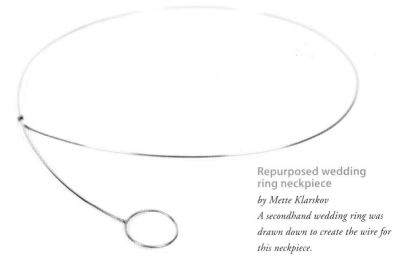

Repurposed wedding ring neckpiece
by Mette Klarskov
A secondhand wedding ring was drawn down to create the wire for this neckpiece.

Specialist forming tools can be used to quickly curve or bend metal to set specifications, allowing fast replication of component parts.

DAPPING AND SWAGING

Dapping blocks and punches

Dapping blocks and cubes are usually made of steel or brass, and have concave depressions in the surface that get incrementally smaller. Dapping blocks with oval depressions and matching punches are also available.

Dapping punches are made either from steel or boxwood. Steel punches will work more quickly, and with less force, but hardwood punches are less likely to mark metal. Use a mallet to strike the punch.

Dapping metal forms

Dapping is used to make hemispherical components, which can be soldered together to make a sphere (or bead), or used in a variety of ways. Most metals can be dapped, but it is important that they are annealed, cleaned, and dried before dapping. The form being dapped does not have to be circular—practically any shape can be dapped as long as it will fit into a recess in the block. Take care when dapping forms that have large holes in them, because the

FORMING TUBING USING A SWAGE BLOCK

The swage block is very useful for bending larger pieces of metal than would be possible with pliers, such as forming sheet into tubing to your own specifications.

1 Select a recess in the swage block that is large enough to fit your metal sheet. Use a dapping punch of the correct diameter—place it over the sheet lengthwise and tap with a mallet until it is curved evenly. Repeat for the next size down, then anneal the sheet.

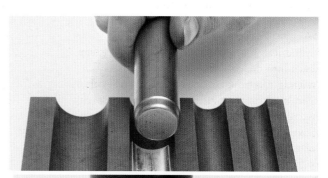

2 On a wooden surface, tap down the edges of the curved form so that they almost meet. Use a steel rod and the swage block to even up the curve. Once the edges are touching, cut through with a piercing saw, tap the edges together, and solder.

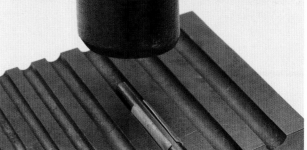

punch is likely to stretch the hole rather than dome the surrounding metal. It may be necessary to cut the hole in the domed surface after it is formed. The small holes in fretwork should not cause this problem, but it is advisable to use a wooden punch so that the form is not distorted.

Making domes

Working with the dapping block on a sandbag will greatly reduced the volume of mallet blows. Ensure punches and blocks are clean and free of grit or the stamped metal will be marked.

Select the correct size of punch for the size of depression that is being used—this should also take the thickness of the metal into consideration. Disks that are too large to fit into the available dapping block can be "sunk" first—this technique uses a bossing mallet to hit just in from the edge of the disk, forcing the edges up. Support the disk on a sandbag while you are hitting it and keep rotating it to form an even line of mallet marks. Small, very curved dapped forms should be started off larger than is necessary and gradually reduced in size, working sequentially down the depressions in the dapping block. Making the dome too small too quickly will cause it to wrinkle.

Regular annealing will be necessary—use the change in sound quality of the mallet blows as an indicator—as a rough guide, the metal should be annealed every three or four holes.

Swaging

Cylindrical punches are used to force metal down into the curved troughs of a swage block. Swaging can be used to make tubes and other cylindrical forms, and to curve metal forms in one plane. The swage block can also be used to make "D"-section wire—use a metal hammer to hit a round-section rod down into the channel of the block, taking care not to let the hammer hit the block.

DAPPING METAL DISKS

Although disks are most commonly dapped, any shaped piece of sheet that will fit into the dapping block can be curved using this technique.

1 Place the dapping block on a sandbag—this will help reduce noise. Place the disk centrally into a depression in the dapping block. Select the right size punch for the hole and hit the punch into the depression with a mallet. This will force the disk down into the depression, curving it.

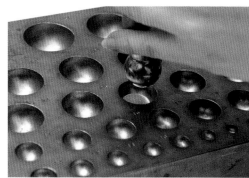

2 Always start in a larger diameter depression than the final form, and work your way down through the sizes until the desired diameter is reached. It may be necessary to anneal the silver at stages throughout the dapping process.

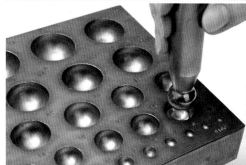

3 The resulting forms should be evenly curved. When dapping pieces that are textured, use masking tape to protect the surface of the silver—wooden dapping punches can be used instead of steel ones, as they will not mark the silver.

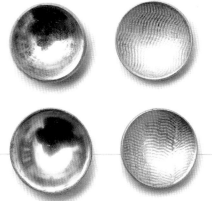

Cold forging is an ancient technique that uses controlled hammering to deform and shape metal. The basic methods for achieving several different outcomes are explored in this section.

FORGING

Hammers and stakes

Choosing the right hammer for the job is very important, because the shape of the hammerhead directly influences the direction in which the metal will move. Round, domed heads will push metal out in all directions, whereas cylindrical faced hammers, such as raising and creasing hammers, will displace metal at right angles to the axis of the cylinder. The choice of stake also has an effect on the outcome of forging—domed stakes can be used to exaggerate the effect of hammering, or for certain jobs will help to avoid the hammer hitting the stake. Flat stakes are suitable for many jobs, and are a vital tool for the jeweler. You need a bench vise to hold the stakes while you are working.

Uses for forging

Forging works because of the "plastic" properties of metal, which causes the metal to permanently displace when it is hit. One of the simplest demonstrations of this is the process of stretching a ring band with a metal hammer on a mandrel.

Silver, fine silver, copper, and gold can all be forged. Aluminum may be forged, up to a point, but it is liable to crack if overworked. Steel has to be forged while it is red-hot. Clean tools thoroughly after forging to avoid them contaminating other metals.

Organic forms are well suited to the forging process, in effect "growing" the metal to the desired form, with graceful transitions from thick to thin. Forging can be used to create curves, tapers, and wedges, and to spread metal by fanning or upsetting it.

Forging safety
• Forging is very noisy, so if you are doing a lot of forging, it's a good idea to use ear protection.

• Working height is also a consideration—the work should be at the same height as your elbow—if the position of the vise means that the working height is too high, stand on a box to raise the level of your elbow.

• Hold the hammer at the very end of the handle, and use it as an extension of your arm—it should pivot from the elbow and not from the wrist.

• Wearing a wrist support will help when hammering, especially in the beginning, when wrist muscles are not as strong.

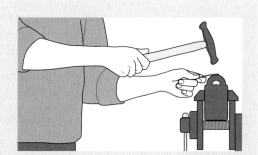

• Wear sturdy footwear when forging, just in case you drop something. For this reason, do not leave unsecured stakes or punches on the bench top where vibrations from hammering could cause them to fall off.

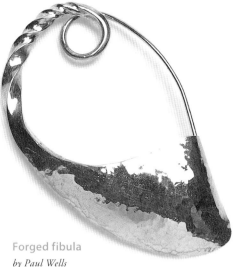

Forged fibula
by Paul Wells
This fibula was created by
forging, twisting, and spreading
a length of silver rod.

It is possible to apply forging to only a small area of a piece, such as planishing the front of an earring hook to flatten it slightly—and this also has the advantage of work-hardening the metal.

The removal of hammer marks when the piece is complete is a matter of taste—some jewelers like to leave the marks on the surface to show the working methods; an aesthetic that was used extensively within the Arts and Crafts movement at the end of the nineteenth century. However, uneven or random hammer marks rarely look good, so planishing is used to refine the surface and remove unwanted marks.

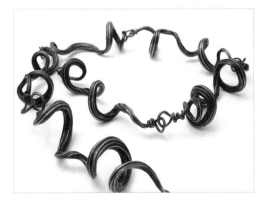

Strangler fig necklace
by Paul Wells
Forging, milling, twisting,
and soldering were used to make
this organic necklace.

FORGING: SQUARING AND TAPERING ROD

Carefully controlled rounds of forging can be used to taper round-section rod. Before tapering begins, the rod must be made square in section.

1 Working on a flat steel stake, use a raising hammer to flatten one face of the silver rod. Turn the rod 90 degrees and repeat. Work all four sides in this way, keeping them an even width. Anneal and pickle the rod.

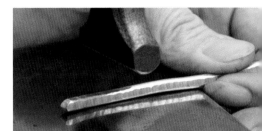

2 Continue forging, working on the bottom 1in (2.5 cm) of the rod, using overlapping blows of the hammer. To reduce the width and make the taper thinner, forge nearer the tip of the rod, forging a smaller length of the rod with each round.

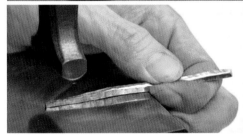

3 In order to make the taper round in section, use a raising hammer to flatten the corners of the square rod so that it has eight sides. Anneal and pickle the piece.

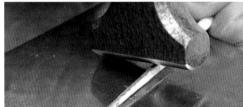

4 Then rotate the rod as it is planished to create an evenly rounded surface—the hammer blows should get more gentle as you progress.

5 To neaten the square portion of the rod, use a planishing hammer to knock out marks made by the forging hammer. This will also make the edges of the rod crisper.

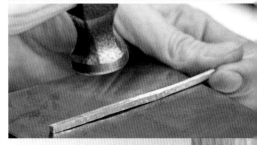

TWISTING SQUARE-SECTION ROD

Square-section rod and wire can be twisted to create striking visual effects. You will need an adjustable spanner for this technique.

1 Bend the square section wire as shown—this will prevent the wire from rotating in the vise when it is being twisted. Any variation in the thickness of the rod will affect how it twists—thinner sections will twist much more readily than thicker sections.

2 Fix the wire in the vise using protective jaws. Attach the adjustable spanner or clamp to the exposed end of the wire and slowly begin to rotate the spanner.

3 Continue twisting the wire until the desired effect has been achieved. Before any further forming, anneal the wire.

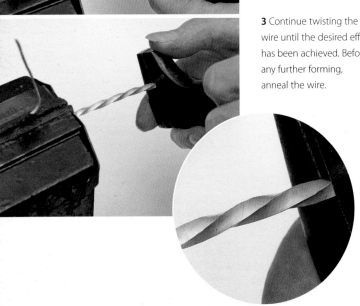

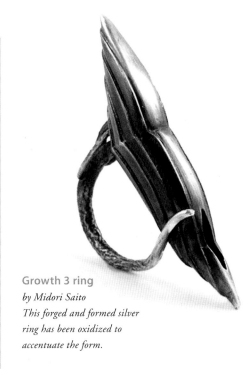

Growth 3 ring
by Midori Saito
This forged and formed silver ring has been oxidized to accentuate the form.

Squaring off wire

In order to taper a wire or rod, it is usual practice to square it off before starting the taper. This is to make it easier to accurately decrease the diameter of the wire gradually. A raising hammer is used on a flat steel stake to flatten and then taper the rod. Take care when forging, that the square section does not start to become rhomboid, and try to rectify the angles if this does happen. When tapering over a long length, the outer surface of the wire will tend to move farther than the center, which starts to create a tube at the end of the taper. You should periodically cut this off, as it can easily split when hammered.

Fanning and spreading

Spreading is a forging technique used to increase the surface area of a piece of metal, making it thinner. In this way, rod can be transformed into sheet, or areas of a piece of sheet may be stretched and thinned. Raising, creasing or ball-peen hammers can be used, depending on the direction and amount of spread required.

Use a slightly domed stake for this process—it will give more control over which part of the piece is in contact with the stake and makes it less likely that the hammer will hit the stake.

Twisting square-section wire

Square wire can be twisted, with one end secured in a vise. A clamp applied to the other end provides leverage. Wires may be twisted in different directions in different areas. The wire should be well annealed to prevent the process causing cracks in the metal. If twisting does cause the wire to break, it can be annealed, reclamped, and twisted more. The clamp will mark the metal, but a half-round needlefile can be used to remove the marks.

Caulking and upsetting

"Caulking" is a technique used by silversmiths to thicken the edges of a piece of sheet metal, using a raising or creasing hammer to hit straight down at right angles to the line of the edge. This forces the metal down into the form and increases the width of the very edge. "Upsetting" is a similar process, but applied to rod. A heavy hammer is used to strike the end of a rod, which is vertically held in a vise. The force squashes the end down, effectively increasing the diameter of the top surface.

Forged bangle

It is possible to spread and twist wire into a great many shapes using forging (see right).

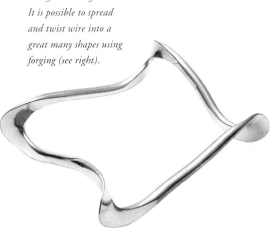

FORGING: SPREADING

This project demonstrates an organic bangle made from an 10½ in (28 cm) length of 6-gauge (4-mm) annealed silver wire.

1 Starting 1½ in (4 cm) in, mark 2½ in (6 cm) intervals on the wire. Bend the wire over at both ends, corresponding to the first mark. Work on a slightly domed stake that is secured in a vise.

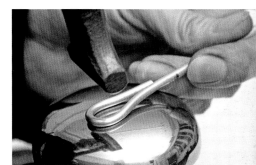

2 Use a raising hammer to start spreading the apex of the curve, which will start to flatten and lengthen. Begin to anneal when the metal work-hardens, and continue forging until the tip of the curve is ⅟₃₂ in (0.8 mm) thick.

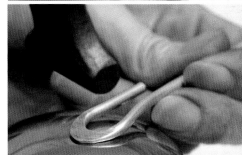

3 Anneal and pickle the wire. Use a planishing hammer to even out the hammer marks. Repeat these processes on the other bent end of the wire.

4 Open up the two spread ends slightly, so that the two remaining marks on the rod can be bent around—then repeat the spreading on these two curves. Now open up the curves—pull the wire either side of each curve in opposite directions to make a roughly square shape. The ends can then be cut and soldered.

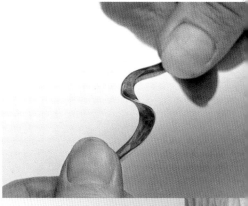

This technique utilizes the properties that can be applied to sheet metal once it has been folded, exploiting differences in the thickness of the metal to cause it to curve dramatically.

FOLD FORMING

Tools for fold forming

The technique of fold forming can be performed with relatively few tools. A raising hammer, mallet, flat steel stake, and vise are essential for the process, and a rolling mill may also be used. You will also need basic hand tools to prepare the metal.

Gold, silver, copper, steel, and aluminum can all be fold-formed, but the characteristics of each metal should be taken into consideration—steel should not be used in a rolling mill and aluminum is prone to cracking if overworked, for example.

Silver pieces should not be pickled after annealing until after the form has been opened, as this can cause the inner surfaces to fuse during subsequent heating.

Sheet metal used for fold forming should be around 26 gauge (0.4 mm thick), which will give optimum results, and allow the form to be opened up without too much effort.

Uses

Fold forming is ideal for creating lightweight and structurally strong forms, which lend themselves to large-scale sculptural pieces. Due to the organic nature of the process, it is difficult to produce exact replicas of a piece, making the production of pairs (for earrings) difficult. It helps to keep a detailed record of templates, metal thicknesses, and the number of folds, so that you will know which outlines produce which forms—this will make it easier to reproduce similar forms. The creation of copper test pieces to explore the technique will also help.

One major advantage of this type of form is that there are no solder seams, which may be of benefit in further construction of a piece, but care must be taken when soldering fold forms as the sheet metal can be incredibly thin in places and prone to overheating.

Single folds

It is necessary to use a "shim," or strip of metal, set into the fold of a piece in order for the curving effect of fold forming to work when the form is milled or hammered. In essence, the side of the sheet with the fold is being stretched, which causes the form to curl, as the other side

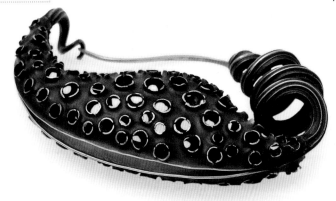

Pod brooch
by Paul Wells
*A shaped fold form was combined
with forged and milled rod to create
a brooch with an integral catch.*

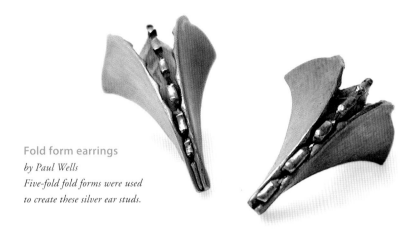

Fold form earrings
by Paul Wells
Five-fold fold forms were used
to create these silver ear studs.

remains the same length. The shim also raises the height of the area that will be hammered or milled, making it easier to judge progress. Once the sheet is folded, the distribution of curvature along the length of the fold may be adjusted by trimming the form. Thinner areas of the form will curve more quickly than those that are wider because there is less resistance.

Hammer or mill the form until the thicker side of the piece is the same thickness as the legs, at which point no more curvature will occur. The form can be annealed and opened.

The curve will be more pronounced when the form is opened—the amount the form is opened is a matter of taste and design.

Multiple folds

Folding a sheet of metal so that it has a number of folds situated at one side eliminates the need for a shim when fold forming. The metal is folded in the same manner as for a single fold, but without the shim. Once it is closed with a mallet, mark a line a little way in from the fold and, in a vise, use this as a guide to bend the legs down. Fold the legs down to make an "M" shape. This process can be repeated, but the metal will need annealing. Remember to allow enough extra length in the piece of metal you start with, so that the legs do not get too short when making multiple folds. If too many folds are put into one sheet, there is a tendency for the stack of folds to fall over to one side, and the folding must be very accurate in order to keep the folds in alignment.

The sheet should be cut to shape, filed, and annealed before hammering it or using the rolling

mill to create the curve. Overworking the folds will lead to splitting when the form is opened—it is not as easy to judge when to stop as with a single-fold form. The form can be curved more, by hand, once it has been opened.

Forged fold forms

A raising or creasing hammer can be used to effect the curve along the fold. Use the hammer so that the head is at right angles to the fold, and start hammering at one end, making overlapping marks. When the form has begun to curve, the hammer marks must still be made at right angles to the fold, but because of the curve, they will be radial rather than parallel. It is important that the very edge of the fold is not hit, otherwise it may become too thin and weakened, which can cause a split. Successive rounds of hammering and annealing can be carried out until the desired degree of curvature is reached.

Fold forming with a rolling mill

When using a rolling mill for fold forming, the thickness of shim or the amount of folds will determine the amount of milling that is possible. The form should be milled slowly, reducing the distance between the rollers each time the form is passed through—milling too much too quickly can cause the legs to shear off from the folds. The fold must always be fed into the mill at right angles to the rollers, which will be more difficult to maintain when the curve has started to take effect.

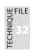

FOLD FORMING: MAKING A SINGLE-FOLD FORM IN THE ROLLING MILL

You will need a piece of 26-gauge (0.4 mm) silver sheet, with the dimensions 2½ in (7 cm) by 1½ in (4 cm), and a piece of 18-gauge (1 mm) copper shim, ⁵⁄₃₂ in (4 mm) wide and 2½ in (7 cm) long.

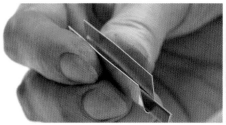

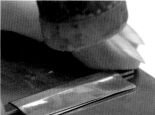

1 By hand, fold the sheet of metal in half along its length so that it is a "U" shape, and insert the shim.

2 Clamp the piece in a vise to close the fold more tightly and trap the shim in the base of the fold. Then, working on a steel block, use a mallet to trap the shim tightly in place.

3 Use tin snips, a piercing saw, or a guillotine to cut the piece to shape, then file the edges smooth. Anneal the form, but do not pickle.

4 Insert the folded form, end on, between the rollers of a rolling mill so that the fold is at a right angle to the rollers. It is better to do several rounds of gentle milling than to mill the piece hard and quickly. Anneal regularly and do not pickle.

FOLD FORMING: HAMMERING MULTIPLE FOLDS

For this project you will need a piece of 26-gauge (0.4 mm thick) silver sheet, with the dimensions 2½ in (7 cm) by 1½ in (4 cm), and a creasing hammer.

1 Fold the sheet of silver in half widthwise, in the same way as for the single-fold form, but without a shim, and mallet it shut. Anneal the sheet but do not pickle it. Use dividers to mark a line ⁵⁄₃₂ in (4 mm) from the fold.

2 Position the piece in the vise, with the fold at the base, and so that the scribed line is level with the top of the vise jaws. Pull the two sides of the sheet apart by hand or with the aid of a blunt knife, and then use a mallet to flatten the fold.

3 Remove the piece from the vise and fold down the sides of the sheet to make an "M" form. Working on a steel block, mallet the fold flat.

4 Insert the folded side of the form into the vise to the same depth as the previous fold—you can scribe a line with dividers again to ensure the fold stays level—and fold down the two sides of sheet. Mallet the fold flat.

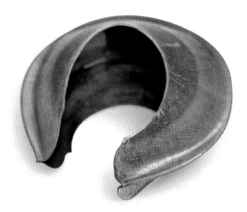

5 For the maximum amount of curvature, the fold must be kept at a right angle to the rollers—and so may need readjusting in the rollers to maintain the correct angle.

6 Roll the form until the folded side with the shim is the same thickness as the rest of the sheet. Anneal again.

7 To open the form, lever the shim from side to side. Work from one end of the form and, with the aid of a blunt knife or a hard wood wedge, pull the form open. Take care not to damage the silver. Further opening or manipulation can be done with your fingers.

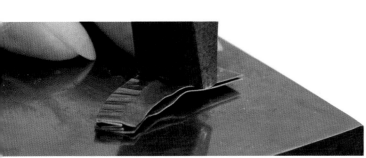

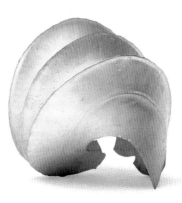

5 Use a creasing hammer to forge along the fold, working just in from the edge so that the fold itself is not being hit. The hammer should make marks that are at right angles to the fold. Anneal regularly and continue forging until the desired curvature is achieved, but not before the silver gets too thin.

6 Anneal the form again so that it can be more easily opened. You can use a blunt knife or a hard wood wedge to help open the folds. Final adjustments should be made by hand.

7 The opened fold form.

Rapid dimensional changes occur in sheet metal when it is raised. Anticlastic raising is a specialist technique that enables concave curves to be created around a form that is itself curved.

ANTICLASTIC RAISING

Hammers and stakes

A "sinusoidal" (meaning snakelike) stake is necessary for anticlastic raising. The shape of the stake allows metal to be forced down into the gaps, or troughs, with a wedge-shaped hammer or mallet.

A creasing hammer can be used for this technique, but it will impart a texture of hammer marks on the surface of the metal. Nylon mallets can be adapted to a wedge shape and will work just as effectively as a metal hammer without the risk of adversely marking the piece or the stake.

Forming sheet metals

Raising is a technique that typically produces "synclastic" forms—these are bowl-shaped, with the axes curving in the same direction.

"Anticlastic" raising produces saddle-shaped forms in which the axes are curving in opposite directions.

The sheet metal used should be 21–26 gauge (0.4–0.7 mm thick) depending on the piece being made and the metal which is used—gold, silver, copper, and aluminum are all suitable.

Designing anticlastic forms

Bangles and rings are the most suitable jewelry forms made from closed anticlastic forms, but pieces may be adapted to produce earrings, brooches, and pendants. Rings should not be raised too far, as the pronounced edges would make them uncomfortable to wear.

The shape of the sheet metal used to make the form will directly affect the outcome—a parallel strip of metal will produce a parallel curve around the form, but an uneven strip can yield interesting changes in width and profile, as the different widths affect the rate of curvature of the piece. Some designs will naturally try to dictate the shape around the circumference of a form when it is raised, making the form oval or triangular, which can be very attractive. When truing up a form between rounds of raising, this

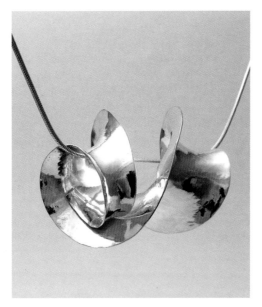

Anticlastic pendant
by Paul Wells
This piece was formed
from one flat sheet of
metal, using the anticlastic
raising technique.

Template

This template can be used to produce the anticlastic bangle demonstrated on the right.

MAKING AN ANTICLASTIC BANGLE

TECHNIQUE FILE

In this project, a wedge-shaped mallet and sinusoidal stake are used to raise an 8¼ in (21 cm) strip of silver. Cut to shape, file, and solder the bangle shut before raising it.

1 Secure the stake horizontally in a vise. Place the piece on the stake so that it sits in the crook of the largest curve. Use overlapping blows of the mallet just in from the edge of the form and work all the way around the outside edge. Turn the piece around on the stake and repeat the process.

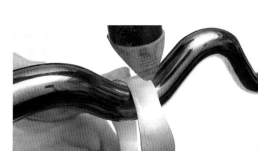

2 On a round bangle mandrel, true up the central area of the bangle. Anneal and pickle, then return the bangle to the stake and do another round of hammering on both sides, slightly farther in than the last.

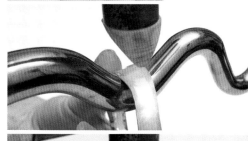

3 Continue working, alternating rounds of raising with truing on the mandrel and annealing after each round, until the curve of the bangle has filled the void in the stake.

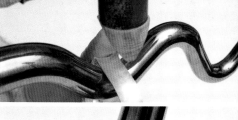

4 The bangle can then be worked through the successively smaller crooks of the stake until the desired degree of curve is reached.

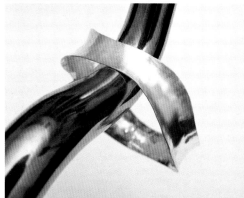

ANTICLASTIC RAISING: OPEN FORMS

Use 22-gauge (0.6 mm) silver sheet for this project. This may seem thin, but the resulting structure of the piece gives the form an integral strength, and helps keep the piece light.

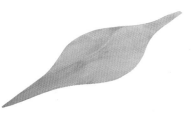

1 Design a template, and pierce around it on silver sheet. Wide areas will cure more slowly than thinner parts, but a greater degree of curvature may be achieved.

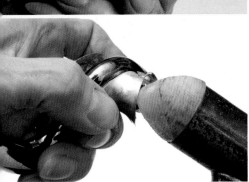

2 Bend the sheet around its length so that it is circular. Work on the sinusoidal stake as previously described, starting at one end of the silver piece. Hold the silver tightly to prevent the circle from opening up as it is hit. Work along the full length of one edge, before malletting the other edge.

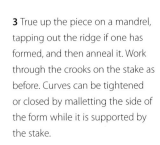

3 True up the piece on a mandrel, tapping out the ridge if one has formed, and then anneal it. Work through the crooks on the stake as before. Curves can be tightened or closed by malletting the side of the form while it is supported by the stake.

4 The finished piece.

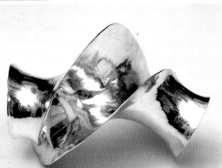

shape does not necessarily have to be distorted into a circle—the main aim of truing is to knock down the ridge that forms around the central portion of the width of the sheet metal.

Judging the length with which to start is not straightforward—the outside edges of the form will stretch, but the central length of the piece actually shrinks, and the amount of curvature affects the rate at which this happens as well, but generally, an 8¼ in (21 cm) strip will produce a small- to medium-sized bangle. Keep a record of any cut shapes and their lengths by drawing around them—remember that the ends of the strip should be the same width so that they meet up neatly.

Closed forms

Forms that have been soldered closed are easier to raise than open forms. The solder seam must be a close fit, held securely with binding wire, and soldered with excess hard solder that should

Anticlastic rings
by Sonja Seidl
The anticlastic form of these gold and silver rings allows them to have smaller rings trapped around them.

be removed with a file prior to raising. This is to ensure that the seam is strong enough to withstand hammering and repeated annealing. If the solder seam does dry out or split, rub it lightly with a file to expose fresh metal and resolder it with hard solder.

Starting in the largest trough or crook of the sinusoidal stake, the form is gradually knocked down into the void of the trough with a wedge-shaped mallet. Work just in from the edge to start with, and along one side at a time. These rounds of raising are alternated with the truing of the piece on a mandrel that will prevent, or rectify, the ridge that can form around the center of the piece. Once the form sits in the trough with no gap underneath, the stake can be inverted in the vise so that the next-smallest trough can be used to tighten the curve. This process is repeated as necessary.

Open forms

In theory, any shaped piece of sheet metal can have an anticlastic form applied to it, but fluid forms with a minimum width of ½ in (10 mm) will be the easiest to start with. The form must be curved to start with, otherwise a cylinder will be produced. Open forms need to be held more tightly than closed ones, as the action of raising will try to open up the curve along the length of the piece.

Forms that begin to curl in on themselves can be pulled apart to allow raising to continue, and closed again afterward. Curves can be tightened or reduced in diameter by hitting them from the side, using the stake as a support.

Using dapping punches for anticlastic forms

Dapping punches can be used to stretch the edges of a ring, forcing them to spread outward. This is not true anticlastic raising, but it does result in an anticlastic form.

The diameters of the two dapping punches used must be large enough so that they cannot touch through the center of the ring when applied to either side. This will also depend on the height of the band ring—shallow bands will need to be spread with larger dapping punches than deeper bands.

ANTICLASTIC FORMING WITH DAPPING PUNCHES

A simplified method of making an anticlastic ring is to use two dapping punches to spread either end of a silver band ring. Clean up the ring and anneal it before you start this project.

1 You need two dapping punches—1¼ in (30 mm) would be an appropriate size for a ⅝ in (17 mm) diameter ring. The two dapping punches must not make contact inside the ring or the process will not work. Set one dapping punch in a vise.

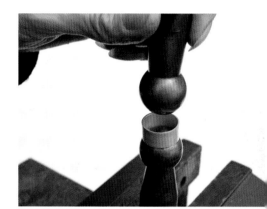

2 Place the ring on top and rest the other doming punch on top of the ring. Strike with a mallet ensuring that the punches stay truly vertical so that the ring spreads evenly. Anneal the ring.

3 Use larger doming punches to spread the edges of the ring until it reaches the desired shape, remembering to anneal regularly so that the solder seam does not split.

These two techniques are used together to emboss designs on sheet metal, working from the back and the front of the form to give a high degree of detail.

CHASING AND REPOUSSÉ

Tools and materials

Silver, copper, and higher-karat golds are ideal for chasing, and the thickness of the metal used will affect the degree of detail—for heavily worked pieces the thickness should be up to 18 gauge (1 mm), but where minimal detail is required, 24-gauge (0.5 mm thick) sheet should be sufficient.

When chasing, the sheet metal is set into pitch, which is a tarlike substance with a degree of elasticity to allow the metal to move when it is hit. The pitch is set into a heavy hemispherical bowl, which sits in a donut-shaped ring, allowing the bowl to be angled for easier working.

The bowl should be situated at a comfortable working height, which is usually achieved by placing it on a stool directly in front of the stool on which you are sitting.

Chasing punches and hammers

You can purchase a wide range of punches but, as you often need many versions, it may be advisable to make the punches from tool steel. 4 in (10 cm) lengths of steel can be cut from rod stock with a hacksaw, before being ground or filed to shape. The faces of the punches should be slightly curved and have no sharp corners or edges so that they do not split the metal. Lining tools should have narrow faces, while blocking and planishing punches should be cushion-shaped. Matting punches have a pattern on their face and are used to texture areas of a design. The top end of the punch should be chamfered to counteract the spreading that will occur from the repeated hitting with the chasing hammer. Handmade punches will need to be hardened and tempered before use.

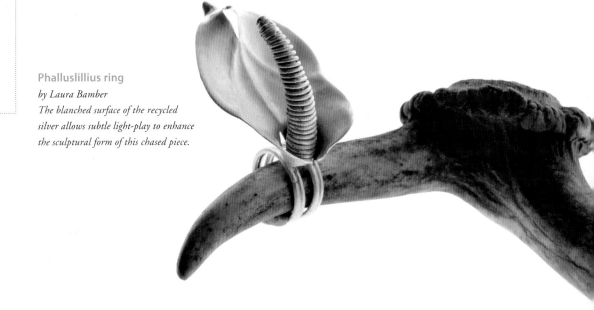

Phalluslillius ring
by Laura Bamber
The blanched surface of the recycled silver allows subtle light-play to enhance the sculptural form of this chased piece.

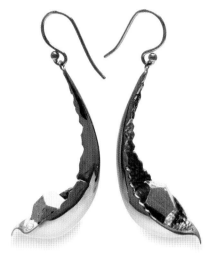

Magnus opus in Crucible no.1
by Ornella Iannuzzi
Octahedral pyrites have been set into
chased and plated silver forms to make
this pair of earrings.

Chasing hammers have a special handle, with a thin shaft, which helps the hammer spring back after it has made contact with the punch, and a shaped end that sits in the palm of the hand. The hammers come in several weights, so a heavier hammer will hit the punch with more force than a lighter one, causing the metal to move more quickly.

Applications for chasing and repoussé

Technically, chasing is worked from the front of the piece, and repoussé from the back, but when used together, they are referred to simply as chasing. These techniques can be used to create incredibly intricate three-dimensional relief on sheet metal, including areas with undercuts, and historically were used to decorate watch cases, small boxes, and lockets.

Chasing can be applied to press forms, to define and embellish them, and the process of press forming in itself can be used to "block in" areas that would otherwise take a great deal of time to chase.

SETTING UP—PUT THE PIECE IN PITCH

Pitch is a tarlike substance used to support work while it is being chased. It holds the piece securely and facilitates accurate work with chasing tools. Use 19–22-gauge (0.6–0.9 mm thick) silver sheet to make a press form. The thickness of the sheet will depend on the design being chased—use thicker sheet for heavily chased work.

1 Anneal the sheet, and bend down the four corners with parallel pliers.

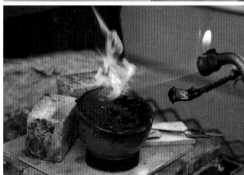

2 Gently warm the pitch with a soft flame so that the surface becomes soft. Take care not to let the pitch boil or get charred by the torch.

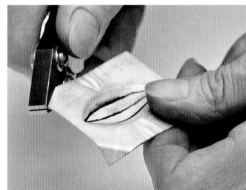

3 Wet the back of the piece and push it into the pitch, corners pointing down. Ensure that the surface is level and use wet fingers to push the soft pitch right up to the edge of the piece. Allow the pitch to cool completely before starting to chase.

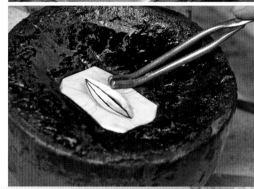

CHASING ON THE DESIGN

After the design has been marked out with a lining tool on the back, the piece can be turned over and chased from the front to define the form.

1 Sit with the pitch bowl on a stool in front of you. The bowl can be angled slightly forward. Mark out the design with a chasing hammer and a lining tool, using the heel of the tool to chase a continuous line with a gentle tapping motion of the hammer.

2 To remove the piece from the pitch, use a slightly bushy flame and gently warm the piece of metal until it can be lifted out with tweezers. Scrape off the excess pitch and remove any residue with solvent. Anneal and clean the silver.

3 Bend down the corners so that they are facing the opposite way, so the concave form is now the back. Melt broken chunks of pitch into the recess to fill it.

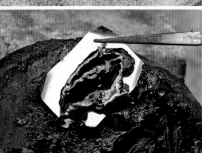

4 Warm the pitch in the bowl, and scrape together a small mound in the center. Set the piece in the pitch, ensuring that there are no pockets of air trapped underneath.

Setting up

Before starting to chase, the piece of metal must be set into the pitch. Anneal and pickle the metal, and mark out the design that will be chased, either with a scribe or a permanent marker pen. Folding down the corners of the sheet so that they will stick down into the pitch will stop the piece from moving around while you are working on it.

The pitch should be warmed with a soft flame so that the piece can be pressed down into it. Use water to keep your fingers wet so that pitch cannot stick to them—if this does happen, run your fingers under a cold faucet to cool the pitch before removing it.

Chasing lines

Traditionally, the outline of the design is chased onto the metal first, from the back, by tapping the punch lightly with a chasing hammer. Overlapping marks are made by moving the punch forward slowly while tapping, to make a continuous line. Once the outlines have been marked, remove the piece from the pitch and anneal before continuing with the process.

Chasing form

Blocking punches are used to chase form and deepen areas of the design gradually. The metal will need to be removed from the pitch and annealed at regular intervals during the process. Working on a press form will mean that an amount of depth has already been applied to the piece, so this stage will not take so much time.

Take care not to overwork any areas too much as this can cause thin patches in the metal that are likely to split or become overheated during annealing. Splits can be repaired by tapping the edges together and soldering the split shut—this area should be masked off with rouge paste during subsequent heating so that the solder does not melt again.

Finishing

Once the basic form has been executed from the reverse of the piece, fine detail should be chased in from the front, and planishing punches are used to smooth and even up areas of the design. The piece can then be removed from the pitch for the final time.

The surrounding sheet metal can then be pierced away from the chased design, ready for the piece to be finished. This could mean that it is sweat-soldered onto a flat back plate, or matched up with a corresponding form to make a locket.

The finished chased form

It's possible to create highly sculptural three-dimensional forms using chasing and repoussé (see right).

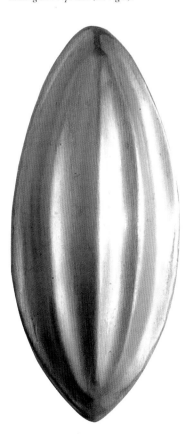

DEFINING A CHASED FORM

Blocking punches are used to "block" in form—a small dapping punch is used for this step-by-step. The back of the piece can also be worked in the same way.

1 Set the piece in the pitch, ensuring that there are no pockets of air trapped underneath.

2 Once the pitch is cool, use a blocking punch to chase the form. Use light, regular taps of the hammer to deepen recesses with overlapping marks. When working becomes more difficult, remove the piece from the pitch and anneal it.

3 Planishing punches can then be used to even out the marks made by blocking punches. Once the piece has been removed from the pitch for the final time, a lining tool should be used around the outside edge of the form to ensure it is flat.

Sheet metal can be pressed into three-dimensional forms, using a die to define the shape of the outer edge. The metal is forced through a hole in the die, giving a rounded form.

HYDRAULIC PRESS FORMING

Tools and materials

The press used for forming is a steel frame with an integral moveable shelf, which is raised by increasing the pressure in the hydraulic bottle jack fixed into it. The shelf is lowered by loosening a nut, which reduces the pressure.

Press forming can be done in a large vise, but achieving the same effects as a hydraulic press can take a lot of effort, and can only really be used for smaller shapes. A fly-press can be used to stamp forms, but always needs to have matching male and female dies.

The die used for pressing is usually made from ⅜ in (10 mm) thick acrylic sheet, with a pierced hole. If many identical forms are to be produced, a brass plate with a matching hole can be stuck to the surface of the acrylic and this will help make the die more durable, and also give crisper edges to the pressed form. For large, deep forms, it may be necessary to stick two sheets of acrylic together to allow more depth. Medium density fiberboard (MDF) can also be used to make dies, but the die will have a much shorter lifespan.

Silver and copper are the most suitable metals for this technique as they are soft enough to move well, and durable enough to cope with the pressures involved. The sheet metal used for press forms needs to have a border all the way around, usually ⅜ in (10 mm), which means that gold is prohibitively expensive. Copper sheet should be around 22 gauge (0.6 mm thick), and silver sheet can be 20–24 gauge (0.5–0.8 mm thick)—the larger the form, the thicker the sheet should be.

Urethane rubber sheet is the ideal material to use when pressing, as it becomes almost fluid

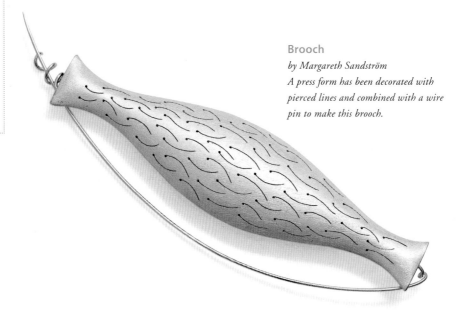

Brooch
by Margareth Sandström
A press form has been decorated with
pierced lines and combined with a wire
pin to make this brooch.

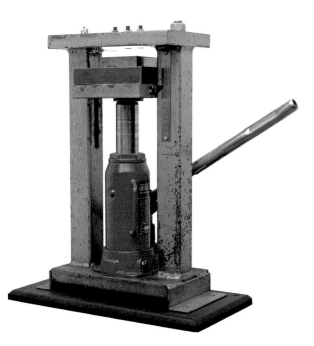

Hydraulic press
A hydraulic press can be used for a number of forming and embossing techniques on sheet metal.

under pressure and gives the best results, but standard black rubber will work fine. Use several sheets of rubber layered up.

Cutting a die

Careful consideration needs to be given to the shape that will be pierced out of the acrylic block. Fluid organic shapes will work best for pressing—try to avoid sharp corners and points as they will either encourage the sheet metal to split, or not allow it to move adequately. Metal will not push as easily through small apertures, but will quickly and easily move through large ones; narrow areas of a form will not press as easily as wide areas. If an asymmetrical form is being cut, both sides of the die will need to be used if two halves are being formed.

Draw the design on the acrylic block, drill a pilot hole, and pierce out with a wax blade. It is very important to keep the blade vertical, as the thickness of the material will magnify any slight angle and the underside of the piercing will not

FORMING OVER AN OBJECT

Any solid object without undercuts can be used for this project. Items such as keys, cogs, and nuts are ideal, but forms could also be carved from acrylic. The sheet metal used should larger than the object—a ⅜ in (1 cm) border is adequate—and 20–24 gauge (0.5–0.8 mm thick) depending on the object and degree of detail required.

1 Use masking tape to secure the silver sheet in position over the object. Place several layers of rubber sheet on top of the silver, and then place the sandwich in the center of the table of the hydraulic press.

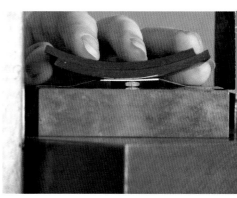

2 Pump up the pressure of the hydraulic jack until the rubber is forced up against the top of the press and you can feel resistance. Release the pressure and remove the pieces. Anneal the metal and repeat the process if necessary.

3 The resulting form can be pierced out and soldered onto a base plate, or chased to add further detail. Anneal the piece if more forming techniques will be used.

HYDRAULIC PRESS FORMING

The hydraulic press is used to make cushion-shaped forms. Rubber forces sheet metal through a hole in an acrylic block when pressure is applied.

1 Mark out a design on ⅜ in (1 cm) acrylic sheet, making sure there is a border around the shape. Drill a hole inside the template, and use a spiral saw blade to pierce around the outline. Use a file to true the inner surface of the die so that the top edge of the outline is smooth.

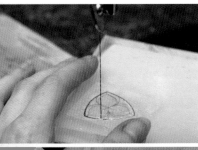

2 Place a piece of annealed silver sheet centrally over the die, making sure there is a surrounding border, and secure it in position with masking tape. Place a piece of urethane, or several layers of rubber, on top of the silver.

3 Place the die centrally on the shelf of the hydraulic press and increase the pressure to raise the shelf. When you feel resistance, release the pressure to lower the shelf and check the progress of the piece.

4 Anneal and pickle the silver before repeating the process. Once a depression has started to form in the silver, cut pieces of rubber to fit and insert them under the larger sheets of rubber.

5 Repeat: keep on annealing and pressing the sheet until the desired depth of form is reached.

be the same as the top. Keep the pierced-out center if you are making an insert, or male die. File the inside of the pierced hole to even it up, and to remove any sharp edges that could cause the metal to shear—but do not round off the edges or the pressing will have less clearly defined edges.

Press forming metal sheet

Use annealed sheet for pressing, and secure it to the die with masking tape, having the pierced hole centrally positioned. Several rounds of pressing will be required to reach the desired depth—do not use too much pressure, as this can make the metal sheet split. It is much safer to build up the depth of pressing slowly—stop increasing the pressure when you feel resistance. For deep pressings, use thicker sheet so it won't split as easily.

Once the form is pressed, anneal it again and secure it to a flat steel stake with masking tape. Tap the edges flat with a mallet and, if required, a lining tool can be used to chase around the outline of the form, which will make it crisper. The form may also be chased in a pitch bowl to add detail or define the form further; press forms are an ideal starting point for making lockets and pendants.

To join two halves together, pierce around the outline and sand down the underside so that there is a ledge. The pieces can then be soldered together (see Sweat soldering, page 100).

Male and female dies

Carved inserts (male dies) can be made from the pierced-out portion of the (female) die. Remember to take the thickness of the sheet metal into account when carving. The inserts can give more accurate or better-defined profiles when used in conjunction with the female die.

Begin to form the pressing in the same way as previously described, and add in the insert when the form starts to be established. The dies can be inverted, and the parts secured with masking tape during pressing.

Embossing with the press

Sheet metal can be formed over robust objects such as keys and other solid metal forms. Handmade forms can be constructed from wire, carved acrylic, or cast metal, and must be able to withstand the pressure used in the process of hydraulic pressing.

Any undercuts in the form are unlikely to be transferred to the metal, as it is pressed directly down over the object, rather than around it. Fine details will also not transfer well, but using a thinner sheet will help give better definition.

The metal can be textured before pressing, using etching or rolling mill textures, for example, but take care not to make the metal too thin with deep impressions.

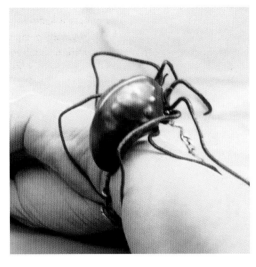

Wrist spider
by Anastasia Young
The main body of this piece is constructed from two pressed forms soldered together. The punched marks give the piece texture as well as increasing the depth of the pressed forms.

FORMING USING A CARVED INSERT

TECHNIQUE FILE

When a female die is used in conjunction with an insert (male die) a more defined form can be created, allowing different profiles to be applied to the basic cushion shape.

1 The offcut from the die made in the previous project was carved with files into a trefoil design. Your insert must fit inside the die with enough space to allow for the thickness of the sheet metal being used. Tape a piece of annealed sheet over the insert onto a steel block.

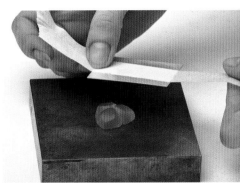

2 Put several layers of rubber over the silver sheet and press in the hydraulic press. The silver sheet will wrinkle around the edges—use a mallet and steel block to flatten the sheet before annealing and pickling it.

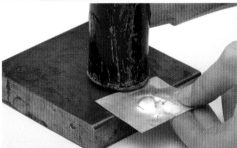

3 Press the sheet using both the die and the insert. Small pieces of rubber can be inserted into the void in the die, which will help to force the silver more closely around the insert.

4 Continue annealing and pressing until the form is satisfactory. To make a press-form locket, see page 192, Hinges.

Thermoplastics, when heated to make them soft and flexible, can be manipulated into many shapes and forms. Once cooled, the plastic becomes rigid and holds its new form until it is heated again.

BENDING ACRYLIC

Heat-forming thermoplastics

Thermoplastics can be made soft and flexible when they are heated. Localized heating can be used to bend specific areas of a piece—a heated metal element applied to the acrylic will make it easy to bend straight lines and create angles. Larger areas may be locally heated with a "heat gun," but take care not to overheat the plastic as bubbles will form under the surface. For bending smooth curves over a length or twisting a form, the whole piece of acrylic needs to be heated in an oven or kiln.

The oven should be set at 340°F (170°C); it will take a few minutes for the acrylic to become soft and flexible. Be careful not to overheat the material as bubbles will form under the surface, and these cannot be removed. Form twists and bends by holding the acrylic in position until it sets. Wear thick leather gloves when working with heated materials.

Savoy bangle
by Lesley Strickland
This bangle was thermoformed from cut and shaped cellulose acetate. The matte surface gives it a subtle translucency.

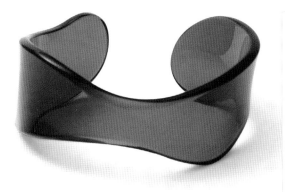

Acrylic bangle

It's possible to make simple but elegant items of acrylic jewelry using heat forming (see right).

Using formers with acrylic

To make an oval acrylic cuff, cut a shape using a wax blade, and file the edges smooth. The basic shape should be around 6 in (15.5 cm) long; avoid making the ends too pointy, as this will make it uncomfortable to slip the cuff on and off.

Once the acrylic has been polished (it is much safer to polish acrylic cuffs while they are still flat), place it on a tray or rack in the oven and let it warm up for a couple of minutes. Wearing gloves, wrap the form around an oval bangle mandrel and hold it in position until it sets. Wider cuffs will need more careful support until they set—make sure that there is an even gap between the two ends, and that they are sitting flat against the mandrel. Acrylic will start to set around 60–90 seconds after it has been removed from the oven. If the resulting form is not satisfactory, simply return it to the oven and reheat. Plastic has a memory, and will revert to flat sheet when heated again; the heating process can be repeated many times before the plastic will start to degrade, as long as it is not overheated.

Other forming tools such as dapping blocks and punches and swage blocks can also be used with heated acrylic, but only use firm pressure applied by hand, rather than a hammer.

FORMING AN ACRYLIC BANGLE

The acrylic should be cut to shape, cleaned up, and polished before it is formed. This technique can be done in a conventional oven or a kiln.

1 Preheat the oven or kiln to 340°F (170°C). Place the acrylic blank on a wire rack in the oven, and leave it to heat up for two or three minutes.

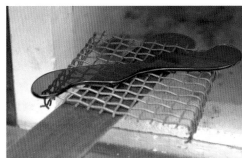

2 Wearing heat-protective gloves, remove the acrylic from the oven when it is soft and flexible.

3 Wrap the acrylic around a former such as an oval bangle mandrel, and hold it in position—the plastic will start to harden after about 60 seconds.

4 Once the acrylic has set, place it under cold running water in order to cool it down.

CARVING AND CASTING

This section explores the creation of volume and three-dimensional form in ways that are not possible with other techniques. Carving involves reducing the volume of a piece to create a form that can be as simple or as intricate as desired, and can be applied to a range of materials, including jeweler's wax, wood, horn, plastic, and metal. The use of molds to reproduce identical forms in a number of materials such as wax and resin is ideal for jewelry forms that would be difficult or prohibitively time consuming to make in any other way, especially if multiple components are required—molds allow many identical objects to be cast. Models cast or carved in wax can be transformed into base or precious metal using the lost wax casting method, which is described in more detail in the Outwork section, page 257.

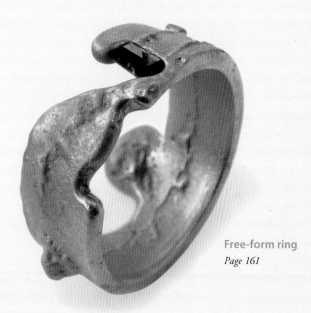

Free-form ring
Page 161

Using the lost wax casting process, you can create metal forms from carved wax masters. This is a useful way of producing pieces that would take a long time to construct or carve in metal.

WAX CARVING AND MODELING

Jeweler's wax is designed for making models that will be cast using the lost wax casting method (see page 260) and its properties are ideal for creating intricately detailed, small-scale three-dimensional forms. A variety of waxes with different properties are available, and the type used will depend on the model being made.

Wax files, spiral saw blades, and carving or dental tools are useful for working wax. Burrs, gravers, and lino-cutting tools can also be used. As well as a spirit lamp, electric wax welding tools and specialist heat guns are useful for welding.

Carving wax

Wax is usually carved by the subtractive method, meaning material is removed from a larger piece of wax than is required, to create a form. The basic form can be pierced out using a spiral saw blade, before defining the form with wax files; carving tools can then be used to add detail.

Always carve thin areas last as they are more liable to break—soft red wax can be used to patch areas if necessary. The thickness of the wax can be judged by holding it up to a light source—thin areas will appear almost white.

Modeling and melting wax

Wax can be modeled using heated carving tools, which can be used to quickly remove material, or if a heated blade is passed between two surfaces the wax will fuse when both parts are molten. This technique can be used to repair breaks or to join sections together. Use an alcohol lamp to heat tools as it has a clean flame.

Wax carving for a button
by Paul Wells
This intricate wax carving was enhanced with the careful use of a flame to gloss the raised areas of the surface.

CARVING A RING IN WAX

TECHNIQUE FILE

The use of jeweler's wax allows detailed three-dimensional forms to be carved relatively quickly. A section cut from a wax ring tube is used for this project

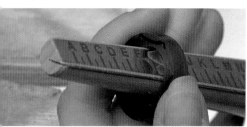

1 Use a wax ring sizer to increase the inside of the ring blank. Gently twist the stick to shave wax away from the inside surface until the ring is the right size. Work from both sides of the ring to allow for the taper on the ring sizer.

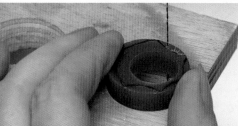

2 Spiral-piercing saw blades may be used to cut away larger areas of wax. If working to a template, leave a little excess to file back down to the line.

3 Large, rasping wax files quickly remove material. Work around the sides of the ring first to define the outline, and then use wax needlefiles to shape the form further.

4 Once the basic form has been achieved, use carving tools to smooth the surface of the wax ring, and to add detail.

5 Use fine wire wool to polish the surface of the ring, removing fine scratches. Take care not to rub away the detail. The wax ring is now ready to be sprued for lost wax casting.

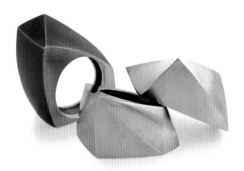

Cast ring series
by Melanie Eddy
These rings were cast from
wax forms, carved into
angular shapes, and internally
hollowed to reduce the weight.

Molten wax can be poured into open or two-part silicone molds, or dripped into cold water to create free-form shapes. Never melt wax over an open flame—it catches fire very easily.

Cleaning up waxes

Before cleaning up the wax, weigh the piece to check how heavy it will be in metal; silver is 10.6 times heavier than wax and 18-karat yellow gold is 16.3 times heavier. As a guide, wax rings should weigh less than one gram, otherwise the finished ring will be uncomfortably heavy to wear. Internal areas of a piece can be hollowed out to reduce the weight using burrs or carving tools—regularly hold the piece up to the light to check that the wax is not getting too thin.

The surface qualities of the wax model are very important, as they will transfer directly into the metal form, and it is far quicker to refine a wax surface than a metal one. Rougher grades of wire wool can be used to remove file marks and round off edges, before using a fine grade to polish the form. The wax can be carefully licked with a flame to give it a glossy surface—and then it is ready to be cast.

Molds can be made from objects so that multiple replicas of the object can be produced. Rubber is commonly used for this process; the type of rubber used will affect the properties of the mold and the materials that can be cast into it.

MOLD MAKING

Rubber is the material most commonly used for making molds, and the variety of the compounds, whether latex, silicone, or polyurethane, are suitable for making a range of different molds. Pourable rubbers can be used to make molds of three-dimensional objects that can be reused, or if a thickening agent is added, they can be used to coat objects to make a skin that can be used as a mold. Silicone also comes in putty form, which can be modeled and have objects impressed into it. Latex, plaster, and alginate are also useful mold-making materials; they are all inexpensive but the molds have a very limited lifespan. Vulcanized rubber is used to make durable high-quality molds for wax-injection in order to create multiple waxes for lost wax casting.

"Open" molds are made from flat-backed objects, and the rubber is pushed or poured over the form. Once cured, the object is removed to reveal an open void that can be cast into.

Three-dimensional objects require more complex molds, which are carefully cut to allow the original object and subsequent casts to be removed.

Vulcanized molds

When rubber is heated in the presence of sulfur its structure changes, becoming more durable. Specially manufactured sheet rubber is used to make vulcanized molds, which can be used many times, and are used in lost wax casting to produce multiple wax models from a metal model. Due

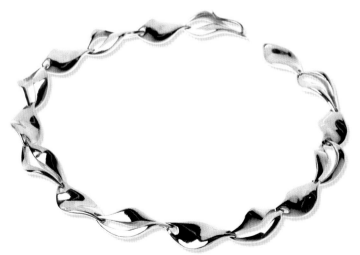

Gold digger's necklace
by Emily Richardson
The identical links of this
necklace were created using
a mold to replicate the
component parts.

MAKING A VULCANIZED RUBBER MOLD

Vulcanized rubber molds are used to make multiple waxes of a single design. These molds are durable, but can only be used to take molds from metal masters because of the heat and pressure involved in the process.

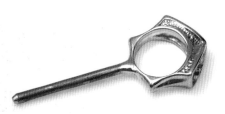

1 Once the cast "master" has been cleaned up and polished, it needs to have a sprue soldered on, which will form the channel for the injected wax to enter. The sprue is usually 9-gauge (3-mm) base metal rod, and is soldered using easy solder.

2 Mark and cut out pieces of vulcanizing rubber. The number of sheets will depend on the depth of the mold. Lay the first piece of rubber in the frame and peel off the backing to stick the second layer on. Any dirt or dust can be removed from the rubber using lighter fluid applied with a soft cloth.

3 Continue joining layers of rubber until the height reaches the level of the piece at the center of the frame. Cut the next rubber sheet to fit around the piece, and pack any gaps with scrap rubber. Add more layers until the rubber sits just proud of the top of the frame.

4 Place a steel sheet either side of the mold to stop it from sticking to the heat plates, and insert the mold into the preheated vulcanizer. Clamp the plates tightly. The amount of time required to cure the rubber depends on the number of layers, but is usually between 30 and 50 minutes. Tighten the plates again after ten minutes.

to the heat and pressure used to vulcanize the rubber, only metal objects (masters) are suitable for this process. Once the mold has been cut, and the master removed, hot wax is injected into the mold under pressure to fill the void left by the master; a very high degree of detail is possible with this type of mold.

For complex objects or forms, it may be worth having a mold made professionally, especially if many multiples are required (see Outwork: lost wax casting, page 260).

Cold-cure molds

Since no heat is involved in the process of making silicone molds, a range of materials can be used as masters, including those that would be damaged by the heat and pressure involved in vulcanizing. Soft, flexible silicones are suitable for making molds from objects with undercuts,

as the mold can be manipulated to release the cast form once it has set. Objects with porous surfaces should be sealed with varnish before adding a modeling clay sprue to make a pouring channel in the mold. Seal the base of the sprue in a suitably sized container, or construct a box from folded foamboard. The box must be well sealed with wax to prevent leaks and should have a ⅜ in (1 cm) border around the object.

Once the silicone has been mixed with the catalyst, it can be degassed with a vacuum pump to remove the air from the mixture. This is not critical, but it does lessen the chances of air bubbles sticking to the object inside the mold and will give better results. When the mold has cured, it can be carefully cut to release the object—do not cut right through the mold, or it will be difficult to register the two halves and make an accurate cast. The container or frame

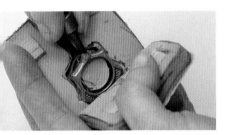

5 Remove the frame from the vulcanizer and allow it cool before taking out the rubber mold. Use a scalpel or craft knife to cut the mold—separate the halves only enough to remove the master from the mold and do not cut right through.

the silicone was cast into can be reused to hold the mold together when resin or wax replicas are cast in it.

Impression molds

Simple open molds can be created by pushing an object into a medium such as silicone putty. This type of silicone is usually mixed in equal parts with the hardener, and has a very short cure time of about ten minutes. The impressed object should have no undercuts so that it can be easily removed from the mold. Resin, wax, and metal clay can be cast in impression molds; the resulting form will have a flat back due to the open mold.

MAKING A COLD-CURE MOLD

 TECHNIQUE FILE

Silicone cures at room temperature when mixed with a catalyst, and so is ideal for making molds of nonmetallic or fragile objects. Soft, flexible silicone is used for this mold of a poppy seedpod.

1 Attach a sprue to your object—wax will work well, but you could also use modeling clay if the object is not too heavy. Seal the base of the sprue into the bottom of a suitably sized container.

2 Place a clean plastic container on electronic scales, and pour in enough silicone to fill the mold container. Add the catalyst, working out the percentage from the weight of the silicone. Mix thoroughly. If possible, use a vacuum pump to remove air bubbles from the mixture.

3 Use a plastic spoon to pour the silicone down one side of the mold, allowing it to rise up around the object; this lessens the chances of air being trapped. Continue filling the mold until the object is covered. Leave to cure for 24 hours.

4 Release the silicone from the container and remove the modeling clay sprue. The mold can then be cut with a scalpel to remove the object. When tightly resealed with tape, the silicone mold can be used to make replicas of the object in wax, plaster, or resin.

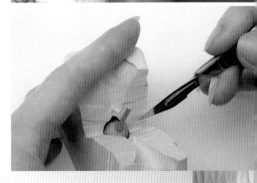

There are several techniques used to cast metal, these include cuttlefish casting, and sand or clay casting. These methods don't require much specialist equipment and are quick and easy methods for reproducing pieces in precious metals.

CASTING METAL

Lost wax investment casting requires too much specialist equipment for the small-scale jeweler to affordably do in the workshop; in reality most makers will take waxes to a professional caster as the results will be far superior and much more complex forms can be reproduced (see Outwork: casting, page 260).

In addition to the mold-making materials required for clay and cuttlefish casting, a crucible and handle for melting metal, a large gas torch, borax powder, and good ventilation are needed. These casting techniques rely on gravity to pull the heavy molten metal down into the recess of the mold, so no specialist equipment is necessary. For cuttlefish casting, a knife, scribe, binding wire, matches, and an object to impress into the mold are also needed. Clay casting requires a two-part cast aluminum frame to contain the clay so that it can be compacted, allowing accurate detail to be reproduced. The frames are available in several sizes. Talcum powder, a knife, thin rod, and a steel rule will also be required.

Selecting an object to cast

Clay and cuttlefish casting molds can easily be impressed with objects that will then be reproduced in metal. The object must have no undercuts, otherwise it cannot be removed from the mold without damaging the impression. Simple three-dimensional forms and flat-backed objects are most suitable for casting by these methods and models can be made from a range of materials, including cut and carved acrylic.

Finished castings, once cleaned up, have a range of applications as they can be soldered to other elements, cut, drilled, and lightly formed. Thin sections of cast metal can be brittle, so choose forms where this will not be an issue, and anneal the form before attempting to form it.

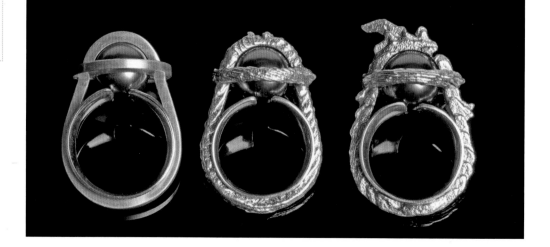

Sextant ring series

by Pamela Deans-Dundas A cuttlefish casting of the left-hand ring was used for the central ring, and for the ring on the right.

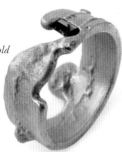

Free-form ring
by Kelvin Birk
The sapphire in this 18k gold ring was embedded in the compacted sand mold before the molten metal was poured in.

Cuttlefish casting

Cuttlefish bones are soft and fragile, yet heat-resistant: on contact with molten metal, the surface will char, but not change in shape. The size of object that can be cast will be determined by the size of cuttlefish bone that is used. One cuttlefish may be cut in two, or a pair can be sanded to flatten the surfaces if a greater width is required. The object is pushed halfway into one flat face, together with three or four short lengths of matchstick to act as locating pegs, and then the other side is gently pushed on until it meets the first. The pieces are then separated so that the model can be removed. Air vents should be cut in one side of the mold with a sharp knife, and do not need to be more than ¹⁄₃₂ in (1 mm) deep; a funnel-shaped pouring channel must also be cut at this stage. Reassemble the mold, securing the two pieces together with binding wire. The locating pegs will ensure accurate repositioning of the two halves of the mold, which is important, as misaligned molds will give incomplete castings or large flashes, where the metal bleeds between the two halves. The cuttlefish is now ready for casting.

Sand casting

This type of casting uses clay or sand compacted in a frame to create a one-use mold into which molten metal can be poured. An object or model with no undercuts is used to make an impression in the clay, and more clay is packed on top of the model before a channel is cut through one half of the mold. The accurate cutting of a pouring channel and air vents is crucial. The channel must allow easy access of the molten metal into the form and as it floods in, the air it is replacing can escape through the vents. The small holes

CUTTLEFISH CASTING

A simple two-part mold made from cuttlefish bone can be used to create castings with a unique texture. The cuttlefish can be carved, but impressions made from objects will work equally well.

1 Flatten the surfaces of two pieces of cuttlefish bone by rubbing them on rough emery paper and push the model halfway into one cuttlefish surface. Push three locating pegs around the model—short lengths of matchstick work well.

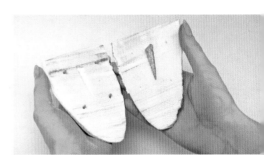

2 Ease the pieces of cuttlefish together until they meet. Separate the pieces and remove the model. Cut a pouring channel for the molten metal with a knife, and make air vents from the impression to the outer edge by dragging a scriber across the surface.

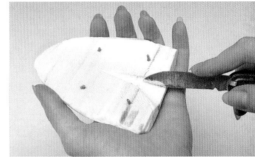

3 Rejoin the pieces of cuttlefish, using the pegs. Secure the mold with binding wire and stand it beside the heating area. Heat the metal with some borax in a crucible. When the metal is molten, pour it down the pouring channel and then wait a few seconds before quenching the cuttlefish in cold water.

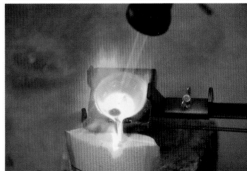

4 Separate the two pieces of cuttlefish and remove the casting. Cut away the excess metal from the pouring channel with a piercing saw and file the area smooth, staying sympathetic to the form. Emery and polish the piece to finish it.

SAND CASTING

Specially prepared sand or clay can be used to make an impression mold of an object; when molten metal is poured in, a copy of the form is produced. A two-part aluminum frame is required for this technique.

1 Prepare the clay by chopping it, to break up any lumps. Pack the clay into the half of the frame with a lip, and hammer the surface to compact it; add more clay and level the top using a steel ruler. Push the object into the clay and dust the whole surface with talcum powder.

2 Place the top half of the frame in position, fill it with clay, and compact it. Separate the two parts of the frame and carefully remove the object. Use a knife to cut the pouring channel and a thin rod to poke holes for air vents. The air vents must not cross the channel.

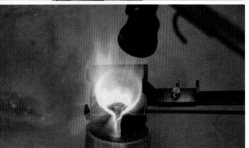

3 Ensure no loose clay is present in the mold, as it could end up in the molten metal. Heat the metal with a pinch of borax powder in a crucible. Keep the torch on the metal as it is poured into the frame.

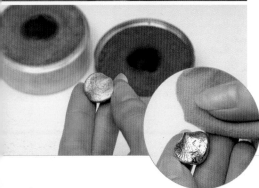

4 Quench the frame in cold water before splitting it to remove the casting. Pickle the casting to remove the oxides and then cut off any excess metal from the form and clean it up.

pushed through the clay to form vents must not intersect the pouring channel, otherwise cooled metal (which exits them) and clay particles may end up in the casting. The clay can be reused—throw away the charred material, and chop up the clay before packing a new mold.

Heating the metal

Calculating the correct amount of metal that will be needed for a casting is important—too much metal is dangerous as it will spill out when being poured, but not enough will give an incomplete casting. The amount can be worked out easily if the specific gravity of the object used to make the impression is known—sterling silver is about 10.3 times the density of wax and plastic; or the volume of metal can be calculated through water displacement in a narrow vessel. An extra 2–5 grams, depending on the size of the form, should be added to ensure that the whole form is cast.

Clean scrap can be cut into smaller pieces so that it takes less time to heat, and melted in a crucible with a small amount of borax powder. Commercial casting grains are not suitable for sand or cuttlefish casting due to the additives they contain. The metal should be brought up to melting point as quickly as possible, and when completely molten will form a single spheroid mass; the torch must be kept on the metal even as it is being poured into the mold, otherwise it cools rapidly. The cast form will be a bit smaller than the original model because the metal contracts as it cools—this will be more obvious on larger forms where there is a greater volume of metal.

Cleaning up castings

Once quenched, castings must be pickled to remove any oxides or borax residue before they can be cleaned up. Cut off the residual metal from the form with a piercing saw. Files can then be used to refine areas of the form and remove rough patches. Use emery paper or flexshaft motor attachments such as split pins or silicone points to prepare the piece for polishing.

This material consists of silver particles held with an organic binder, and can be used in a similar way to ceramic clays. When the clay is fired, the binder burns away, leaving a solid silver form. Fired pieces can be cut, filed, soldered, and polished.

PRECIOUS METAL CLAY

It is important to have a clean working area when using metal clay, as contaminants may affect the outcome. Tools that can be used with the clay include metal or silicone molds, cutters, and templates. Metal clay can also be formed around plastic formers, or modeled with carving tools.

Several different forms of clay are available in fine silver—paste and paint varieties can be applied to modeled clay pieces, or used to coat natural forms such as leaves, which will burn out during the firing process. Fine gold paint can be used to add accents to designs.

Modeling metal clay
Metal clay is a soft and pliable medium and can be pressed into molds to give it texture or form,

or impressed textures may be applied directly to the clay form. Prevent the clay from sticking to fingers and surfaces with a little olive oil. If the clay begins to dry out while it is being worked, add some water to the surface and smooth over any cracks—this method can also be used to join elements. When not being worked, cover the piece with polythene to keep it from drying out; the clay should be allowed to dry

Leaf pendant
by Victoria Dicks
A real leaf was coated in precious clay paste. Once fired, a bail to hang the piece was soldered on.

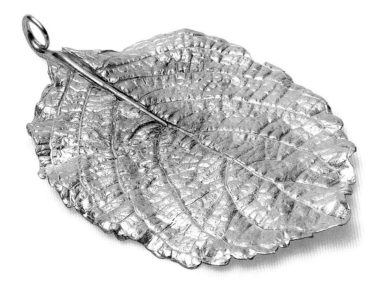

MODELING PRECIOUS METAL CLAY

One way of using "PMC" is to press the clay into a mold and then refine the form once it is dry. Follow the manufacturer's firing instructions for the best results.

TECHNIQUE FILE 49

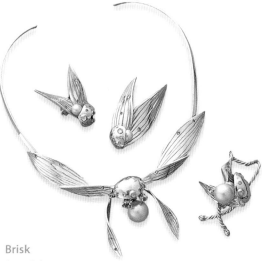

Brisk
by Yoshiko Saito
The flower and leaf shapes used in this set of jewelry are modeled from metal clay supported with stainless steel net. Veins are carved into the surface of the leaves.

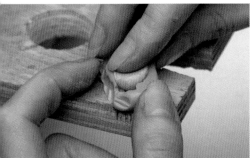

1 This mold is made from a fast-setting silicone paste that is mixed in equal parts and does not need to be vacuumed after mixing. Press an appropriate amount of precious metal clay into the mold, and allow it to dry.

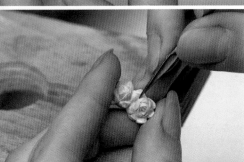

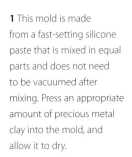

2 Once the clay is dry, it can be removed from the mold. The form should be cleaned up with files and emery at this stage—this will take less time prior to firing. Use carving tools to refine and clarify the form, and add further detail if you like.

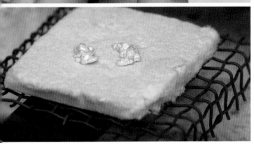

3 Fire the clay in a kiln for the recommended length of time, then allow it to air cool or quench it in water.

4 At this stage, the piece can be filed, drilled, and soldered. Any further refinements should be made before barrel polishing, which will help to work-harden the fine silver and make the surface finish more durable.

completely before it can be fired. The clay form will shrink slightly during the firing process, so rings especially should be made larger than required to compensate for this.

Carving detail in clay

Once dry, further detail can be added to the metal clay form, using carving tools, files, and burrs. The clay is still relatively soft at this stage and can be worked quite easily. Emery paper and wire wool can be used to refine the surface of the piece further.

The clay is fired in a kiln at the recommended temperature for the particular type of clay; firing times vary, too. The piece can be quenched once it has been fired, and barrel polished to work-harden the surface of the fine silver form.

Including objects in clay forms

Gemstones and glass can be incorporated into clay forms before the clay is dried—this allows for experimental ways of "stone setting" that are not possible when working with metal. Laboratory-grown gemstones, which are heat-resistant, as well as cubic zirconia, garnets, diamonds, rubies, and sapphires can all be used safely—but do not quench after firing, allow the piece to air-cool slowly in a draft-free place.

There is a range of materials suitable for use in jewelry making that require casting in a mold. Materials can either be cast into a block from which a form is carved, or cast into a shaped mold that produces a piece with the exact shape required.

CASTING RESIN, HAC, AND PLASTER

Most casting materials are suitable for use with most types of molds. The main limitations arise when removing objects from the molds, with undercuts or rigid molds being problematic.

Molds can be constructed from silicone, modeling clay, and plaster. Store-bought molds or polypropylene containers can also be used.

All of the materials discussed in this section rely on a chemical reaction to cure them, but the process for each material will be different and successful results depend on accurate measuring and mixing, as well as other factors such as temperature—for example, resin will cure much more slowly on a cold day than on a hot one.

When working with a new material, it is always a good idea to do a couple of tests before working on the final piece—become familiar with the processes needed for a successful result, and test the material to find out what its limitations are.

The use of cast materials in jewelry

Cast forms require much less shaping and cleaning up than fabricated or carved ones, as the shape of the mold will determine the form of the piece. The casting process has a number of benefits—because less shaping needs to be done, there will less dust created when working these materials; forms which would take many hours to carve individually can be made quickly and in multiples; and in some cases it will be possible to make hollow forms, which reduces the amount of material used as well as the weight of the final article. Complicated forms with large undercuts will be more difficult to successfully achieve than simple ones, and very thin areas should be avoided wherever possible as many of the materials used for making cast objects are relatively soft and brittle.

A snowy street
by Karin Kato
This cast resin brooch combines
dyes and sand to create a subtle
color and texture combination.

CASTING A RESIN FORM

Polyester resin can be cast into a variety of molds—most hard plastics will give good results, and modeling clay can be used to make single-use impression molds.

 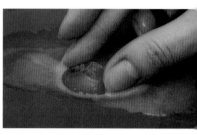

1 Prepare the mold you will be casting into—a small shell was pushed into modeling clay to make an impression for this demonstration. Pour a suitable amount of resin into a measuring cup.

2 Add 2 percent by volume of catalyst to the resin with a pipette and stir the mixture with a plastic spoon. Stir slowly, to prevent air bubbles from forming.

3 Use the plastic spoon to fill the mold with resin. For larger molds, more than one layer may be required to prevent excessive shrinkage. Drag out any air bubbles with a pin, and leave the resin to cure for 24 hours.

4 Remove the resin from the mold and scrub away any remaining modeling clay. Soak the piece in warm, soapy water for about ten minutes, until the top surface becomes cloudy. Use wet-and-dry paper with water to remove the sticky surface residue and clean up the form, starting with 320 and working up through the grades to 1200.

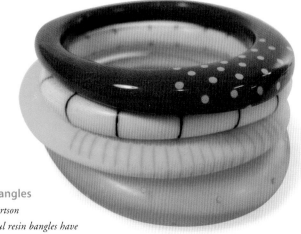

Wangle bangles
by Kaz Robertson
These colorful resin bangles have a magnet cast inside so that they can be stuck together; the resin was cast in a mold.

When deciding which materials to use for a piece, consider the material's properties, how appropriate it is for the piece that will be made and, if it is a component rather than a complete form, how it will be attached within the piece.

Casting polyester resin

Polyester resin is hardened by the addition of MEKP catalyst (liquid hardener). For casting small amounts of resin, the amount of catalyst required is usually 2 percent, but this may vary between different types of resins and larger amounts of resin will require less catalyst. Once the catalyst has been stirred through the resin, the mixture has a "pot life" (the working time available before curing starts to thicken the mixture) of about 15 minutes, depending on the ambient temperature.

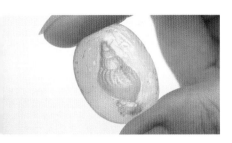

5 Polish the piece with Vonax on a polishing motor, or buff with a liquid polish. Polishing the piece will restore its transparent qualities.

Resin can be cast into molds made from polypropylene, silicone, plaster, or modeling clay, or poured directly into metal frames, which should be backed with greased acrylic or Melinex foil. Metal frames can be sealed to the base with modeling clay, to prevent leakage.

Resin forms more than ⅝ in (12 mm) deep must be built up in several layers to minimize shrinkage and prevent internal cracking. Subsequent layers can be applied as soon as the previous layer has turned to "gel."

Once cured, the piece can be removed from the mold—the top surface will remain tacky if it was exposed to air, and must be removed with wet-and-dry paper. A tack-free finish can be produced by mixing in up to 2 percent of a wax-in-styrene additive; this will also help certain

CASTING HAC

TECHNIQUE FILE

When cast into a mold, HAC produces a hard durable material that will take on the texture and surface qualities of the mold it is cast into.

1 Wearing gloves, mix one part HAC with three parts sand or other fine aggregate.

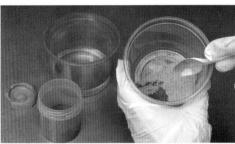

2 Add water to the mix until a firm but moist paste is formed.

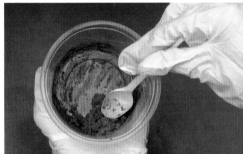

3 Press the HAC mixture into a prepared mold—an impression mold made from silicone putty is used here. Wrap the mold in a damp cloth and leave the piece to cure overnight.

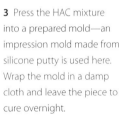

4 Remove the cast from the mold, and brush off any loose material in a well-ventilated area.

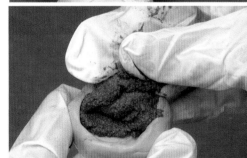

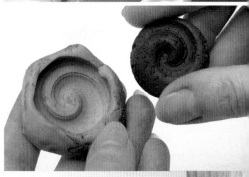

CASTING PLASTER

Dental plaster produces a hard material when cast, and is ideal for model making where a high degree of carved detail is required. This step-by-step shows how to cast a plaster "blank" for carving.

1 Place some water in a bowl—the amount of water is determined by the size of the cast being made. Begin to sprinkle plaster onto the surface of the water, breaking up any large lumps with the fingers.

2 Continue adding plaster to the water until it becomes visible on the surface and forms protruding peaks.

3 The reaction that causes the plaster to set does not start until it is mixed with the water—mix slowly and thoroughly, taking care to dissipate any lumps of powder still remaining in the solution.

4 Pour the plaster mixture into the container in which it will be cast, and tap the container to release any air bubbles. The plaster cast can be removed from the container as soon as it is set, and can be carved before it is completely dry—material can be removed more quickly but less accurately than on dry plaster.

types of resin to cure in silicone molds, where the silicone prevents the surface of the resin from curing properly.

Plaster forms for model making

Plaster is a very useful substance for making models and molds in jewelry. Fine dental plaster will take a very high degree of detail and can be intricately carved. Plaster casts of low-relief designs with no undercuts can be taken from carved plaster blanks. The surface of the carved piece must be sealed with soft soap to make it waterproof before a wall is constructed around it so that a further layer of plaster can be added. Once set, the two plaster pieces can be pried apart. This technique allows designs to be accurately worked in negative as well as positive, giving greater accuracy especially when lettering is carved; this process is used in the production of art medals.

If there are holes or air bubbles in the surface of the plaster, it must be soaked in water before a paste of plaster and water is used to fill the holes, otherwise it will just draw the water out of the applied mixture. The finished plaster model can be sealed with watered-down PVA adhesive, before a mold is taken from it.

Cement

Fine cement, known as "high-alumina cement" (HAC), is ideal for jewelry making—it is very fine and casts hard dense forms that are suitable for a number of applications, and is available in white or dark gray. The cement can be combined with inclusions such as gemstones or dyes, and because it must be mixed with a fine aggregate such as sand, this can also be used to vary the color and texture of the outcome.

The mold will determine the surface qualities of the casting—shiny molds will give a shiny surface, silicone molds can be used for textured surfaces, and plaster molds will leave a white bloom on the surface of the finished piece.

Natural materials such as wood, horn, and bone are easy to carve, and can be used for larger forms because they are comparatively lightweight. A number of processes can be used to carve these materials; all will take a high degree of detail.

CARVING NATURAL MATERIALS

The material properties of wood, shell, horn, and bone allow the exploration of three-dimensional form, but they are all limited to some extent by their structure. It is important to take into account the grain of the material being used; integral strength is best maintained by working along the grain of the material. Interesting visual effects are often present on cut end-grain, but the structure of the material is likely to be weaker and pieces may need to be backed with metal.

Many plastics can be worked in the same way, and some are manufactured to imitate ivory, horn, and shell so it is relevant to mention them here. The same precautions should be taken against the dust created when filing or cleaning up, but one big advantage is that plastics do not have a grain and are not as prone to splitting as their natural counterparts.

Tools for carving

As these materials are relatively soft, a wide range of tools can be used to shape them. Chisels can be used for carving, especially wood. Burrs, cut-0 files, and gravers can be used to shape and add detail.

MMA ring
by Fabrizio Tridenti
This organic ring was carved from a single piece of buffalo horn, and the raised areas were polished.

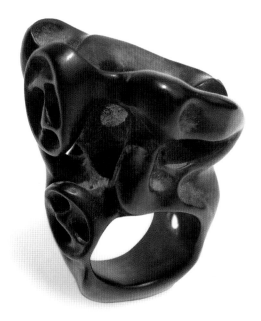

CARVING NATURAL MATERIALS

Most natural materials can be carved using the techniques described here. This step-by-step shows how to carve a hairpin from pressed buffalo horn.

1 Mark the outline on the horn, ensuring that there are no structural faults or flaws in the material that could weaken the hairpin. A 5 in (12 cm) length should be sufficient. Use a spiral blade in a jewelry saw to cut around the outline, then file the form to a taper at one end using a cut-0 file. Do not make the taper too thin.

2 Carve the design for the head of the hairpin using a hand file; any concave surfaces can be created using a burr in a flexshaft motor. Wear goggles and a dust mask and clean away the resulting dust with a vacuum cleaner and then a damp cloth.

3 Clean up all file and burr marks with wet-and-dry paper used with water, starting with a rough grade such as 400, and working through the grades to 1200. Ensure that the end of the pin is smoothly rounded.

4 Buff the piece using Vonax with a polishing wheel, or a cream or liquid polish applied on soft leather—the horn will soon begin to shine.

Natural materials in jewelry

Natural materials are often combined with metal components, or set onto or into metal structures. The metal elements may be purely decorative, or form the fittings that allow the piece to be attached to the body. Cold-joining techniques such as riveting, prong- or bezel-setting, screw threads, and adhesive are necessary when combining different materials.

Carving to a design

Unless pinning or riveting is used to join elements of natural materials, a piece of material larger than the final piece should be used to start working with. If carving to a design, a similar method can be used to that described for wax carving (page 155). Sometimes a particular piece of material will suggest the way in which it should be carved, in the pattern of the grain, changes in color, or the form of the piece. The most successful carved forms do not give away the shape of the piece from which they were cut, and carving lends itself to fluid, organic forms. Burrs can be used to quickly carve large areas from these soft materials, but the cutting action of larger burrs can be quite aggressive, so use those with a diameter of less than in $\frac{1}{16}$ in (3 mm).

Do not make any areas too thin as these will be weak points and liable to fracture—metal frames or supports can be used to strengthen areas if necessary.

Wet-and-dry paper used with water is the best method for removing file or burr marks, but where materials such as wood may absorb too much water and should be sanded dry, it is important to wear a dust mask. Vonax is suitable for polishing many of these materials (see page 114).

A range of tools and techniques can be used to carve metal, to give intricate low-relief designs on the surface. Carved metal textures can be used for a finish on a final piece, or as a master to take a mold from for casting.

CARVING METAL

Traditionally, a hammer and chisel are used to carve chips from a metal surface. Chisels for metal are much finer than those used for carving wood, and should be sharpened on an oilstone regularly while you are working. Gravers may also be used to carve metal; they remove less metal than chisels so carving will be more time-consuming, but a greater degree of accuracy can be achieved. Files can also be used to carve metal, and are more appropriate for formed pieces than flat sheet.

When using a chisel, take great care as it may slip and can cause injury. Make sure that you keep your hands behind the blade and cut away from you, not toward you.

Carving on formed pieces

Carvings made on flat sheet may be pierced out and filed to shape, to form the body of a piece or be applied as decoration, and carving can also be carried out on formed pieces. Fabricated forms should be made from thick-gauge wire or sheet, which is sturdy enough to cope with the forces involved in carving.

Carved silver brooch

By Anastasia Young
The design on this silver brooch was carved using both a ball burr on a flexshaft motor and a chisel (see page 172).

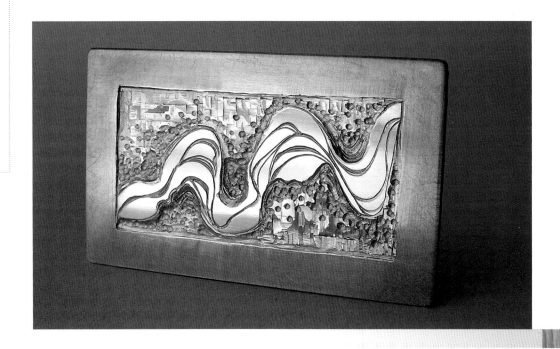

CARVING A DESIGN IN METAL

Use thick silver sheet—16 gauge (1.2 mm) is ideal. Drill holes in the corner of the sheet, and use small nails to secure it to a piece of wood—this will make it much easier to hold while carving.

TECHNIQUE FILE 54

1 Rub modeling clay over the back of a design on paper. Trace over the paper onto the metal—then trace over the modeling clay lines with a scribe so that they are not rubbed away.

2 Large areas of silver can be quickly recessed by using a ball burr in a flexshaft motor. Regularly add lubricant to the burr so that it cuts efficiently.

3 A well-sharpened chisel, tapped with a hammer, can also be used to carve silver. Tap the chisel into the metal almost vertically, before adjusting the angle to about 20 degrees to avoid removing too much metal at once.

4 Once the basic design has been defined, use engraving tools to refine lines and add further detail and shaping to the carving.

Chip-carving sheet metal

The gauge of the sheet used will depend on the depth of the carving that will be done—it should not be less than 18 gauge (1 mm), and thicker if deep carving is intended. The metal must be fixed to a block of wood so that it can be clamped in a vise—this can be done with nails, pitch, or setter's wax.

To make a cut, place the tip of the chisel against the metal with the handle almost vertical and tap lightly with a small hammer. This starts off the cut and the angle of the chisel can now be lowered—repeated tapping with the hammer should shave off a sliver of metal that can be flicked out with the chisel when required. It takes practice to get a feel for the way in which the chisel cuts the metal, how much force to apply with the hammer, the angle of the chisel, and how the angle of entry affects the depth of cut. Regularly apply lubricant to the metal to help the chisel cut efficiently, and check that the chisel is sharp. Different shapes of chisel can be used to make cuts with different profiles, and polished chisels will give a polished cut and create a reflective texture.

Once the basic design has been cut with chisels, gravers can be used to tidy up edges or add further detail to the carving, see Engraving, page 203.

Finishing carved pieces

Carved pieces can be polished, but care should be taken not to wear down the surface texture. Carefully check the piece for burrs or sharp edges and remove them, before giving the piece a light buffing on the polishing motor using a swansdown wheel and fine rouge polishing compound.

MECHANISMS

This section is a detailed guide to moving parts and mechanisms, from simple earring hooks and chain-making processes to complex forms such as barrel catches and hinges, encouraging the jeweler to explore the possibilities of integrally designed mechanisms, utilizing handmade elements wherever appropriate. In order for jewelry to fit on the body, fasten around it, and move, it is often necessary to incorporate moving parts such as hooks, catches, and chains so that movement of the body is not inhibited or impaired. Some mechanisms require very accurate construction so that they function correctly, but for others accuracy is less important so long as a few basic rules are adhered to. The scope for personal design input is endless, even in this small area, and should be encouraged—for example, a signature clasp can help define and brand a piece of work, making it instantly recognizable.

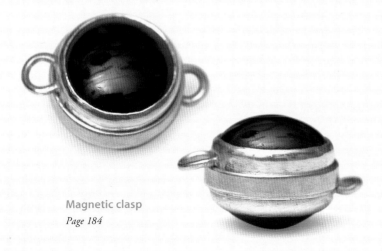

Magnetic clasp
Page 184

Earring hooks and studs, brooch pins, and cufflink backs are all examples of findings. While it is possible to buy a wide range of findings, those that have been specifically designed and made for purpose will add intrinsic aesthetic value to a piece.

FINDINGS

Findings are used to attach jewelry to the body or clothing and need to be strong, so the choice of metal used for components is important.

Silver or gold should be used for parts that will be worn in piercings, as base metals can cause a skin reaction. However, silver and higher-karat golds may be too soft for some functioning parts such as the pinstems of brooches and springs. Pin wire is made from a special alloy of gold that does not get soft when annealed, and white gold is a very hard alloy that can be used when rigidity and strength are required of a component part. Often, hallmarking regulations do allow for small working parts of base metals such as steel in mechanisms.

The fabrication of the mechanisms described in this section uses many of the techniques covered in earlier chapters, such as soldering, riveting, and cleaning up. Accurate working will be necessary to ensure all the parts function as intended, and are easy for the wearer to use.

Manufactured findings

A wide range of manufactured findings is available, but they often appear incongruous when combined with handmade jewelry. There are certain findings though, such as earring scrolls, which are not economical or practicable for jewelers to make and these are usually bought. Manufactured findings are a useful reference—they can be used to check sizes of elements in relation to function, and also use a wide range of moving mechanisms that may be studied and adapted to suit your own designs.

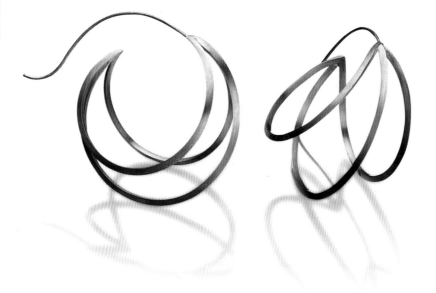

Wave earrings
by Laura Jayne Strand
The hooks on this pair of
silver earrings accentuate
the overall form.

Earring findings

Earrings for pierced ears are usually one of two styles: studs or hooks. A few basic rules apply to each style, which will ensure correct function and comfort for the wearer.

In general, 19- or 20-gauge (0.8 or 0.9 mm diameter) round wire should be used for earring studs and wires; hooks must have enough length so that they will not slip out easily, and posts should be around ⅜ in (1 cm) long. The ends of earring wires must not be sharp or they will be uncomfortable to insert into the piercing—file the cut end flat before rounding off the edges with emery paper and polishing with a leather buffing stick.

All pierced findings should be cleaned and sterilized with a suitable liquid before they are worn. Specialist fluid is available, but surgical spirit (rubbing alcohol) will also work.

Earring hooks and loops

Half-hard or work-hardened wire should be used for making earring hooks and loops because it will be slightly springy, and retain its shape

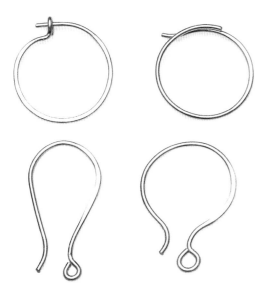

Earring hook variations

There are many different variations on the basic design of the earring hook.

FINDINGS: EARRING HOOKS

You will need two 2½ in (6 cm) lengths of half-hard, 19 gauge (0.9 mm) diameter round silver wire to make these earring wires. To achieve a well-matched pair, perform each step on both wires before moving onto the next stage.

1 File one end of each wire flat, and bend a right angle ⅜ in (1 cm) from this end using flat pliers. To make a loop, roll up the wire starting at the tip and using round-nose pliers. The loop should sit neatly on top of the wire, and not to one side.

2 Cut the two wires so that they are exactly the same length. File the ends flat and use a fine grade of emery paper to round off the edges— this is the end of the hook that will pass through the ear piercing, so it must not be too sharp.

3 Bend each wire around a steel former that is a bit smaller in diameter than the desired curve, ensuring that the open side of the loop is against the former so that it will end up on the inside of the earring.

4 Adjust the shape of the hook with half-round pliers. The curved side of the pliers always goes on the inside of the curve that is being formed. Curve out the very end of the hook so that it can be inserted into the ear more easily.

FINDINGS: HINGED EARRINGS

TECHNIQUE FILE 56

This sample is an adaptation of the basic Creole hoop design. Two pieces of tube are soldered to an open ring form—one side holds the wire and acts as a pivot, and the other side secures the end of the earring wire.

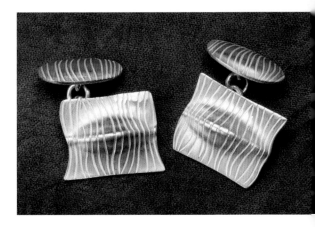

Emergence cufflinks
by Annette Petch
Chasing and repoussé create a decorative surface on the front and back of these cufflinks.

1 A circular form with a diameter of 1 in (2.5 cm) is used for this sample—cut a ⅜ in (10 mm) gap in the top of the form. Clean up the ends of the gap and use a round file to make a curved groove on the top surface of either end. Cut four pieces of tube using a tube-cutting vise.

2 Secure two pieces of tube in position on the earrings with binding wire. It may help to thread a steel rod through the tube. Solder the tube to the main form—as this is the last solder join in the piece easy solder can be used. Pickle and clean up the forms.

3 Ball one end of a piece of half-hard 19 gauge (0.9 mm) wire and clean it up. Thread the wire through the tube on one side of the earring.

4 Bend the wire to shape and cut it to length, so that it locks into the other tube. Ensure that all parts of the earring are well cleaned up, and burnish the wire to work-harden it.

for longer than soft wire. Make the basic form by bending the wire around a former, before adjusting the shape with pliers. Wires will look better if the form is a smooth curve, so start with straight lengths of wire, as any major adjustments will be difficult to rectify. If several pairs of hooks are made at the same time, the ones that are most similar can be paired together.

Earring hooks can be planished at the point up to where they enter the front of the ear piercing; this work-hardens the wire and also creates an attractive change in dimension, giving the piece a more professional finish, as well as making it more functional. Check the center of gravity of a finished hook by balancing it on a round-sectioned former—the angle it hangs at can be adjusted by manipulating the form with pliers.

Hinged earrings use a wire to bridge the gap between the two sides of an earring. The wire must be able to pivot, so making a rivet head or balling one end of the wire will be necessary to hold the wire position in a ring or tube, and allow it to move. The other end of the wire is secured in a catch or tube.

Stud earrings

Stud earrings consist of a post soldered to a form—the post is inserted through the ear piercing

and secured behind the ear with a scroll or butterfly. Different styles include omega fittings, where a hinged wire clips over the post at the back to hold the earring on, and screw-threaded backs.

The solder join between the post and the form will be stronger if the post is inserted into a drilled hole, or the contact area between the base and post is increased in size by soldering a small jump ring at the base of the post.

Soldered pin wires can be work-hardened first by twisting them with parallel pliers, and then rubbing with a burnisher. Barrel polishing the piece when it is finished will also help to work-harden any softened wires.

Cufflinks

Cufflinks are a decorative device used to hold shirt cuffs—they must be easy to insert and stay in position while in use. Cufflinks are either rigid pieces made from a single piece of metal, or have a back that is articulated in some way to aid insertion. At least one end must be able to pass through the buttonhole, but can be applied side-on; lozenge-shaped panels are a commonly used form in cufflinks. The two sides of the cufflink may be the same. To test whether a design is functional, make a model in base metal first and try it out in a cuff.

Swivel-back cufflinks

In this style of cufflink, the base is pivoted so that it can lie in line with the stem and be pushed through a buttonhole. The pivot can be formed with a rivet, or with a linking system such as a half jump ring. The profile of the wire used is often square or rectangular in section to minimize wobble and make insertion easier. Manufactured cufflink backs have a steel mechanism inside that makes them snap open and closed—do not rivet the back in position before soldering is complete or the steel will lose its springiness.

Chain cufflinks

A piece of chain can be used to link the two faces of the cufflink, one of which must be able to pass through the buttonhole. Chain may be handmade or bought and is often made

FINDINGS: SWIVEL CUFFLINK BACKS

This simple mechanism allows the bar of the cufflink back to swivel into alignment with the stem so that it can be pushed through the cuff with ease.

1 Make a length of square wire in the wire rollers of the rolling mill. The finished wire should be 6 gauge (4 mm) so start with a larger gauge of round wire and work down through the slots in the rollers until the correct size is reached. Cut two $^{11}\!/_{16}$ in (18 mm) lengths from the wire.

2 Fold a length of 14-gauge (1.5 mm) round wire in half—at least ¾ in (20 mm) folded. Use parallel pliers to close the folded end, but leave a gap at the top of the fold. Run hard solder between the two sides of the wire to close the gap. Make a second folded wire.

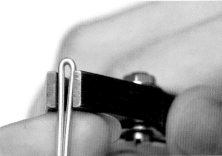

3 Pickle, rinse, and dry the folded wires, then drill a 16-gauge (1.3 mm) hole through the gap left where the wire was folded. Make two 17-gauge (1.2 mm) jump rings, and cut them in half. File and emery the ends of the square wire.

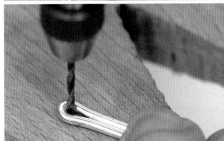

4 Insert a half jump ring through the hole in the folded wire, and use tweezers to balance the pieces on the square wire. Solder the half jump ring to the square wire—the piece should be able to pivot through the drilled hole. Before soldering a cufflink front to the stem, cut its length to ½ in (16 mm) and file the end flat.

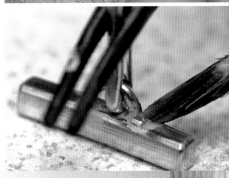

FINDINGS: SIMPLE BROOCH PIN

The simplest form of brooch pin consists of a piece of tube to hold the pinstem, and a hook to secure the end of the pin, with both elements soldered to a flat metal sheet.

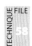

TECHNIQUE FILE 58

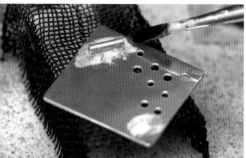

1 Solder a length of cut tube to the base sheet that will form the brooch. Use hard solder, and work on a steel mesh table so that the base sheet can be heated from underneath to prevent the tube from overheating.

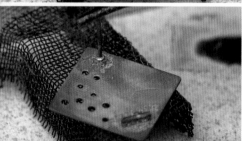

2 Use a piece of 18-gauge (1 mm) silver wire for the catch, and make a tiny jump ring to fit around the base of the wire to give the solder join a greater surface area. Solder with easy solder.

3 Pickle the piece, then remove any excess solder with a file. Cut the silver wire shorter and curl it over to form the catch. Clean up the piece with emery paper and polish if desired. Insert a piece of 21-gauge (0.7 mm) stainless steel wire through the tube.

4 Bend one end of the steel wire so that it is in alignment with the catch, and fold the other end of the wire around and down so that it forces the pinstem up. Cut the ends of the steel wire to length. The pinstem should spring into the catch when the mechanism is closed.

from oval links, and soldered on with half jump rings or suspended from a bar, depending on the design of the faces of the cufflink.

Rigid cufflinks

This style of cufflink is formed from one piece of metal, with wider ends and a thinner section in the middle. The ends must be small enough to push through the cuff, but large enough to stay in position.

Brooch findings

Brooch pins consist of a pivoted pinstem that is sometimes sprung to make it more secure in the catch. These may be formed of separate parts for the hinge and the catch, or both pieces may be located at either end of a bar. Brooch pins can be soldered onto a piece, or riveted to mixed materials where cold-joining is a necessity.

Pinstems should be made from pin wire or hard metals, such as white gold or stainless steel dental wire. The sharpness of the pin depends on the material that it will be passed through; large-gauge pins can only be used with loosely woven fabric and the end is round rather than pointed.

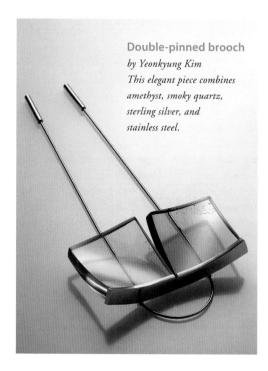

Double-pinned brooch
by Yeonkyung Kim
This elegant piece combines amethyst, smoky quartz, sterling silver, and stainless steel.

The pin should be located so that the brooch hangs correctly, usually above the center of gravity, and the catch should have its opening positioned on the underside when worn, to help keep it from coming undone.

Using a coiled wire for a spring helps to keep the pinstem located in the catch. The long end of the wire coming off the coil forms the pin and the short end, which is angled down, sits against the base of the brooch and forces the pin up.

The fitting of the pinstem is usually the last stage in making a brooch, and it is always done after all the soldering is complete so that the temper of the wire is not affected.

Template for brooch pin (right)

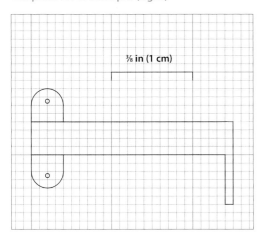

⅜ in (1 cm)

Other forms of brooch pin

Simple brooch pins can be constructed following the basic form of the safety pin—pieces or elements can be suspended from or soldered to the pin. A fibula is an ancient form of brooch, constructed from one piece of metal—the body of the brooch forms the catch at one end and the pinstem at the other. The pinstem is often coiled where it thins from the body of the piece and this gives it spring, making the catch more secure.

Safety chains are often attached to large brooches for extra security in case the main catch comes undone. This is a fine chain with a small wire safety pin at one end, which is fixed independently to the clothing.

FINDINGS: RIVETED BROOCH PIN

The coiled spring of steel wire in this brooch pin must be a snug fit between the two walls it is riveted through. Use 21-gauge (0.7 mm) stainless steel wire coiled on a former the same diameter as the tube rivet.

1 Trace the template onto 21-gauge (0.7 mm) silver sheet and pierce it out. File and emery the edges, and drill one of the marked holes.

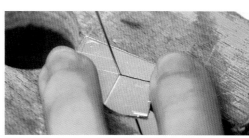

2 Score and then fold up the catch and the walls using parallel pliers. Run hard solder along the folds to strengthen them. Once pickled, use round-nose pliers to bend up the hook for the catch, and drill the second hole through the first so that they line up.

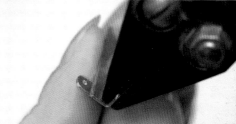

3 Anneal and coil the stainless steel wire—the number of turns must not exceed the width of the walls of the brooch pin. The two ends should have an angle of about 45 degrees between them. Cut one end to ¼ in (7 mm) to form the counter, and the other end so that it is just longer than the hook.

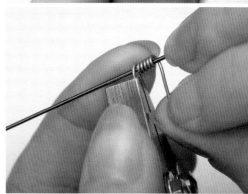

4 Insert a tube through one wall and secure the pinstem in position. Use a burnisher to open both ends of the tube, forming a tube rivet. The short end of the wire rests against the base of the brooch pin and forces the pinstem up, so that it is under tension when secured.

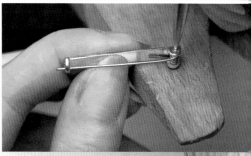

Handmade catches can be designed to complement the form and structure of a piece in a way not possible with store-bought catches. The function of the catch is also important—it should be easy for the wearer to use, and also secure.

CATCHES

Silver and gold are ideal for making many catches, but are too soft for some mechanisms—if an element within the catch will have a lot of use, or is required to withstand great force, then white gold or stainless steel may be more appropriate. Simple catches can be constructed from mixed materials, but more complex mechanisms should be made from metal so that they function accurately.

Choosing a suitable catch

Certain styles of catches are more suitable for some pieces than others, so consider the weight of the piece and the ease of use of the catch. Catches for bracelets may have to be closed with one hand and the clasp must be strong and not come undone through movement or slight force—box catches and barrel snaps are suitable for heavy bracelets and even though they are strong, sometimes a safety catch and chain is also present. Catches should be easy to use.

Catches as features

The style of a catch should be in keeping with the design of the piece it is combined with, whether it is integrally designed to be discreet through its size or resemblance to other parts of the piece, or made as a decorative accent that provides contrast. In general, small catches are used for thin chain in order to be as subtle as possible.

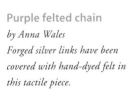

Purple felted chain
by Anna Wales
Forged silver links have been covered with hand-dyed felt in this tactile piece.

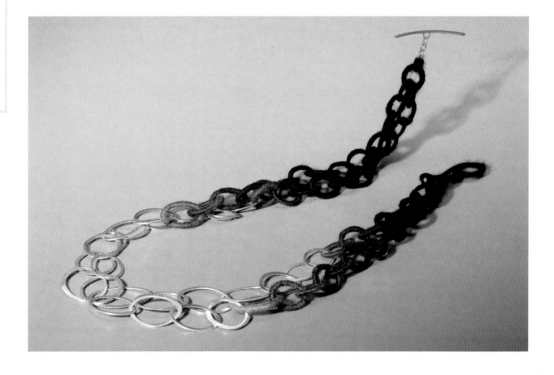



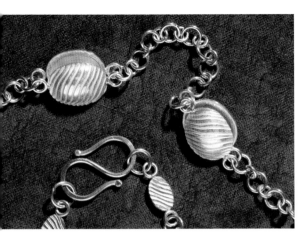

Stripe pod necklace
by Annette Petch
An S-hook forms the catch on this
handmade silver chain.

Catches can be located at either the front or the back of a piece, whether they are simple or outlandishly decorated, and can dictate how a piece is worn. The length of a piece of chain can be adjustable if the catch can locate at several points along it, allowing the length to be altered. The locating points can be made more obvious by increasing the diameter of the wire used. There is no limit to the range of forms that can be used as catches, but the function should not be compromised by the design.

Manufactured catches

Handmade catches can look out of place on bought chain, especially if it is a fine chain. The manufacturing process allows small machine-made catches to be fitted with very small mechanisms. Clasps such as bolt rings and lobster claws are supplied with an unsoldered jump ring attached so that they can be fitted to the ends of chain—do not solder this jump ring closed otherwise the function of the clasp will be affected.

Simple clasps

Simple linking mechanisms can be constructed from wire to make secure catches. An S-shaped form will hold two ends of a chain, and is made more reliable if the ends of the wire intersect with the main form; one end can be soldered closed. The wire should be work-hardened, by

CATCHES: S-HOOK

An S-hook is a simple linking mechanism that is very easy to use, but the two loops must be the same size for the hook to look well made. One end can be soldered closed for greater security.

1 Make a loose coil of 15-gauge (1.5 mm) round silver wire on a former. Annealed wire will be easier to coil.

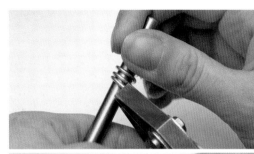

2 Cut the straight portion off one end of the wire, and use small flat-nose pliers to pull up one turn of the coil, so that the cut end is at the base.

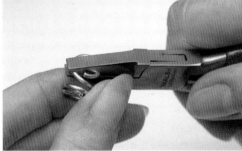

3 Cut the other end of the wire, so that another full turn is left. Bend the piece so that it is flat, and clean up the ends so that they look neat and are not sharp.

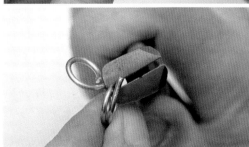

4 The S-hook can be planished to work-harden it. This also spreads the wire slightly and gives the piece an attractive texture.

CATCHES: T-BAR

This mechanism works because of the relational proportions of the elements—the bar must be long enough so that it cannot slip through the ring easily, but the weight of a necklace will also keep the catch closed.

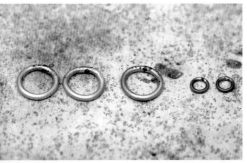

1 Use 14-gauge (1.5 mm) wire to make three ¼ in (7 mm) diameter jump rings, and 18 gauge (1 mm) to make some ⁵⁄₃₂ in (4 mm) diameter jump rings. Close the large jump rings and two of the small ones, and solder them shut with hard solder.

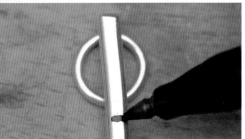
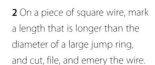

2 On a piece of square wire, mark a length that is longer than the diameter of a large jump ring, and cut, file, and emery the wire.

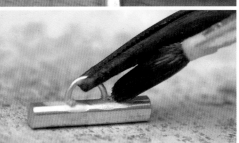

3 Cut a small jump ring in half and hard-solder it to the square wire. Use one small unsoldered jump ring to join two large ones and solder it shut with easy solder—this forms one side of the catch.

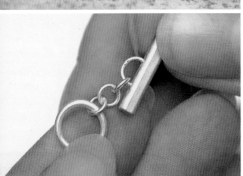

4 Using unsoldered small jump rings to join up the soldered ones, make a short chain to link up the square wire and a large jump ring—the chain must be long enough for the bar to lie in line with the chain so that it can pass through the large jump ring on the other part of the catch.

planishing or barrel polishing, so that it cannot be bent easily. Adaptation of the basic form will lead to different outcomes, but can be used to personalize fittings. Many of the techniques described in other sections of this book can be applied to make simple clasps more interesting or relevant to the piece they are securing.

T-bar catches

The main requirement is that the T-bar is longer than the diameter of the link it slips through, and this holds the clasp shut. This type of clasp functions more successfully on necklaces, as the weight of the necklace prevents the clasp from coming undone; bracelets closed with a T-bar should not be loose around the wrist, or the length of the bar may need to be longer than is usually required.

Sprung catches

Sprung catches can be challenging to make, but the satisfaction of hearing the two parts click shut for the first time makes it worth the trouble! A folded piece of hardened metal forms the "tongue" on one side of the clasp, and is pushed into a slot on the other part. The receiving side has a protruding element that locates in a groove in the tongue when it is fully inserted—the two halves are separated by squeezing the tongue to lessen its height, releasing the groove.

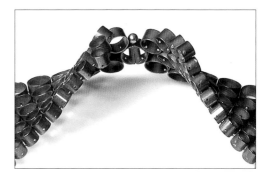

Modular necklace (detail)
by Salima Thakker
The catch for this articulated necklace is entirely in keeping with the design.

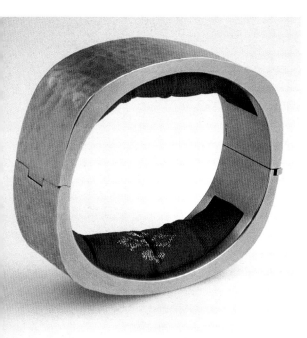

Victoria bangle
by Chus Burés
This 18k-gold bangle has an
internal box catch and the inner
surface is padded with handwoven
and embroidered silk.

These catches are also referred to as box catches or barrel snaps, depending on the shape of the form, and must be made accurately in order to function well. The scale of the catch can be changed so that it complements a piece, but the tongue should not be shorter than ⅜ in (1 cm), otherwise it can break due to the stresses required to open and close the catch. The tongue must not wobble inside the catch or it may come undone; if soldering is performed on the piece of metal that forms the tongue, then it should be done before the metal is folded, and work-hardened so that the fold does not sit completely flush. If a small catch is being made, consider white gold or steel for the tongue, as silver may not be strong or hard enough to cope with the stresses involved.

The design of the outside of the piece can be adapted to be more in keeping with the aesthetic of a piece, and this type of catch is ideal for heavy bracelets or pieces that are dimensionally large.

CATCHES: BARREL SNAP

The tension in the folded tongue of this catch makes it a very robust closing mechanism that cannot easily come undone with movement of the body, making it an ideal clasp for bracelets.

1 Mark the center of a piece of D-shaped wire, and file a shallow V-shaped groove. File a groove on the curved face of the wire, ⅛ in (3 mm) in from one end, using a round needlefile. Use pliers to bend out this top section, which forms the thumb piece.

2 Bend the wire in half, with the flat side on the inside. File a continuation of the groove on the thumb piece on the other side of the wire. Drill a hole above this groove, shape the end of the wire, and attach a jump ring.

3 The other side of the catch is made from tube that has clearance of about ¹⁄₃₂ in (0.8 mm) around the folded D-wire. Solder a cap and jump ring onto one end. Make a jump ring from 18-gauge (1 mm) wire that fits tightly around the D-wire, and solder it to the other end of the tube.

4 When the folded wire tongue is pushed into the tube, the jump ring at the top locates around the filed groove just below the thumb piece, and should make a satisfying click. Adjust the depth of the groove if necessary.

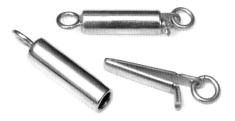

CATCHES: MAGNETIC CLASP

In this catch, the magnetic mechanism is hidden under two bezel-set cabochon stones. Strong magnets and thin silver sheet allow the powerful attraction to keep the two halves together.

TECHNIQUE FILE **63**

1 Make two bezels from 22-gauge (0.6 mm) fine silver sheet. The bezels must fit snugly around the stones and the height must leave enough depth for the magnets to sit underneath.

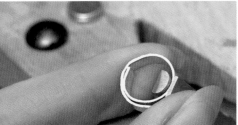

2 Solder the bezels closed, pickle, and then true the forms on a triblet. Rub the bases of the bezels flat before soldering them onto a base sheet of 24-gauge (0.5 mm) silver sheet. Pickle, and pierce out the forms. File and clean up the bezel cups so that the bases are flush with the sides of the bezels.

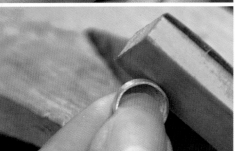

3 Make a collar to fit around the outside of the bezels, and solder it to one bezel cup with a small amount protruding past the base. Solder one half jump ring onto the side of each form, below the level at which the stone will be set but above the edge of the collar.

4 Place the bezel cups in setter's wax to secure them while the stones are set. Place a magnet in the base before positioning the stone on top—make sure the magnets are the right way up, otherwise the clasp will not close. Set the stones (see page 238).

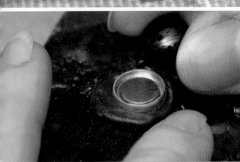

Magnetic clasps

Magnetic clasps are very easy to use as there are no moving parts, and very strong and small magnets are easy to source in a range of shapes and sizes.

When designing, check that the magnets are strong enough to work through the gauge of sheet metal chosen. Magnets pull apart more easily sideways than if pulled directly, so a mechanism or bezel to prevent sideways movement may be required if the magnetic attraction has been diminished because of the method of securing the magnets.

Magnets cannot be glued directly into position and expected to stay in place with the use of adhesive alone—many magnets are so strong that they can pull themselves out of settings if not very securely fitted.

Self-locking catches

Springs can be used within clasps in a number of ways; in this example (see diagram), a push spring is used to hold a piece of tube against the end of a triangular form—the spring allows the tube to be pulled back, but snaps back into position when released, forming a secure, closed circuit. The triangular form ensures that the loops that are caught within the mechanism cannot be accidentally pulled free. This basic design can be adapted in a number of ways, but the basic rules that allow the mechanism to function should be followed.

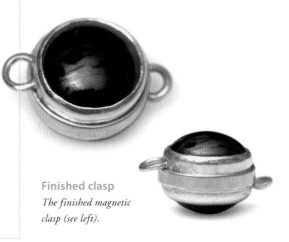

Finished clasp
The finished magnetic clasp (see left).

Cross section of a sprung clasp

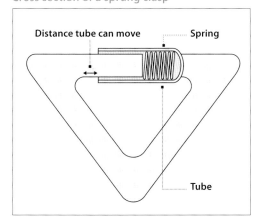

When designing moving mechanisms, construct a base-metal model to check that the mechanism will function as intended. It may be necessary to adjust lengths or proportions to ensure that moving parts work smoothly, and it is not possible to account for the behavior of moving elements when designing on paper.

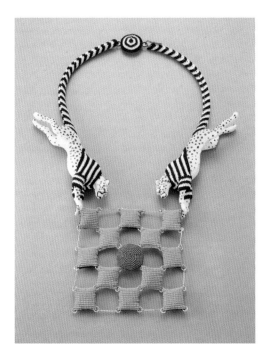

Game of the cheetahs necklace
by Felieke van der Leest
The crocheted catch for this reversible piece echoes elements of the design. Textiles, beads, plastic animals, oxidized silver, and 14k gold were used.

CATCHES: SPRUNG CLASP

This catch uses a simple premise, but requires technical accuracy for it to work well. A tube section slides back to allow the catch to be fastened, but is sprung so that it will always return to close the clasp.

1 Make a roughly triangular form from 8-gauge (3 mm) wire. Use a forging hammer to spread the corners, leaving a small section of the wire round at the center of each side. Tidy up the form with a file and emery sticks, and true the ends—there should be a clear gap.

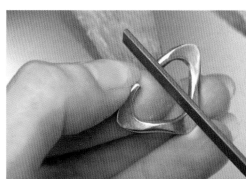

2 Use a ball burr to make a depression in the shorter end of the form—this will help to lock the mechanism shut.

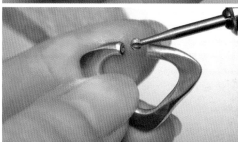

3 Solder a domed cap onto a piece of tube with an 8 gauge (3 mm) inside diameter, and cut the tube to length (see diagram). The tube only needs to slide back about ¹⁄₁₆ in (1.5 mm), but needs to be as long as possible to function properly. Clean up the tube, and insert a steel spring.

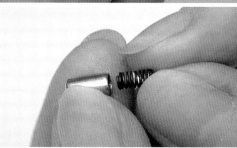

4 Bend out the ends of the triangular form sideways, just enough to slip the tube over the side that was not burred, and then bend the catch back into alignment. The tube section can be slid back to reveal a small gap, and will snap back to close the gap when released.

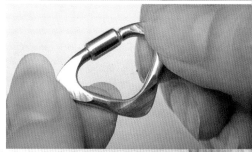

Chain is a structure of component parts that articulate in some way, giving flexibility. Chain is often made from small wire links but many other techniques and materials can be used to create unique structures.

CHAIN

The construction of basic chain requires formers for coiling the wire, a jewelry saw, two pairs of flat- or snipe-nose pliers, and soldering equipment; a bench vise is another useful item of equipment. Making other types of chain may involve using more specialist tools, such as those needed for riveting or stone setting, depending on the forms that are being made.

18-gauge (1 mm) silver wire is a good diameter to start out working with, and it should be coiled around a former that is at least 6 gauge (4 mm) thick so that the rings fit together and can be easily soldered. Many different profiles of wire can be used to create different effects, and may also be combined in the same piece to create visual textures.

Functional and decorative chain

Handmade chain may be designed to be a piece in its own right, or made to specifically complement a piece such as a pendant. Chain for suspending pendants is often understated so that the pendant remains the focal point and does not distract from it, but this does not have to be the case.

In order to be functional, chain should be comfortable to wear and flexible, to accommodate the movement of the body. A chain worn around the wrist may need to be more flexible than one worn around the neck as the degree of movement and curvature required is greater.

The length of the links in a chain will have a bearing on its ability to conform around a curved

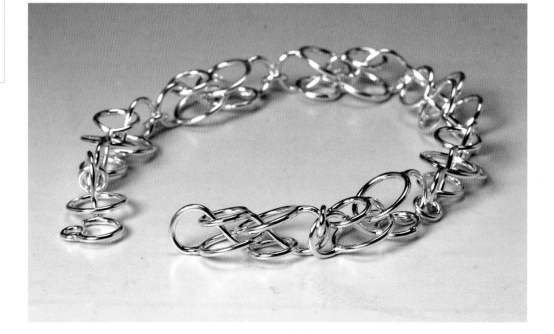

Infinity links bracelet
by Victoria Marie Coleman
Shaped silver wire
components have been
cleverly interlinked to
create this bracelet.

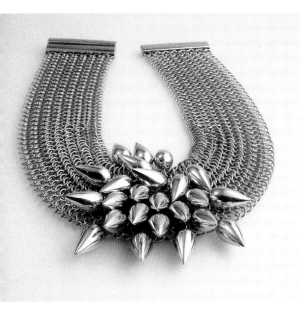

Lotus flower necklace
by Chus Bures
Handmade chain mail and cast
elements were combined to make
this fluid and tactile necklace.

form—long links will make a less fluid chain than small links, but the number of links needed to cover the same distance will be less. It is a good idea to make a model of a small section of chain to determine how many links will be needed for a specific length, and therefore how much metal will be required.

Machine-made chain

Available in a great range of designs and sizes, machine-made chain offers the jeweler wider possibilities than hand-making will allow in terms of scale and uniformity of links. Chain is sold "loose" off the reel by weight, or "finished" —having a catch already attached and cut to a standard length, usually 16 in (40 cm), 18 in (45 cm), or 20 in (50 cm) for necklaces.

Machine-made chain can be cut and soldered in the usual way; the main difficulties arise from very fine chain that can easily be melted, or snake chain that is liable to draw solder along its length, making the chain rigid. Use an insulating heat paste or rouge powder mixed with water to inhibit the flow of solder along the chain when soldering a closure in place.

CHAIN: BASIC LINKS

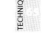
TECHNIQUE FILE

Making simple chain is a rewarding process—but the smaller the rings are, the more you will need to make up the length of the chain. Try varying the shape of the rings, hammer texturing them, or using a different section of wire.

1 Form a coil to make some jump rings (see Bending metal, page 109). Use a jewelry saw to cut down one side of the coil, and close half of the resulting jump rings with two pairs of flat-nose pliers. Hard-solder these rings shut. Pickle and rinse the jump rings before removing any excess solder with a file.

2 Join two soldered jump rings using one unsoldered ring. Make up groups of three rings in this way until all the soldered rings have been used.

3 Solder the joining rings closed with hard solder—position the join at the back of the ring and use only one small pallion of solder per ring.

4 Join up two groups of three jump rings with one unsoldered ring. Once soldered, the groups of seven are then joined together and so on until the chain is complete. Clean up the piece and barrel polish it.

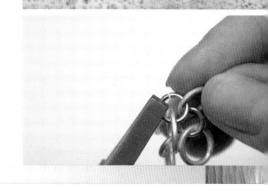

CHAIN MAIL

There are a great number of ways of linking together jump rings to create chain mail. This project demonstrates how to construct a chain mail bracelet.

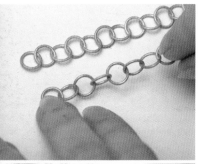

1 Make up three 4 in (10 cm) lengths of chain using 18-gauge (1 mm) diameter silver wire jump rings made on a ¼ in (6 mm) steel former. Solder all the links with hard solder.

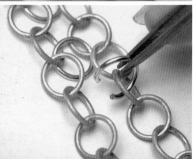

2 Begin to link two lengths of the chain together with cross rings. Secure the chains at one end so that it is easier to keep the links in alignment. Close and solder the jump rings.

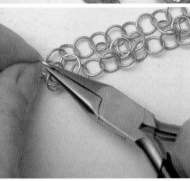

3 Use a jump ring to link the first two cross-links at one end of the piece. If another jump ring is used to link the upper and lower rings either side of the new jump ring, a petal design will be formed. Repeat this design at regular intervals along the chain and solder the rings closed.

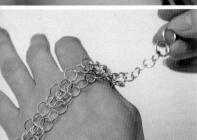

4 Add on enough extra chain to make the piece long enough to fit around the wrist; leaving extra length will make the bracelet adjustable. Barrel polish the piece and add an S-hook to one end of the chain.

Fabricating a simple chain

Round or oval section wires function better than other shapes of wire as linked jump rings, giving smooth, unrestricted movement of the chain. Wrap the wire around a former in a spiral, keeping the turns as close together as possible to ensure all the links are the same size. Cut through the coil at an angle, so that as the first jump ring is being cut the blade is also beginning to cut the next one.

Close half of the jump rings, using two pairs of flat-nose pliers—no light should be visible through the join. Lay the closed jump rings out on a soldering mat with the joins at the back, and apply flux and a small pallion of solder to each. (It is important to use small pallions of solder otherwise there is a danger of rings getting soldered together in subsequent rounds of soldering.) Start heating at one end of the line, and solder the first jump ring; the next ring will be heated by its proximity to the first and will quickly reach temperature.

Work along the line until all the rings are soldered shut, then pickle, rinse, and dry the rings. Any excess solder should be removed at this stage with a needlefile, and then the rings should be emeried smooth.

Link up two soldered jump rings with one open ring, which can then be soldered closed. Make groups of rings, and join them up; this lessens the chances of confusion or overheating during soldering. Continue this process until all the jump rings have been soldered closed. Check for any unsoldered links by giving the chain a sharp pull, before barrel polishing it.

Jump rings can also be fused to close them, but take care not to overheat thin wires as they will become very brittle.

Simple chain variations

Variations to the gauge or profile of wire used can help to make a simple chain more visually interesting. Links may alternate in size along the chain, or be graduated so that the largest links are at the center of the piece. Using different metals can also be effective—gold accents in a chain can be regularly or randomly spaced, and the other metals oxidized. Once soldered, jump rings

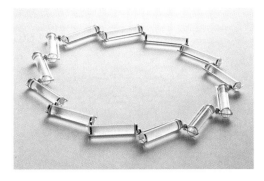

Rock crystal necklace
by Peter de Wit
Cylinders of rock crystal were set into 18k yellow gold frames to form this articulated necklace.

can be flattened, hammered, textured, twisted, or stretched, and joined with either plain or decorated jump rings. Handmade chain may be combined with machine made, which will often benefit from rubbed-back patination.

When constructing chain that uses mixed metals or different gauges of wire, the jump rings made from the metal with the highest melting point or from the thicker gauge of wire should be soldered closed first. They can then be joined using thinner rings so there is no risk of the first set of solder seams being affected, or the thinner wires melting.

Chain mail

There are too many variations of chain mail to describe in detail—the basic structure is composed of lengths of chain that are cross-linked with jump rings. It is important to make sure that the links are in alignment before joining them up, otherwise they will not sit correctly. This is made easier if the ends of the chain are hooked over nails that are secured in a board, and to save time all the cross-links can be inserted and closed before they are soldered.

The ways in which the rings join together can be varied by increasing the number of rings used per link to two or three, by joining several rings with one to disrupt the structure in some manner—and myriad other variations. Although its manufacture is a time-consuming process, chain mail is a very tactile and fluid material and worth the effort.

CHAIN: REPEATED UNITS

This technique uses the pierced elements created on page 90. The forms have been twisted along the length with pliers so that one end of the piece is perpendicular to the next.

1 Cut through the loop at the top of the piece with a piercing saw on all the pieces except one.

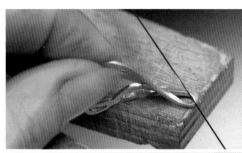

2 Open the cut section with two pairs of flat or chain pliers, insert the base of the next loop, and close the gap. Join all the links in this way—soldering one join will not heat up any other links, as the forms are quite large and thin.

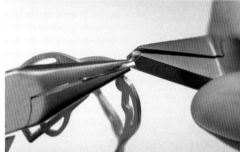

3 Solder each join shut using hard solder; a small pallion should be sufficient if the forms have been closed neatly.

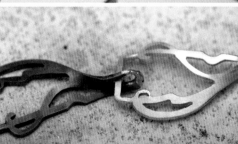

4 Clean up the solder seams with a file, and emery the piece to remove file marks. The chain can now be barrel polished.

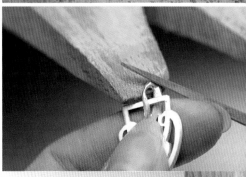

CHAIN: MIXED METAL LINKS

Using different metals in a piece will allow color contrasts or patination techniques that will only affect one of the metals. Silver and brass are used in this example.

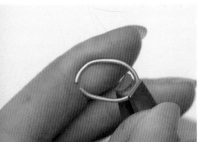

1 Form some randomly shaped wire forms of varying sizes and ensure the ends meet neatly.

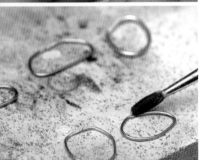

2 Solder about half of the rings, making sure that the thicker rings and those made from the metal with the higher melting point are included in this first batch.

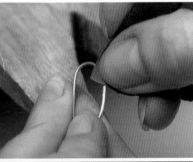

3 Pickle the rings and clean off any excess solder. Use unsoldered links to join the soldered ones—more than one link can be used to join elements, so be creative in the construction of the chain.

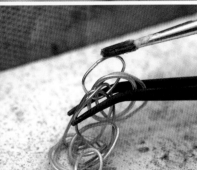

4 When soldering links closed, support the chain in reverse-action tweezers with the unsoldered link sitting at the top. The tweezers will absorb heat from the links they hold and will help prevent them from becoming overheated.

Loop-in-loop chains

This type of chain is formed from wire links that are stretched and then folded in half to make a U shape. The most basic form of loop-in-loop chain consists of one ring threaded through the loops at the top of the U on the next one, and so on. A denser chain can be formed if two U-shaped links are soldered together at the base in a cross formation; this allows two loops to be used for each junction, rather than one. Very tightly woven, but flexible chain can be constructed in this way if even more links are used in the base. The finished chain can be pulled through a hole in a piece of wood that is slightly smaller than its diameter to even out the links.

Linked repeated units

This type of chain is often made from wire units or components that have been cast, pierced, or fabricated, and lends itself to the exploration of ingenious methods of linking forms together in a way that is integral to the overall design. Many different designs can be adapted to fit this premise—a simple solution is to twist each link so that one end is at right angles to the other, allowing the links to all register in the same direction. Alternating links are also an option, but jump rings should be avoided when making this type of chain, as they are too easy an answer. The linking mechanism does not have to be restricted to loops and holes—rivets, balled wire, or other materials and mechanisms can be explored within the design process. You should adapt the form of the link so that an integral catch can be incorporated into the piece.

Other linking mechanisms

There are a number of standard mechanisms that can be used for making chain; these include ball-and-socket joints, which are very flexible; riveted links or hinges, which pivot on one plane; and balled wires secured through loops. Such systems can be adapted to a particular design. It is worth studying objects that use mechanisms—toys, machines, furniture. Many solutions to functional design problems associated with moving parts can be modified to suit your own needs.

Hinges are used when the components of a piece need to move, for example, the two halves of a locket. The construction of hinges requires a high degree of accuracy so that the mechanism functions well.

HINGES

In addition to basic hand and soldering tools, a tube cutter will be useful for making accurate "knuckles" from tube.

For certain types of hinges that will receive heavy use, such as those in large bangles, jointing tube, which has very thick walls, may be more appropriate than the standard tube, which often has a wall thickness of less than $\frac{1}{32}$ in (1 mm). Brass, silver, and gold are all suitable materials to work in.

Uses for hinges

Hinges are most commonly found on boxes, lockets, and bangles, and the form they take varies greatly. A simple hinge can be constructed from a curled extension of a sheet that wraps around a bar to make a pivot. The most stable type of hinge is formed from several cut lugs or knuckles of tube, which are soldered alternately to the two pieces that pivot around a central pin. There is usually an odd number of knuckles along a hinge.

With clever construction of a piece, hidden hinges that are located on the inside of a piece can be created; or it may be desirable to have the hinge as a decorative feature on the piece.

Soldering hinges in position

The intersection between the knuckles and the edges of the form it joins are crucial in

Love/hate rings
by Frieda Munro
The letters on these rings are
hinged so that they lie across
the knuckles when worn.

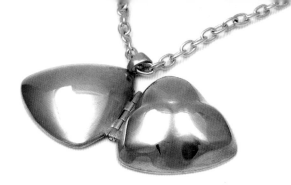

MAKING A HINGE FOR A PRESS-FORM LOCKET

This project uses the press forms from pages 150 and 151 to make a locket. The press forms were pierced out and sanded down before having a liner soldered inside to provide greater width for the hinge.

Hinged locket
The finished hinged press-formed locket (see left).

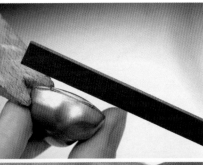

1 Glue the halves of the form together. Make a groove for the hinge with a parallel round needlefile or jointing file. It should have the same curve as the outside of the tube, and be almost half as deep. Remove the glue from the press form and bind the halves together.

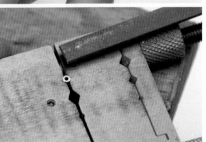

2 Cut the tube into "knuckles"— the length of each piece will depend on the length of the hinge, and there should be an odd number of lugs. Ensure that the ends of each knuckle are parallel using a tube block.

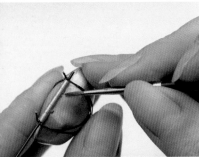

3 Support the form with heat bricks so that the groove is at the top, and horizontal. Thread the knuckles onto a steel pivot rod and position. Apply a little borax and hard solder to each knuckle, alternating sides. Heat until the solder melts but does not run, to tack the knuckles in place.

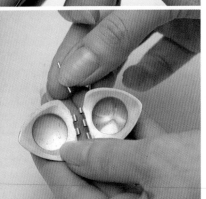

4 Unbind the halves. Place the steel pivot through the tube knuckles and resolder them— the piece must be well balanced so that they do not slip out of alignment. Repeat on the other half. A reamer can be used to align the hole of the hinge if necessary, before it is riveted.

determining how far the hinge will open. A groove or channel the same diameter and profile as the tube is filed along the join with a jointing file; this creates greater contact between the knuckles and the sheet so that the solder joins will be stronger. If the gauge of the sheet is too thin for good contact, a liner can be soldered to the inside of the form; this is also useful when applying hinges to curved forms, as a straight edge can be left proud of the form on which the hinge will sit.

The pieces of tube for the knuckles should all be the same length and fitted to the length of the channel. The knuckles are threaded onto steel pivot wire of the same diameter as the tube's internal hole—there is less risk of the steel becoming soldered inside the tube than other metals. The knuckles and pivot should be lightly bound in position on the form so that they can be tack-soldered (if it is possible, laser or PUK welding can be used to tack the knuckles to the form).

The piece can then be taken apart and the two parts soldered separately, ensuring the knuckles do not move out of position—misaligned knuckles may make the hinge wobble, or it may be difficult to insert the pin, which should be the same diameter as the inside of the tube. Any soldering, such as adding a catch to a locket, should be completed before the pin is riveted in place.

COLOR AND TEXTURE

This section covers a wide range of techniques that are used in addition to the techniques described in previous chapters, to add another layer of visual interest and personality to your jewelry. Most jewelers use some of these techniques to give their work an individual voice, helping to express a particular aesthetic or element of the original design, whether simply creating contrasting surface finishes on metal, engraving an inscription or pattern on a piece, or embellishing the work with gold leaf. Many of the techniques described are used predominantly with metal, but can be applied across other materials; interesting effects that can be achieved only with nonmetallic materials are also explained here, including embossing leather and the use of dyes. Some of these techniques, such as enameling, are broad subject matters in their own right, involving complex or time-consuming processes and sometimes speciality equipment; they are nonetheless incredibly rewarding and can produce stunning results.

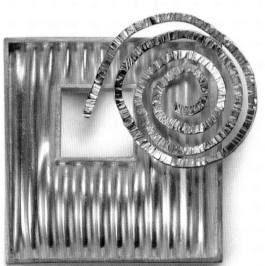

Spiral brooch
Page 196

When sheet metal is passed through a rolling mill with a textured material, an impression is forced into the surface of the metal. Many materials can be used for this technique, including paper, fabric, pressed leaves, and metal templates.

ROLLING-MILL TEXTURES

Metal should be annealed before it is textured so that a good impression will be made—softer metals such as copper, silver, and aluminum will take fine detail better than harder metals. Aluminum sheet should be sandwiched in paper to prevent transfer of the metal onto the rollers, because it is a contaminant to other metals.

All materials being passed through the rollers, including the texturing materials, must be absolutely dry—if the rollers are exposed to moisture they can rust, and the smooth surface will be damaged.

Never be tempted to use steel or titanium in the rolling mill because they are hard enough to mark the rollers permanently.

Most dry materials can be used to roller-print onto metal and this gives infinite possibilities into the range of textures and effects that can be created. More than one material can be rolled at the same time, but thicker materials will always dominate the thinner ones, which may not transfer well.

Rolling textures into metal

Texturing materials should be sandwiched between two sheets of annealed metal; the materials can be accurately arranged and secured with masking tape, or the texture may be left to chance. The thickness of the material being rolled will affect how far apart the rollers need to be—this can be difficult to judge when rolling bulky textures. If the rollers are too far apart, then the texture may not be transferred, but if the rollers are too close (and the mill's handle is

Oval neckpiece
by Bernadine Chelvanayagam
Finely textured silver ovals have
been linked to form this necklace.

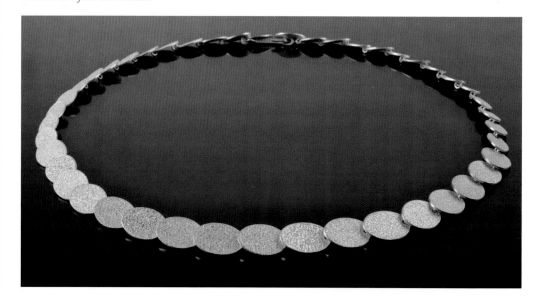

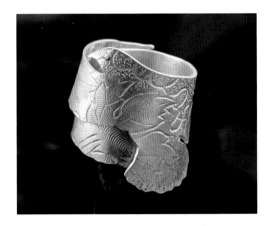

difficult to turn), there is a danger that the metal
will become too thin, and that the texture will
split the metal.

When impressing very fine textures such as
leaf skeletons and feathers, the best results will
be achieved with a single sheet of metal and the
texture rolled together. Set the distance between
the rollers at slightly less than the gauge of the
sheet metal; any tighter and the delicate pattern
will be distorted.

After rolling, the metal will be curved and
work-hardened, so anneal it before using a mallet
to flatten it on a steel block.

Working with textured sheet

Because rolling-mill textures can only be made
on a flat sheet, this means it is, in effect, the
raw material from which pieces are fabricated.
Texture a larger sheet than is required for the
piece so that it can be cut out and filed to shape.
Care must be taken not to damage delicate
textures when forming—protect surfaces with
masking tape while they are formed. Masking
tape will also protect the texture from accidental
slips of the file.

Textures made on a sheet that will be used for
press forming should not be too deep or they
will cause weak points along which the metal
can split.

ROLLING-MILL TEXTURES

A huge variety of dry materials can be used to
make impressions in sheet metal when passed
through the rolling mill.

1 Anneal two pieces of
19-gauge (0.9 mm) silver
sheet. Pickle, rinse, and
ensure the metal is completely
dry. Sandwich the texturing
material between the two
sheets. Coiled twine is used
in this example.

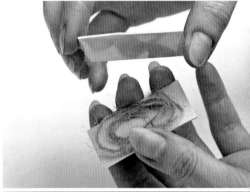

2 Adjust the distance between
the rollers so that the piece
will pass through without too
much force, as this is likely to
stretch the sheet and distort
the texture. If the rollers are too
far apart, then the texture will
not imprint well.

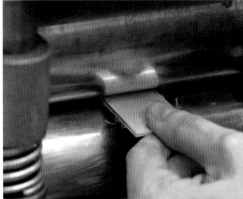

3 Once the piece has been
passed through the mill, flatten
it with a mallet on a steel block
and brighten the surface with
fine wire wool to make the
texture more visible. Textured
surfaces often benefit from
the application of patination
techniques to enhance the
contrasts within the design.

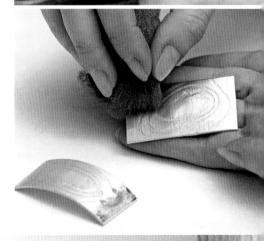

Textures made with hammers and punches may be used to add contrast to the surface of a piece, or to add small areas of decorative detail or text. This technique can be used on flat sheet and some formed pieces.

HAMMERS AND PUNCHES

Stamps or impression punches are usually made from hardened and tempered tool steel, making them very hard and durable. Punches are either straight rod or "swan-neck," having a kink in the rod to allow the insides of rings to be marked.

Several different types of punches can be used for making textures—pattern punches can be bought or made by carving, drilling, or etching the steel rod; letter and number punches are useful for inscriptions, and come in several different sizes; and chasing punches are also suitable for creating textures on sheet metal.

The direct hammering of metal can make attractive textures, and the shape of the hammerhead directly influences the marks that are made. Hammerheads may be carved or textured, and hammers can also be used to impress other textures, such as fabric, by hammering over the material as it lies on the piece of metal.

Texture-stamping flat sheet

When stamping flat sheet, work on a steel block and secure the piece to the block with masking tape—this will force the metal to be compressed rather than distorted by the punch. Annealed metal will be more receptive, and the piece should be clean and dry. Place the punch vertically on the metal so that its face is in contact, and strike the end of the punch with one hard blow from a jobbing hammer. If the metal warps from being stretched by the process, it will need flattening with a mallet, after having first been annealed.

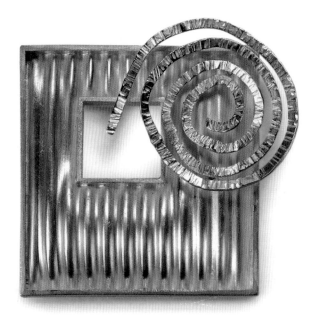

Spiral brooch
by Felicity Peters
A hammered gold spiral decorates
this corrugated silver square.

Promenades brooch/pendant
by Rinaldo Alvarez
Heat patinas and hammer textures
have created the impression of age in
this piece, which combines silver,
brass, and paper.

Stamped impressions on formed pieces

Formed pieces must be supported on a steel surface while they are textured so that the form is not distorted. Rings should be hammer textured while on a mandrel—the inside of the ring should make contact with the top surface of the mandrel only, and not sit tightly, to allow it to be freely rotated while being textured. Rings textured in this way should be made one or two sizes smaller than is required because the hammering will stretch the ring, making it have a greater circumference; remember to take into account the taper of the mandrel, and turn the ring around so that one side does not stretch more than the other.

The ring may be taped in position on the mandrel if stamps will be used to texture the outside; this will stop it from slipping, but the ring should be repositioned for each strike of the punch. When using a swan-neck punch on the inside of a ring, work on a flat steel block; the process will leave a small mark on the outside of the ring, which should be cleaned off with files and emery paper after all the stamping has been completed.

TECHNIQUE FILE

TEXTURING METAL WITH HAMMERS, STAMPS, AND PUNCHES

A range of textures can be applied to metal using direct or indirect force—striking the piece with a hammer, or using a hammer on the end of a punch to impact and impress the surface.

1 To hammer texture a ring, anneal, pickle, rinse, and dry it before putting it on a mandrel. Use overlapping hammer blows to mark the ring. The shape of the hammerhead will affect the pattern that is made—here, a creasing hammer is used.

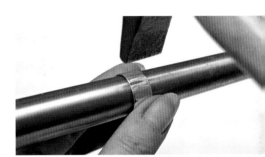

2 To use pattern punches, tape a piece of annealed sheet onto a steel block. Select a punch, and position it on the sheet so that the face is making good contact and the punch is absolutely vertical.

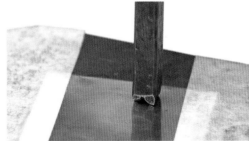

3 Strike the punch from above with a jobbing hammer. One good strike should make a clear impression in the silver sheet, but punches with large faces may not transfer completely, so careful repositioning and repeated strikes can be used to create the entire design.

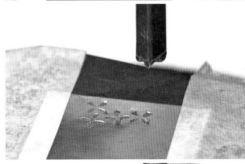

4 Repeated patterns of punched marks can make up attractive designs; use a center punch to add strategically placed dots. Flatten the sheet with a mallet before annealing to allow you to apply further forming or construction techniques.

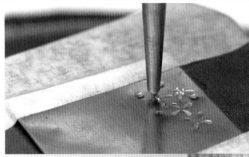

Etching is a process that uses nitric acid to remove areas of metal from the surface of a piece. A resist is used to mask off a design, as only the exposed metal will be dissolved—different resists may be used to create different effects.

ETCHING

Nitric acid is a dangerous substance, but if proper care is taken, it can be used to create beautiful effects on the surface of metal. The acid must be diluted to the correct strength for the metal to be etched—as the solution ages through use, the rate at which it etches will gradually increase, before eventually tailing off when the solution becomes saturated with dissolved metal. New solutions can be kick-started by adding a little spent acid. A slow etch is more accurate than a fast one. A solution that works very quickly will have an aggressive "bite," which can give an unevenly etched surface and may also cause undercuts if the metal is being deeply etched.

Ferric chloride and ferric nitrate are salts, usually supplied in crystal form, which are dissolved in warm water. Ferric nitrate will only etch silver, but ferric chloride can be used for copper, brass, and gilding metal. These salts are

Machine ring
by Anastasia Young
Etched silver labels were riveted in
place on this buffalo-horn ring.

Etching solutions for different materials	
Material	Chemical solutions recipes
Copper, brass, gilding metal	9 oz (250 g) ferric chloride crystals to 1 pint (0.5 l) warm water, at 104ºF (40ºC), or 1 part nitric acid (70% reagent grade) to 1 part water, at room temperature
Silver	1 part ferric nitrate crystals to 3 parts warm water, at 104ºF (40ºC), or (Aqua fortis) 1 part nitric acid to 3 parts water, at room temperature
Steel	1 part nitric acid to 6 parts water, at room temperature
Shell, ivory	1 part nitric acid to 5 parts water, at room temperature
Gold	(Aqua regia) 1 part nitric acid to 3 parts hydrochloric acid, at room temperature

Brush ring
by Jessica de Lotz
When the brush is removed from this
silver ring, an oxidized, photo-etched
image is revealed.

much safer to use than acid, but have a much slower rate of metal erosion and tend to form a residue on the surface of the metal that inhibits etching, unless it is suspended upside down in the solution or used in a bubble-etch tank (see page 202). The slow etch time means that the salts have a very gentle bite and will retain a very high degree of detail.

When mixing acid solutions, wear goggles, gloves, and a ventilator designed to filter acid fumes if you are not working in a fume cupboard. The work space must have good ventilation, and wooden surfaces especially should be prevented from absorbing spilled acid. Use clean, calibrated chemical glassware and ALWAYS ADD ACID TO WATER. Store mixed chemicals in glass bottles that are clearly labeled with the dilution rate or metal and the date, so that they can be reused safely.

Ferric nitrate and chloride do not give off such harmful fumes as acids, but the warmed solutions do release vapor that should not be inhaled. They will also cause staining of work surfaces, clothes, and skin, so take sensible precautions against this. Read the health and safety information on pages 10–11 for more information.

Resists

A resist is a substance used to mask off areas of metal in order to create designs; the acid will not erode the protected areas. Metal must be thoroughly clean and degreased so that the resist adheres well—any areas that lift up will let acid

ETCHING BRASS WITH FERRIC CHLORIDE

Copper, brass, and gilding metal can be etched with a solution of ferric chloride. This solution produces a very clean etch, and so can be used for fine detail.

1 Prepare the metal for stop-out application by degreasing it. Mask off the back of the piece with sticky-backed plastic or packing tape, and paint the remaining exposed metal with stop-out varnish. Once the varnish is dry, scratch a design through using a steel point, ensuring the lines are at least 1⁄32 in (1 mm) thick.

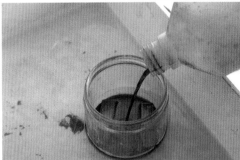

2 In a well-ventilated area, or out-of-doors, warm the ferric chloride solution by placing the plastic container it is in into an outer container of hot water. Two pieces of acrylic can be placed in the container to raise the metal up from the base.

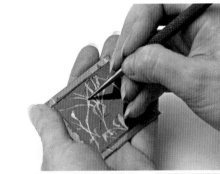

3 Suspend the piece of metal face down in the solution and check the progress of the etch at regular intervals.

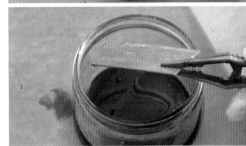

4 When a satisfactory depth of etch has been achieved, remove the piece from the solution and rinse it well. Remove the resist using a suitable solvent and scrub the metal thoroughly to remove any chemical residues.

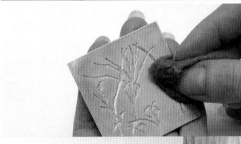

ETCHING WITH PNP RESIST

Press 'n' Peel (PnP) paper is a resist that can be used to apply images to sheet metal when etched. Only black-and-white images can be used, and a high contrast will give the best results.

1 Photocopy the design onto the matte side of the PnP paper. The black areas of the design will form the resist and will not be etched, so consider whether a negative of the image is more appropriate. A mirror of the image will be created, so any text should be reversed before it is transferred to the PnP paper.

2 Cut an image from the sheet of PnP, leaving a border around it, and place it image side down on a piece of silver (which has first been degreased and wiped with acetone). On a wooden board, use a medium-hot iron to apply the image, working in a circular motion.

3 Lift a small section of the PnP paper to see if the image has transferred well, continue ironing if it has not. Mask off the back and borders of the piece, and fill any gaps in the design with stop-out. Etch the piece in nitric acid until a satisfactory depth of recess has been achieved.

4 Remove the PnP resist with acetone and steel wool, and cut the etched design to size. This sample has been oxidized with liver of sulfur solution and rubbed back, see page 213.

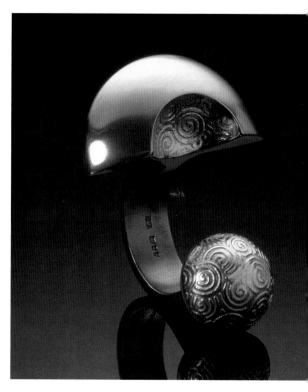

Double terminal ring
by Shelby Ferris Fitzpatrick
Photoetched elements enhance this rhodium and 24k gold-plated silver ring.

come into contact with the metal and allow it to be etched. Resists suitable for use with nitric acid are sticky-backed plastic, packing tape, aquatint resin, stop-out varnish (sometimes called black polish), and Press 'n' Peel (PnP) paper. In addition to the resists just mentioned, ferric chloride and nitrate will be resisted by nail polish and permanent marker pen. The exposed areas of metal should be at least $\frac{1}{32}$ in (1 mm) wide to etch successfully, but there are few other restrictions on the design. Painterly techniques can be used to apply the stop-out varnish, sticky-backed plastic can be cut to make stencils, or a few different methods can be combined. By using several rounds of etching, cleaning, and then reapplying a resist, designs with several depths of recess can be created.

PnP paper can be used to create a form of low-tech photoetching. A high-contrast image is photocopied or laser printed onto the matte side of the blue PnP acetate, and applied to the metal with an iron. The black areas of the design

are transferred to the metal and form the resist. Accurately executed images and designs can be etched using this form of resist, which is ideal for champlevé enameling, to create a "cell" recess for the enamel to sit in. Detailed instructions are also supplied with PnP paper.

Photoetching involves a more complex process of stopping out, using a UV-reactive film to develop the resist, but it can be used for very detailed images and pierced shapes. There are professional companies that will photoetch to order (see Outwork: photoetching, page 268).

Etching sheet metal with nitric acid

Use a larger sheet of metal than required so that it can be cut to shape after etching, and carefully mask off the back of the sheet with packing tape before applying the design to the front with the chosen resist. Wearing gloves, transfer the metal to the acid solution with plastic tweezers, sliding it under the surface so that it does not cause splashing. The acid will start to etch immediately, and small bubbles will begin to form on the surface of the metal; these should be brushed away with a feather, otherwise they will prevent the acid from etching evenly. The length of time a piece should stay in the acid will depend on the depth of etch required and the speed of the solution.

To check the progress of the etch, remove the metal and rinse it under running water to remove acid traces; a pin can then be used to check the depth of the etched areas. Return the piece to the acid if it requires further etching.

After etching, rinse the acid off thoroughly under running water, and remove the resist with a suitable solvent.

Other forms of metal such as rod and wire can also be etched, but offer a more limited scope for the application of designs.

Etching formed pieces

Take great care to mask off and stop out any areas that are not intended to be etched on formed pieces, as it will take time and perhaps thin areas too much if they have to be filed to remove unwanted marks made by the acid. Simple pieces such as band rings are the most suitable for

ETCHING PEN

TECHNIQUE FILE

More commonly used for printed circuit boards, etch-resist pens can be used to draw designs directly onto metal. This example shows a band ring being etched using this method.

1 Degrease the ring, and mask off the inside with stop-out varnish. Do this in two or more stages, allowing the varnish to dry in between. Any gaps in the varnish will lead to unwanted marks in the piece.

2 Apply a design with the etching pen, and allow it to dry. Lighter, thinner areas may be weakened by the action of the acid, so apply another layer of ink to these.

3 Etch the ring—the level of the acid must be higher than the top of the ring so that the whole piece is submerged. Check the depth of the etching at intervals.

4 When the design has clearly etched into the ring, rinse the piece well and remove the stop-out and etching-pen resist. Scrub the piece thoroughly to remove any chemical traces before barrel polishing the ring.

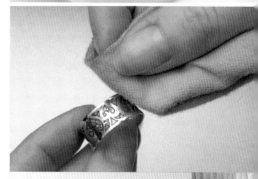

ETCHING SHELL

Designs can be effectively etched on shell using a weak nitric acid solution—this process works very quickly and with a great deal of fizzing!

1 Use several layers of packing tape to mask off the underside of the shell, and paint a design onto the exposed surface with stop-out. Let the stop-out dry and apply a second layer to ensure there are no gaps, and paint over the edges of the packing tape.

2 Mix the nitric acid to the correct strength and pour it carefully into a high-sided beaker. Place the shell in the acid.

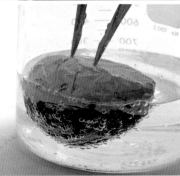

3 The exposed areas of the shell will quickly start to fizz as the acid aggressively eats them away—keep a close eye on the progress and check the depth every ten or twenty seconds.

4 Remove the shell from the acid when the paler material under the surface of the shell has been adequately exposed. Rinse well and remove the stop-out and packing tape.

etching, and will allow for a continuous design around the circumference of the ring. Etching can be done on component parts before they are assembled—but care must be taken to avoid solder flooding into etched areas and obliterating the design.

Bubble etching

Bubble etching involves the use of a special tank that has an air-pump bubbling through the etching solution; more expensive models of tank will also heat the solution so that it works more quickly. These tanks are only suitable for use with ferric chloride and ferric nitrate. The action of the continuous bubbles helps to prevent sediment forming on the piece by constantly agitating the solution and gives a very clean, well-defined etch.

Ferric nitrate and chloride can be used without a bubble-etch tank, but due to the potential buildup of sediment, the metal must be suspended face down in the solution. Plastic threads or coated wires can be used to support the piece just under the surface of the etching fluid. The solution can be heated by placing the dish it is in into an outer container of hot water.

Etching other materials

Steel can be prepared and etched in the same way as other metals, but requires a weaker solution of nitric acid. Etched steel is useful for making durable texture templates for embossing leather.

Ivory can be etched with a solution of one part sulfuric acid to six parts water; some stop-out varnishes may stain the ivory, so make a test sample first.

Shell must be thoroughly masked off because the action of the acid is very aggressive—a chemical reaction between the calcium carbonate of the shell and the acid gives off carbon dioxide gas that fizzes violently—a very dilute solution should be used for a more accurate etch. Traditionally, for cameo work, etching is combined with engraving techniques to create delicately carved low-relief designs, often with a contrasting background where the top layers of the shell have been removed.

Engraving is a technique that requires much skill and practice, using sharp steel tools called gravers to cut away fine slivers of metal. Pictorial designs, lettering, or textures can be produced, and are often the last process performed on a piece.

ENGRAVING

The most important tool in engraving is the graver. There are many shapes of gravers (see page 309 for a guide). For the beginner, a 1/16 in (2.5 mm) square graver is the best tool to learn with, and can be used to cut a variety of lines, textures, and effects.

As gravers are sold without handles, first the graver must be cut to length and then have a mushroom-shaped handle with a flat underside fitted. This allows the graver to be applied at a low angle when engraving flat sheet.

Gravers must be sharpened before use, so they have a tip that is sharp enough to catch in the thumbnail when touched on it. Well-sharpened gravers will need sharpening less often because they will cut efficiently and the tip is less likely to break off.

The work being engraved is secured to a larger surface, such as a block of wood, so that it is easy to hold while it is worked, and this is supported on a sandbag. Other tools include oilstones, oil, a scribe, a curved burnisher, modeling clay, a pointed wooden stick, and a steel ruler.

The optimum working height for engraving is about chest level—the use of a sandbag may make it more appropriate to work at a table rather than at the bench. Good lighting is essential when engraving, as such intensive working can cause eyestrain. Although many hours of practice are required, do not spend too long at a stretch of engraving, and take regular breaks.

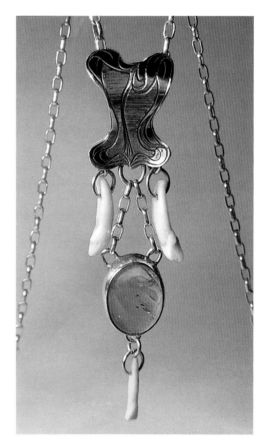

Engraved pendant with teeth
by Anastasia Young
The engraved decoration on this
pendant makes use of lines and
shading in the pattern.

ENGRAVING: SETTING UP A GRAVER

Engraving tools, or gravers, are sold in standard lengths without a handle. It is crucial that the graver is set at the correct length for the size of your hand.

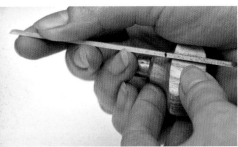

1 With a handle resting in your palm, the tip of the graver should be a bit longer than your thumb. Mark where to cut on the graver, leaving enough length to secure it in the handle. Grind or file around the mark until it is possible to snap the end off.

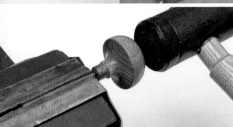

2 Place the graver horizontally in protective jaws in a vise with the angled face on top and the tang protruding. With a mallet, tap the handle onto the end of the graver, making sure the flat base of the handle is underneath.

3 Apply three-in-one oil to a fine oilstone, and sharpen the top face of the graver, making sure it is in good contact with the stone. Work the graver up and down the stone, using long, even strokes.

4 Square and lozenge gravers need the underside of the cutting face to be "backed off," which adjusts the angle they are held at when engraving. Grind a face on each side of the back, so that the graver will cut at 5 degrees.

5 Remove any burrs from the ground faces of the graver by stabbing it into hardwood. The faces can now be polished on an Arkansas stone, which will sharpen it further and help prevent the tip from chipping.

Designing for engraving

Georgian and Victorian jewelry is often decorated with engraved designs and inscriptions, and is a useful source of study for the kinds of images that can be constructed by mark-making with gravers. Form and shadow can also be created through engraving, as lines cut at different angles will reflect the light differently, changing from black to white against the uncut areas.

It is possible to engrave on flat sheet and form and solder it afterward, but the bright finish of the cuts will need to be restored through careful polishing (see "Finishing engraving" on page 206). Care should also be taken that solder does not run into engraved areas and damage the design, so consider cold-joining techniques on heavily engraved surfaces.

Cutting lines

Lines are cut with a square graver, using the scribed design as a guide. Straight lines can be cut more easily if short overlapping cuts are made. Dig the engraver into the metal and then lower the angle—push forward to lift a sliver of metal and flick it out with the tip of the graver when the cut is long enough.

For a right-handed person, curves are always cut counterclockwise so that the back of the

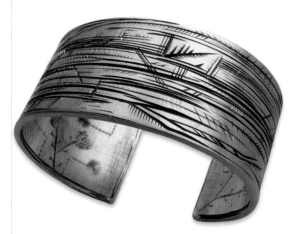

Frost bangle
by Ruth Anthony
The engraved designs on the inside and outside of this bangle were oxidized to accentuate the pattern.

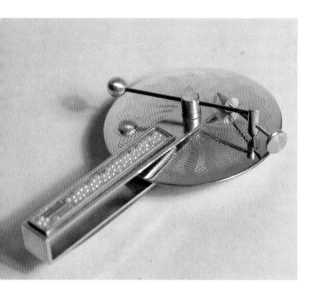

Turning brooch
By Michelle Xianon Ni
An engraved geometric design contrasts with
loose pearls in this silver and steel brooch.

graver does not damage the metal; the piece is turned into the path of the graver as it is pushed forward and the speed of the turn will determine the curvature of the arc. The left hand is used to rotate the work, with the right thumb and left index finger forming a pivot.

A curved, oval steel burnisher is used for "rubbing out" mistakes or slips of the graver. To lessen the visibility of an unintentional cut, rub the curved face of the burnisher along the unwanted line. This will encourage metal from the sides to fill the groove, and the action can be aided with a smudge of oil to lubricate the burnisher. Do not rub across the lines, as the burnisher will drop into the groove and may widen it. Very deep marks can only be erased by lowering the surrounding metal with a scraper.

Engraved textures

"Wriggling" is a zigzag texture created by rocking the graver from side to side as it is gently moved forward, and can be used to cut straight or curved lines and borders, or to create fields of texture. Most shapes of graver can be used for this technique, as well as for the mark-making of dots, dashes, and any conceivable combination of these.

ENGRAVING: TEXTURES

Gravers of any profile can be used to create textures on metal and other materials using simple mark-making techniques.

1 Create a zigzag texture, called wriggling, by rocking the graver from side to side as you gently push it forward. Straight lines or curves can be created, and square, round, and lining gravers will all produce slightly different results.

2 To make a dot, use a round graver to push into the metal and then flick out a small piece of metal. Larger round gravers will require greater force to cut a circle than smaller gravers. Alternatively, a square graver can be used to make dots if the work is sharply rotated with the graver's tip in the metal.

3 Engraved textures often have sharp burrs sticking up from the surface where slivers of metal remain. Use a steel rule to scrape across the texture to break off the burrs.

4 A burnisher can be used to polish areas of the texture, and will lessen the effect in the areas it is used on. This is useful for creating contrasts on large fields of texture, and can be used for shading on engraved images as well.

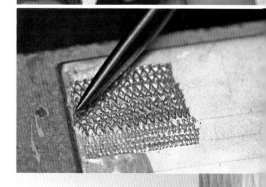

ENGRAVING: LINES AND LETTERING

It takes many hours of practice to develop the skills necessary for successful engraving, but once basic line-cutting can be satisfactorily achieved, a range of effects will be possible.

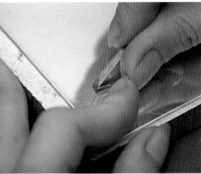
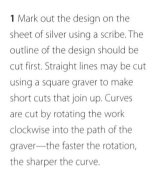

1 Mark out the design on the sheet of silver using a scribe. The outline of the design should be cut first. Straight lines may be cut using a square graver to make short cuts that join up. Curves are cut by rotating the work clockwise into the path of the graver—the faster the rotation, the sharper the curve.

2 The design may be shaded using a lining tool, or stitch. Use straight, parallel strokes of even depth to build up a field of texture. Try not to cut into the outline—angle the stitch when cutting up to a curved line so that not all of the tool makes contact with the surface of the metal.

3 When the shading is complete, recut the outline, and thicken some of the lines to create the illusion of depth in the design. To make a wider cut, roll the graver slightly to the right at the apex of a curve and back to the left to tail it off.

4 Handwritten lettering can be engraved effectively and is much easier to achieve than script. Mark out the words in full before starting to cut, and cut all the straight lines first so that they are parallel.

Engraving inscriptions

Inscriptions formed of letters and numbers are often engraved on the insides of rings. This technique requires a great deal of skill in order to cut accurately, and would usually be taken to a professional engraver (see Outwork: engraving, page 265). However, it is possible for the beginner, with practice, to engrave satisfactory inscriptions on flat sheet metal. Block lettering should be avoided as the regularity it demands is not easily achieved, but handwriting can be reproduced to a satisfactory standard—the idiosyncrasies will distract the eye from any inaccuracies.

A piece of modeling clay is rolled over the surface of the polished metal to coat it, and the point of a cocktail stick is then used to write the inscription. These lines are then traced with a scribe to make them permanent. All upright strokes should be cut first with a square graver so that they are parallel, and then the remainder of the lettering can be cut.

Finishing engraving

The surface of the metal can become scratched while engraving, as any pieces of swarf caught under the fingers will cause marks. Care must be taken when cleaning up engraved pieces, as the fine lines can easily be damaged—the effect will not be as bright if the edges of the cuts become rounded through abrasion or polishing. Use charcoal, which is a fine abrasive, to work out any scratches before polishing the surface by hand using buff sticks loaded with fine rouge compound. Rouge caught in the fine lines can be removed with lighter fluid applied on absorbent cotton, and the piece can then be buffed with a polishing cloth.

The qualities of a piece of jewelry are strongly influenced by its surface finish—but there are also practical considerations. Matte or satin finishes can enhance areas of a form, but are not as suitable for pieces that will receive a lot of wear.

SURFACE FINISHES

Studio jewelry has a long tradition of experimental surface finishes, often related to the aesthetic of the piece or the underlying message or narrative. This is because, unlike commercial jewelry, which is often polished, studio work is usually less concerned with displaying the intrinsic value of the materials used and more concerned with design or concept. However, there are factors other than design that will influence the choice of finish—polished surfaces are hygienic because they are not porous and should be used for piercing parts such as ear posts. Matte and frosted surfaces will tend to pick up dirt because they are textured, and will eventually become shinier through wear; they are not as suitable for areas that will receive a lot of wear. However, they do allow the colors of different metals to be seen more clearly than if they were polished, so can be good finishes for mixed-metal items, especially where the contrasts are flush, as in inlay techniques. Different surface finishes may be combined on one piece to exaggerate textures or create contrasting areas.

Surface preparation

There are certain finishes that can be used to disguise marks and blemishes on the surface of a piece, such as burred textures made using the flexshaft motor, but most finishes require that the surface is well cleaned up before they are applied. Metal should be prepared as if it will be polished, so remove all marks, solder, and firestain with a file and work through the grades of emery or wet-and-dry paper; going up to the finest grade of emery paper will provide a good basis for any surface finish.

Plastics and natural materials can be prepared in a similar manner to metal before the application of matte or satin finishes.

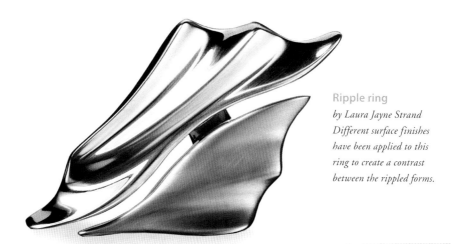

Ripple ring
by Laura Jayne Strand
Different surface finishes
have been applied to this
ring to create a contrast
between the rippled forms.

SURFACE FINISHES

TECHNIQUE FILE 79

The surface finish of a piece can greatly affect its appearance, so try out a few different finishes on scrap metal before deciding on the final effect. Combinations of different finishes can be very effective.

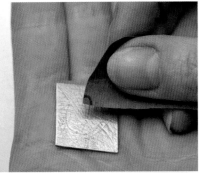

1 Emery paper can be used to give a satin finish if a fine grade is used in one direction only. Preparation of the surface requires scratches to have been removed with rougher grades of paper before the final surface finish is applied.

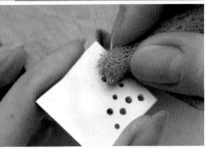

2 Scotch-Brite creates an attractive, brightly scratched surface. Use an even circular motion to work over the surface of the metal until all parts have the same quality of finish.

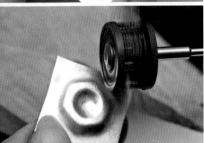

3 Flick wheels create a frosted texture on metal, but should not be used on fragile pieces. Some blemishes on the metal's surface will be disguised, but a well-cleaned piece always gives the best results.

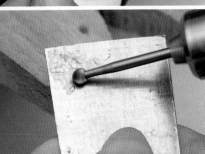

4 Burrs can be used to grind textures into metal—use plenty of lubricant and keep the burr moving unless deep pits are required. Keep your fingers well out of the path of the burr.

Materials for creating finishes

Any abrasive medium can be used to create a surface effect—pumice powder, Scotch-Brite, emery paper, and wire wool will all give different results. Working the abrasive backward and forward in one direction only will produce a satin finish; the finer the abrasive, the finer the effect. An even circular motion will scatter light, giving a matte finish—only fine abrasives will give a truly matte surface; rougher materials leave scratches that do reflect light, but will scatter it randomly. The most important factor is that the texture appears deliberate.

Finishes with flexshaft motor attachments

A variety of tools can be used in the flexshaft motor to create textures and finishes, including frosting wheels, and matte or satin wheels. The rotary effect of the motor means that greater areas can be covered more quickly, but the finishes cannot easily be applied to corners and inside edges. Burrs are good for texturing concave areas, such as the insides of carved-out rings, which will not be seen and which would take considerable time to polish to a satisfactory level.

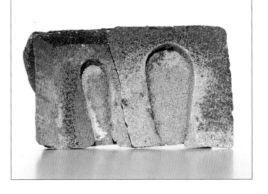

Domus brooch
by Adrean Bloomard
The enameled surface finish of this brooch makes the silver look like weathered stone.

When the surface of a sheet of metal is melted, a rippled texture is formed. The best results are achieved when areas of the metal cool at different rates, as this creates tension within the surface. Reticulation works best with silver, gold, or brass.

RETICULATION

Reticulation is a process that yields unpredictable results—no two reticulated pieces will be identical. The process can be performed on sheet metal before or after cutting and filing an outline, and the results will differ in both cases. If the metal will be pierced after it has been reticulated, work on a larger sheet than you need. Silver, brass, or gold can be used for this technique, and sheet metal should be flat, and around 18 gauge (1 mm) in thickness.

Creating the surface

This technique works on the difference between melting points and cooling rates within the piece of metal—when areas contract more quickly than others, then rippling will occur. One way to achieve this on sterling silver is to force a layer of fine silver to the surface of the sheet by annealing and pickling the piece at least seven times.

Work on a charcoal block as it will retain the heat better, and rapidly bring the sheet up to red heat. The surface will start to become molten, and can be manipulated with the flame to create differences in temperature that will give a good effect as the sheet cools. Take care that the sheet does not get too hot, as the edges have a tendency to pull in and distort the outline.

Variations on the process

Adding very small slivers of fine silver will disrupt the surface tension when the piece is heated—the fine silver does not melt and can be used to create controlled patterns; repeated annealing is not necessary for successful results.

Areas may be masked off so that they are not textured—use clay or heat paste to paint out sections of the sheet.

RETICULATION

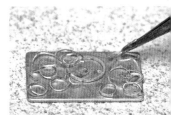

This technique relies on the differences in melting points between areas of a piece of metal—adding a few scraps of fine silver to sterling silver sheet greatly enhances the effect.

1 Paint the base sheet with watery flux and position fine silver scraps on the surface.

2 Heat the piece until the surface of the base sheet begins to turn liquid. The flame can then be used to move the molten metal so that it pools around the fine silver.

3 As the piece cools, the different contraction rates will cause ridges and furrows to form.

Granulation is the name given to the application of tiny balls, or granules, of metal to a surface or structure. This technique can be used to create detail on a small section of a piece, or to cover an area with a field of texture.

GRANULATION

Place cut, fluxed wires into small depressions in a charcoal block; this will stop the granules from rolling away once they are formed. Heat the wires until they melt, forming little balls. If you require a uniform size of granule, use small jump rings, as the length of the wire in each one should be the same. Pickle the granules in a small plastic sieve to minimize loss.

Soldering method

Granules can be soldered onto flat sheet that has depressions marked in the surface, giving greater contact, or balanced between two wires, or set along chased grooves. Use filed solder mixed with borax to a paste, or place the granules on a silver base that has already had hard solder sweated onto the surface (see page 100). Paint the base sheet or wires with the solder paste and heat the piece until the solder runs, allow to air cool, and then pickle.

Fusing method

This method is better for three-dimensional surfaces as balls are stuck in position and cannot move during fusing. Copper-plate the silver granules and the piece using binding wire in the pickle tank—this helps the elements fuse more easily due to a eutectic action that lowers the melting points of both metals when in contact. Dip the granules in a mixture of Auroflux and gum Arabic or gum tragacanth and position them on the piece. Allow the piece to dry, and then gently heat; after the glue burns off, continue heating past annealing temperature until the "granulation flash" occurs, and then stop heating. Do not quench the piece, but air cool, pickle, and repeat the fusing process if some granules didn't fuse.

GRANULATED EARRINGS

TECHNIQUE FILE 81

Granulation is an ancient technique that involves the application of tiny balls, or granules, to a piece. The granules may be fused or soldered into position.

1 Burr shallow holes into the surface of a charcoal block. Place a fluxed piece of cut wire or a jump ring in each hole. Heat the wires until they melt and form granules. Pickle the granules in a jar, and carefully rinse them.

2 Use tweezers to position the granules on the piece—here they are balanced between two curved wires, but small depressions in sheet work well, too. Solder the granules on with a paste made from filings of hard solder mixed with borax. Resolder any granules that do not bond with the first heating.

The coloring of metals with chemicals is called patination, and occurs through the accelerated formation of surface oxides. A range of colors may be produced on silver and base metals, using a number of different chemicals and methods.

PATINATION

Patinas are destroyed by heat or pickling, and so this should be the last step in the making of a piece, unless cold-joining methods of construction such as riveting or screw threads will be used to hold pieces together. The surface qualities of the metal directly affect the outcome of the patination—matte surfaces may appear darker or more intense than polished areas.

Patinas work well to enhance textured metal, where a raised surface can be rubbed back by a light polishing or the use of very fine emery paper, leaving lower areas contrasted. It is very important to ensure that metal is clean before patinating (see Degreasing, page 111). Even fingerprints can inhibit the action of some chemicals. If a patina does not work very well, clean the metal again and have another go; this will often help to obtain darker colors with oxidization chemicals.

Protect patinas with microcrystalline wax—this works best on black oxidation techniques as the wax darkens the colors, but it is not suitable for some patinas, such as verdigris, and it deadens refractory colors on heat patinas.

Chemical patination baths

Liver of sulfur solution can be used to create dark gray oxidized surfaces on silver, copper, gilding metal, and brass. Dissolve a tiny amount of potassium sulfide in 3 fluid oz (100 ml) warm

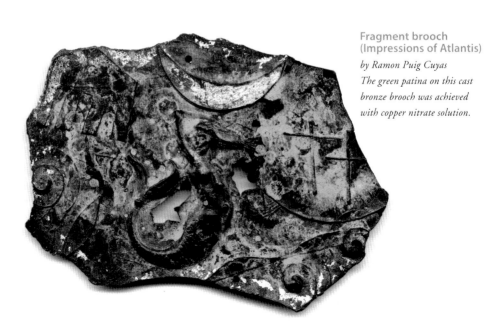

**Fragment brooch
(Impressions of Atlantis)**
by Ramon Puig Cuyas
The green patina on this cast
bronze brooch was achieved
with copper nitrate solution.

PATINAS: VERDIGRIS

TECHNIQUE FILE 82

When copper nitrate solution is applied to copper, brass, or gilding metal and gently heated a layer of blue-green oxides is formed. Colors will vary depending on the type of metal used.

1 Emery paper can be used to give a satin finish if a fine grade is used in one direction only. Preparation of the surface requires scratches to have been removed with rougher grades of paper before the final surface finish is applied.

2 Put the piece on a heatproof mat and apply the copper nitrate solution with a brush.

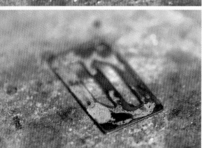

3 When the piece is gently heated with a torch, the chemical evaporates, leaving a residue of oxides. Take care not to overheat the metal, as the oxides will burn and turn black.

4 Reapply the solution, licking the piece with the torch flame to develop the color. Continue until a satisfactory result has been reached, and allow the piece to air cool. Do not wash or wax the patinated surface, as this will change the effect.

water, or 1 fluid oz (25 ml) of liver of sulfur solution per quart (liter) of water. The solution should be warmed to 145–160ºF (60–70ºC), but if this is awkward—this solution smells strongly of rotten eggs and if a fume cupboard is not available, should be used outdoors—then the piece can be heated in a pot of hot water before it is immersed in the solution for about twenty seconds. Rinse the piece thoroughly and repeat the process if the result is not dark enough.

Painted patinas

Concentrated oxidization chemicals such as Platinol can be applied to silver, copper, brass, and gilding metal with a synthetic bristled paintbrush to oxidize specific areas of a piece. The applied solution takes a few seconds to darken the metal and does tend to bleed across the surface slightly, but areas of the piece can be masked off with wax or varnish. The effect can be darkened with further applications, but it is often difficult to achieve a true black—wax will help to darken the patina, especially on matte surfaces.

These chemicals give off strong fumes and should only be used in well-ventilated areas and when wearing protective gloves.

Blue and green patinas

In this method, the chemical is transferred to the metal using a medium such as sawdust, absorbent cotton, or rolling tobacco; this allows the chemical to come into contact with the metal in a more random way, and gives a textured coverage. Place the chosen material in a sealable plastic container and pour over enough of a mixture of one part vinegar to three parts household ammonia to make the material damp. Degreased metal can be left in the sealed container for several days, or until a satisfactory patina develops.

Ammonia gives a blue-green patina with varying shades of background on copper, brass, and gilding metal.

Copper nitrate solution applied with a brush to metal, and gently evaporated with a torch, will produce a pale green patina on copper,

Oxidized bronze bangle
by Akiko Furuta
The oxidization on this bangle
was rubbed back to expose the
bronze in places, creating a visual
flow around the form.

brass, and gilding metal. Dissolve 7 oz (200 g) of copper nitrate crystals in 1 quart (1 liter) warm water to make the solution.

Heat patinas

As metal is gently heated with a torch, a spectrum of colors develops on the surface. When the flame is removed, the development will be halted, leaving a thin patina of colored oxides. The results are somewhat unpredictable and uneven, but interesting effects can be achieved. This patination technique can be used on a greater range of metals than any other and, like other patinas, is a surface effect and can be easily scratched or damaged. However, this means that if you don't like the results they can easily be removed by abrasion or pickling.

Titanium produces vivid spectral colors when it is heated with a torch, similar to those produced by anodizing, but it is not as easy to control. Several colors will be created on the same piece and a banded effect can be created if a piece is heated from one end only, with the colors spreading out from the heat source as the metal gets hot.

PATINAS: LIVER OF SULFUR

TECHNIQUE FILE

Liver of sulfur solution produces a dark metallic gray on silver, copper, brass, and gilding metal. This process is useful for oxidizing an entire piece, and may be repeated several times to deepen the color.

1 Warm the liver of sulfur solution on a hotplate to about 150ºF (60ºC). Work in a well-ventilated area and wear goggles and gloves.

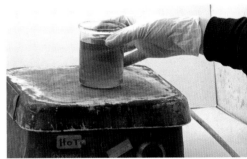

2 Clean the piece of work to be patinated—any grease will inhibit the process. Use tweezers to lower the piece into the solution. Allow the color to develop—this should take less than a minute.

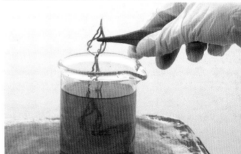

3 Remove the piece from the solution and rinse it well under running water. If the color is too pale, scrub the piece with a little pumice powder and return it to the solution.

4 When the piece is dry, it can be buffed with a silver cloth to brighten the patina and expose silver on the edges of the piece, which will give an attractive highlight.

Temperatures and colors for heat-patinating steel					
Color	Yellow	Brown	Purple	Dark blue	Pale blue
Temperature °F	390–470	500	52–540	550	610
Temperature °C	200–245	260	270–280	290	320

PATINAS: PLATINOL

TECHNIQUE FILE 84

Platinol is a branded patination chemical that may be applied to small areas of a piece with a synthetic paintbrush for a black oxidized finish.

1 Degrease the surface of the metal before starting. Wear gloves if there is any chance the solution will come into contact with your skin. Dip the paintbrush in the solution and wipe off the excess on the side of the bottle before applying it to the piece.

2 Several applications of Platinol may be necessary to achieve a very dark patina. Rub back the raised surfaces of the textured silver either with a silver cloth or with very fine emery paper. This will expose fresh silver and create a contrast with the oxidized areas.

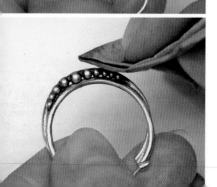

3 Apply renaissance wax to the piece with a tissue or soft cloth to deepen the color of the patina, and also to protect it from wear. Buff the waxed surface to give it a sheen.

The colors that develop on steel can be predicted when it is heated to a specific temperature in a kiln, and are dependent on the temperature to which it is heated (see chart, above). Quench the piece in cold water once the color has developed.

Different color effects can be created if the surface of the metal is painted with a thin borax solution before prolonged heating at annealing temperature. This process is not suitable for pieces with solder joins, and the result can be brittle and flake off if the metal is flexed. To achieve a purplish red patina on copper, heat it quickly to red heat and then quench it in hot water.

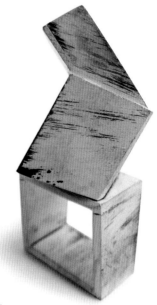

White ring
by Fabrizio Tridente
This silver ring was heat-patinated to achieve its contrasting black-and-white finish.

Dyes can be applied to synthetic and natural materials, and are used to add color, contrast, or patterns. Some dyes will work well on many materials, but others are specific to a particular medium.

DYES FOR MIXED MATERIALS

Dyes are often specific to the kinds of materials they work on—natural materials can be dyed with a wide range of chemicals, including tea, bleach, hair dye, fabric dye, and wood stain, but synthetic materials such as polyester resin and silicone each have their own specific dyes.

A number of methods can be used for the application of a dye to a surface—dyebaths where the material is immersed in a solution, the dye may be applied with a brush or sponge or printed, and resists may be used to mask off areas of the surface so that the dye cannot stain the material.

Take sensible precautions when working with chemicals, always wear goggles and gloves, and protect work surfaces to prevent staining.

Using dyed materials

The type of material being used and the method of dye application will often affect the stage at which a material will be dyed—always make a test sample first so that there are no nasty surprises when it comes to the final piece. Some materials should be dyed and allowed to dry before being cut and formed, and others, such as wood and ivory, should be dyed after fabrication

Flowerpot brooches
by Deukhee Ka
The wooden bases were stained
different shades to complement
the flowers' patinated metal.

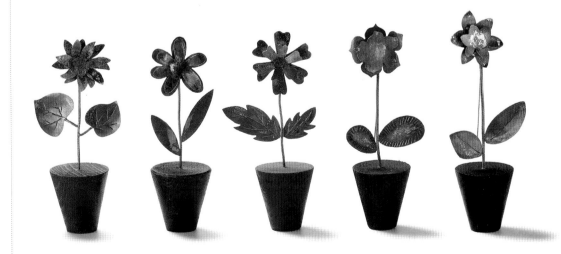

COLORING POLYESTER RESIN

TECHNIQUE FILE 85

The dyes for polyester resin are available in two main types—transparent and opaque. Different colors may be combined to create variations, and also combined with metallic powders to add a little glamour.

1 Mix up enough polyester resin (see page 166) to fill the mold that will be used—the silicone mold made on page 159 is used here. Add the catalyst to the resin, and select the dye that will be used. The dye is very concentrated and you only need a small amount.

2 Add the dye to the resin and mix slowly until the color distribution is even. You can add more dye to intensify the color, but too much dye will inhibit the curing process.

3 Use a plastic spoon to pour resin into the mold, which has been taped closed. Half-fill the mold and gently squeeze it to expel trapped air. Add more resin to the mold—shrinkage will cause the final level to be lower than when the resin is liquid.

4 Dyed resin can take a little longer to set than clear resin, so leave the mold to cure overnight in a fume cupboard. When fully cured, the resin form can be removed from the mold and cleaned up.

but before the final polishing. This is because the unpolished surface is more receptive to the dye, which also causes the material to swell slightly, so it may need a light sanding before it can be polished.

Many materials such as shell, leather, and feathers are available already dyed in a wide range of colors, so consider whether it is necessary to go to the trouble, unless you require a specific pattern or image to be applied to a surface.

Polyester resin dyes

Dyes for use with polyester resin are either opaque or transparent and can be mixed with one another to create a greater range of hues, and also with metallic powders. The dyes are very concentrated and only a small amount should be used, as a quantity more than 2 percent of the total mixture will inhibit the action of the catalyst and the resin may take a long time to cure, or not cure properly. Dyes are usually added to the resin before the catalyst is mixed in, but check the manufacturer's instructions.

Dyeing anodized aluminum

Pre-anodized aluminum can be colored using a number of techniques. Specialist dyes come in powder form and are mixed with water to make a dyebath; these dyes are either opaque or transparent. Fiber-tip pens, food coloring, photocopies applied with acetone, and block-printed images may also be used in combination. Once the design has been applied, the surface of the metal must be sealed to bond the color to the porous surface—this is done by immersing the piece in boiling water for 10–20 minutes.

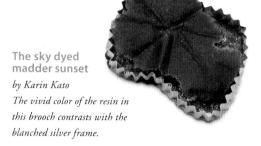

The sky dyed madder sunset
by Karin Kato
The vivid color of the resin in this brooch contrasts with the blanched silver frame.

The refractory metals—titanium, niobium, and tantalum—can be anodized to produce vivid colors. The colored oxides are produced on the metal when it is immersed in an electrolytic solution, and a current is applied.

ANODIZING

The process of anodizing uses high voltage electricity in close proximity to liquids, so can be dangerous. Always keep the work area clean and dry, wear rubber gloves without holes in them while working, and ensure children and animals have no access to the equipment. Ensure that the equipment is correctly set up before starting to anodize, and seek advice if in any doubt.

Preparing the metal for anodizing

Titanium, niobium, and tantalum can be cleaned up in the same way as other metals and should be thoroughly degreased and cleaned with acetone before they can be anodized. The surface of the metal will directly influence the intensity of the colors produced through anodizing—etched titanium gives the brightest colors as the porous surface supports a thicker layer of oxides; matte surfaces give dull shades. The colored oxides produced are permanent but can be damaged through wear or scratching as they are only a surface effect. A range of different surface effects can be tested at a few different voltages to compare the effects, and find out which surfaces give a desirable effect.

Anodizing techniques

The metal being anodized must be attached to the anode, and suspended in the electrolyte—this will give one even shade on clean metal. A range of effects can be used, many relying on the fact that higher-voltage colors remain unaffected by anodizing at lower voltages. Masking off can be used to inhibit the formation of oxides on areas of the metal—nail polish or sticky-backed plastic are suitable stop-out methods—or oxides can be removed from an anodized piece with an abrasive to expose fresh metal, which can then be anodized at a lower voltage. Only metal that is in contact with the electrolyte will be anodized; this premise can be used to create bands of color, or special pens with conductive nibs can be used to draw designs on the metal.

Anodizing equipment

Basic anodizing equipment consists of a variable-voltage power unit, a plastic tank for the electrolyte, insulated leads, a cathode of platinized titanium mesh, and a 10 percent solution of ammonium sulfate for the electrolyte. Always keep the work area clean and dry and wear rubber gloves without holes while working.

ANODIZING

TECHNIQUE FILE
86

When an electric current is passed through refractory metals, it causes a colored layer of oxides to be formed on the surface. The color relates to the voltage used.

1 Attach the piece to the anode of the variable transformer using a titanium wire inserted through a drilled hole, so that the piece is submerged in the electrolytic solution. A piece of burr-textured tantalum sheet is being used for this sample.

2 Switch on the power, and gradually increase the voltage applied to the piece. The color may take a few seconds to develop. The voltage was increased to 135 on this piece, before being slowly reduced.

3 Switch off the power and remove and rinse the piece to check the color. Rub back the surface of the piece to expose fresh metal—the anodized color on the recessed texture will not be affected.

4 The piece can now be anodized again at a lower voltage (95 for this shade of orange on tantalum) without the first color changing.

Colors produced on refractory metals at specific voltages

When a current is passed through refractory metals the colors below can be achieved at the indicated voltages.

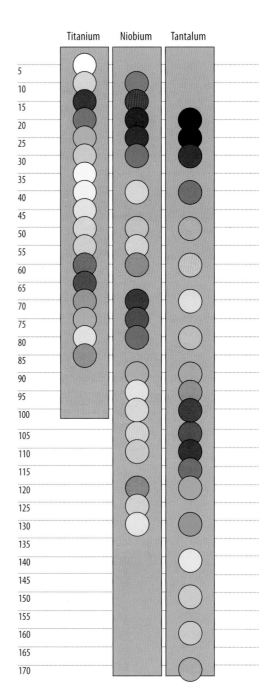

Metal leaf and powders can be applied to any nonporous surface, and are often used to add color to recessed areas of a piece. Many different shades of metal leaf and powder are available, so there is great scope for experimentation.

GOLD LEAF AND METALLIC POWDERS

The application of gold leaf is usually the final stage of a piece, unless elements will be cold-joined and the leaf is on a lower layer. Because leaf is only a surface application, it is prone to wear and is best used in recessed areas where it cannot easily be rubbed away. Recesses can be created by etching, carving, and rolling-mill texturing, or may be present due to the form of the piece, for example in anticlastic jewelry.

Metal surfaces should be clean, dry, and dust free. Porous surfaces should be sealed with a couple of layers of varnish and allowed to dry completely, otherwise the leaf will not adhere properly.

Applying gold leaf

There are a wide range of metal leafs available; in addition to a range of shades of high-karat golds, it is possible to source silver, platinum, palladium, aluminum, copper, and gilding metal, as well as heat-treated and mosaic leafs.

Gold size, which is the adhesive used to bond the leaf to a surface, is either oil-based or acrylic, and sizes with different drying times are available. A thin layer of size is applied to the piece with a paintbrush and left until it is tacky. "Transfer leaf," which comes on a sheet of tracing paper, can be applied directly—rub on the reverse of the sheet with a cotton swab to transfer the leaf to the size.

"Loose leaf" must be cut into manageable-sized pieces so that it can be more easily applied. Remove a leaf from its booklet and place it in a

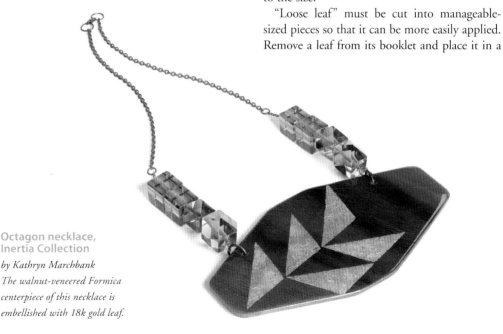

**Octagon necklace,
Inertia Collection**
*by Kathryn Marchbank
The walnut-veneered Formica
centerpiece of this necklace is
embellished with 18k gold leaf.*

GOLD LEAF AND METALLIC POWDERS

Gold leaf can be applied to any nonporous surface, using a special glue called gold size. This technique requires patience and a clean, draft-free work space.

1 Apply oil-based gold size to the area of the piece that will have leaf applied—recessed areas are more suitable because the leaf will be protected to some degree. Wash out the brush with white spirit and then detergent.

2 The size must be allowed to almost dry before the leaf can be applied, so check the manufacturer's recommendations for the drying time. Meanwhile, place a piece of loose leaf in some folded tracing paper, and cut it into small squares with scissors.

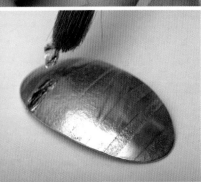

3 Use a large natural-hair brush that has been charged with static—you can rub it in your hair—to pick up a square of leaf and apply it to the size, which should be slightly tacky. Gently brush the edges of the square down, but do not use any pressure. Repeat this process until all the size is covered.

4 Metallic powder can also be applied to a piece with gold size in a similar way. Take care not to load the brush with too much powder—a little goes a long way. Gently brush away excess powder from the piece after 24 hours, when the size should be dry.

sheet of folded tracing paper; use scissors to cut squares of leaf from the main sheet. A natural hairbrush, or "gilder's tip" charged with static, can be used to pick up the leaf and apply it to the size. Gently brush the leaf into position, and overlap the squares slightly until the whole area of size has been covered. Allow the size to dry overnight before brushing away any loose edges of leaf.

Wax and varnish

Microcrystalline wax or transparent varnish may be applied over leafed surfaces to protect them. Varnish such as ormolu may be painted on, and aerosol varnishes can also be used to cover large areas evenly. Wax is applied sparingly with a soft cloth, allowed to dry, and then buffed.

Using metallic powders

Metallic powders can be used to give brightly colored surfaces or lusters to a piece and are applied to "tacky" gold size with a soft paintbrush. The size should be allowed to dry completely before the excess powder is gently brushed away. The powdered surface cannot be waxed or varnished to protect it, as the color tends to be adversely affected.

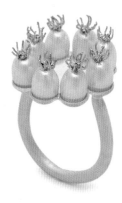

Laccotrephes japonensis ring
by Rui Kikuchi
Gold leaf accentuates the metal fronds that secure the pearls on this silver ring.

There are a wide range of leather-working techniques that jewelers can use—it is worth investigating processes used by shoemakers and bookbinders for more information. Leather is soft, flexible, and lightweight, lending itself to large pieces.

TOOLING LEATHER

Leather is often used for tools in jewelry making—for mallets, sandbags, work surfaces, and protective clothing. The properties of this material also make it ideal for making jewelry, and the type of leather used for a project will depend on the requirements of the piece—a wide variety of weights, colors, and effects, including metallic finishes, is available. (See Natural materials, page 82 for more information on leather.)

Embossing leather

Leather is much more pliable when damp, and can be stretched or compressed with the aid of formers or texturing materials that will leave a permanent effect. Deep impressions will work best on thicker leathers.

Clamp the leather together with a texture in a vise or hydraulic press until it is dry. Protect steel surfaces from moisture by placing a block of wood on either side of the pieces.

Alternatively, heated impression tools, which can be made from pierced or textured sheet soldered to a stem, warmed in an oven to 250°F (120°C) can be applied to dry leather; the heat and pressure of application causes the leather to compress permanently.

Another method of surface decoration is to draw on the leather directly with the tip of a heated soldering iron. This scorches the leather and can be used to execute accurate designs—the contrasts will be greater if a pale-colored leather is used.

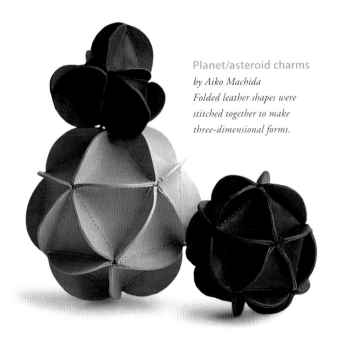

Planet/asteroid charms
by Aiko Machida
Folded leather shapes were stitched together to make three-dimensional forms.

EMBOSSING LEATHER

Textures and patterns can be permanently embossed in leather when it is dampened and the texture applied with pressure for several hours.

TECHNIQUE FILE 88

1 Place the leather in a container of warm water for a few minutes, to allow it to absorb water. Remove the piece, and pat it dry with paper towels to draw off the excess.

2 Position the leather over the metal template that will be used to emboss it and place a piece of wood on either side.

3 Clamp the pieces in a vise very tightly and leave overnight. It is possible to use a hydraulic press for this technique if one is available, and this is preferable, as a greater area of evenly applied pressure will be achieved.

4 Release the piece from the vise—the texture has been transferred onto the leather with a high degree of fine detail.

Boiling leather

Cut leather forms can be hardened in boiling water. The forms will shrink a little and may distort, but the process makes the material very rigid and durable, allowing other techniques to be applied.

Leather or vellum can also be formed using this process—use a piece of leather that is larger than the object it will be formed around and secure it tightly over the form using strategically placed stitches. When the piece is boiled, the leather will contract around the object and, once dry, forms a strong, hard three-dimensional form that can be accurately cut, and combined with other elements.

Once boiled, leather is hard enough to carve quite intricately and, if lighter material is exposed through this process, it can be dyed or stained to create color contrasts.

Other techniques for leatherworking

Leatherworking is another craft form entirely, involving specialist treatment of the material, and can be studied more fully if desired. Only a few leatherworking techniques can be mentioned here, and in brief.

For the jeweler, there is wide scope for handmade fittings, findings, decorative rivets, eyelets, or other metal components that may be combined with leather elements in the construction of pieces. Leather can be cut with a craft knife, or repeated forms can be stamped out using a specially made tool. The edges of leather forms should be sealed and polished to prevent them from fraying, and there is a range of specialist chemical solutions and waxes for these processes.

Finished texture
The finished leather texture, (see left).

Inlaid materials are set into recessed areas on a base sheet—traditionally, this is done by chiseling away metal and fitting wires into the spaces. There are a number of different ways of removing material from the base sheet, and almost any material can be inlaid into another.

INLAY

Mixed metals and mixed materials can be used to create flush areas of inlay. Wood, horn, mother-of-pearl, bone, ivory, and stone are all materials that are associated with inlay techniques in which one material is secured into the surface of another. Inlay can be used to create designs with any combination of materials, and variations include marquetry, micro-mosaics, and pique work, in which wires are pushed into drilled holes to create patterns formed of dots.

Carving method

This traditional method of inlay involves carving a recess in a base sheet with chisels, burrs, or gravers. Recesses can also be created with etching. When lengths of wire are inlaid into a channel, one end is tapped into the end of the channel with a hammer, and tack-soldered in position. The rest of the wire can then be chased along the channel to fill it, and soldered in place before being filed flush and cleaned up. Pierced forms of any material will need to have a matching recess carved in the base sheet; metal forms can be soldered in position and other materials can be fixed with epoxy resin adhesive. In both cases, the carving of the base sheet must be very accurate, as any gaps will be apparent in the surface once it has been cleaned up.

Piercing method

Two different colored sheet metals of the same gauge, about 18-gauge (1 mm) thick, are used for this technique. Pierce a shape out of one sheet, transfer the design to the other metal sheet, and cut a corresponding hole that is a little smaller

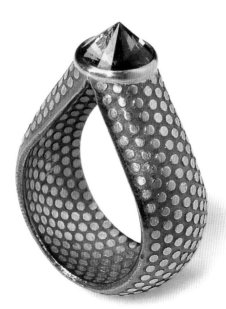

Ring, Grid Collection
by Salima Thakker
The inlaid metal can be seen on both the inside and outside of the ring shank.

SHELL-INLAID SILVER

Inlay requires the careful placing of pierced out elements into closely fitting recesses carved out of a base sheet. In this example, shell is inlaid into a silver base.

 TECHNIQUE FILE 89

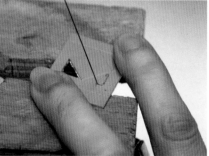

1 Mark out the design on 24-gauge (5 mm) silver sheet, and pierce out the recesses with a fine saw blade. File the recesses accurately to shape, before sweat soldering the pierced sheet onto a base sheet of the same size and thickness.

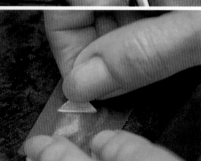

2 Apply the design to the sheet shell, and pierce out around the outline, ensuring that the form is very slightly larger than the recess in the metal so that it can be carefully filed to fit. Use water on the saw blade to minimize dust production, and true the edges with wet-and-dry paper.

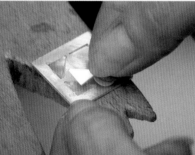

3 Ensure that the shell fits well and sits level in the recess before using a two-part epoxy adhesive to secure it in position. Allow the adhesive to dry.

4 The shell can be sanded flush using wet-and-dry paper and water, and polished. A layer of varnish will help protect the surface of the shell from wear.

than the pierced shape. File the hole until the shape fits inside. Ensure good contact between the two metals before soldering from the reverse.

Solder inlay

Recessed areas in a metal surface, such as those made by an impression stamp, can be flooded with silver solder and then filed back so that the borders are crisp—this method will only work when metals other than silver are used for the base, as it relies on the color difference between this metal and the silver solder. Work on sheet that is at least 20-gauge (0.8 mm) thick to allow for the depth of the recess and the filing involved.

Rolling-mill method

The effect of inlay can be created if pierced metal designs are sweat soldered onto a base sheet of a different colored metal, and thinned in the rolling mill until the surfaces are flush. Start with thicker sheet than is required for the final piece to account for the reduction in thickness caused by the milling. Several colors of metal can be used in the same piece and enhanced with applied surface finishes or patinas.

Inlay necklace
by Shelby Ferris Fitzpatrick
A subtle design in 18k gold was inlaid into this satin-finish silver pendant.

Mokume gane is a Japanese technique for creating metal that has the look of woodgrain by layering different colored metals and laminating them together. Mokume gane sheet or rod can be used as a starting material for the construction or applied decoration of jewelry objects.

MOKUME GANE

Copper, gilding metal, silver, and 18k or higher gold can be used for this technique. A piece of mokume may contain several different metals, or as few as two, which will give two-tone patterns.

The metal sheets used must be of a similar size and thickness, and cleaned so that they are without pits or deep scratches that could cause air pockets; prepare one sheet of each metal being used. Anneal the sheets, and ensure they are flat by hitting them with a mallet on a steel block—they must make good contact when stacked together. File a chamfer on one edge of each sheet and then degrease them with pumice powder and liquid detergent applied with a brush.

Making the billet
Holding the sheets by the edges, flux the faces with borax solution and stack the sheets up so that the filed chamfers are all on the same side.

Secure the stack with binding wire and place it on a heatproof mat, surrounded by a wall of soldering blocks to help keep the heat localized.

Heat the piece up quickly, and apply a stick of fluxed hard solder to the chamfered edges when the piece begins to turn red hot—the solder will be drawn through the layers as the heating continues, and will eventually be visible around the sides. Large tongs may be pushed down on the stack while the solder is molten, to force the layers together if they have warped. Once soldered, allow the stack, or "billet," to air cool slightly before transferring it to a steel block; this will draw the heat out more quickly than air cooling alone. Do not pickle the billet.

Increasing the number of layers
Run the billet through a rolling mill a few times to thin the sheet; work from the same end each

Patterned rings

by Royston Upson
A range of bold patterns has been created
on this series of mokume gane rings.

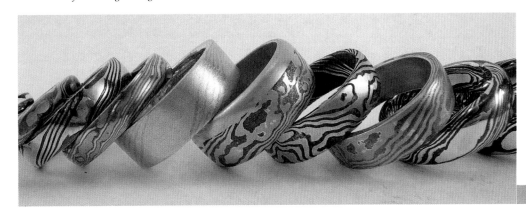

MOKUME GANE: MAKING THE BILLET

This process begins with the soldering of three 18-gauge (1 mm) thick sheets of different colored metals. Pieces of silver, copper, and gilding metal (1 in/2.5 cm) are used in this example.

1 File an angle on the edge of the bottom two sheets, to bevel them. Degrease all surfaces of the metal thoroughly.

2 Lightly flux the sheets with borax, before binding them in a stack.

3 Apply flux to a piece of hard solder, and stick feed the piece, making sure that solder has flooded in between each layer. Allow the piece to air cool. Remove the oxides using pumice powder applied with a brush, or wet-and-dry paper—do not pickle the billet.

4 Mill the billet to double its length and cut it in half. Keep milling in the same direction and from the same end, to prevent splitting. Mallet flat the two halves, and bevel the inner edge of the top sheet before stacking, binding, and stick feeding again. Repeat the rolling, cutting, and soldering processes until the desired number of layers is achieved.

time and continue until the billet is twice its original length.

Cut the piece in half, flatten it, and bind again before stick feeding solder between the two layers.

The process of milling, cutting, and soldering is repeated to create as many layers as is desired.

The number of layers determines the final pattern of the mokume—few layers will give wide bands of color and greater numbers of layers will produce fine striations—the samples produced here have 24 layers, but up to 80 can be used before the visibility of the different bands is affected.

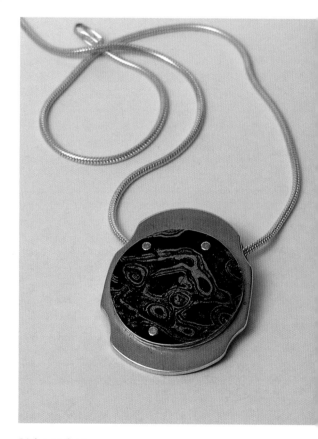

Disk pendant
by Paul Wells
A heat-patinated mokume disk was riveted onto a silver pendant base. Silver, copper, and gilding metal were used in the mokume.

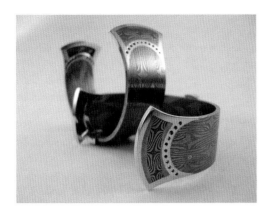

Bracelets

by Royston Upson
Patinated mokume gane sheet has
been formed and fabricated to
make these open bracelets.

Creating the effect

The pattern in mokume gane is created by removing areas of metal to reveal the differently colored layers. This can either be achieved through drilling and burring into the surface of the sheet, or by displacing areas of the sheet by punching or chasing them and filing away raised areas. The sheet is then milled until the depressions have been leveled out; it can be annealed when work-hardened during this process, but do not pickle it until the milling is complete.

Drilled holes will give concentric circles once milled, as will dots made with a hammer and punch. Burrs can be used to widen and join drilled holes to create a woodgrain effect. Simple geometric design can be chased into the billet; the whole sheet may be disrupted, or just a few selected areas.

The deeper the marks are, the more layers will be revealed; but take care not to go too deep, especially when drilling, as the sheet will need to be made very thin to even out the depressions.

Enhancing the effect with patinas

The color that is left on the sheet after the final round of milling can be left as the finish if wished. Pickling the sheet will reveal the true colors of the metal but they will be matte—a surface finish such as satin can be applied; the choice of surface finish will depend on the piece it will be used for.

MOKUME GANE: REVEALING THE LAYERS

TECHNIQUE FILE

The pattern is created on mokume gane by carving or disrupting the surface of the laminated billet so that the different colored layers of metal can be exposed.

1 Clamp the piece in a drill vise, and set the depth gauge on the drill so that the bit cannot cut too deeply into the billet. Using plenty of lubricant, drill some holes in a random pattern.

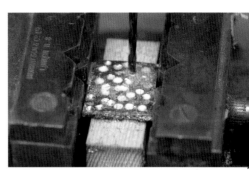

2 For a true woodgrain effect, burr across the drill holes using the side of a ball burr. The top layers of metal should be virtually removed during this stage.

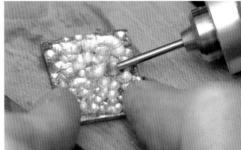

3 Another method of texturing the sheet to expose the layers is to hammer a dapping punch into the billet while it is supported on softwood. This will make deep depressions.

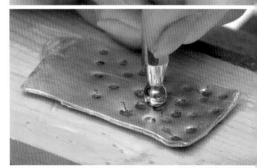

4 A rough file is used to remove the raised areas of the billet—this method creates concentric circles.

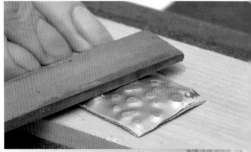

MOKUME GANE: COMPLETING THE EFFECT

TECHNIQUE FILE 92

Once the billet has been carved, it must be milled to make a flat piece of sheet. A range of patination techniques can then be applied to enhance the colors of the different metals.

1 Anneal the piece, ensuring the temperature never rises above the melting point of the solder, or it will flood over the surface and obscure the pattern. Thin the piece in the rolling mill until the surface is completely smooth.

2 The finished sheet of mokume can be treated in a number of ways to create different color combinations. This sample shows the finish on the metal before it is pickled.

3 When the piece is pickled to remove the oxides, the colors of the silver, copper, and gilding metal can be clearly seen.

4 This coloring was achieved by heating the piece gently with a torch until the colors developed—the base metals are affected more than the silver.

5 The piece was immersed in an oxidizing solution for base metals, and removed and rinsed before the colors developed into black.

Heat patinas develop at different rates for different metals and can be used to create stronger definitions between the colors of metal. Overheating may lead to dull, even tones—simply pickle the piece and try again if it doesn't work the first time.

The sheet can be immersed in a dilute chemical patina solution, such as black antiquing fluid, which will not affect the precious metals. The solution is made weak so that the colors will develop more slowly and the progress can be checked at regular intervals before the patina gets too dark.

Mokume can also be etched; if a combination of base and precious metals are used in the sheet, then ferric chloride can be used to remove the exposed base metals from the piece, giving a raised grain effect.

Working with mokume gane

It is possible to bend or form sheets of mokume, but as there is a risk of cracking the surface—only minimal stretching should be used, with wooden or nylon mallets and formers.

Because of the solder present throughout a piece of mokume, any subsequent heating of the piece (including annealing) risks movement of the solder, which may damage the surface effect or weaken the structure of the sheet. It is therefore better to use cold-joining techniques such as riveting, screw threads, or bezel setting to incorporate elements of mokume within a piece of jewelry.

Pierced elements can be applied to other forms, and sections could be used for inlay or mosaic designs set into a range of materials.

Many different materials can be used in combination to make laminates, creating bands of color. Once the layers of material have been bonded, they can be cut, carved, and drilled to expose the striped edges.

LAMINATION

Lamination is a technique for combining layers of different metals or materials. The layers are permanently bonded together so that they can be cut or carved as if one; the type of bonding used will depend on the materials used, and the way in which the resulting laminate will be worked. Metals can be soldered with the stick feeding method (see Mokume gane, page 225), but other materials will need to be bonded with a suitable adhesive, or drilled and riveted.

A wide range of materials can be used for this technique, allowing plenty of room for experimentation and interesting color or material combinations. Any thin rigid sheet material can be used—shell, stone, hardwood veneers, acrylic—to name a few! If the resulting piece will

be subject to wear, then it is advisable to face the laminate with a harder material that will protect the softer layers inside.

Working with laminated sheets

The sheets that will be laminated must be flat—some materials may need sanding to create an even surface before they can be joined. Epoxy resin adhesive is suitable for joining most materials and forms a strong bond; apply glue to one side of each sheet and sandwich them together before clamping the stack in a vise, or under a heavy weight to force out any pockets of air.

Once the adhesive is completely dry, the stack can be cut and carved—angled edges will make

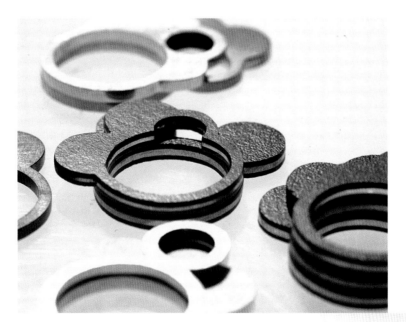

Cluster rings
by Frieda Munro
Layers of pierced Formica
and metal were laminated
together to make this set
of playful rings.

LAMINATING MIXED MATERIALS

TECHNIQUE FILE 93

In this example, slices of a hardwood are combined with transparent gray acrylic in alternating layers to make a carved form with contrasting stripes.

Layered rings
by Akiko Furuta
Soldered laminate metals form the shanks of these stone-set rings.

1 Cut sheets of two different materials, and ensure they are clean, dry, and dust free before continuing.

2 Mix up some two-part epoxy resin adhesive and apply it to one side of each piece of sheet. Layer up the parts so that the materials alternate, and wipe off any excess adhesive.

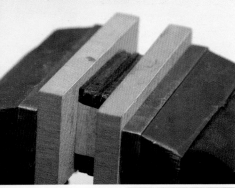

3 Wrap masking tape around the pieces, and place a piece of wood on either side so that the surfaces are not damaged when the piece is clamped in the vise. When the adhesive begins to "go off," tighten the vise a little more to ensure good contact between the layers.

4 When the adhesive has completely set, remove the piece from the vise. It can now be cut and carved to expose the different colored layers to great effect. Use files to refine the form, and wet-and-dry paper to clean up the surfaces before polishing.

the bands of color appear wider, and this can be achieved by carving, grinding, or filing the piece. Be aware that softer materials will carve more easily than hard, and will be worn down much more quickly during the cleaning-up process.

Laminating acrylic

Sheets of acrylic can be bonded together using heat and pressure alone. The pieces of acrylic must be completely clean for the process to be successful; stack the acrylic, in alternating colors and place the stack on a wire rack in a kiln or oven preheated to 355ºF (180ºC). The plastic needs to reach temperature all the way through, so the more layers there are the longer this will take—check the piece at regular intervals to make sure it is not overheating. Once heated through, remove the stack from the kiln and place a very heavy weight on top, leaving it in position until the plastic is completely cool. The layers should have bonded, and the acrylic can be cut and carved as if it were one piece.

It is possible to sandwich thin textures between the layers of acrylic, and gold leaf can also be very effective if used with transparent or translucent acrylic.

Enameling involves fusing colored glass to the surface of copper, silver, or gold. The range of colors and designs that can be applied in this way is vast, and the range of techniques that can be used reflects this.

ENAMELING

Copper, sterling silver, Britannia silver, fine silver, and 18-karat gold are all suitable for enameling onto.

The thickness of the sheet metal used for projects should be around 18 gauge (1 mm), and thicker if etching or textures are recessed in the surface.

Metal should be annealed and pickled, before it is thoroughly scrubbed with pumice powder.

A glass brush is then worked over the surface that the enamel will be applied to; work under running water until the water can form a continuous sheet over the surface and does not pull back from the edge. Rinse the piece in distilled water and dry it, taking care not to touch the prepared surface.

Fabricated pieces should be treated in the same manner to prevent contamination of the enamel and ensure successful results.

Scrafitto test pieces
by Ashley Heminway
The top layer of enamel
was scratched through
before it was fired,
to expose the color
underneath. A range
of designs has been
explored here.

ENAMELING: PREPARATION

Preparation is an important part of enameling. The work space must be clean and dust-free and the enamels must be carefully washed before use.

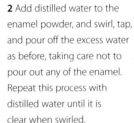

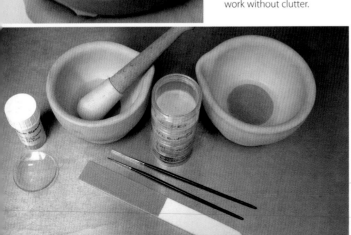

1 Place some powdered enamel in a mortar and add tap water. Lightly grind with a pestle to remove any lumps. The water will become cloudy—swirl the mortar and tap it with the pestle to settle the enamel grains at the bottom. Wait a few seconds before draining off the excess water.

2 Add distilled water to the enamel powder, and swirl, tap, and pour off the excess water as before, taking care not to pour out any of the enamel. Repeat this process with distilled water until it is clear when swirled.

3 Transfer the enamel to a small plastic container with enough distilled water to cover the surface and label the container with the color of the enamel. Organize your work space so that all the required equipment is close at hand, and there is enough space to work without clutter.

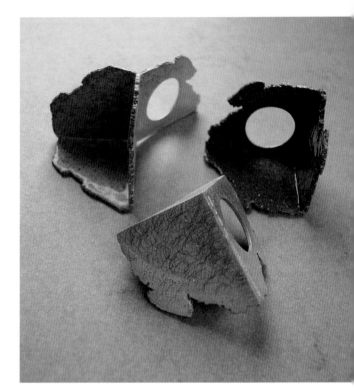

Corner rings
by Margareth Sandström
Enamel adds color to parts
of these silver rings.

Preparing the enamels

Enameling requires meticulous method and preparation. It is very important to maintain a clean work space—any speck of dust or oxide that gets into the enamel can be permanently fired in a piece, causing a blemish. To minimize the risk of this happening, do not prepare enamels next to the kiln, and always keep enamels covered, whether they are wet or dry. Spilled enamel powder should be cleaned up with a damp cloth—any dust is hazardous to health; for this reason enamels should always be applied by the wet-packing method rather than sifted.

Powdered enamels need careful washing to remove any impurities before they can be used (see left). Once washed, enamels can be stored in distilled water for up to one month before they need to be washed again.

Wet-packing powdered enamels

Transfer some enamel from its storage container to a shallow dish. The enamel is applied to the prepared metal in neat rows with a quill or paintbrush—start on one edge, and build up the rows until the whole surface is covered. The enamel should only be two or three grains thick.

Tap the edge of the piece with the paintbrush to settle the grains, and draw off the water carefully with a paper tissue. Any enamel that has been disrupted from the edge should be repaired before continuing. Place the piece on a wire rack and leave it on top of the kiln for a few minutes to dry out; the enamel must be perfectly dry before it is fired. Take care when moving pieces around, as knocks can dislodge enamel grains.

Counter-enameling

The action of the enamel cooling and contracting on the surface of a metal sheet can cause it to warp. This can be avoided by firing a layer of counter-enamel on the reverse of the piece, so that there is equal force on both sides. Counter-enameling is mainly used when working with flat sheet, as the structure of curved or domed metal forms means they have enough integral strength to withstand these forces and so do not usually need counter-enameling, unless they are reasonably large.

Counter-enamel is made up from scraps of other enamels, and is usually hidden in the construction of a piece; the reverse of a piece is fired before work starts on the front surface.

Firing enamels

The kiln should be preheated to 1600°F (870°C). This is hotter than the melting point of many enamels, but it is better to fire enamels quickly at a higher temperature than to slowly heat them at a lower one.

Wearing a thick leather glove, use a spatula under the wire rack to transfer the piece to the center of the kiln, and close the door. The enamel should take between one and two minutes to fire—the time will vary depending on a number of factors, such as the thickness of the metal used, how long the kiln door was left open for, or the melting range of the enamel being fired. A glossy

COUNTER-ENAMELING

TECHNIQUE FILE

To prevent the metal from warping when it is enameled, a layer of counter-enamel is fired on the underside of the piece. Counter-enamel is usually made up from scraps of unused enamel powder.

1 First, anneal and pickle the silver, then scrub it with a glass brush under running water. When the metal is completely degreased, water should cover the surface completely without drawing in at the edges.

2 Handle the dry piece only by the edges. Use a paintbrush to apply a row of counter-enamel along one edge. Build up rows until the whole surface is covered. Carefully tap the edge of the piece with the paintbrush to even out the enamel grains. This process is wet-packing.

3 Use a paper tissue to draw the water out from the enamel. Apply the tissue to the very edge of the piece, taking care not to move the enamel. Place the piece on a trivet and leave it to dry on top of the kiln.

4 Fire in the kiln, which should be preheated to 1600°F (870°C). When the surface of the enamel appears glossy, remove it from the kiln and allow it to cool on a heatproof surface in a draft-free place.

5 Pickle to remove the oxides, before cleaning the front surface in preparation for wet-packing and firing enamel onto it.

ENAMELING: GOLD FOIL OPAL CUFFLINKS

TECHNIQUE FILE 96

Pure gold or silver foil may be fused to a layer of enamel and, when subsequent layers are fired over the foil, a bright contrast is created within the piece. Opalescent enamel is fired over 22-karat gold foil in this example.

1 Fire a layer of clear flux over the surface of the cufflink top. Pickle the piece and clean the surface of the enamel with a glass brush. Rinse the piece in distilled water. Apply a piece of foil with a damp brush and ensure the edges are making good contact with the enamel. Leave to dry.

2 Fire the piece at 1450°F (780°C) for about 90 seconds—the foil should fuse to the layer of flux.

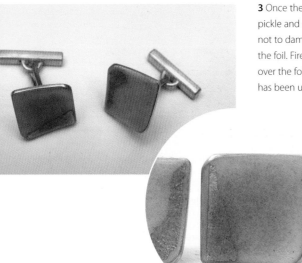

3 Once the piece has cooled, pickle and clean it taking care not to damage the surface of the foil. Fire a layer of enamel over the foil—opalescent blue has been used here.

surface indicates that the enamel has melted and fused—remove the piece from the kiln as soon as this appears. If the surface looks like orange peel, then the enamel is not hot enough to truly fuse and should be returned to the kiln. Allow the piece to air cool in a draft-free area.

Oxides that have formed on the metal should be removed with pickle, or an abrasive stone. The enamel surface should always be cleaned with a glass brush under running water to ensure it is absolutely clean before further layers of enamel can be added.

Foils and lusters

Gold and silver foils can be fired with enamel to create highlights and intensify areas of color, or left exposed as a surface effect. These foils are thicker than leaf, and are made from pure silver or gold.

The foil can be cut or torn to shape, but should not be touched with the fingers. Fire a layer of flux onto the metal and allow it to cool completely before cleaning the surface of the enamel.

Apply the piece of foil with a damp paintbrush, using a little distilled water to seal the edges down. Leave the piece on top of the kiln for an hour or so—it must be absolutely dry. Fire until the surface of the enamel begins to turn glossy, and allow it to cool; if the foil has not bonded properly, burnish down the edges and return it to the kiln. Layers of transparent enamel can now be fired over the foil, which will stay shiny underneath, giving the colors a vivid quality and the impression of depth.

Liquid lusters are very finely ground metal particles in an oil-based medium, and come in a range of colors. They are fired over enamels and can be made to produce special effects such as pearl finishes, veining, or crazing. Once cooled, lightly burnish the luster with a glass brush.

Enameling over textured surfaces

Etching, carving, engraving, texture stamps, and rolling-mill textures can all be used to create an effect under transparent enamels, in a technique known as "basse-taille."

Paler, transparent colors will give the best effects; where the impressions are deeper, the color appears darker because the layer of enamel is thicker in those areas, with subtle shading between. Darker enamels tend to obscure the underlying texture, but several layers of a subtle shade will give more intense hues in deeper areas of the design.

Champlevé enameling

This is an enameling technique in which etched recesses in a metal sheet are filled, giving the effect that the areas of enamel are bounded by a metal border. The metal should be at least 18 gauge (1 mm) to begin with, and the recessed areas etched to about half the depth—PnP resist is useful for etching accurate graphic designs or text for use in champlevé, (see page 200).

The surface of the metal and the recesses must be thoroughly cleaned before the enamel can be packed in. Fire several thin layers of enamel until it is flush with the raised surface of the metal. The surface should be ground smooth with a diagrit pad before it is given a final flash-firing to return the shine to the enamel.

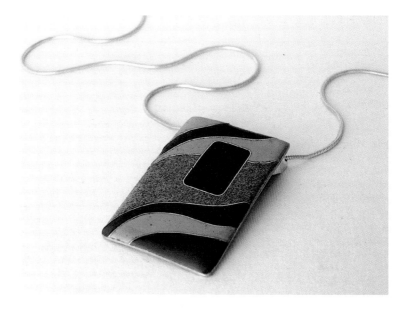

Blue pendant
by Georgie Dighero
Fine silver wire divides the different shades of blue enamel on this silver pendant.

Plique-á-jour earring
by Anastasia Young
This 18-karat yellow gold ear stud is decorated with stained glass window effect plique-á-jour enamel (see page 236).

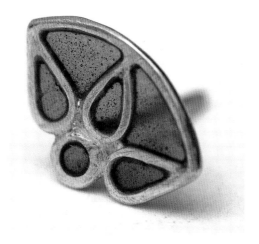

Using cloisonné wire

Cloisonné wires are used to create small cells or "cloisons," into which enamels can be packed. This allows clear definition between colors so that precise designs can be executed. Work out the design on paper first, before using pliers to bend the fine wires to shape. The flat wires must be relatively short, otherwise they cause internal stresses within the enamel that can make it crack, and the wires must be bent or curved so that they can sit up, side-on.

The base sheet used for cloisonné pieces should be of Britannia or fine silver—many firings mean that firestain is likely to develop under the enamel on sterling silver. The sheet should be annealed, pickled, and cleaned before a layer of counter-enamel is fired on the reverse and a layer of flux on the top, which should be ground flat before the wires can be applied.

Dip the wires in a solution of Klyr-fire gum diluted 1:1 with distilled water, and position them on the flux. The gum must be allowed to dry before the piece is fired—careful timing is important here, as the wires must sink slightly into the flux so they bond in place and a thin,

ENAMELING: CLOISONNÉ

TECHNIQUE FILE 97

Thin wires of fine silver or gold are used to create a design that is fired into a layer of flux. Colors can then be packed in and around the wires, which allow clear definition between the different colors.

1 Prepare the fine silver cloisonné wires by bending them into shape—it is useful to work to a drawing. As the wires need to sit on their edge without falling over when fired, curves or bent angles will produce the most successful designs.

2 Fire counter-enamel to the underside of the silver disk, and flux to the front. The flux must be ground completely flat—use a diagrit pad under running water and dry the disk to check progress; all areas should be matte. Clean with a glass brush.

3 Dip the wires in diluted gum and apply to the fluxed side of the disk. Do not allow the wires to become flooded with gum—a small amount is sufficient. Take care not to move the piece until the gum is dry or the wires may move out of position.

4 Fire the piece to fuse the wires into the flux—they will sink into the surface slightly. When the piece is cooled and has been cleaned, different colors of enamel can be wet-packed into the cells. Several rounds of packing and firing may be needed. Grind and flash-fire the piece.

shiny line should be visible around the base of each wire. Allow the piece to cool and clean it thoroughly before continuing.

The cells can then be wet-packed with different colors of enamel in thin layers and fired, until the enamel reaches with the top of the wires. Grind down the enamel so that it is flush with the wires, and curves down to the edges of the metal, and flash-fire to restore the glossy surface.

Cloisonné panels can be relatively thick, and may be carefully set using fine silver bezels (see page 238), or spectacle settings (see page 250).

Plique-à-jour

Plique-à-jour translates as "light of day" and is used to describe transparent enamels that have been fired into a pierced framework or wire structure without a metal base, allowing light to pass through the enamel. Paler colors will be give a better effect than darker ones, unless the piece will be viewed under very bright light.

The simplest form of plique-à-jour is made by wet-packing drilled holes with enamel, but pierced sheet and wire forms are also ideal for this technique and allow greater design variation. Round-section wire should be used as it holds the enamel better than the parallel walls of square or flattened wire.

Because the area containing the enamel is open-backed, during packing and firing the piece should be supported by a piece of sheet mica that will prevent the enamel from falling out. Once enough layers of enamel have been fired into the cells to reach the top surface of the metal, and any gaps have been filled, the piece can be cleaned up and flash-fired without the mica to give a perfectly shiny surface. (See page 235 for an example of plique-à-jour enamel.)

STONE SETTING

Stones can add color, light, and allure to a piece of jewelry, but choosing the right style of setting for a particular stone and securing it permanently in position are crucial to the success and longevity of a piece, especially as the stone often forms the focal point. The method of setting will depend either on the type of stone, which may determine how it is set due to its hardness or shape, or the design that may dictate the way in which a stone or stones are incorporated into a piece of jewelry to maximize the effect. Jewelry that is worn on a daily basis must be durable and comfortable, so the stones must be resistant to wear and tear and the setting robust so that it doesn't loosen over time. Occasional jewelry need not be so practical, so the range of settings that can be used is much greater, allowing a greater arena for creative solutions to fix the stones in place with metal.

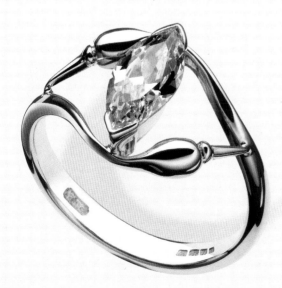

Swan ring
Page 240

A basic bezel is the "wall" that sits around a stone and, once it has been rubbed over, holds the stone securely in position. The basic bezel may be used with both cabochon and faceted stones, and can be constructed from sheet metal, or made from tubing.

BASIC BEZEL OR TUBE SETTINGS

As well as basic bezels, which are described on these two pages, jewelers also use cone-shaped bezels, which are discussed on pages 240–241.

Setting a cabochon

Cabochons are usually domed, unfaceted stones that come in a variety of shapes and sizes, (see page 306 for stone shapes). The bezel used to set a cabochon must be accurately formed to fit the shape of the stone, whether round, square, pear-shaped, or freeform—round and oval are the least challenging forms to make. Soft or fragile stones should be set with a bezel made from fine silver or gold, as these metals are softer than

standard alloys. A flat-ended pusher, which has been matted with emery paper to keep it from slipping, is used to gradually compress the metal around the diminished circumference of the curve of the stone.

Setting a faceted stone

Faceted stones can also be set using the rub-over method, but the construction of the setting must account for the difference in shape of the stone. Often tubing is used to form the bezel—choose a size of tube that has a smaller inside diameter than that of the stone, and a larger outside diameter. A round burr that is the same diameter

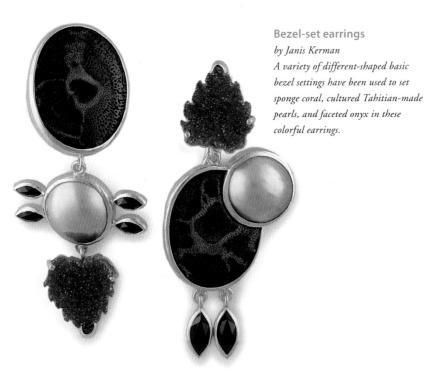

Bezel-set earrings
by Janis Kerman
A variety of different-shaped basic bezel settings have been used to set sponge coral, cultured Tahitian-made pearls, and faceted onyx in these colorful earrings.

as the stone can then be used to "burr down" into the tube so that the stone sits just below the surface; the wall is then set around the edge of the stone in the same manner as for a cabochon.

Constructing a bezel

The construction of a basic round bezel is similar to that of a band ring, but the bezel must fit the stone accurately. 26-gauge (0.4 mm) sterling silver or 28-gauge (0.3 mm) gold sheet can be used to form the bezel wall. The circumference of the stone can be measured mathematically, or by wrapping a piece of paper around it. Once formed, soldered closed, and trued on a mandrel, the internal diameter of the bezel should be checked by dropping the stone into it from above; the stone should fit snugly into the bezel without any trouble. If the bezel is too tight, it can be gradually stretched on a mandrel with a mallet, but if it is too big, then it will need to be cut smaller and resoldered.

The process for soldering a basic bezel onto a ring shank is illustrated on page 101.

Cabochons that are not polished on the back will require a closed-back setting. To make an open-backed setting, which will allow light to pass through the stone, the base sheet of metal onto which the bezel is soldered may be pierced out underneath to leave a border around the edge, on which the stone is supported. If the cabochon is a particularly shallow cut, it may be desirable to use a bearer, or wire soldered into the base of the setting, to raise the height of the stone. Other variations to the technique include piercing, filing, or carving the bezel to add interest, but take care that these decorative features do not weaken the bezel wall.

The curve of the dome will affect the height of the bezel, as only a small amount of metal needs to be rubbed over the stone to hold it in position—look at the stone from the side to see where it starts to curve, and work out the height of the bezel you need, giving less than 1/32 in (1 mm) extra. If the bezel wall is too high, more of the stone will be covered than is necessary.

BEZEL-SETTING A CABOCHON STONE

This technique is continued from "multiple solder joins in one piece," see page 101, and demonstrates how to set an 8-mm cabochon into a basic fine silver bezel cup on a ring shank.

1 Check there are no burrs on the inside edge of the setting, before carefully inserting the stone so that it sits level, and is touching the base of the bezel cup. Set the ring in a ring clamp—this will provide steady support while you are setting.

2 Rest the ring clamp against the bench peg for support. Using a flat bezel pusher, apply pressure, side-on to the bezel wall at its base. Push in at "north," "south," "east," and "west"—this is so that the bezel will contract at an even rate around the ring.

3 Continuing to work directly side-on to the bezel wall, apply pressure at "northeast," "southwest," "northwest," and "southeast." Any gaps can then be closed by applying pressure, but keep working from one side to the other with the pusher at a low angle.

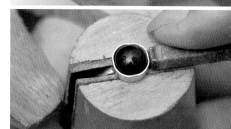

4 Use the pusher at a higher angle, to force the middle and top edges of the bezel against the stone. Keep working from opposite sides until the metal is flush around the stone.

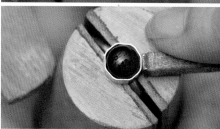

5 Use a burnisher to rub the very top edge of the bezel around the stone so that there is no sharp edge. The bezel may need to be cleaned up and polished after setting—but take care not to damage the stone.

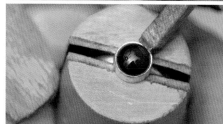
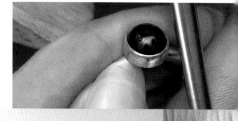

Cone-shaped bezel settings are used to hold faceted stones, and are made using a bezel block. Cone-shaped bezels can be used as a solid form, or pierced and carved to allow more light to enter the stone.

CONE-SHAPED BEZEL SETTINGS

Making a cone-shaped bezel

Traditionally, cone-shaped bezels are made from sheet metal, and you need to make a template in order to construct a cone that has the correct proportions for a particular stone.

The shape bounded by GEFH (see panel, right) is the template for the cone. Transfer this to metal and pierce it out, then form and solder the join closed. The cone can then be trued in a bezel block—the taper of the cone will dictate whether a 17-degree or a 28-degree bezel block and punch should be used.

Cone-shaped bezels can also be made from tubing that has been stretched and compressed in a bezel block, but it is difficult to ensure that it stretches evenly and that the top and bottom surfaces stay true.

Cone-shaped bezels can be pierced or carved to create gaps, and this is one method for making prong settings. Gaps in the bezel will allow more light to enter the stone, while solid bezels will intensify the colors of pale stones.

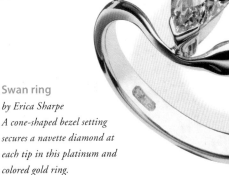

Swan ring
by Erica Sharpe
A cone-shaped bezel setting secures a navette diamond at each tip in this platinum and colored gold ring.

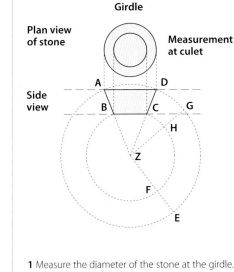

Cone-shaped bezel template

Girdle

Plan view of stone

Measurement at culet

Side view

1 Measure the diameter of the stone at the girdle. Use this measurement to draw A–D.
2 Measure the vertical distance from the girdle to the culet, allowing extra if you are making prongs as part of the cone = AB–DC.
3 Use these measurements to draw lines, continuing AB and DC to meet at Z.
4 Draw a circle, center Z, with a radius DZ.
5 Draw a second circle, center Z, with a radius CZ.
6 Use dividers to measure the distance AD, and mark this dimension on the outer circle starting at a point G three and one seventh times (π), and mark this point E.
7 Draw in line GZ.
8 Draw in line EZ.
9 Make points H and F on the inner arc.

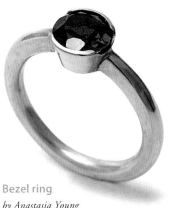

Bezel ring
by Anastasia Young
This synthetic ruby is set in a
cone-shaped bezel on a silver
ring shank (see right).

Placing the setting

Single cone-shaped bezels can be applied to a range of jewelry forms, including earrings, pendants, and rings. When set into a ring shank, the bezel can be inserted into a filed gap with the base of the bezel sitting level with the inside of the shank; cone-shaped bezels can also be soldered on top of a shank so that they stand proud. Multiple bezels should have enough of a gap between their top edges so that the setting tool can easily get in between.

Soldering the bezel in position will anneal it in preparation for setting the stone. Polish the inside of the setting before proceeding—it is important that the metal is reflective so that maximum light-play is achieved within the stone.

Seating the stone

Place the ring in a clamp, and file the top of the bezel so that it is level. The stone's girdle should sit halfway across the width of the bezel wall. Use a ball burr the same diameter as the stone to carve the seat—this will remove sufficient metal from the setting to allow it to be easily set and it should not need to be thinned.

The cone-shaped bezel is pushed over the stone in a similar way to basic bezel setting, working "north," "southeast," and "west," before closing all the gaps and burnishing the metal flush. If sterling silver is being used and if the bezel wall is not of equal thickness, it may be necessary to "chase" the metal over the girdle, using a small hammer to tap the pusher, giving it more force than would be possible by hand.

CONE-SHAPED-BEZEL SETTING A FACETED STONE

In this example, 19-gauge (0.9 mm) silver sheet is used to form a cone-shaped bezel setting for a 5 mm brilliant-cut synthetic ruby. The ring shank is formed from 8-gauge (3 mm) round wire.

1 Pierce out the bezel template from the sheet, and form it into a cone using half-round pliers. Ensure the ends meet neatly before soldering the join. File and clean up the bezel.

2 True the bezel in a bezel block. Cut a gap in a ring shank and file the ends with a crossing needlefile so that they fit the curve and angle of the bezel. Solder the bezel into the shank, and then clean up the form.

3 File the top surface of the bezel until half the wall is visible around the stone. Use a ball burr exactly the same size as the stone to burr down into the bezel, until the stone's girdle sits just below the top of the bezel. A graver can be used to make fine adjustments to the inside of the setting.

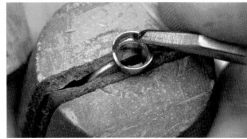

4 Position the stone in the setting using a wax stick, and ensure that the stone sits level in the setting before using a pusher to chase the bezel over the edge of the stone.

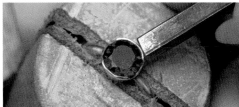

5 Use a burnisher to smooth the metal so that it is flush against the stone, then clean up and lightly polish.

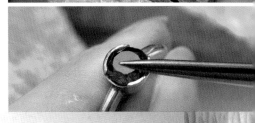

This type of setting uses thin metal prongs (also known as claws) to hold a faceted stone, allowing the maximum amount of light in around the stone, so that the internal reflections are intensified. Prong settings are usually made from hard metals such as yellow or white gold, or platinum.

PRONG SETTINGS

Prong settings from cone-shaped bezels

Cone-shaped bezel settings can be adapted to form prong settings by filing "V" shaped sections at regular intervals on the top and bottom edges of the bezel; these must be evenly spaced, otherwise the width of the prongs will not be equal. The number of prongs should be three or more, and is determined by the number of filed areas on the bezel. A jump ring is soldered to the base of the filed bezel to close the base, giving the effect that the setting has been pierced.

Constructed prong settings

You can make prong settings from wires that are soldered to each other in a cage construction; placing wires individually to form prongs can be troublesome, and it is far easier to use one wire to form an opposing pair of prongs, either by bending the wire into a U shape or by forming a cross from two wires before continuing with construction. The wires for the prongs can be soldered directly onto the shank, or into drilled holes, which will give them greater strength. Wire prong settings can be used to create open structures that will allow light to enter the stone, and offer far more design possibilities than bezel settings. The design must account for the strength of the metal and its resistance to bending if caught, so prongs should be made in a hard metal such as white gold, palladium, or platinum—especially if they are holding a valuable gemstone. You can use silver to make prong settings, but the gauge of the wire used will need to be much thicker than for other metals. It is possible to buy prefabricated prong settings, but these lack the charm of handmade settings.

High-set rings
by Linnie McLarty
Faceted amethyst and garnet have been set into exaggerated prong settings in these silver rings.

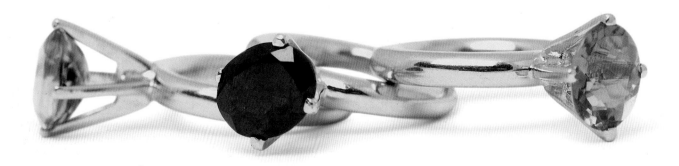

"He loves me this much" ring
by Sonja Seidl
The different-sized prong settings on
this ring allow stones appropriate to
any budget to be set.

Seating the stone

The stone must sit evenly within the setting: if the girdle is not touching each prong, then adjust the angle of the prongs until it does—make sure that the prongs look even overall. Then mark inside the prongs at the level at which the stone will finally sit—it is crucial that the marks are all at the same height, otherwise the stone will not be level once set. Use a graver or bearing cutter burr to remove a small amount of metal from the inside of the prong for the stone to sit in—the stone should click into position, and be held level while it is cut. It is often necessary to thin the tips of the prongs with a file before setting, otherwise the thickness of the metal prevents it from moving easily.

A prong pusher, which is a setting tool with a groove in the end for the prong to sit in, is used to push the tip of the prong over the girdle. The prongs must be burnished down flush with the stone so that there are no edges that could catch.

PRONG-SETTING A FACETED STONE

TECHNIQUE FILE 100

This example uses square-section wire to construct a prong setting, which is soldered onto a ring shank made from square wire. The stone used is a 6 mm cubic zirconia (synthetic diamond).

1 Bend two pieces of thin, square-section wire into identical "U" shapes. Cut a small section of tube, and file both sides flat. File a groove on either internal side of the U-shaped wires so that the tube can be held horizontally in place. Solder the pieces together, ensuring they are centrally located.

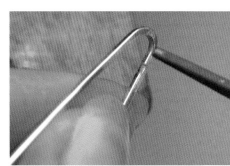

2 Cut a gap at the base of the first wire, so that the second can be soldered in place. Cut the wires at the base to fit the ring shank, and file accurately before soldering the two pieces together. Clean up the ring, ensuring that the inside of the setting is polished, and cut the prongs shorter.

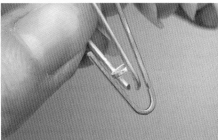

3 Put the ring in a ring clamp, and use dividers to mark each prong at the same height—the marks should be a little lower than where the stone sits in the setting. Use a fraise burr (see page 309) in a flexshaft motor to carve a small groove in each prong—they must be at the same height or the stone will not sit level.

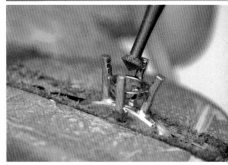

4 File the tips of the prongs so that they are thinner and can be more easily set; only remove metal from the outside edge, and around the tips, before cleaning up the surface. Click the stone into position. Use a prong pusher to force the tip of each prong over the stone, and burnish the metal flush. Clean up the setting.

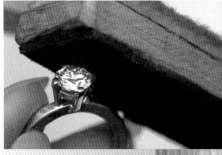

Faceted stones can be set into a recess in a piece by burnishing the edges of the metal around the girdle of the stone; this makes the stone appear flush with the surface of the metal form. This type of setting is also called gypsy setting.

FLUSH SETTINGS

Forms for flush setting

Flush setting is often applied to curved surfaces, as the method of setting is made easier by having raised edges. The metal should be at least 18-gauge (1 mm) thick to support the stone and withstand the pressure applied during setting. The culet of the stone should not project out from the underneath of the metal form, especially if stones are being flush set into a band ring, as they will dig into the finger uncomfortably. Domed thick sheet is ideal for flush setting, as are curved cast forms. The piece of jewelry should be finished and polished before setting begins; protect the piece from slips with masking tape, use a piece of leather over the bench peg, and work in a ring clamp or use setter's wax on a block or stick if appropriate.

Certain types of stone, which can be prone to fracture because of their crystal structure, are not suitable for flush setting and may chip or fracture during setting.

MBR series rings
by Anastasia Young
These cast multiple rings were hand engraved and flush set with garnets, green tourmaline, and white sapphires.

Seating the stone

A ball burr that is the same diameter as the stone is used to open up a drilled hole to a depth where the girdle of the stone sits just under the edge of the metal. The stone must sit level in the setting, and not too deep, otherwise it will be covered by too much metal once set—use a piece of wax rolled to a point or stuck on a small wooden stick to pick up and place the stone. Adjustments can be made to the angle of the ledge on which the girdle of the stone sits using a seating burr. A flush-setting tool, which has an angled end, can then be used to ease the metal down over the girdle, first pinning the stone at "north," "south," "east," and "west" so that it remains level during the subsequent setting. Test that the stone is set by trying to pull it out of the setting with the wax stick.

Finishing the piece

Once the stone has been set, rub the surrounding metal down further with a curved burnisher, and tidy the inner edge of the setting with a graver or run around it with the tip of the burnisher to even and polish it. Any scratches or slips should be carefully removed with a file if deep, or burnished or emeried out if light. The piece can be repolished to give the final finish.

Channel setting

This type of setting involves setting small square or rectangular stones in a row, often in a recessed channel in an accurately constructed frame. The stones are set on two sides, and touch along the side edges, creating a continuous channel. The construction of the piece must be very accurate, and the stones used should be calibrated so that they are all the same size and sit evenly on the ledge inside the setting, or the effect will not be even.

FLUSH SETTING

TECHNIQUE FILE

Flush-set stones can be used to decorate a simple D-shaped band ring. The back of the stones must not protrude inside the ring; 2 mm stones are used in this demonstration.

1 Mark regular intervals around the band using dividers. Make marks along the midpoint of the ring to form crosses. Use a punch to mark the center of each cross before drilling 16-gauge (1.2 mm) holes. Use a ball burr to tidy up the holes on the inside of the band.

2 Use a ball burr that is exactly the same diameter as the stones you want to set to "burr down" into each hole. Burr down to around the widest point of the burr, before checking to see that the stone will fit.

3 Check that the stone is sitting correctly in the ring— the girdle should be just below the edge of the hole and the table should be level. Use a piece of wax to pick up and place small stones.

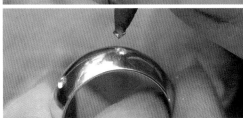

4 Use a burnisher or flush-setting tool to push the metal down over the stone at north, south, east, and west. This should pin it in position while the rest of the edge is burnished.

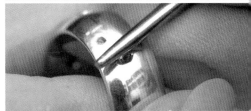

5 Use the tip of a burnisher to tidy up the inside edge of the setting. Remove any scratches from the metal before polishing.

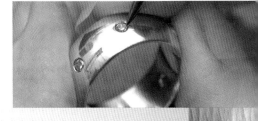

"Grains" are small beads of metal that secure a faceted stone in position; when stones are set in a line or grouped using this type of setting, it is called pavé setting. The surfaces of a piece can be carpeted with small stones in this way, for a glittering effect.

PAVÉ AND GRAIN SETTINGS

Grain setting

Grain setting uses small beads of metal to hold stones in recesses in a piece. It is more commonly used with small brilliant-cut stones that are set into sheet or cast forms, but can be applied to a wide range of pieces. This type of setting can also be used to set rose-cut stones, which are flat-backed faceted stones, or cabochons.

The "beads" of metal, or grains, are formed by raising slivers of metal with a graver. The cut is started a short distance from the stone, with the graver at a 45-degree angle; the front of the cut creates a bulge in the metal, which should sit just over the edge of the stone, securing it. The

sliver must stay attached to the main piece in order to function properly. Once all the grains have been raised at regular intervals around the stone, a graining tool is pushed down and rotated over the sliver, and this forces it into a ball, just overlapping the edge of the stone. The size of graining tool used will depend on the amount of metal raised and the size of the stone being set.

Pavé setting

Clusters of stones that have been grain set are called pavé set, and are positioned very close together, with the girdles almost touching. Decorative grains can be raised and beaded

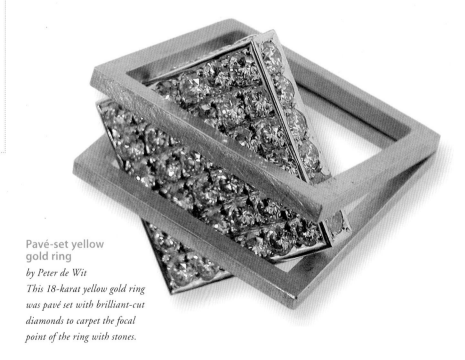

Pavé-set yellow gold ring
by Peter de Wit
This 18-karat yellow gold ring was pavé set with brilliant-cut diamonds to carpet the focal point of the ring with stones.

between the stones to create the illusion of more stones, especially with colorless stones in white metal. Traditionally the borders surrounding pave-set areas are decorated with a millegrain wheel, which creates a line of tiny beads, adding to the illusion.

Pavé setting can be done on flat or curved surfaces, and with open- or closed-back settings for the stones; open-back settings are used for larger stones and allow light to enter the stone from behind as the back of the setting is burred out at a wide angle. Round stones are most commonly used for this type of setting, but other shapes may be used, sometimes in combination. The challenge of using stone shapes other than round is cutting the seat for the stone accurately—the basic profile can be cut with a piercing saw and then accurately enlarged, shaped, and angled with a graver.

This type of setting can be used to cover the surface of a piece in tiny stones, or just to add sparkle to a particular area, drawing the eye to the emphasized section of a piece.

Illusion setting

Illusion setting is a variation on grain setting— the stone itself is set with grains, but is mounted on a metal disk that is bright-cut with engraving tools to mimic the reflections within a stone. This device makes the faceted stone appear larger than it really is through optical illusion, and allows a less expensive stone to be used. Small, colorless, brilliant-cut stones are usually set into a white gold, palladium, or platinum disk, which has been mounted on a ring or other jewelry form. This type of setting requires a great deal of skill—raising grains and engraving hard white metal accurately is not easy.

GRAIN SETTING

This example shows a pair of yellow gold earrings, produced using CAD/CAM, being grain set with 1 mm diameter rubies.

1 Drill holes in the correct positions for the stones—the holes should be deep enough to receive the stones and must be smaller than the stones' diameter. Use a ball burr that is the same diameter as the stones to recess the drilled holes so that the top of the girdle of the stone sits just under the hole's edge.

2 Once the stones have all been seated and placed in position, use a fine oval graver to raise four grains around each stone. Dig the graver into the metal about $\frac{1}{32}$ in (1 mm) from the hole and push down; angle the graver up to lift the grain. The bulge of metal at the front of the cut will hold the stone in position.

3 Use an onglette graver to cut a line around the inner and outer circles that surround the line of stones—this will tidy up the marks made by raising the grains, and create a reflective border.

4 A suitably sized grain tool can then be used to form grains from the raised slivers, neatening them and securing the stones further. Rock the grain tool firmly over the metal so that it forms a tidy dome.

The term "fancy" is applied to any nonstandard setting method. Fancy settings are often used to set unusually shaped stones, and can involve cleverly devised solutions that may utilize several different setting techniques.

FANCY SETTINGS

Combination settings

When more than one type of setting is used to secure a stone, it is known as a combination setting. These might involve half the stone being supported by a cone-shaped bezel while two wire prongs secure the other side, or a rub-over setting that has been partly carved to form prongs that are grained at the tip. The metals used in such settings should be strong enough to hold the set stone securely. The methods of setting may be dictated by the jewelry form and the position in which the stones are placed; remember that stones do not have to be set in a traditional manner and can be placed upside down, on their sides, or back to back; the only restriction is that they are securely held.

Spectacle setting

A spectacle setting is used to hold spectacle lenses in position, without chipping the edges. It consists of a frame with an internal groove for the edge of the lens to sit in, with a cut in it that can be closed with a rivet or screw thread, that passes through two small sections of attached tubing. The closing of the gap exerts a small, but equally distributed, force around the edge of the lens, and reduces the chances of it being chipped or cracked during setting (see page 250 for a demonstration of spectacle setting).

Spectacle settings are useful for setting glass, stones, cloisonné work, or metal disks that cannot be soldered, and are not limited to being round in form.

Tension setting

Tension setting uses the strength of work-hardened metal to hold a stone in position, often between the cut ends of a ring shank. Silver is not hard enough to maintain the tension, so gold, platinum, palladium, or titanium should be used. A groove or recess to fit the stone is cut in each end of the pieces of metal, and the gap between the ends is closed to a smaller distance than the diameter of the stone. When the ring is forced up a mandrel, the gap will open enough to allow the stone to be inserted and, once the ring is released from the mandrel, the stone will be permanently set. Hard stones that are not sensitive to pressure or prone to fracture are most suitable for this type of setting.

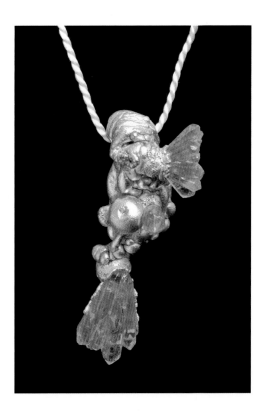

Metamorphic Flourite 1 pendant
by Ornella Iannuzzi Hand-carved fluorite has been set in silver to create this pendant, which appears to have "grown" to its final form.

Other methods for setting stones

There are a number of ways of approaching stone setting from a nontraditional angle, using metal and other materials to explore techniques that can be used to secure stones permanently without damaging them.

When using metal, cold-joining techniques such as riveting or screw threads can be employed to trap stones in confined spaces. Laser welding can also be useful—ideal for cages and applying settings to forms where soldering may cause complications. Some stones are not sensitive to heat and can actually be soldered in position—cubic zirconia, diamond, garnet, ruby, and sapphire can all be used in this way—but the stones must be allowed to cool very slowly as any sudden change in temperature can cause them to crack. This technique should not be used with stones of any value, and the color of heat-treated stones will be affected by further heating; in any case, stones should never be directly heated. You can find specially grown laboratory gems that are completely heat resistant, and their colors will remain stable. Stones can also be incorporated into wax models so that they are cast into position—remember not to quench the piece, otherwise the stone will shatter, and cover enough of the stone so that it will remain in position when the wax is burned out. Heat-resistant stones can be embedded in precious metal clay forms before they are fired.

Adhesives can be used to place stones on or in a form; some adhesives are crystal-clear, and so will not show. Stones can be set in polyester resin, whether clear or dyed.

SETTING FANCY-CUT STONES

TECHNIQUE FILE

It is possible to solder some synthetic stones, allowing for more unusual ways of holding the stone. A pair of triangular cubic zirconias are used to make a pair of earrings in this example.

1 Form a dome that is slightly larger than the diameter of the stone. Mark the three points of contact of the stone on the edges of the dome and use a triangular file to make three grooves for the tips of the stone to sit in.

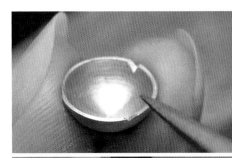

2 Check that the stone sits below the upper edge of the dome. Solder an earring wire to the back of the dome, with a tiny jump ring at its base to make a greater point of contact. Make a larger jump ring, the right size to sit on the edge of the dome—solder and then true it on a mandrel.

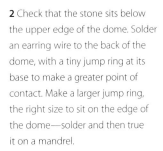

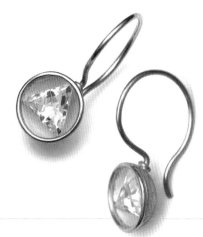

3 Place the stone in the setting and position the jump ring over it. Use pins made from binding wire to support the piece during soldering—use easy solder and try not to heat the stone directly. Once soldered, allow the piece to cool in position. Pickle, clean up, and bend the earring wire to shape.

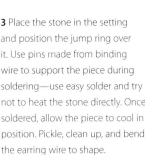

10 ring
by Anastasia Young
This patinated silver ring includes
a flush-set black sapphire and
a combination prong and bezel
setting for the main stone.

SPECTACLE SETTING

This technique shows how to form a silver frame for the enameled cloisonné disk that was demonstrated on page 236. Spectacle setting is ideal for making pendants with fragile contents.

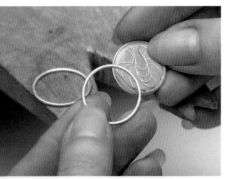

1 Make two wire rings—they need to be just a bit smaller than the diameter of the enameled disk. Solder the rings closed, then true, clean up the solder seam, and solder the two rings together, one on top of the other.

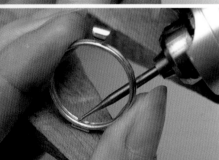

2 Make a bail or loop to hang the frame, and cut a piece of small-diameter tube, which will form the closure of the setting. Solder the tube and bail on opposite sides of the frame, using easy solder. Use a ball burr the same diameter as the gauge of the metal disk to follow the groove between the two wires, making an even channel.

3 Clean up and polish the frame. Cut through the wire and tube at its midpoint, and lightly file the cut ends to make them even. Insert the disk and check that it fits, squeezing the setting to close the gap. If the setting is loose, you can file the ends more.

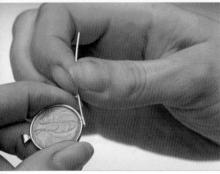

4 Rivet one end of a wire that is the same gauge as the internal diameter of the tube, and thread it through. Cut, file, and rivet the other end of the wire on the edge of a steel block, using a small punch to spread the end of the wire—a second pair of hands may be useful to hold the piece steady while you are riveting.

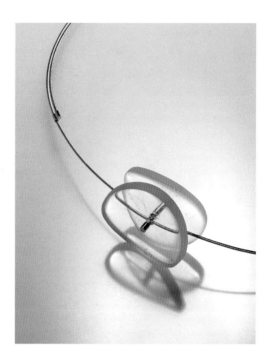

Carved rock crystal pendant
by Yeonkyung Kim
This pendant uses carved rock crystal in an unusual setting; the two stones are minimally attached to the necklet with silver wire.

Working with pearls

Half-drilled pearls are set onto jewelry forms in shallow cups that support the base of the pearl and hide the securing method, which is usually a twisted square wire that is cemented into the pearl. The twist in the wire gives the pearl cement more purchase, making it less likely that the pearl will come loose.

Full-drilled pearls are often strung on silk—see page 254—but can also be attached to forms with thin-gauge wire that has been balled at one end, or incorporated into wrapped or knitted wire forms, adding an attractive accent.

Undrilled, or full-round pearls, can be drilled as required, or contained in a manner that shows off the natural gem to its best advantage, such as a wire cage in which the pearl can be viewed in the round.

STRINGING BEADS

For many of us, stringing may have been our first introduction to jewelry making as a child: threading bottle tops, pull-tabs, or beads onto some string to form a necklace. However, its accessibility belies its importance. Stringing is an essential beading and jewelry-making technique.

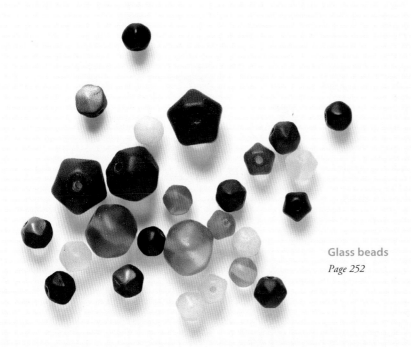

Glass beads
Page 252

There are many different shapes, sizes, colors, and textures of beads available, made from many different materials. When purchasing beads, "you get what you pay for," so always buy the best that you can afford.

STRINGING MATERIALS

Beads

Ever since historians and archeologists started to study the origins and progress of mankind, beads have been of huge importance. People throughout time have adorned themselves with any material they could work with, such as shells or bone.

The descriptions of beads listed here serve as a brief insight into what is available; there is an enormous variety of materials, shapes, and sizes. Materials for beading continue to improve and there is a considerable choice, not only of beads but also of findings and tools to facilitate beading tasks and help achieve professional results.

Glass beads come in countless styles and sizes. Seed beads (rocailles) range from 1 to 5 mm; bugles are long, thin tubes of glass; and larger glass beads vary from faceted crystal beads to lampworked beads and pressed-glass beads.

Natural beads such as pearls are rare and can be expensive, but freshwater pearls are more accessible. Cultured pearls and plastic and glass varieties provide an abundance of colors, shapes, and sizes.

Stone beads (semiprecious and precious) are produced from a variety of gemstone materials, including the truly luxurious precious stone beads, such as rubies, sapphires, emeralds, opals, and even diamonds.

Bone, horn, and wood beads range from the colorful wooden beads of childhood to intricately carved bone items.

Metal beads occur as plastic beads with metallic coating and in base, plated, and precious metals, from plain rounds to intricate filigree beads and elaborate cloisonné enameled metal beads.

Ceramic beads vary from primitive terra-cotta to finely painted porcelain beads from China.

Shell and coral beads are simply shell-chip beads, drilled shells, mosaic shell beads, or coral and mother-of-pearl beads.

Acrylic, plastic, and resin beads are lightweight and useful when creating large, clustered pieces where the weight of multiple stone or glass beads would prove problematic.

Threads and wire

Threads are available in both natural and synthetic materials; the most popular choices are nylon and silk. Ribbons and cords of leather, waxed cotton, silk, and synthetic materials can be used for stringing. Sewing supplies stores provide plenty of variations that can add a unique touch. Wire is also suitable for stringing. Nylon-coated beading wire, an extremely flexible multistrand steel wire, is a popular contemporary choice because of its strength, flexibility, and ease of use. Gimp, a flexible tube of coiled metal wire, is used to protect silk/thread where it attaches to the clasp or jump ring and to give a professional finish (use a length of about ½ in/1–1.5 cm per strand end).

Tools

Basic jewelry tools can be used for stringing projects, for example flat-nosed pliers, round-nosed pliers, chain-nosed pliers, snips, and instant glue. Specialist tools useful for stringing are crimping pliers, bead reamers, needles, Chinese clippers, and a knotting tool. For further details on suitable tools and stringing materials, see page 55.

Preparation: design and layout

Before you begin stringing, arrange the beads how you want them to appear in your piece. This will help you avoid mistakes, which otherwise may not be noticed until stringing is complete. Beading trays are helpful as they often contain separate compartments in which to store beads, and grooves in which you can lay out your design. However, shallow trays, beading mats, or even a creased piece of paper will suffice.

Note the diameters of the holes of various beads that you plan to use in a piece and choose threading materials that will accommodate all of the beads. Knotted strands work best when you are utilizing beads with holes of uniform diameter; otherwise it can be difficult to knot consistently and to keep the beads secured between the knots. The holes in pearls and semiprecious beads (which are often hand-drilled) sometimes have irregular diameters. If necessary, enlarge smaller holes with a bead reamer; you want to avoid having to force a bead along the thread, which will lead to either the thread or the bead breaking.

Choosing threads or wire

Match the thickness of your cord, thread, wire, or other material to the size and weight of the beads to be used. If possible, take your beads with you when purchasing silks or thread. When knotting, the knot should not slip into the bead. Keep in mind that knotted strands require you to double the thread length back through the beads near your clasp. Make sure that you can pass the cord or doubled thread comfortably through the same bead twice while the needle is attached, otherwise you may put undue stress on the beads and the thread.

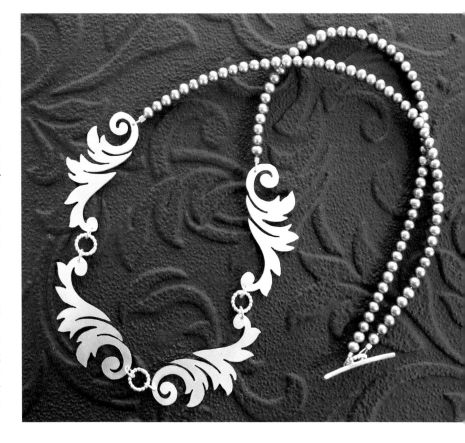

Multiscroll Necklace
by Hannah Louise Lamb
Pale blue pearls were combined with pierced scrolls to form this elegant neckpiece.

Knots provide security, flexibility, and protection. Fine pearls are always knotted, as are many semiprecious and glass beads. If a knotted strand breaks, only the beads adjoining one knot will be lost.

STRINGING AND KNOTTING

Knots also prevent abrasion of stones and protect the delicate nacre on pearls with the added bonus that they improve the appearance of strands. However, it is not always necessary to knot between beads and, if you are using cord, silk, or thread, you only need a few knots near the clasp or connection to complete a strand. To provide extra security, you can evenly space a number of knots throughout otherwise "unknotted" strands.

String with a double thread when using silks or threads; if there is a weakness in one thread, the second will keep the strand secure. A doubled thread will also form more attractive knots between beads. Knotted strands require your working length of cord or doubled silk/thread to be three times the length of your finished strand of beads. If you are not knotting between the beads, then you will need a working length of cord or doubled silk/thread one and a half times the length of your finished strand. To knot

between beads, tie a loose overhand knot in your cord or doubled silk/thread and proceed to bring the knot close to the bead by placing an awl or sewing needle into the middle of the knot. While holding the awl in place, push the knot (without fully tightening it) as close to the bead as possible, then pull apart the doubled thread to tighten the knot. Alternatively you can use a knotting tool (see page 56) to help you with this technique. The knotting tool is especially useful in producing consistent knots when using cords with needles attached.

Beading wire is often too thick to be knotted and so crimp beads are necessary to secure ends and attach clasps. Most beading wire is stiff enough to guide through beads without a needle. You can create a "self-needle" on thicker cords or other materials by coating an inch or two of the end with instant glue. You may need to taper your "needle" by trimming with scissors for some materials such as ribbon.

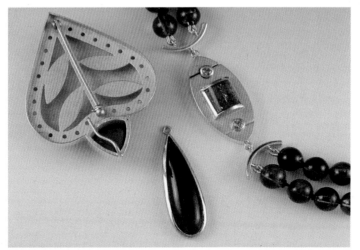

Interchangeable necklace/brooch

by Janis Kerman
Tourmaline beads were strung onto an 18-karat yellow-gold clasp, to form the necklace for this interchangeable pendant and brooch, which also incorporates amber and pink sapphires.

TECHNIQUE FILE

KNOTTING: STRINGING WITH CORD OR SILK

Stringing beads on cord or silk makes strong yet supple strands; it is the preferred stringing method for pearls and precious or semiprecious beads. NOTE: If you are making an "unknotted" strand, follow steps 1–5 and 7–9.

1 Use your needle to string your first three beads, then your length of gimp and your clasp, jump ring, or connector onto your cord or doubled silk/thread length. Push the beads near to the bottom of your thread length, leaving about 4 in (10 cm) as a tail.

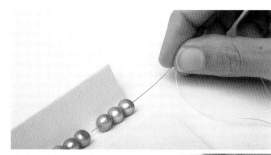

2 Guide your needle and thread back through the first bead until you bring your gimp and clasp, jump ring, or connector near to the bead. Center your clasp on the gimp and guide the bead snugly up to the gimp by pulling both cords.

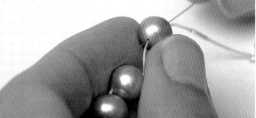

3 Separate the two cords coming out from the first bead (the tail and the main cord) and use them to tie a knot, pulling the ends to tighten the knot next to the bead. Pass your needle through the second bead and pull the thread through.

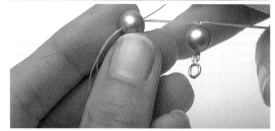

4 Push the bead up snugly next to the knot you have just tied and then tie another knot using the same method as before. Pass the needle through the third bead and push the bead snugly next to the previous knot.

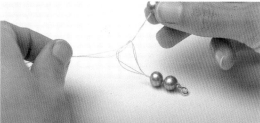

5 Instead of using both cords to tie this knot, leave the tail dangling and proceed to tie a loose overhand knot in the main cord. Bring this knot close to the bead and tighten it by pulling apart the doubled thread.

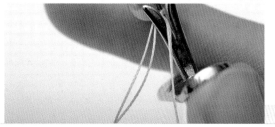

Tip

As you continue knotting you will need to pass your growing knotted strand through your overhand knot. It is easiest to make a large knot around your open hand to facilitate this process.

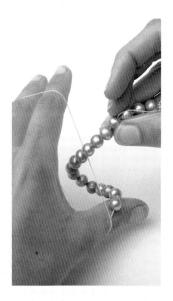

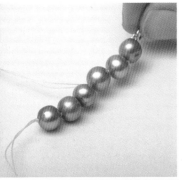

6 String a number of beads onto the cord. Push the beads along the cord individually as you continue to knot using the method described in the previous step, excluding the last three beads of the strand and the other half of your clasp, or jump ring.

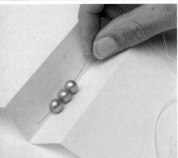

7 Thread the last three beads onto the cord and push them snugly up to the latest knot. Thread a length of gimp and the other half of your clasp or a jump ring. Pass your cord back through your last bead, pulling it through until the gimp and clasp are in place.

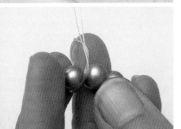

8 Tie a knot between the last bead and the penultimate bead. Pass your needle through the penultimate bead, pulling the cord all the way through it.

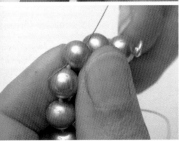

9 Tie a knot between the last two beads, then pass your needle through the third-to-last bead and pull the cord all the way through. (This may prove challenging, as you will have to negotiate the knot that is butted up against the bead on the other side.)

Tip

Use glue or clear nail polish to seal the two knots on either side of the clasp, or the two knots closest to your jump rings or connectors. Use Chinese clippers or sharp scissors to carefully trim the excess thread.

STRINGING BEADS WITH BEADING WIRE

Beading wire is useful for stringing beads with rough-edged holes that otherwise might cut silk cord or thread, or when the weight of the beads is a concern.

1 To finish each end of the strand securely, thread the wire through a crimp bead and then pass the wire through the clasp, jump ring, or connector. Use alligator clips or some tape on the ends of wire to keep beads from falling off.

2 Pass your wire back through the crimp bead and, if possible, through a few beads on the strand.

3 Slide the crimp bead close to the clasp, jump ring, or connector.

4 Place the crimp bead in the back notch in the jaws of the crimping pliers (this notch is round on one side and dipped on the other) and press down, making a crease in the crimp.

5 Use the notch in the front of the crimping pliers (this notch is round on both sides) to shape the tube into a round cylinder. Trim the excess wire close to the beads using your snips.

OUTWORK

There are certain techniques or processes that many jewelers will outsource, either because the processes involved require expensive equipment, use chemicals for which special precautions must be taken, or require highly specialized skills. Service providers, or outworkers, will vary in the range of techniques that they provide—some perform only one specialized service, but some companies are linked and will provide a design and production facility, creating jewelry to your design specifications from start to finish, and as small batch production if required. When using outworkers, be clear about what you want—ask for advice about the process and types of outcome that are possible if necessary, but it is always a good idea to be well informed about the particular process before approaching a company or individual so that you understand one another well.

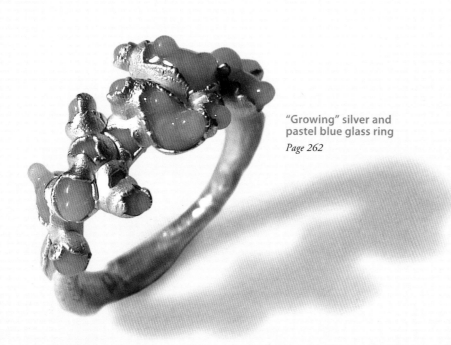

"Growing" silver and pastel blue glass ring
Page 262

Electroplating is a process used to deposit a thin layer of pure metal over the surface of a finished piece. This technique is often used to cover firestain on silver or to change the color or appearance of a piece, and the plating service is usually combined with polishing to give the jewelry a professional finish.

PLATING AND POLISHING

Preparing a piece for plating

Your piece must first be completely finished, including any set stones (with the exception of chemically sensitive stones). The plate will have the same finish as the metal it is plated on, so carefully prepare your piece before handing it in to be plated—it cannot be heated or adjusted afterward because the plate will be damaged, and any scratches or blemishes will show.

No steel, adhesives, or natural materials can be put through the plating process, but copper, brass, gilding metal, silver, and gold can all be plated without problems.

The areas of a piece that are plated can be controlled by masking off in a similar manner to stopping-out when etching, but this will be done by the plater—the masking fluid is a special one designed to resist the highly noxious chemicals used in the plating process.

Types of plate

Not all platers will provide the full range of metals it is possible to plate with, but many will do gold, silver, and white rhodium plating. Black gold and rhodium, as well as ruthenium, may be difficult to source, but some platers specialize in special finishes such as antique shades of gold.

Body concealer 2, breast piece
by Il Jung Lee
This large form was raised from copper sheet before being gold-plated; a padded velvet interior completes the piece.

Hard plate should be used on pieces that will receive a heavy amount of wear; this plate is more durable than soft plate, but may not be available in the same range of colors. All plate will wear through eventually because such a thin layer of metal is deposited.

Flash plating is only 1μm (micron; one-thousandth of a millimeter) thick, but is useful for changing the color of a large piece, keeping the cost down, or for a piece that will not be worn, for example, for photography. It is also useful for recesses where there is no risk of the plate rubbing away. 5μm is standard plate thickness and, with care, will withstand a reasonable amount of wear, especially if it is hard plate, but up to 20μm can be applied.

The plating process

Your piece will be cleaned and degreased in several different chemical baths before it is suspended in the plating bath attached to a cathode by copper wire. The plating bath contains a solution of a salt of the metal to be deposited—the electric current that is run through the solution from the anode causes the metal to dissolve out of the solution and be deposited on the cathode. During plating, the piece is agitated or rotated so that the metal is deposited evenly.

The solutions used in plating precious metals contain potassium or sodium cyanide that are highly toxic and should only be handled by trained professionals.

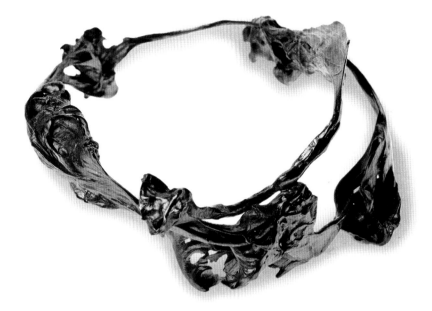

Plated bangle
by Akiko Furuta
Once finished, this cast bangle was plated with black gold.

Professional polishing

It is often part of the plating service to have the piece polished by experienced polishers who can bring a polished piece to its full potential. Do say if you don't wish the piece to be polished; this may be the case if it is a particularly fragile piece, or you have applied a particular finish that would be damaged by polishing. Many platers also offer a sandblasting service, which puts a matte, frosted finish on metal.

Points to remember when outsourcing work

- When you take your piece to be plated, make sure you know what you want—most platers will have a sample set of the various plates and finishes that they do, so ask to see this if you need to clarify which finish would look best on a piece, and ask for advice if you need it.
- Call in advance to find out when the platers would be able to have the piece ready, and if they do the particular type of plate you require. It will be difficult for a plater to estimate how much a particular piece may cost to plate unless they see it.
- Try a few different platers to see which ones do the finishes or colors you like—ask other jewelers who they use, and you will hear good and bad stories about their experiences.
- If you are not happy with the results, say so—but do be polite!
- Use a well-established service—you are trusting them with potentially valuable work, which could cost you time and money if it is mistreated.

The lost wax casting process transforms wax models into solid metal forms, and modern production techniques mean that the results are a high-quality copy of the original wax, in the precious metal of your choice. Casters can make molds of pieces and objects so that many identical pieces can be produced.

CASTING

Lost wax casting

Once a form has been carved in jewelers' wax, you can take it to a caster where it will be transformed into a metal replica. The wax will have a sprue attached, which is a wax stem that connects the wax to a tree along with other waxes. The tree is mounted in a base and set in a flask, which is filled with a special type of plaster called "investment." Once the investment has set, the flask is placed in a kiln, upside down, and the wax is melted out to leave a void, giving this technique its name. While the investment is still hot, molten metal is vacuumed into the flask, filling the void and creating a copy of the wax form. The resulting metal form will have a good surface finish with little porosity and minimal shrinkage, due to modern casting technology.

Although most casting for jewelry is done in gold alloys, silver, and platinum, it is also possible to find companies who will cast in other metals such as brass, bronze, stainless steel, aluminum, palladium, and tarnish-resistant alloys of silver. Several different alloys of gold can be cast—make sure you know which one you want, because some are much harder to work than others.

Gothic window rings
by Anastasia Young
Multiple waxes of this ring were produced
from a vulcanized rubber mold (see page 158)
before being cast into silver.

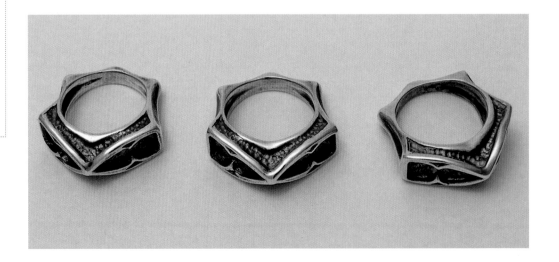

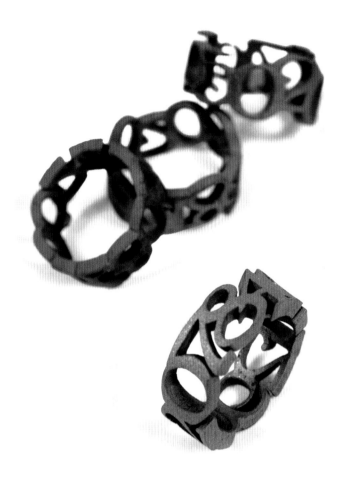

Phone number rings
by Mette Klarskov
This series of oxidized rings was designed
and produced using a computer; the wax
forms were then cast in steel.

Molds for multiples

The lost wax process causes the original form to be destroyed, so if you require more than one copy of a form, then a mold will have to be made. Vulcanized molds are the most commonly used in jewelry casting because they are very durable, and will allow many wax reproductions to be made from a metal master. The cost of the mold-making process will depend on the size and complexity of the piece being reproduced. A charge is also made for each wax produced.

Molds as a method of making multiples should be considered when producing cast CAD pieces, as the cost of three-dimensional wax prints is considerably higher than wax injection replicas, although the detail may be slightly diminished through replication. Cold-cure molds can also be used to make metal casts of objects such as natural materials or fragile objects that would not withstand the vulcanizing process.

Casting for CAD/CAM

Models that have been created using technology such as wax printouts can be cast directly in metal. Some casters will offer services related to CAD/CAM, including printing the models and casting them—see page 270 for more details of these processes.

Cleaning up castings

Castings are usually returned pickled, cleaned, and lightly barreled. A remnant of the sprue will still be attached, so pierce this off with a saw and file the area true to the form. The amount of work that needs to be done will depend on the type of form—heavily textured pieces will not take as long as polished surfaces, which require more preparation. Sprues can be returned to the caster as scrap.

Points to remember when outsourcing work
The cost of casting is dependent on several factors:
• The size of the piece—this determines how many pieces can fit on a tree and therefore in a flask; the price will be a percentage of the flask price.
• The metal alloy used. Casters use their own metal stock and will not accept scrap metal to be used for casting unless it is their own sprue offcuts; this eliminates the risk of contamination.
• The current price of metal.
The turnaround between handing in a wax to collecting the metal form is usually between four days and a week; mold-making services may take longer.

Electroforming is a process similar to electroplating, but with a thicker layer of fine metal being deposited on the surface of a nonmetallic object that has been coated with conductive paint. It is very good for making large hollow forms that would be difficult to construct in any other way.

ELECTROFORMING

The electroforming process

Electroforming works on the same basis as electroplating, but uses a soluble anode of the metal, which will be deposited onto the cathode. This is suspended in the electrolytic solution, along with the piece of work, which forms the cathode. The temperature of the chemical bath and its agitation with air bubbles are crucial to the even deposition of metal onto the cathode. Electroforming can only be done with pure copper, silver, or gold, which means that the resulting forms are made from relatively soft metal, limiting its applications. As with electroplating, the chemicals used in the process are extremely toxic, containing salts of cyanide.

The main difference between this process and electroplating is that nonmetallic objects can have a layer of metal applied to them, as long as they have been coated in a conductive metal paint. The resulting metal shell can be worked in a number of ways, depending on the intentions for the piece.

Electroforming can also be used to create metal forms from the insides of silicone molds taken from objects or textures, which will create an exact replica with no loss of surface detail—it will give better results if the service provider makes the mold, as they will know the exact requirements for a successful outcome.

Preparing a piece for electroforming

Almost any object can be electroformed. Many jewelers choose to make forms from wax or modeling clay, which can be combined with

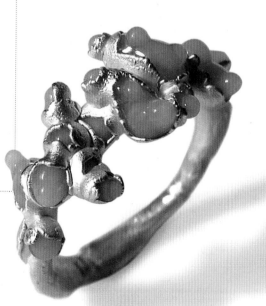

"Growing" silver and pastel blue glass ring
by Serena Park
Fine silver was electroformed over a wax and glass ring to make this piece; areas of the glass were not coated with conductive paint and so remained exposed.

Electroformed/glass pendant
by Lina Peterson
A linear structure was electroformed and combined with glass beads to form this pendant.

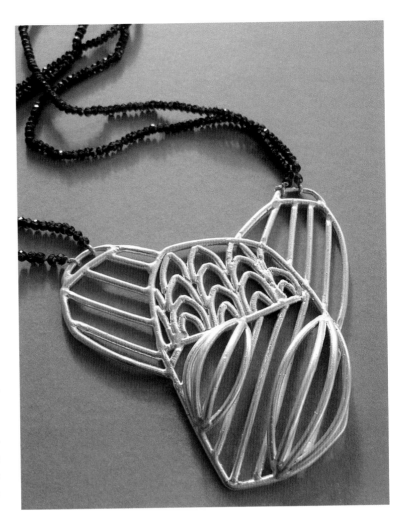

metal structures to strengthen them. Protruding wires provide a useful way to attach the piece to the cathode. Natural objects, or those made from natural materials, can be electroformed, but will require several coats of aerosol varnish so that they are entirely sealed—the chemicals used in electroforming will dissolve natural materials, which may contaminate the chemical baths. Gemstones, glass, or other inert materials can be incorporated into the model so that they will, in effect, be set by the metal deposition.

The object or form must be coated with a layer of copper or silver paint so that it will conduct the electric current; the company will usually do this for you, as the most even coverage is achieved with an aerosol spray. You will be able to specify how thick you would like the layer of deposited metal to be, and the company will be able to advise you, as each form may have its own specific requirements—if you want a highly polished surface, then the layer will need to be thicker to allow for a degree of cleaning up. The thicker the metal is, however, the less fine detail will remain on the surface of the piece.

Working with hollow forms

Electroformed objects that have been formed over wax models can have the wax carefully melted out after electroforming to create a hollow form. The resulting metal form can then be treated as a hollow form, and drilled, polished, or soldered if the form is thick enough to allow this without risk. There is occasionally the risk of releasing cyanide gas when heating electroformed pieces—discuss how you will be treating the resulting form with the company so that they can warn you if there are any potential risks.

Electroforms can be joined to other pieces of work, but remember to incorporate linking methods before the piece is electroformed so that strength and integrity of design is not compromised.

Points to remember when outsourcing work

- Discuss your project with the company—they will be able to tell you the specific limitations relevant to what you require.
- Remember that copper and fine silver are very soft, and so are not suitable for thin parts. Metal wires can be used within the model to strengthen it.
- As the equipment is very similar, most electroforming companies also offer a plating and polishing service.
- If you are working to a deadline, make sure you hand in your piece with plenty of time to spare—there are not many electroforming service providers and they are often in demand.
- Cost will be dependent on the metal used, the amount of metal, and the time it takes to carry out the work. Electroforming can be a very expensive way of producing jewelry, especially as each piece is a one-off.

*Earrings, bracelet, and
ring suite*

by Janis Kerman
*Many jewelers would consider
outsourcing pavé setting to a
professional stone setter.*

Stone setting requires patience and skill. Professional setters are highly experienced in setting and mounting gems in metal and, when you are making a piece with valuable stones, perhaps for a commission, it is important that a stone is properly set.

STONE SETTING

When to use a professional

Stone setting can be a daunting task, especially for the inexperienced, and although practice is the best way to learn, there are times when you may not want to risk things going wrong. When working with valuable stones and precious metals such as platinum, mistakes can be expensive, so it is generally worth the money to employ a professional to set the stone. Certain types of stone setting, such as pavé or illusion, take years to master and will only be of a satisfactory quality if done by an experienced professional. There are certain types of stones that setters may refuse to set, such as those renowned for being fragile or brittle.

Preparing your piece

Your piece should be complete, except for the stone setting. The insides of settings, or other areas that will not be accessible once the stones have been set, should have their final surface finish. You will need to indicate where the stones will be set; this may be obvious or not depending on the type of setting. Holes can be drilled for flush or grain settings, but these must be smaller than the diameter of the stones that will be used. Areas that will be pavé set should be left, as the setter should decide the exact position of the stones; provide calibrated stones for pavé work that are all the same diameter, as these can be set much more easily than stones that vary in size.

Pieces may be electroplated once the stones have been set (see page 258).

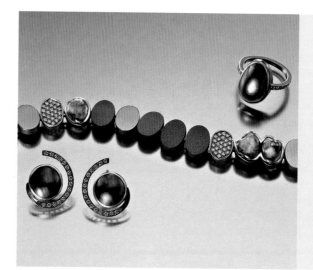

Points to remember when outsourcing work

• Some types of stone are more suitable for certain types of settings than others—hard stones are more versatile than softer ones, but check how brittle the stone can be—some methods of setting require more pressure applied to localized points and can cause brittle stones to fracture.

• Setters usually charge per stone, but this will depend on the type of setting that is being done.

Engraving is a technique that takes years to master, so for difficult designs and inscriptions it is a good idea to get it done by a professional. They will have stock designs and monograms, but you may wish to provide your own design.

ENGRAVING

Types of engraved work

Traditionally, engraving is used for inscriptions, seals, signatures, and heraldic devices on jewelry and other small metalwork, but is now used to create a wide range of other effects on metal. Victorian jewelry was often engraved, but since engraving has to some extent been superseded by computerized techniques and mass production it is now far less commonly used.

Skilled hand engraving can enhance contemporary jewelry in a number of ways, providing unique methods for decoration, personalization, or historic reference. Amazing light-play can be achieved in pictorial representations, and depends on the direction in which the metal is cut, and the angle of the tool. Inscriptions can be applied to a wide range of surfaces, including the insides of rings.

The same technique that is used for laser-cutting can be used to laser-engrave metal, but the effect resembles fine photoetching or sandblasting rather than the bright cut of a steel graver.

Engine turning is a form of machined engraving that creates concentric overlapping patterns on metal with the use of a milling machine, which can be computer controlled. This service is usually available only from specialist companies.

Preparing a piece for engraving

As with many other outwork techniques, engraving is carried out as one of the final processes and so all cleaning up and polishing should be completed first. Delicate engraved lines can be worn away through polishing, so if you think your piece may need polishing further, then discuss this with the engraver, as they will know how to achieve good results.

Silver coaster
by Ruth Anthony
This piece has been hand-engraved with Victorian-style doves and scrollwork.

Points to remember when outsourcing work

• Engravers will either be employed as part of a workshop, along with other engravers with a range of specialties, or on their own as a self-employed craftsperson. It takes many years to become a skilled engraver, and engravers will typically specialize in one area, such as lettering, seal engraving, gun engraving, or pictorial work.

• Machines can engrave repeated batches of work much more cheaply than hand engravers can, and workshops will have both.

• Workshops will often take commission work from individual jewelers, as well as companies; self-employed or freelance engravers generally work to commission.

• The complexity of the work required will determine the cost of a job, as well as how long it will take.

Laser and TIG (tungsten inert gas) welding provide a neat way of fusing small areas of metal to each other; welding also allows nonmetallic materials to be combined with metal pieces in ways that would not be possible by any other method.

LASER AND TIG WELDING

Applications for cold-joining
When soldering cannot be used to join metal components, small areas may be welded to permanently bond them. The laser beam, or electric current used in TIG welding, provides a very high intensity and localized temperature increase, causing the metal to melt and fuse, and is fired as a pulse with an inert gas such as argon present; the gas behaves in a similar way to the fluxes used in soldering, preventing oxidization and the join becoming porous.

The effect of the pulse does cause some metal to be displaced, and although the marks are small they can be unsightly. A piece of wire of the same metal as the pieces being joined can be applied at the welding point, to feed into the join while it is being welded. Overlapping weld points will make for a stronger join, with a larger area of contact.

Welding can be useful to aid tricky soldering jobs such as those involved in hinge-making; the knuckles of the hinge can be tacked in position while the whole hinge is in situ, and then the two parts taken apart and soldered separately without them moving out of alignment. Pieces can be temporarily held in position during welding with binding wire or modeling clay.

Most metals can be joined in this way, but some perform better than others.

Limitations of welding precious metals
Welded joins on metal can be brittle—don't expect the join to perform structural tasks under stress, as it will not withstand much force or leverage. This is mainly due to the small scale of welding used in jewelry making, but also because of the way the different metals react—aluminum and steel weld much better than other metals. Silver welds poorly because it is so reflective—it helps if you make the metal dirty with modeling clay or ink before welding.

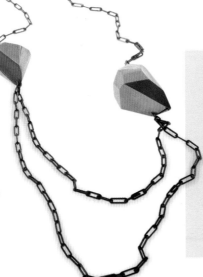

Double facet neckpiece
by Frieda Munro
The crystal-like metal forms of this neckpiece were fabricated from sheet; PUK welding was used to hold the facets in position before they were soldered.

Points to remember when outsourcing work
• In addition to companies who perform welding services, you can attend training courses at some educational institutions to learn to use laser-welding equipment; once trained it may be possible to rent time on a welder.
• Always protect your eyes when using welding equipment—check the manufacturer's safety advice before use.
• Welding equipment should never be used without proper training. Some parts can be very dangerous if misused.

Ideal for small-batch production, these techniques use a computer-driven water jet or laser to follow the vectors of an image file, cutting a very accurate design. Laser cutting cannot be used for metal, but water cutting can be used to cut a very wide range of materials.

LASER CUTTING AND WATER CUTTING

Preparing a design for 2-D milling

You will need to supply the company with a computer file of a vector-based drawing or outline created using software such as Adobe Illustrator or AutoCAD. Online design programs are also available to use, and mean that you can produce vector-based drawings without the expense of purchasing specialist software. It is always a good idea to check with the service provider which types of files they will accept; some types of files can be easily converted by them into usable data but others cannot. Most companies will accept original artwork, which they will convert into a data file, but this can be rather expensive.

Production of multiple components

Although the processes used mean that it is possible to produce individual pieces, prototypes, or small-batch runs, it will generally be most cost effective to use these techniques when producing reasonable quantities of identical components or pieces. However, very intricately pierced components can be created using either of these cutting methods, drastically reducing the amount of manual labor required.

Laser vs. water cutting

In laser cutting, the computer uses vector information to direct the laser beam. Lasers cannot be used to cut metal, but will mark it. Wood, plastic, leather, fabric, shell, felt, and rubber can all be laser cut. The intensity of the beam will cause slight scorching on natural materials, which will be more visible on lighter colored materials.

Water cutting uses a fine jet of water mixed with abrasive media fired at the piece under pressure to erode the material, and will cut metal as well as most other materials. The finish is finer than possible with laser cutting, and can be varied depending on the requirements of the piece. The machine is computer-driven, using vector data in the same way as with laser cutting.

Some companies will charge for time, some per piece, and some charge a flat rate per sheet of material—ask for a quote before agreeing to the work.

Paper bracelet

by Jennaca Davies
The intricately cut paper components of this bracelet were laser cut in order to achieve the design, which would not have been feasible by any other method.

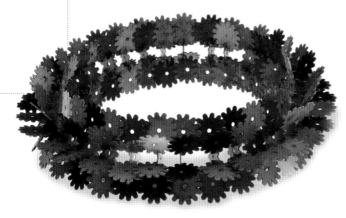

A type of photosensitive film is used to create the resist for photoetching, and this allows incredibly precise designs, graphic images, and text to be etched onto sheet metal. Both sides of the metal can be etched simultaneously, and can be used to effectively "pierce" out designs.

PHOTOETCHING

Preparing a design for photoetching

Photoetching is useful for a number of applications in jewelry, including the accurate replication of text or images in low-relief designs on metal, as well as pierced forms. As it is a relatively expensive technique, thought should be given as to whether or not it is the most suitable method for achieving the required outcomes, but when producing large numbers of patterned and intricately pierced forms it is ideal.

Photoetching is often done on standard-sized sheets of metal to make it easier for companies to make the tooling and etch the metal; this means that you will need to have enough designs to fill a specified area or you will just be paying for blank space. Try to tessellate forms as efficiently as possible so that you can get the maximum number possible onto the sheet of metal.

The design must be black-and-white, and can be supplied as a computer file—check which types of files the company will accept before sending them. Hand-drawn images should be created at twice the actual size and then reduced, as this will give greater accuracy. The minimum thickness of a line will depend on how deeply the line will be etched, as will the minimum gap between designs, and both factors may depend on the gauge of the metal being etched.

Once the company has your design, they will use it to make a transparency, or phototool. Photosensitive film is adhered to the metal, the transparency is placed over the film, and it is exposed to light for a specified time. The undeveloped film is dissolved from the metal, leaving the resist in place as a representation of the artwork; the piece is then etched.

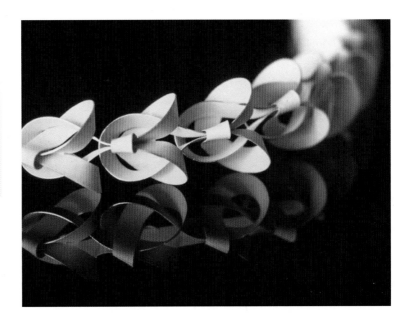

Photoetched silver necklace
by Inni Pärnänen
The component parts of this silver necklace were pierced out with photoetching before they were formed and soldered closed.

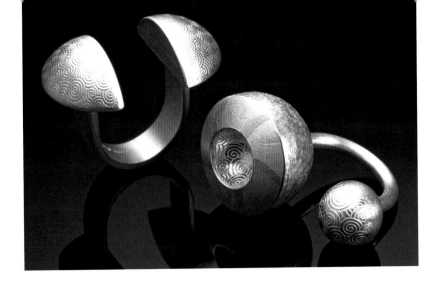

Double terminal rings
by Shelby Ferris Fitzpatrick
Photoetching has been used
to add textured accents to
these silver rings.

Double-sided photoetching

Working with transparencies allows accurate placing of the images on both sides of the sheet, and also allows the metal to be etched from both sides simultaneously and in exactly the same places. This method can be used to effectively pierce out forms, and is sometimes called "photochemical milling."

Using this process, it is possible to produce multiple forms that have a pierced outline and a graphic image on one side, which will have been etched to half the depth of the sheet. It is advisable to leave tabs on your design to connect the pierced forms to the main sheet of metal so that they are not lost in the tank during etching.

For double-sided etching, you will need to provide two designs—one with the outline of the shapes, and another with the outline and the pattern.

Cleaning up photoetched pieces

Pierced photoetched pieces will require more cleaning up than those that just have an image etched on, leaving the edges intact. The tabs that connect the pieces to the sheet of metal can be clipped to release the forms. Etched edges of forms will be rough and require filing

Points to remember when outsourcing work

- Charges are made for the cost of the tooling, conversion of artwork if it is not in a digital format, the cost of the metal, which is usually supplied in standard sizes such as letter (A4) or tabloid (A3), and the depth of the etch.
- It is a good idea to discuss your design with the company before finalizing the artwork, to ensure that there are no errors, and that the effects you require can be successfully achieved.

and cleaning up before they are polished or assembled. Finely etched designs can be damaged by abrasion or polishing as well as by forming techniques; photoetching is always done on flat sheets of metal and it may be desirable to form the metal once it has been etched in order to construct a piece. Treat the metal as you would any textured surface—use only plastic or rubber mallets and formers and protect the surface with masking tape whenever possible. Remember that areas of the piece that have been deeply etched will bend more easily than those that have not.

Computer-aided design and modeling can be used to create jewelry from start to finish by creating a virtual three-dimensional model, which can then be printed in wax, allowing it to be cast in metal.

CAD/CAM

After the virtual three-dimensional model has been created, it can be used to create a realistic image of the piece; the design can then be created in wax by a 3-D printer, allowing it to be cast in metal.

Computer-aided design (CAD)

CAD/CAM covers a range of techniques that use data produced by or fed into a computer to aid or effect design, and drive the technology that performs the technique. Each process has its benefits and its limitations, but as technology progresses it is exciting to see how it is applied to jewelry making. CAD/CAM is already used extensively within the commercial jewelry-making industry as it is a cost-effective method of producing large numbers of high-quality models for casting. Research institutions are exploring the ways in which this technology can be used in more innovative ways and on a more individual basis for the designer–jeweler. Software and hardware advances make the processes accessible to more people; some software is available to use online, allowing anyone with a computer, and the inclination, to design imaginative objects.

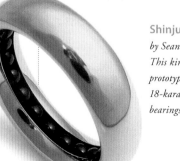

Shinjuku carborandum
by Sean O'Connell
This kinetic ring was rapid prototyped, cast, and fabricated in 18-karat yellow gold—the ruby ball bearings move inside the form.

While the term CAD/CAM is generally understood as the process of building 3-D models for wax printing, other forms include engine turning, routing, laser cutting, water cutting, laser engraving, and photoetching, which all involve the use of computers in one way or another.

Building a 3-D model

The principle of three-dimensional modeling is based in linear graphic shapes that can be built up to construct complex forms, described as "vectors." The shapes and forms can be stretched, twisted, rotated, added, subtracted, duplicated, and have their scale changed with ease, allowing infinite possibilities in the exploration of form, and the computer stores detailed information on spatial relationships between all points of the form.

It is the spatial information held within a drawing that allows a computer to track the lines and apply them to technological processes. The simplest designs are two-dimensional, and can be used to create patterns for laser cutting and marking, water cutting, and photoetching. Adobe Illustrator is often used for this type of design work—it can also be used to create 3-D designs.

Rhinoceros is a software application often used by jewelry designers, and allows forms to be constructed and manipulated as a mesh of lines that outline and describe the form.

Rendering images

Once a jewelry form has been constructed in a 3-D package, the design can be "rendered." This is the equivalent of producing a presentation image of the piece. When working in Rhinoceros, the file is sent to Flamingo, an affiliated program

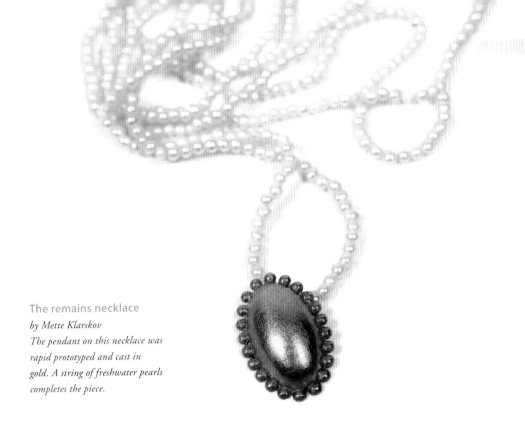

The remains necklace
by Mette Klarskov
The pendant on this necklace was
rapid prototyped and cast in
gold. A string of freshwater pearls
completes the piece.

that allows a choice of materials, finishes, and stone colors to be applied to the piece, in effect creating a skin over the mesh; different lighting effects can also be applied, showing what the piece will look like once made. Rendering can take considerable time, depending on the quality of the image required; it is possible to render computer-generated images of pieces that are almost indistinguishable from photographs, but these may take days of processing to produce.

Computer-aided modeling (CAM)

The vector-based virtual model can be translated into reality using a 3-D wax printer, which deposits layers of wax into the shape of the design in a process known as "rapid prototyping." Two types of wax are used: a hard brittle wax to make the piece, and then a second type of wax is deposited in order to support areas of the piece; this wax is water-soluble and is dissolved once the printing is complete to leave a form in hard wax that can then be lost wax cast. These wax models are incredibly fragile and should be handled with extreme care, as they are expensive to produce.

The same type of vector data can be used to carve relief designs in a number of materials using a router, but the designs are limited by the inability of the router to carve undercuts.

Creating jewelry using CAD/CAM

There is a growing number of companies that offer complete CAD/CAM jewelry-making services, from translating hand-drawn images into 3-D models, to rendering presentation images, to wax printouts, casting, and even cleaning up and stone setting. All you have to do is design the piece! It sensible to design with the process in mind—there is little point in going to the expense of modeling a simple piece if it could be constructed inexpensively using wax carving or other fabrication methods. Consider the differences in design and manufacturing time between processes when deciding which will be the most suitable for a particular piece. For example, some CAD designs are such complex objects that it is not possible to make a mold to create multiple waxes, so a wax printout will need to be created for each piece, which can be costly; but CAD is particularly useful for creating accurately geometric forms, or those that require the accurate placing of stone settings at regular intervals.

Many colleges now offer training in CAD/CAM packages and technology as short courses or as part of the undergraduate curriculum for jewelry design.

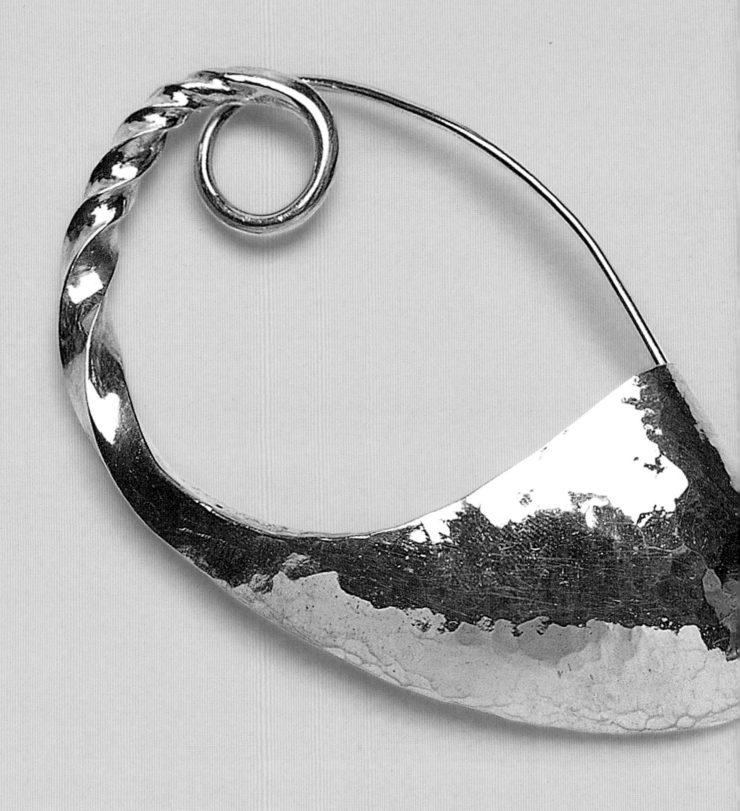

DESIGN

All jewelry design originates from an inspirational source, whether it's a technique or material, or visual information from images or objects. You can gather information from a wide range of sources, and it should spark your interest to investigate further.

INSPIRATION

Natural objects

Investigate which aspects of an object you find interesting—is it the texture, the way the structure is formed?

Where to look

Museums, galleries, and exhibitions can be a good place to start looking for inspiration. They are filled with objects and images that have been chosen for their interesting qualities, and allow you to view actual objects in the round, rather than just flat images of them. Books, magazines, and the Internet are useful research tools, but there is no substitute for experiencing something firsthand. Look at both historic and contemporary items, taking note of how they might be made, and why they look the way they do. Design disciplines other than jewelry, such as architecture, textiles, ceramics, glass, and furniture, can yield valuable ideas.

Nature also provides an infinite source of study, with a magnificent range of structures and forms to be explored—if this area interests you,

try spending a day at a botanical garden with your sketchbook and a camera.

Inspiration may be triggered when it is least expected, by such diverse things as a poem, a conversation, a meal, or a travel experience. There is no limit to the ideas you can use to inform your jewelry design.

Inspirational objects

Jewelry is a three-dimensional medium, so the benefit of studying 3-D forms is that they will help you to understand how form can be expressed, and how shapes and lines intersect with one another in relation to each other and within space.

You can find objects to study in a wide variety of places—if it is not possible to collect or buy the object, try to draw or photograph it so you can

Where to look for inspiration

Make your search for inspiration as wide ranging as possible, visit local museums, galleries, and exhibitions, and try to look at the work of other jewelry designers in your area.

Plan and prepare

Try to assess what you want to see before setting off on a trip around a museum. Ask for a map of the layout and visit the rooms you are interested in first. Take a notebook and pencil with you and jot down anything that you find inspirational.

Museums

Visit museums and study the jewelry, brass and copperware, agricultural and industrial tools, and anything else that you find stimulating. Remember that small local museums can be fascinating and will give you an excellent feel for the topography of an area.

Galleries

Find out where your local galleries are. Visit all their exhibitions and ask to be put on their mailing list—these resources are there for people like you. Recognize which exhibitions you enjoy and those which you don't. It's fine not to like them all!

Exhibitions and studios

Read local newspapers or listings in magazines for news of other exhibitions. For example, your town may have a festival where local artists open their studios to the public. Take the opportunity to see other artists' work and talk to

Objects with different properties can provide a wealth of information— look for interesting forms and functions, textures and materials. Natural forms, vintage mechanisms, and found objects make ideal study pieces.

remember why you found it interesting. Build up a collection of small objects with interesting forms and textures—they can be used for still-life drawing, photography, or collage—you can cut them up, break them, use them as found objects within pieces, or simply have them on display.

Postcards

Start a postcard collection of pieces that you have seen and liked from exhibitions. This will help your understanding of current jewelry trends and practices.

them about what they do. Some exhibits and fairs may feature artists actually making their work. Take the opportunity to observe the techniques and tools they use.

Magazines

Most magazines connected with fashion carry jewelry advertisements or even special features about jewelry. Even in magazines that are unrelated to fashion, you may find pictures of people wearing jewelry or lists of galleries exhibiting jewelry. There are specialist magazines too—ask at your local library or book store.

Books

Books about jewelry provide a fantastic insight into the way jewelers around the world work. Research these sources of inspiration in your local library, or look up jewelry-related books online.

The Internet

Use the image option in a search engine to find inspirational and informative photographs, drawings, and graphics related to any subject you can think of from a huge range of sources. As with any source material, don't copy other artists' work, but do use it to inspire you.

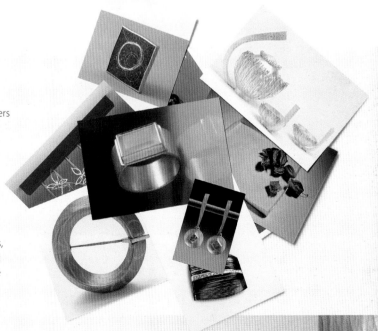

Photographs

Photographs can provide a useful reference; these images of sculptural textures suggest the surface quality of a piece. Replicating and perfecting the textures in metal could form another area of research, before the final piece (below) is constructed.

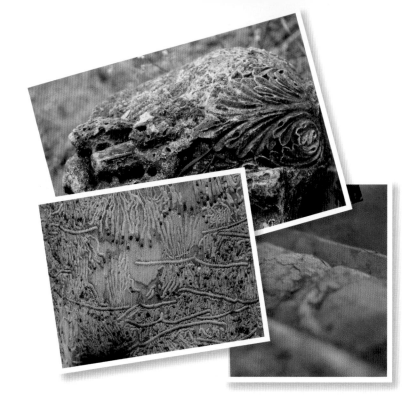

Recording your research

Keep a sketchbook as a sort of visual diary, to record the things you find. It can include your sketches, collages, photos, and notes on the particular aspects that you found interesting. When working with a project in mind, your research should take a particular direction but may lead down several paths—some may be dead ends, but others can provide inspiration and source material for years to come. Make a collage of the key images that you think may be relevant for a particular project—this can provide a wealth of useful information about what your piece of jewelry might look like or function as: information such as color palette, textures, form, and aesthetic.

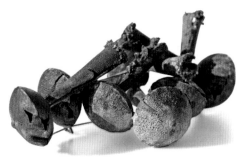

Mood board (below)

Images can be cropped and arranged to create a mood board for a project—consider the ways in which the images interact, the color palette and the range of forms. This mood board contrasts Modernist and Gothic architecture to set the project's parameters.

Drawing is a vital design tool, as it provides a means of exploring and recording ideas in a descriptive medium. A jewelry designer may use several types of drawing as part of the design process— from quick sketches to detailed technical diagrams.

DRAWING

Sketchbooks

A sketchbook is a record of your exploration on paper. There is no right or wrong way of going about it—some sketchbooks are filled with detailed color studies, while others may contain sketchy line drawings. Like other skills, drawing takes commitment and practice for you to be able to achieve the desired results. Don't feel limited by your drawing skills—the only requirement is that you understand the information in drawings you make. Have more than one sketchbook: a small one for making notes, and a large one for exploring ideas in more detail. Large pages will allow several drawings exploring one idea to be put on a page—this helps ideas develop smoothly and feed into one another.

Exploratory drawing

It is important to find a drawing style that works for you—even a few lines put down on a page to convey thoughts can be useful. Drawing is a means of recording thought processes—it doesn't have to be a masterpiece, but should provide clearly communicated ideas—the style of drawing can convey emotion, movement, and atmosphere. Use your explorations to build a personal visual language that will help to justify your design decisions.

To fully understand an object, it will help to draw it from every angle using your drawings to emphasize the parts that are important to you— is it the shape of the form or its open structure? Draw the object until you are familiar with its form. You can also extract areas of an object and abstract them into new shapes and forms, and explore the emotional responses you might have to the object. Take elements or small areas of a form and exaggerate, stretch, shrink, flip, add to them, or interchange parts.

Computer programs such as Photoshop are useful for manipulating images or creating collages. Drawings can be stretched or

Try different media
The same study object can be explored using different media—ink, pencil, paint, and charcoal will all give a different aesthetic to a drawing. Try quick sketches as well as detailed drawings.

Draw from objects
Life studies can provide good source material from which forms and structures can be abstracted.

Personal vision

Use your sketchbooks to create a personal visual language.

Technical drawings (below)

Technical drawings are used as part of the design process when the function of an object directly influences its form.

Jewelry on the body (below, right)

Drawing can also be used to explore how a piece is worn, or the overall aesthetic that it may create with the body.

radically changed in scale—remember to keep copies of your working so that you can see the progression.

Drawing for design

The design process is best explored on paper—it is important to put down your thoughts on paper so that you can understand and explore the way a piece looks. When designing, your drawings need to be about the way the piece works on the body and its physicality, as well as its aesthetic. Give the drawings depth, thickness, and perspective, and start thinking about the way in which the piece can be made; the techniques and processes used. Your level of technical skill will influence the design process—the more techniques you have at your disposal, the more answers there may be to a particular question.

Technical drawing

It is useful to keep technical information all in one book or folder, so that it can be used for future reference, especially if you want to remake a piece several years later when the original is not in your possession. Record all the information you will need to remake the piece,

including thickness of metal, cutting templates, and chemical recipes, as well as extra information such as suppliers of materials. If you used specific or new techniques as part of the production of a piece, write down what you did to achieve the outcomes, and whether or not it worked. Include failures, because these are an important part of the learning process; if something goes wrong, ask yourself why and this will help you to understand some of the processes in jewelry making—often you will learn more about a technique or material if things do not go to plan, and sometimes the results can be surprisingly useful!

Precise drawings should be annotated with all the relevant information, including the scale of the piece. Models, trials, and templates can be included, alongside photographic records of work during production, and once finished. This will help to remind you of the processes used and the stages of production. Technical drawings for a final piece may go through several stages—the piece you planned to make, the revisions to the design caused by technical challenges, and a record of the piece that was finally constructed.

Presentation drawing

Presentation drawings are most useful when working to commission so that the client can see an accurate representation of the piece before it is made.

Traditionally, renderings of jewelry are painted, using gouache on mid-tone gray paper, to create a realistic rendition of the piece. A degree of skill is required to accurately represent metal and stones, and the paintings are usually produced to scale, at the actual size of the piece of jewelry and in very great detail.

CAD renderings are ideal for presentation drawings because they can be easily adapted to create variations of a design, allowing you to offer the client more choice. Variations to the color of the metal or stone can easily be made to illustrate how the piece would look.

The method of illustration you choose will depend on the particular client, but clear communication is the key whatever the style; for example you may prefer to use a style more akin to fashion illustration or graphics for your presentation drawing.

Presentation rendering

A presentation "rendering" is an actual size, realistic representation of a jewelry design that shows exactly how the piece will look once it has been made.

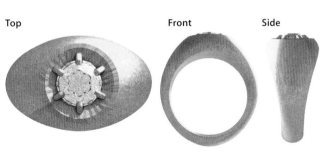

Top Front Side

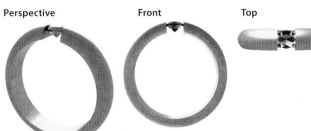

Perspective Front Top

Three-dimensional design software

Three-dimensional design software allows designs to be easily visualized from every angle. The color of metal and stones can be altered to show the piece in different materials.

Writing a specific set of rules, or a "brief," for a project can help to capture the key aspects of a piece, allowing you to quickly identify areas that may need further thought or development. A brief provides a structured framework, and helps to define your intentions and focus.

DESIGN CHECKLIST

What type of jewelry are you making?
- Commercial, art jewelry, small-batch production, one-off?
- Does the piece dictate how it is worn, or is it left open to interpretation?
- Ring, earrings, pendant, brooch, bracelet, bangle, cufflinks, stud pin, tie pin, tiara, body piece, or choker?

What is your inspiration?
- Muses—fictional characters from film or literature, celebrities—pretend you are designing a piece for someone.
- A concept—how is this expressed? An object?
- A particular technique or material, which may dictate the form or function used.

How will you use your research to inform the design?
- Is your research concerned with technical aspects of jewelry making? Aesthetics? Form?
- Have you pushed the design forward from the starting point?

How are you going to make the piece?
- Which techniques are most appropriate for your design?
- How does this affect the function and manufacture of the piece, for example, do cold-joining techniques need to be employed?

Why are you making it?
- Is the piece a commission, part of a larger collection of work, for an exhibition, or for yourself?

What materials will you use?
- Are you making the piece using precious metal, base metal, gemstones, natural or synthetic materials, or mixed materials?

What is your budget?
- If you are working to commission, you must not spend too much on materials, or your working time will not be fully covered.
- Your budget can also be determined by the type of piece you are making and how much you intend to sell it for.

How much time can you give the project?
- This determines how complex the project can be—plan carefully and decide how much time you should spend designing and how much time making.

Key words to consider when designing jewelry

Symmetrical
Asymmetrical
Geometric
Organic
Modernist
Abstract
Sculptural
Figurative
Narrative
Symbolic/iconic
Commemorative/
Sentimental
Historic
Humorous
Political
Fashion
Shape
Scale
Form
Function
Colors
Textures
Finishes

Successful design realization can give a jeweler a powerful voice and means of expression. The transition from two-dimensional drawings to three-dimensional objects can be a challenge, so making models of a piece is a key part of the process, in both technical and aesthetic aspects of designing.

DESIGN REALIZATION

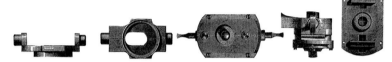

Developing a design

The development of a design is not just about changing how it looks; it also involves the function of the piece and how this may be affected by its form or construction.

The research material you have gathered and the drawings made should directly influence your jewelry design. One idea or process may lead to another—follow the thread that suggests itself through your research, but stay in control of the direction it takes. Not all the information you have collected or produced during the process will be relevant for the project you are working on, but it may prove useful in the future.

Draw the object repeatedly, changing it slightly each time to adapt the form, or to refine specific areas. This method can be performed many times, with a different outcome in mind—you might try simplifying the form by stages, or adding in new elements or structures. Consider how the design might be applied to a different jewelry form—if you are designing a ring, contemplate how the form or motifs could be used for a pair of earrings, for example. Push yourself to generate variations on your original idea, taking reference from your research. It is fine to change direction as long as you keep your original aims in mind.

You will probably not use the early stages of the design—think of it as "showing your working" as part of a complicated mathematical equation—you should be able to look through your drawings and models to see how you arrived at a particular answer.

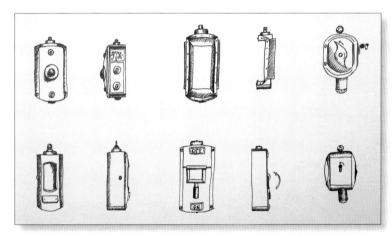

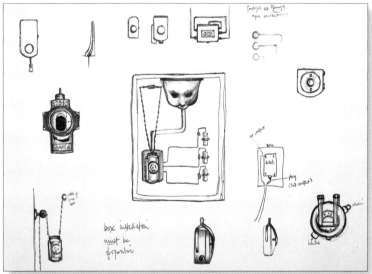

Developing the design
Design development should show the progression of an idea worked out on paper.

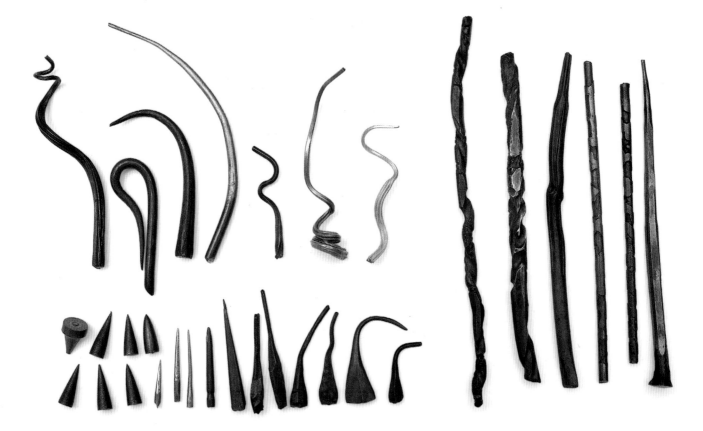

Practice runs should be made when trying out a new technique.

Test pieces

It is often necessary to make a large range of samples before starting work on the final piece. A range of techniques were applied to metal rod to create this series of test pieces.

Once you have determined how the object will look, you need to consider its construction—draw the piece from several different angles, using models if necessary. This will allow you to see if any areas do not look quite right, or are in need of further development.

Making models

Once you have explored the design on paper, start making three-dimensional models. There are a number of reasons for making models: to explore form, function, and weight; to

investigate technical aspects such as mechanisms and moving parts; and to experiment with color or texture techniques, or the suitability of a particular material.

Model making can also help you to test an idea, to see how it looks in three dimensions when translated from a two-dimensional drawing—and sometimes it is necessary to make a model in order to draw a design from several angles, before adapting it further. An exploration of several models may be required to work through an idea to resolve it.

Models are usually made in base metals in order to keep costs down, but quick 3-D sketches can be made from paper, card, modeling clay, or wire armatures. For complex pieces, especially if they are being produced in an expensive material such as gold, it is wise to produce a first run in base metal, so that any complications or problems can be identified before you make the final piece.

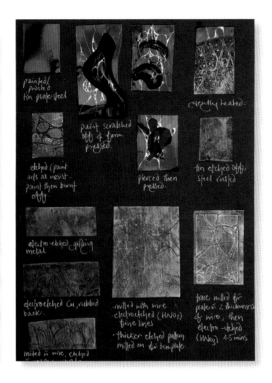

Making samples (above and left)

When producing samples and technical models, make clear notes on how the effect was achieved so that the process can be easily repeated.

Planning a final piece

The technical notes and models you have made exploring the construction of the piece should give you an order in which techniques will be applied. For example, many techniques cannot be carried out on a piece of work before all soldering has been completed—this includes stone setting and patination processes; some texturing techniques are more easily performed on flat sheet metal.

Pieces of jewelry invariably involve more than one technique; the combination of techniques is an important design consideration because it will have an influence on how the piece looks, and how it functions. Plan the sequence of construction carefully before starting on your final piece.

A cutting list detailing the materials needed for a piece will allow you to work out the cost of making it—some bullion suppliers' websites will automatically calculate the cost of a particular-sized piece of metal when you type in the dimensions.

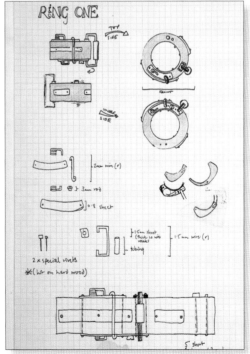

Technical drawing

A good technical drawing should contain all the information needed to make a piece, including metal gauges and the sequence of construction.

CHAPTER FOUR

GOING
INTO
BUSINESS

PHOTOGRAPHY AND PROMOTION

Creating images of your jewelry is crucial if you want more people to see it—whether producing business cards, brochures, or material for a website. Many jewelers will have their work professionally photographed, but this section explores some of the effects that can be achieved with basic photography equipment. The use of lighting, backgrounds, and props can all help to communicate different aspects of your jewelry, and with digital photography it is so easy to explore the many possibilities before deciding on the final outcome. The messages that are conveyed through an image can make a strong statement about the work, but it is crucial that a piece of jewelry is represented in a visually readable manner, no matter where the image is used.

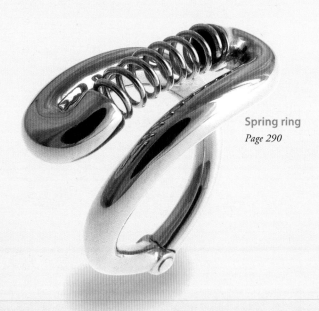

Spring ring
Page 290

With a few key items of photographic equipment, it is possible to take clear images of your work, or other relevant subjects. Most of the equipment can be sourced for a reasonable price; you will only need the basics when starting out.

BASIC PHOTOGRAPHY

Photographic equipment

The most important piece of equipment is the camera—digital cameras can now be found to suit every budget, but if you will be using photography a great deal, you should try to spend as much as you can afford to ensure that the image quality is satisfactory. Make sure that the camera has a macro or super-macro function, which allows the camera to focus close-up on small objects, and use the highest image-quality setting. Computer and image editing software, such as Photoshop may be desirable, but this will not be within everybody's budget; digital prints can easily be ordered online or from your local photography store.

A small tripod that supports the camera will be useful for taking close-up shots, especially when camera-shake is an issue.

It is possible to find small light cubes or tents for sale inexpensively. These are folding fabric structures with a steel frame that have a removable front cover with a slit through which to insert the front of the camera. They are particularly useful for taking shots of polished pieces, as the interior is completely white, eliminating all unwanted reflections. The fabric cover diffuses the light source, softening shadows to give a more professional look to the image.

Lighting

Lighting is crucial to good images, especially for small items such as jewelry—the more light there is, the sharper the image will be, and the greater the depth of field will be—meaning more of the image will be in focus. Normal light bulbs of a high wattage will work, but the overall color of the image tends to be rather yellow. Daylight bulbs, halogen lights, or white LEDs will give better results, but these can be expensive; full sunlight can be sufficient for good photography!

Lightboxes can be used to light objects from underneath, which is especially effective for transparent materials, as it makes them glow and gives them a bit more life.

Basic photographic equipment

Basic photographic equipment should include a digital camera, spare battery and memory card, light tent, and tripod.

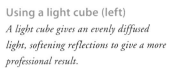

Using a light cube (left)

A light cube gives an evenly diffused light, softening reflections to give a more professional result.

Pyramid (below)

A similar effect can be achieved by using white card to build a pyramid around the camera lens—a piece of fabric or tracing paper is used to diffuse the light source. The amount of diffusion is dependent on the harshness and power of the source light.

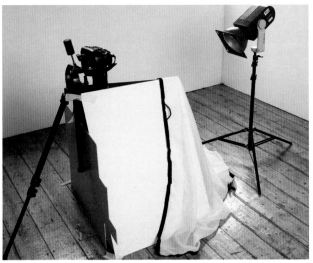

Changing backgrounds

How to light jewelry in a pyramid without a purpose-bought lighting tent and with only one light source.

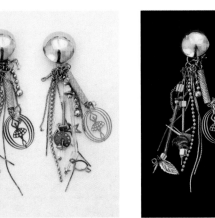

This is jewelry using the lighting rig shown, but using a white background. The result is good but the edges are very subtle against the background.

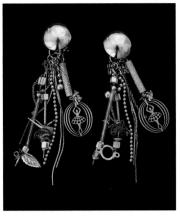

A black background gives a crisp edge and good contrast with silver jewelry when shot with a diffused light source. Other colors would reflect into the subject so beware.

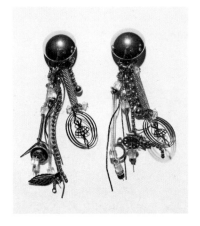

If shooting with no homemade rig or softening and using only a light source, the result has too much contrast and is heavy and unappealing.

Choosing the final image

Take a range of images of a piece using different lighting and compositions; a contact sheet can be used to choose the final image by comparison and elimination.

The tone, contrast, saturation, and exposure of a shot can be adjusted using image-editing software, which can also be used to add a range of effects to the image, but it will be impossible to achieve a really good result if the lighting was inadequate when the image was shot.

Getting good results

Give yourself plenty of time—photography is not as simple as the push of a button. Take far more shots than you think you need and vary the angle of the camera and the lighting—take close-up detail shots as well as wider-angle ones. Digital cameras make it easy to take a large number of shots, which can then be compared and edited down to the one or two that were most successful. Clearly label your images and store them so that they can be found easily; keep a high-quality master copy of each image in one folder, and smaller copies in another.

IMAGE ENHANCEMENT WITH PHOTOSHOP

Most images will require some tweaking, from removing dust specks to adjusting the contrast and light levels. There are many software applications that can be used to make your image perfect.

1 This is the raw file, downloaded directly from the camera. The light levels need adjusting, and the adhesive putty supporting the piece is clearly visible.

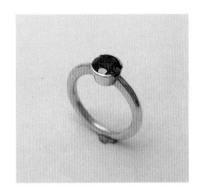

2 Applying "auto levels" greatly improves the color and contrast within the image, but further adjustments can be made to the levels manually.

3 Here, the "clone" tool has been used to remove the adhesive putty from the base of the ring, and any visible dust and scratches. It was then necessary to blur the shadow under the ring.

4 You can even change the color of the stone from ruby to peridot—select the stone and alter the hue of the selected area. The image has also been cropped in more closely.

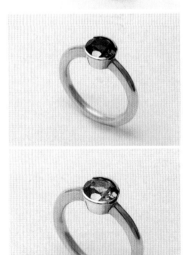

Photography can be a very useful tool in jewelry making, from the gathering of inspirational images, to recording the stages of making a piece, to photographing images of finished jewelry. Photography can be used to show the piece in a different way than that in which it might be displayed or worn, especially where a narrative or concept is conveyed.

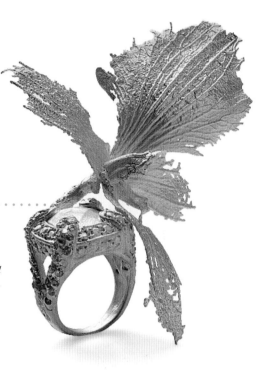

PHOTOGRAPHING JEWELRY

Shooting finished pieces

You may wish to have a professional photographer shoot your work—this can be expensive, but is generally worth the money as your work will be represented to its best advantage. Take enough work to fill the time you have booked, and choose a photographer who specializes in jewelry images, as they will know all the relevant techniques—metal can be tricky to shoot, especially if it is very reflective. You will be provided with a CD of high-resolution images after the shoot. Remember that although the

Good lighting
Simple shots require good lighting to show the piece well. More of the piece will be in focus when a powerful light source is used, and a plain white background can often be very effective.

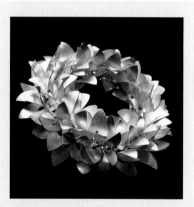

· **Plain backgrounds** often result in the clearest images as there is no distraction from the jewelry, but pale pieces may be lost on a white background—black backgrounds can often make a piece look quite striking, but the lighting is crucial so that the pale areas of the piece are not over-exposed.

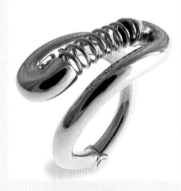

· **Polished surfaces** are highly reflective and will show the camera, photographer, and surroundings unless shot in a light cube, which also softens shadows.

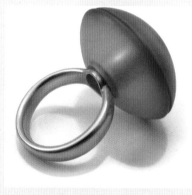

· **Diffused light** often gives the best results when photographing jewelry, and paper, card, and other props can be used inside a light cube.

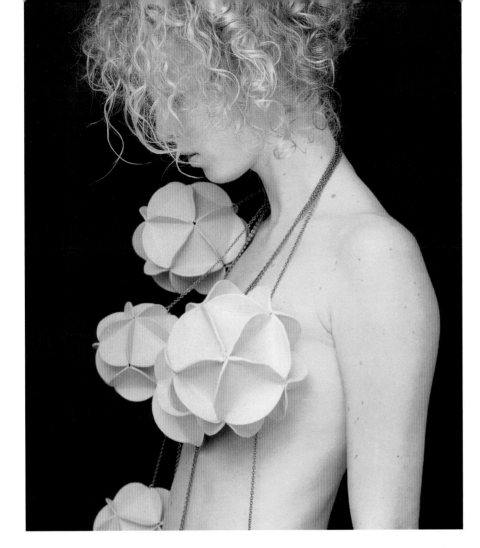

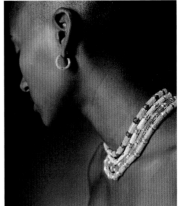

Shooting jewelry on a model

When using a model to display jewelry for photography, make sure the composition is considered—cropping can be crucial. The skin tones and "look" of the model should be appropriate to the pieces being photographed.

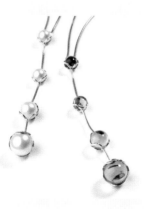

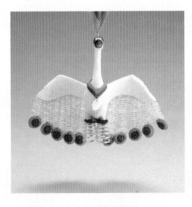

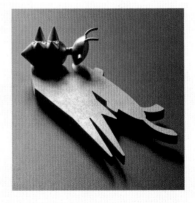

· **Stones look best** when they are caught in the light, showing a glint of color or reflection.

· **Use a large piece of white or gray card** that is curved up at the back to create a gradual darkening of the background.

· **Changing the position of the light** can have a dramatic effect on how the piece appears—try taking shots with the light source in different positions.

work is yours, the rights to the image belong to the photographer, and they must be credited if the image is published.

Working with models

Some pieces of jewelry only make sense when they are displayed on the body, and in these cases you should use a model. The choice of model can greatly influence the impression the image makes—friends will often oblige. Spend time on hair and makeup if their face will be in shot, and use neutral clothing or bare skin—the jewelry should be the focus of the image.

Professional models can be an expensive option, but if you are hiring a photographer or studio time for a photoshoot of a number of pieces, it may be worth it to ensure the best results.

Record keeping

Taking pictures of a piece at stages during its construction provides a useful technical resource; models that were made as part of the project should also be recorded as you may not wish to keep them. It is also useful to record any exhibition displays for future reference.

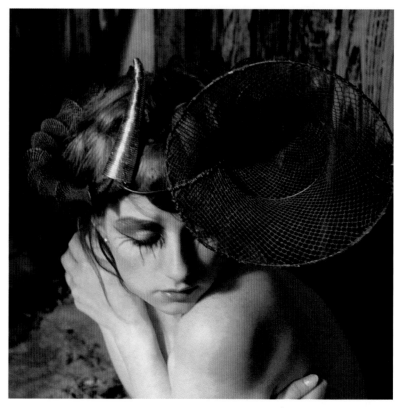

Headpiece

by Laura Bamber

The use of models, styling, and location can all add an extra dimension to the image and are crucial in conveying a narrative and creating an identity for your jewelry.

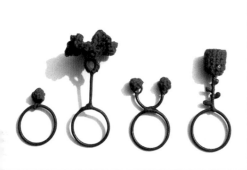

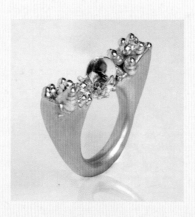

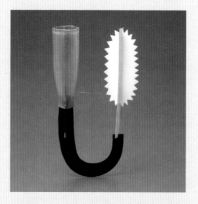

· **When taking group shots** of jewelry, consider the spacing between the pieces, whether they overlap, and which parts form the focal point.

· **Placing the piece on a reflective surface** such as an acrylic block or glass can give attractive subtle reflections.

· **Rings can be invisibly propped up** with wires or adhesive putty to improve the angle that they are seen from; pieces such as earrings and necklaces can be hung from stands or hooked over objects, but these should be neutral unless they are a part of a conceptual piece and integral to the display.

Images of your jewelry will play a key part in its promotion, whether you are applying to a gallery, or for a job, or building a website or portfolio for people to view examples of your work.

PROMOTIONAL MATERIAL

Using images to promote your work

The photographs taken of your work can be used to promote your jewelry through websites, business cards, postcards, and portfolio images, as well as in the press.

All the promotional material used for your business should communicate a clear identity, or brand. It will tell the viewer something about your jewelry, as well as being recognizably yours. The type of image you use speaks volumes about what you do and who you are, so needs to be carefully considered. The way in which an image is cropped can make a lot of difference to the message it communicates. The image should leave the viewer curious to see more of your work. Postcards and business cards also provide a useful reminder for people who have seen your jewelry, so it is important that the image provides a clear representation of your work, and that the card features your contact details.

In general, images supplied for printing should be at least 300 dpi to give a good-quality result. Photographic images that are e-mailed should be much smaller—it is increasingly possible to reduce the file size without too much loss of on-screen quality—saving the file for the Web will reduce the amount of memory it uses, and some e-mail applications will allow you choose the file size before sending.

Creating a website

There are website design companies or individuals who will put together a website for you, to your specifications. You will need to provide all the information and images to them initially as well as each time you need to have the site updated.

Increasingly, there are do-it-yourself online services that allow you to purchase your choice of domain name, and then to build your own website using online software. Although the outcome will be more limited than if the site was built by a professional, the functions of image galleries, video links, e-mail services, and online stores with a secure payment method will be sufficient for many people, and is a good way to start out for a very small cost. Try to keep the design simple and maintain a theme throughout the site.

Building a portfolio

A portfolio is a presentation folder of images that can be shown to clients, customers, or potential employers and illustrates aspects of your working practice. The content will depend on what the portfolio will be used for—it may contain design work and presentation drawings if your design skills are what you are representing, or it may provide a detailed record of the best pieces you have made over your career to date. The content should be carefully edited so that only the strongest images are left. Display the work loose or use matte plastic folders to protect it—shiny plastic is reflective and can make it difficult to view the images.

Website and flyers
Images of your work can be used on many kinds of media: a website (below) or postcards and brochures (above).

Portfolio
A portfolio must clearly communicate the message you wish to project about your jewelry—presentation is everything.

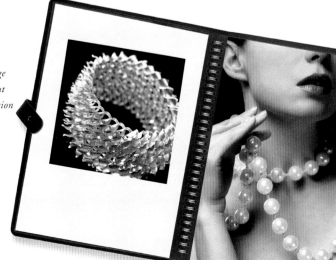

SELLING AND EXHIBITING

Turning your jewelry making into a business is a dream for many, but it is important to make informed decisions on how to go about doing it. Choosing the correct arena for selling your jewelry will depend greatly on the type and price range of the work you make and will be crucial to your success. This section offers practical advice about pricing your work and sourcing the right type of outlet; describing the different options open to the small-scale jeweler, from craft fairs to trade shows and to online galleries. Exhibiting jewelry to its best advantage can be vital for sales, and the visual impact a good display makes should never be underestimated.

Packaging and display

See page 298

Once you are accustomed to designing and making jewelry, the next step is often to start selling the pieces you make. How you go about this will depend to a large degree on what type of jewelry you make, and although setting up in business can be a daunting prospect, it isn't necessarily as difficult as it sounds.

PRACTICAL ADVICE AND COSTING

Setting up a business

You should seek advice from an organization that can give you accurate information for your specific business requirements—it is important that your business is correctly registered to pay tax, and you should be aware of some of the working practices used by self-employed jewelers to ensure their businesses run smoothly, such as issuing invoices and delivery notes and keeping stock sheets.

Join a network that supports jewelers—these might be run by organizations that run workshops or by organizations who aim to help craftspeople running a small business. They will be able to offer help and business advice, sometimes financial bursaries, and provide a way to meet other jewelers in a similar position—it often helps to talk about what you are trying to achieve with like-minded people, especially as jewelry making is quite a solitary pursuit.

There are also a number of books, some aimed specifically at jewelers, which offer detailed advice on all aspects of running your own business.

Types of jeweler

Working out which type of jeweler you are and what type of jewelry you will be making is crucial to where and how you will sell your work. The way in which you make your work will have a direct impact on its cost, and this determines the market you are aiming at. For example, expensive, intricately constructed jewelry is unlikely to sell well at a small, local craft fair, but handmade silver pieces may be very popular.

Do some market research to determine where you think you fit in: go to trade shows, craft fairs, and open studios to see what kind of work other jewelers are making—is this the area you want to be in? Some jewelers make work for exhibitions only, or to private commission; while others work exclusively for companies in a design or manufacturing role.

Pricing your work

It can be a difficult task to place a price tag on the fruits of your labor, but it is a necessity if you

Your identity
Branding should be consistent throughout your business and include letterheads, business cards, and website.

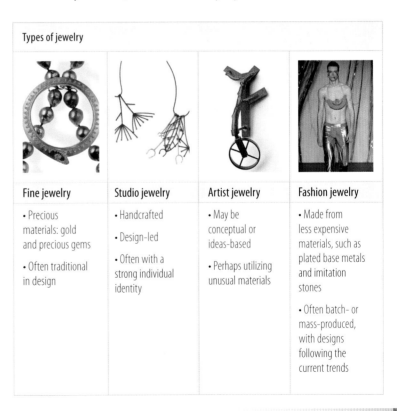

Types of jewelry			
Fine jewelry	**Studio jewelry**	**Artist jewelry**	**Fashion jewelry**
• Precious materials: gold and precious gems • Often traditional in design	• Handcrafted • Design-led • Often with a strong individual identity	• May be conceptual or ideas-based • Perhaps utilizing unusual materials	• Made from less expensive materials, such as plated base metals and imitation stones • Often batch- or mass-produced, with designs following the current trends

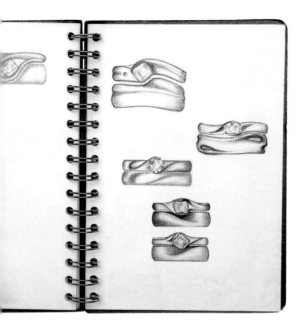

Design variations

After an initial discussion with a client, several design variations may be produced before deciding on the final piece.

Contract

A commission contract should contain all the necessary information for both parties, including costs and time frame.

STONES ● JEWELRY

AGREEMENT OF COMMISSION OF WORK

J N Smith
42 South Street
New Town
The Bury's
Godalming
Gu7 1HR

23rd February 2010

Item: 18k yellow gold ring

Stones: 0.15 ct ruby, brilliant cut.

Ring size: 6

Agreed completion date: 10th May 2010

Price: $1,520
$760 payable on confirmation of design.
$760 payable on delivery of the piece.

I agree to Terms and Conditions to the order of the above item.
Print name _____

Signed _____

Date _____

B R Newton The Studio Top Floor Hyde Tower Western Ford

are going to sell your jewelry! The tendency is often to undervalue your efforts, so consider the following points when pricing a piece:

• The cost of the materials and the time it took to make the piece will be the greatest proportion of the price. Time taken, or labor, can be calculated at an hourly rate, and can include the time it took to design the piece—if several pieces of the same design are made, then this cost can be divided between them. Many jewelers include an "overhead" charge in their hourly rate—this includes the cost of running a workshop and buying sundry items such as saw blades and solder.

• Additional costs may come from outwork such as casting or stone setting, assaying, and postage and packaging.

• Profit is calculated at between 50 and 100 percent on top of the total costs, but you may wish to charge a premium for pieces that you are particularly pleased with, especially if they are a one-off. In general, you should charge enough to allow you to make two more of the same piece.

Working to commission

When you are starting out as a jeweler, the first commissioned pieces are likely to be for friends or family, and will be agreed on a relatively informal basis. If you are working for a client, it is a good idea to agree on the terms and price before you start working on the piece—draw up a contract that clearly states what you will be making, how long it will take, and how much it will cost; both you and the client should sign this.

The contract usually follows the initial discussion with the client, when the parameters of the design will be set. It is then customary to provide a presentation drawing for the client to approve so that they can see what the piece will look like. Suggest that half the fee is paid on agreement and the remainder on delivery of the work; this means you will have the money to buy the materials for the commission and are not taking any financial risks.

Always allow more time than you think you might need, especially if you are using outwork services.

Galleries, stores, and online retailers

The ways in which jewelry is sold can vary greatly. Galleries often work on a "sale or return" basis, which means that the work is not paid for unless it is sold. The gallery will mark up the price in order to make a profit, so it is in their interests

to sell the work. Very few galleries, but more stores will actually purchase work for resale.

Craft fairs, trade shows, and open studio events provide you with the opportunity to sell directly to the public, and the price of the work should be marked up to a retail level—if you have similar work in galleries they will not want you to undercut their prices. These shows can be hard work as you will need to be available to talk about and sell your work to potential customers. Gallery managers go to these events to look for new work, so it is important to make a good impression with everybody you talk to.

Galleries often have "virtual galleries" on their websites, and there are galleries and stores that exist only on the Web. It is also possible to set up your own website with a shop, but unless well advertised, you will be unlikely to receive the same amount of virtual passing trade as an established retailer. With the Internet sales, there will always be the problem of distance— customers cannot try on pieces, and this will affect the number of impulse buys, so always give as much information as possible about a piece.

Jewelry stores and fairs

You might be able to sell your work in specialty jewelry stores (top). Jewelry fairs and trade shows (three central images) provide the opportunity of presenting your jewelry directly to the public and to gallery and store owners.

Online gallery

Online galleries sell handmade pieces by many different independent designer-makers in one place.

Exhibitions are a good way to get your work seen by customers, galleries, and the general public. The type of exhibition will depend on your work, but also on what opportunities come your way; one exhibition can lead to another. It is important to be well organized when exhibiting to make the most of the experience.

EXHIBITING JEWELRY

Exhibition venues

The type of venue will determine your experience of the exhibition. Gallery shows are likely to be curated and set up by the gallery staff, who will have experience of putting together exhibitions. Trade fairs will provide a "stand" that may include a table or a lockable cabinet, as well as lighting. For open studios or venues that you have hired, it is likely that you will need to make most of the arrangements yourself.

Venues provided by trade shows and larger exhibitions are likely to promote the show themselves, and will provide you with flyers and private view invitations and make sure the event is well advertised in the press; the cost of this will be covered by your booking fee. Smaller venues will not provide this service, so you will need to make your own arrangements—some jewelers prefer to hire a PR company to do this for them.

The competition for trade shows and fairs can be fierce as there will be a limited number of places, so ensure that you make a good first impression with your application by sending good-quality images.

Displaying jewelry

The display of your jewelry needs to be eye-catching so that it draws the viewer in for a closer look. There are no definitive guidelines, as each venue and type of jewelry will influence how the work is displayed.

The main criteria is that you have enough jewelry to display, and a balance of pieces. For selling shows, it is customary to display a few larger, striking pieces alongside many smaller, more sellable items such as rings and earrings.

Consider the composition of your display—is the eye drawn around the case? Can the work be clearly seen and understood?

Very valuable pieces should be displayed in lockable glass cases, but other pieces can be displayed openly and discreetly secured to a wall or table surface with nylon thread. Pieces that would display better on the body can be hung using transparent nylon monofilament tied to small hooks that have been screwed into the back or top of the display case or wall.

Display and packaging items (above)

From left to right: Satin bags, acrylic display stands, acrylic display stand props in use.

During the exhibition you may need:		
• Business cards and postcards • Mirror for customers to try on jewelry • Packaging materials—tissue	paper, satin bags, jewelry boxes • Price list • Order pad • Receipt book • Book for customers'	contact details • Portfolio—press clippings, images of work that is not on display
Useful items when setting up:		
• Polishing cloths/ white gloves • Pin vise and drill bits • Nylon monofilament for hanging pieces • Small hooks • Scissors	• Display props— acrylic blocks, paper • Glass cleaning fluid • Pliers • Steel wire • Paintbrush	• Camera—to photograph the finished display • White adhesive putty

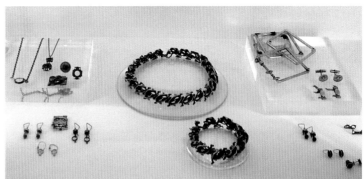

Small stands made from wire can be used to prop up rings, and drilled into wood or perspex bases. Acrylic blocks and props can be used to raise the height of certain pieces within a display, but the key is to keep the layout simple. Lighting can be key to a good display, so make sure that you have adequate light sources so that all of your work is well lit.

It is a matter of opinion whether or not to clearly display the price with each piece; this will depend on the type of exhibition. Many jewelers prefer to use a price list, in which case each piece may need to be labeled with a code or number referenced to the list, or you can use an image of the display case with a key to the pieces.

Setting up

It always takes longer to set up work for display than you might imagine—give yourself a clear day to do it in, and try a few different layouts at home or in your studio first, to find out what works and what doesn't.

You must make sure that your jewelry is clearly displayed, clean, and looking stunning well in advance of the opening of the show, because there will be plenty of other things you will need to do on the day.

Ask for a second opinion on your display, as it is difficult to judge whether the composition of the display is satisfactory after you have been staring at the work for several hours.

Competitions

Competitions are a useful way of getting your work noticed. They are many and varied, and are run by companies, charitable organizations, and cultural institutions. Many will accept international applications, and although some do charge an entry fee, others are free to enter so there is nothing to lose in trying! Some of the websites listed in the resources section have comprehensive links to current international competitions. The prizes vary from bullion to a financial award or may purely be the chance to exhibit—competitions often have an exhibition to accompany them, and even if you do not win a prize, you may be selected to exhibit alongside the prize winners. In these cases, the organizers will be in control of the display of the work, so if there are any special requirements, then attach them with the entry. It may be necessary to make your own arrangements for the return of the work.

Display equipment (below)

Tools which are useful for setting up displays include gloves to prevent fingermarks on work, a pencil, brush, scissors, and white adhesive putty. Steel wire and pliers to cut and bend it into stands, as well as small hooks, a drill bit in a pin vise, and nylon monofilament to suspend work may also come in handy when setting up an exhibition.

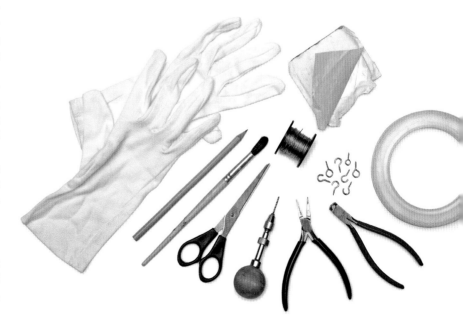

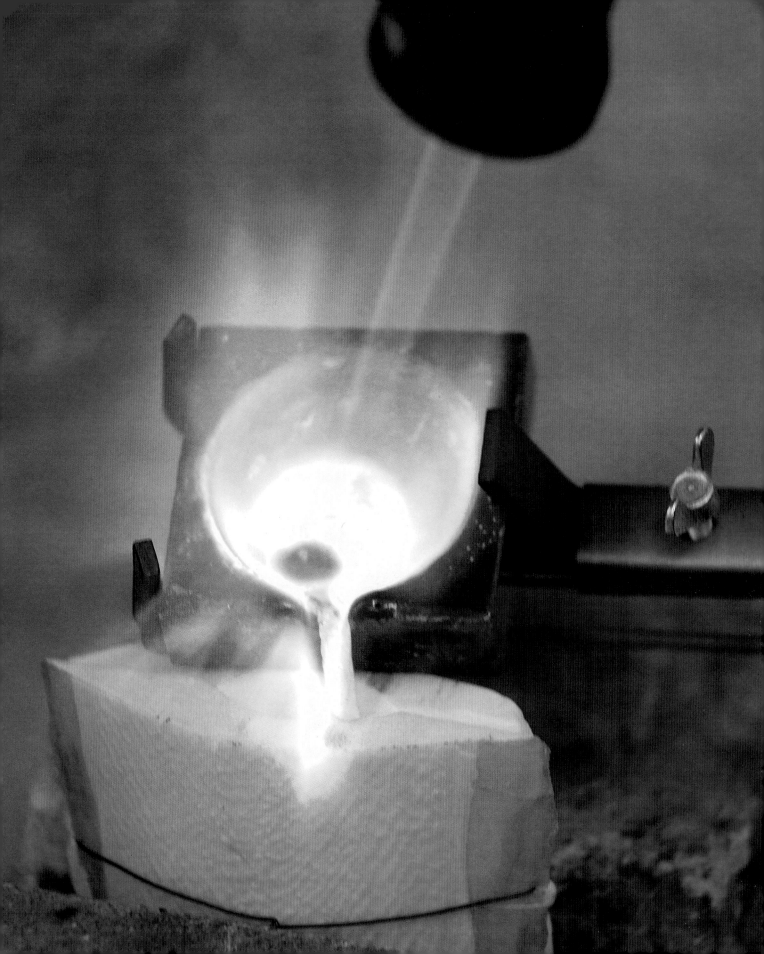

REFERENCE

DIRECTORY OF GEMSTONES

Every type of gemstone has its own particular properties and will be available in a range of shapes and forms. This section makes choosing the right stone for a particular piece or setting an easy task where such factors as hardness, durability, fire, and luster are considered. Recommendations for the types of settings that should be used with particular stones are described as well as tips for successful setting.

Diamond

Group: Diamond

Hardness: 10 Mohs

Specific gravity: 3.14–3.55

Properties: Strong adamantine luster

Diamonds are graded by color, clarity, weight, fluorescence, cut, and shape; each of these factors will affect the price. Always buy diamonds from a reputable dealer, and insist on certification to ensure that the stones are fair-trade—many diamonds are laser-marked so they can be identified.

Range available: Most diamonds are brilliant cut, and a range of natural colors can be found. Heat-treated diamonds are less expensive and are available in blue, green, pink, and yellow, but the colors tend to be a little gray.

Ruby

Group: Corundum

Hardness: 9 Mohs

Specific gravity: 3.97–4.05

Properties: Strong pleochroism

Ruby is the hardest stone after diamond, and valued for its rich, purplish-red color and durability. Good-quality stones carry a higher price than those that are cloudy, a less desirable color, or have inclusions. Rubies are often heat-treated to improve the color.

Range available: As well as faceted gems in a range of cuts, rubies can be found as cabochons and beads, but these will be cut from lower-grade material. Cabochon star rubies can also be sourced.

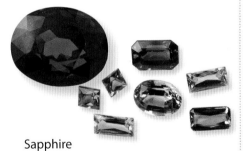

Sapphire

Group: Corundum

Hardness: 8–9 Mohs

Specific gravity: 3.95–4.03

Properties: Pleochroism

The cost of sapphires is dependent on color and cut—blue is the most desirable color. These stones are very durable and suitable for jewelry such as rings, which will receive much wear.

Range available: Many cuts and shades of blue sapphire are available; the stone can also be found in yellow, pink, and white, which can be used as an alternative to diamond. Pink sapphires have become very fashionable and can be expensive.

Chrysoberyl

Group: Chrysoberyl

Hardness: 8.5 Mohs

Specific gravity: 3.7–3.78

Properties: Color-change or chatoyancy

Chrysoberyl is a brilliant, clear gem that is very durable; its color ranges from yellow through green and brown. Other members of the chrysoberyl group are alexandrite, which has color-change properties, and chrysoberyl cat's eye. These stones are sensitive to impact, pressure, and heat.

Range available: Chrysoberyl and alexandrite are usually found in faceted cuts; cat's eyes are cut as cabochons to maximize the optical effect.

Spinel

Group: Spinel

Hardness: 8 Mohs

Specific gravity: 3.54–3.63

Properties: Vitreous luster

Spinel is durable, making it ideal for flush setting and everyday wear.

Range available: Red-orange flame spinel is the most expensive color; most spinels are a soft red and the stone is rarely heat-treated or irradiated to improve the color. Mainly available as smaller-sized stones, spinel is a less expensive alternative to ruby and sapphire, and can also be found in shades of pink, as well as black.

Topaz

Group: Topaz

Hardness: 8 Mohs

Specific gravity: 3.49–3.57

Properties: High brilliance and vitreous luster

Yellow is the most common color, but topaz can also be found in orange-brown, light to medium red, blue, and colorless. Blue topaz is often treated—giving shades of sky blue, Swiss blue, and gray- or green-blue. Care must be taken when setting topaz as it can fracture, and a protective setting should be used if the stone will be set in a ring.

Range available: Large stones can be found and are good value. Pale colors are often step or scissor cut.

Emerald

Group: Beryl

Hardness: 7.5–8 Mohs

Specific gravity: 2.69–2.80

Properties: Dichroism

The ideal color for an emerald is clear, vibrant green with a hint of blue. Emeralds often have inclusions or internal cracks, which can make the stones fragile. Care must be taken when setting, and the stone should not be exposed to heat.

Range available: These stones are often "emerald" cut to suit the shape of the crystals—this is a step cut with no corners. Less expensive emeralds are usually paler shades of green and may have cloudy inclusions.

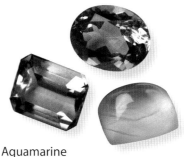

Aquamarine

Group: Beryl

Hardness: 7.5–8 Mohs

Specific gravity: 2.69–2.80

Properties: Dichroic

Aquamarine is a blue stone with good clarity, but many stones are heat-treated to produce a more desirable shade making them prone to damage if they are overheated when polishing. Although many stones are free from inclusions and cracks, aquamarine can be brittle and setting should be carried out with care.

Range available: Many aquamarines are step cut to intensify the color. Intensely colored stones will be more expensive than paler ones. Flawed material is used for cutting beads and cabochons.

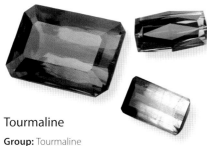

Tourmaline

Group: Tourmaline

Hardness: 7–7.5 Mohs

Specific gravity: 3.01–3.06

Properties: Strong dichroism

Tourmaline is a stone that occurs in many colors, sometimes with several in one stone. Settings should be protective, as stones can be fragile, and are susceptible to pressure.

Range available: Stones are cut to show the color to the best advantage. Cabochons, as well as faceted material, can be easily sourced. The most expensive form of tourmaline is rubellite, which is hot-pink to red. Pink and green watermelon tourmaline has a huge range of color variations. Indicolite is blue to blue-green, and verdelite comes in various shades of green. Dravite is orange-brown, and inexpensive.

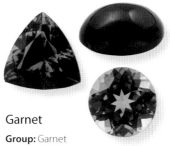

Garnet

Group: Garnet

Hardness: 6.5–7.5 Mohs

Specific gravity: 3.49–4.73

Properties: Heavy, vitreous luster

There are several types of garnets—pyrope is blood-red, rhodolite is violet-red, and tsavorite is green. Other varieties can be found in brown, orange, yellow, and yellow-green. Garnet is a durable stone suitable for most forms of jewelry.

Range available: Relatively inexpensive, but due to their high density, more expensive for their weight than other stones. Tsavorite, demantoid, and mandarin garnets can be valuable. Good-quality faceted stones, beads, and cabochons can all be found.

Zircon

Group: Zircon

Hardness: 6.5–7.5 Mohs

Specific gravity: 3.93–4.73

Properties: Adamantine luster and strong double refraction

Zircon is most desirable in its golden brown form, called high zircon. Low zircon is greenish brown. The stone is often treated to produce a vivid blue. Zircon is more suitable for pendants and earrings than rings as it can be chipped, and heat treatment weakens the stone.

Range available: A range of colors of zircon can be sourced, usually as faceted stones.

Quartz

Group: Quartz

Hardness: 7 Mohs

Specific gravity: 2.65

Properties: Crystalline; asterism and chatoyancy

The quartz group includes amethyst, citrine, rock crystal, tigereye, and rose, smoky, and rutilated quartz. Stones are susceptible to wear as they are only moderately hard, but this makes them ideal for carving and engraving.

Range available: Relatively inexpensive. Good-quality material is usually faceted, with lower-grade crystals being cut as beads or cabochons. Tigereye quartz is found in cabochon form.

Jade

Group: Jade

Hardness: 6.5–7 Mohs

Specific gravity: 2.96–3.33

Properties: Greasy to pearly luster

There are two types of jade—jadeite, which is a precious gem usually colored green but also found in a wide range of pastel shades, and nephrite jade, which is spinach- or sage-green and ideal for carving.

Range available: Both jadeite and nephrite jade are used for cabochons, beads, and carvings. Bright green imperial jade and lavender jade can be expensive if the color is pure and the material is opaque. Dyed jade will be much less valuable.

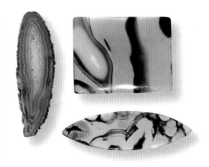

Agate

Group: Chalcedony/agate

Hardness: 6.5–7 Mohs

Specific gravity: 2.58–2.64

Properties: Fibrous, porous aggregates, waxy dull luster

Agate often contains banding or dendritic inclusions within the microcrystalline structure of the quartz. The base material is translucent, with various mineral deposits causing the effects.

Range available: Banded, moss, and dendritic agates are cut to show the inclusions or colors to the best advantage, often as cabochons or slices available in a wide variety of shapes, including freeform. The more beautiful the effect in a stone, the higher the price will be.

Peridot

Group: Peridot

Hardness: 6.5–7 Mohs

Specific gravity: 3.27–3.37

Properties: Distinct striations along the lengths of the crystals

Peridot is also called olivine, which describes its color. It often contains inclusions of silica, mica, or spinel. Polishing with the stone in situ should be avoided, as peridot is quite sensitive to heat, as well as chemicals. Stones are often step or mixed cut to reduce the risk of breakage.

Range available: Paler colors of peridot are inexpensive; lower-grade material is used for cabochons and beads. Large stones with few inclusions will carry a high price.

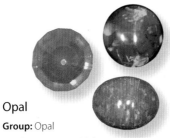

Opal

Group: Opal

Hardness: 5.5–6.5 Mohs

Specific gravity: 1.98–2.50

Properties: Iridescent

Opals are a composition of hydrated silica gel with a water content of 5–30 percent, and are generally described by the background color of the stone, which ranges through white, black, orange, or red (termed fire opals). Vibrant iridescent flashes of color give opals a unique quality.

Range available: A wide variety of color combinations of opal are available, usually cut as cabochons. Because opal is such a temperamental stone to work with, it is often supplied as "doublets" or "triplets." These composite stones have a layer of common opal set under a layer of precious opal. Triplets also have a protective top layer of rock crystal.

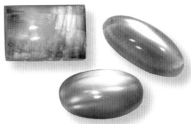

Moonstone

Group: Feldspar

Hardness: 6–6.5 Mohs

Specific gravity: 2.56–2.62

Properties: Vitreous luster, Schiller effect

Moonstone is an opalescent variety of feldspar, and can be found as blue, rainbow, white, pink, and rarely, green. The most attractive and valuable stones are transparent with a good Schiller effect, giving a floating blue sheen on the surface. Internal cracks can affect the durability of the stones, which are best set in a protective setting.

Range available: Moonstones are usually cut as cabochons for greatest visual effect. More attractive stones will be more expensive.

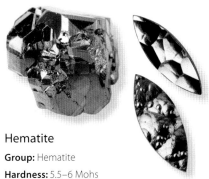

Hematite

Group: Hematite

Hardness: 5.5–6 Mohs

Specific gravity: 5.12–5.28

Properties: Opaque

Hematite is a compact form of iron oxide, is opaque and appears metallic gray to gunmetal gray when polished, and is relatively heavy due to its high specific gravity. As a gemstone, hematite is quite brittle and can be chipped quite easily, so protective settings should be used. The polished surface of the stone is highly reflective, and makes a stylish contrast when combined with matte finishes on metal.

Range available: Hematite is inexpensive, and is often found as cabochons, as well as beads and carvings.

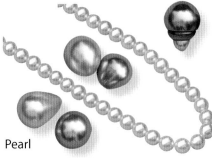

Pearl

Group: Organic

Hardness: 3–4 Mohs

Specific gravity: 2.68–2.79

Properties: Pearl color is a mixture of body color and luster or overtone.

Saltwater pearls come from oysters and mussels, and are usually high quality and expensive. Freshwater pearls are found in mollusks, and are generally more irregular and varied in shape. Layers of nacre are deposited around a nucleus by the animal and can take many years to form.

Range available: A wide variety of shapes, colors, and price ranges of pearls can be found. Natural pearls will be more valuable than those that have been cultivated or dyed. Pearls are supplied drilled, half-drilled, or full round (without a drilled hole).

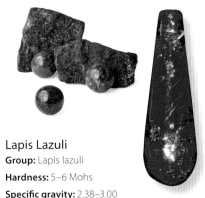

Lapis Lazuli

Group: Lapis lazuli

Hardness: 5–6 Mohs

Specific gravity: 2.38–3.00

Properties: Naturally opaque often containing pyrite veins or layers

Natural lapis lazuli is an intense brilliant blue; it is completely opaque and often contains small gold or silver pyrite inclusions that run through the material in layers or veins. This stone is sensitive to pressure, heat, and chemicals.

Range available: Natural material is valuable, but lapis is often dyed to improve the color, and can be reconstituted in the same way as turquoise; this material should be inexpensive. Cabochons and beads are the most common forms to be found.

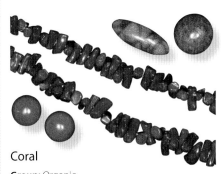

Coral

Group: Organic

Hardness: 3–3.5 Mohs

Specific gravity: 2.68

Properties: Banded structure

Coral is composed of the calcified external skeletons of small marine animals called polyps, which form a branched structure. Natural coral usually has pale or white patches and can be found in red, pink, white, black, and golden shades. Dyed material will have an intense, even color and should be much less expensive. Care should be taken with coral, as it is a soft stone, and exposure to heat can affect the color.

Range available: Coral can be found as branches, beads, carvings, and cabochons.

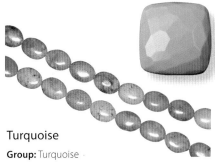

Turquoise

Group: Turquoise

Hardness: 5–6 Mohs

Specific gravity: 2.80

Properties: Opaque to semitranslucent; high porosity

Turquoise is a microcrystalline structure that forms encrustations, nodules, or veins in other minerals, which can give an attractive "matrix" or spiderweb pattern. The stone is lightweight, but can be porous and is affected by heat and chemicals, and may even fade with time.

Range available: Low-quality material can be found very cheaply, and much of the turquoise on the market is dyed or reconstituted using a resin binder. Certain types of turquoise, such as Sleeping Beauty, which is an intense, even blue, carry a high price.

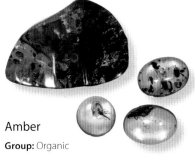

Amber

Group: Organic

Hardness: 2–2.25 Mohs

Specific gravity: 1.05–1.09

Properties: Amorphous

Amber is the fossilized resin of pine trees; its appearance can vary from transparent to virtually opaque and it has a resinous luster. The color of amber ranges through milky white, yellow, red, and black, with the most desirable hue being bright transparent yellow.

Range available: Natural amber can be valuable, especially if it has insect inclusions. Much amber is reconstituted and can be convincingly imitated with plastics, so take care when buying. When tested with a hot needle, real amber will produce smoke that smells like incense.

STONE SHAPES

The way in which a gemstone is cut determines its beauty, value, and the ways in which it can be set into a piece of jewelry. The crystal structure of certain types of gems means that certain cuts are more likely to be used; the emerald cut minimizes the chances of fragile emeralds chipping at the corners.

Carat weights for brilliant-cut stones								
Stone (diameter in mm)	2	3	4	5	6	7	8	10
Diamond	0.03	0.10	0.25	0.50	0.75	1.25	2.00	3.50
Blue topaz	0.04	0.11	0.30	0.56	1.00	1.55	2.50	5.75
Ruby/sapphire	0.05	0.15	0.34	0.65	1.05	1.60	2.25	4.50
Garnet	0.05	0.13	0.30	0.60	1.00	1.60	2.50	5.75
Aquamarine/emerald	0.04	0.12	0.27	0.48	0.80	1.70	2.50	6.10
Quartz	0.04	0.10	0.20	0.40	0.70	1.30	1.80	3.30

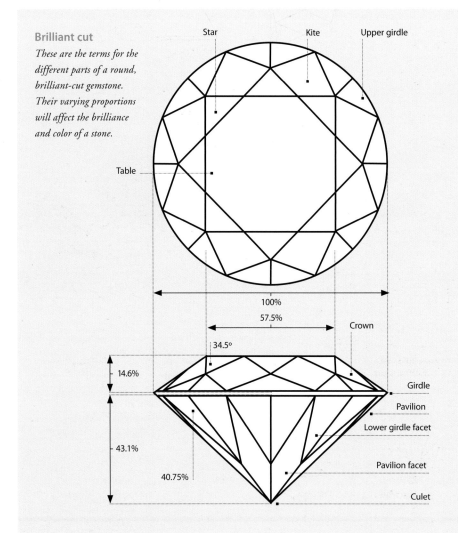

Brilliant cut

These are the terms for the different parts of a round, brilliant-cut gemstone. Their varying proportions will affect the brilliance and color of a stone.

Star Kite Upper girdle

Table

100%

57.5%

34.5°

Crown

14.6%

43.1%

40.75%

Girdle

Pavilion

Lower girdle facet

Pavilion facet

Culet

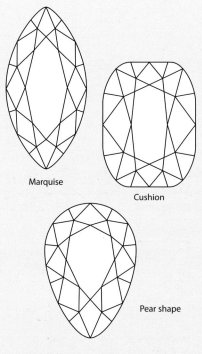

Marquise

Cushion

Pear shape

Maximum light dispersion

The brilliant cut, which was developed in 1919, maximizes the light dispersion within a stone, producing maximum "fire" and brilliance. This cut can be applied to shapes other than round, such as marquise (sometimes called navette), cushion, pear, and square, or "princess cut."

Rose cut

The rose cut is a historic cut; it was used as far back as the early 1600s and was still popular in Victorian jewelry. Its principle feature is the flat back, which allows it to be set like a cabochon. It can be simple, with three or six facets, or more complex with facets radiating in multiples of six.

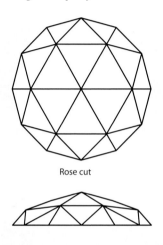

Rose cut

Fancy cuts

Fancy cuts can be used to create optical effects in stones, such as mirror and prism cuts. Variations of existing cuts may be used to retain the maximum weight in irregularly shaped crystals.

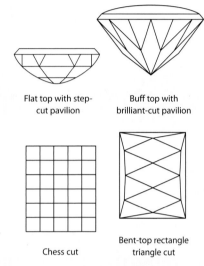

Flat top with step-cut pavilion

Buff top with brilliant-cut pavilion

Chess cut

Bent-top rectangle triangle cut

Cabochon cuts

Cabochon cuts can vary in both outer girdle shape and the convex curve of the surface, which can range from a flat slab to a high-domed bullet. The base can be flat, or rounded as a double cabochon to increase color density in light-colored stones.

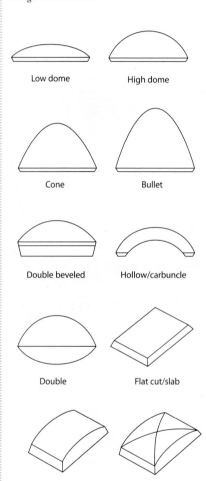

Low dome

High dome

Cone

Bullet

Double beveled

Hollow/carbuncle

Double

Flat cut/slab

Buff top

Buff top (cross-vaulted)

Straight-sided cuts

The step cut is used to show off the color of a stone, but does not produce the same sparkle as a brilliant cut. A modification of the step cut is the French cut, which is usually found on small stones with rectangular, square, and triangular shapes.

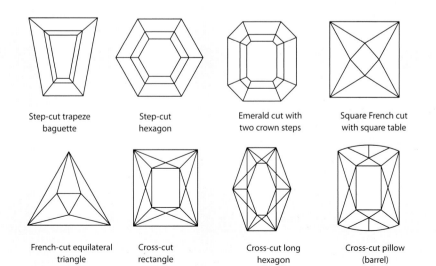

Step-cut trapeze baguette

Step-cut hexagon

Emerald cut with two crown steps

Square French cut with square table

French-cut equilateral triangle

Cross-cut rectangle

Cross-cut long hexagon

Cross-cut pillow (barrel)

CONVERSIONS

Temperatures			
°F	°C	°F	°C
32	0	1100	593
100	38	1200	649
150	66	1300	704
200	93	1400	760
250	121	1500	816
300	149	1600	871
350	177	1700	927
400	204	1800	982
450	232	1900	1038
500	260	2000	1093
550	288	2250	1232
600	216	2500	1371
650	343	2750	1510
700	371	3000	1649
800	427	3250	1788
900	482	3500	1927
1000	538	4000	2204

B&S gauge	Inches		Millimeters
	Thou.	Fractions	
–	0.787	$^{51}/_{64}$	20.0
–	0.591	$^{19}/_{32}$	15.0
1	0.394	$^{13}/_{32}$	10.0
4	0.204	$^{13}/_{64}$	5.2
6	0.162	$^{5}/_{32}$	4.1
8	0.129	$^{1}/_{8}$	3.2
10	0.102	$^{3}/_{32}$	2.6
12	0.080	$^{5}/_{64}$	2.1
14	0.064	$^{1}/_{16}$	1.6
16	0.050	–	1.3
18	0.040	$^{3}/_{64}$	1.0
20	0.032	$^{1}/_{32}$	0.8
22	0.025	–	0.6
24	0.020	–	0.5
26	0.016	$^{1}/_{64}$	0.4
28	0.013	–	0.3
30	0.010	–	0.25

TOOL SHAPES

It is always important to select the correct tool for each task as the shape of the tool will have a direct impact on the effect it makes.

Files come in many shapes, and the profile of the file determines the groove it cuts—always try to match the shape of the file to the shape of the area being filed, especially when cleaning up intricately pierced fretwork with needlefiles.

The shape of a graver determines the mark it will make when it cuts; oval or onglette gravers are used in stone setting to carve a seat for the stone and square gravers are used for engraved line work.

Seating, ball, and bearing cutter burrs are all used predominantly in stone setting, and should be the same diameter as the stone. Other shaped burrs are generally used for carving or making surface textures, and all burrs come in a wide range of sizes.

File shapes

Round	Half-round	Square	Flat	Safety back (barrette)
Crossing	Three-square	Knife-edge	Oval	Jointing

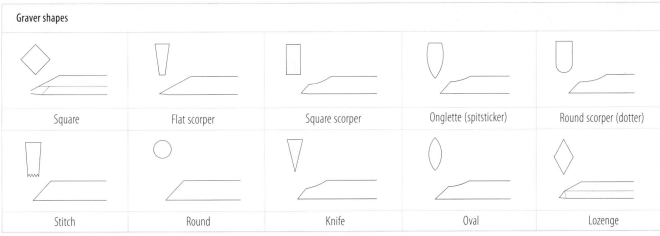

Graver shapes

Square	Flat scorper	Square scorper	Onglette (spitsticker)	Round scorper (dotter)
Stitch	Round	Knife	Oval	Lozenge

Burr shapes

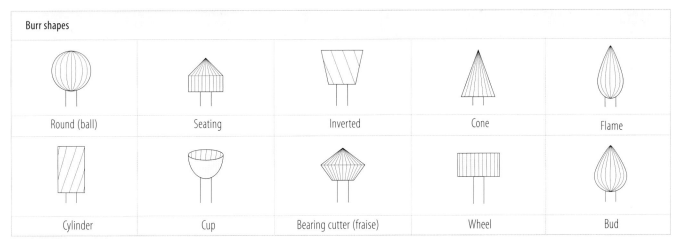

Round (ball)	Seating	Inverted	Cone	Flame
Cylinder	Cup	Bearing cutter (fraise)	Wheel	Bud

STANDARD SIZES AND MEASUREMENTS

Table of ring sizes						
U.K.	U.S.	Europe	Ring blank length* (mm)	Ring blank length* (inches)	Inside diameter (mm)	Inside diameter (inches)
A	½	38	40.8	1.61	12.1	0.47
B	1	39	42.0	1.65	12.4	0.49
C	1½	40.5	43.2	1.70	12.8	0.50
D	2	42.5	44.5	1.75	13.2	0.52
E	2½	43	45.8	1.80	13.6	0.54
F	3	44	47.2	1.85	14.0	0.55
G	3¼	45	48.3	1.90	14.2	0.56
H	3¾	46.5	49.5	1.95	14.6	0.57
I	4¼	48	50.8	2.00	15.0	0.59
J	4¾	49	52.7	2.05	15.4	0.61
K	5¼	50	53.4	2.10	15.8	0.62
L	5¾	51.5	54.6	2.15	16.2	0.64
M	6¼	53	56.0	2.20	16.6	0.65
P	7½	56.5	59.5	2.35	17.6	0.69
Q	8	58	60.9	2.40	18.0	0.71
R	8½	59	62.3	2.45	18.4	0.72
S	9	60	63.4	2.50	18.8	0.74
T	9½	61	64.8	2.55	19.2	0.76
U	10	62.5	65.9	2.60	19.6	0.77
V	10½	64	67.4	2.65	20.0	0.79
W	11	65	68.6	2.70	20.4	0.80
X	11½	66	69.9	2.75	20.8	0.82
Y	12	68	71.2	2.80	21.2	0.83
Z	12½	69	72.4	2.85	21.6	0.85

Some useful measurements		
Standard sizes of	mm	inches
Diameter of earring posts and wires	0.8–0.9	0.031–0.035
Necklace lengths	400 450 500	16 18 20
Bracelet lengths	175 190 200	7 7.5 8.5
Bangle diameters	60 65 70	2.4 2.6 2.8

GEOMETRY FORMULAS

- **To find the circumference of a circle from the diameter:** Circumference = 3.142 x diameter
- **To find the area of a circle:** Area = 3.142 x (radius²)
- **To find the diameter of a circle used to make a dome:** Outside diameter of sphere minus thickness of metal x 1.43
 e.g., 18 mm o. d., 0.6 thickness:
 18 – 0.6 = 17.4 ; 17.4 x 1.43 = 25 mm
- If less accuracy is required, add the diameter of the dome to its height to find the approximate diameter of circle needed.

Using ring blank measurements

Always add the thickness of the metal you are using to the length of the ring blank* required for a particular size, to ensure accurate results. When measuring a finger, use a measuring gauge that is a similar width to the ring you are making—a wide band ring will need to be a larger size to fit over the knuckle than a thin band.

GLOSSARY

Acetone A flammable liquid solvent, used for dissolving resin, stop-out varnish, setter's wax, and permanent marker-pen ink.

Alloy A mixture of metals; sterling silver is an alloy of fine silver and copper.

Annealing The process of heating and then cooling metal to make it softer and thus easier to work with. The required temperature for annealing, the duration of heating, and the rate of cooling vary according to the metal used.

Arkansas stone A fine abrasive stone.

Assaying The process of determining the proportion of precious metal contained in an alloy. Most jewelry is assayed at an official Assay Office and given a hallmark that indicates the type and fineness of the precious metal.

Baguette A gemstone cut so that the shape of the top (table) is narrow and rectangular. It takes its name from the long French baguette loaf.

Base metal Nonprecious metal, such as aluminum, copper, iron, and nickel.

Beveled On a slant or inclination.

Bezel The rim of metal that is used to secure a stone in a rub-over setting.

Billet A thick stack of fused metal, used in mokume gane.

Blank A flat shape cut from sheet metal.

Borax A flux commonly used when soldering jewelry. A special form of borax is produced for use by jewelers, which is easier to dissolve and melt than ordinary borax.

Burnish To polish by rubbing, usually with a polished steel tool.

Cameo A gemstone with a design cut in low relief.

Carat A unit of weight, now standardized as being equal to one-fifth of a gram; this is equal to 3.086 grains Troy. The weight of gemstones is usually expressed in carats.

Chasing The process of punching a relief design in metal from the front.

Chenier Thin metal tube, often used for making hinges in jewelry. It can also form other parts of a piece.

Cone-shaped bezel A conical metal band that surrounds and supports a stone.

Cotter pin A double D-wire pin used to secure items. The pin is passed through a hole and the ends are spread to hold it in place.

Countersink The enlargement of the entry to a hole.

Culet The small facet on the base of some brilliant-cut stones.

Curing The process of liquid components turning solid—resin, for example.

Die A tool used for shaping by stamping or press forming, or a cutting tool used for making screw threads.

Draw plate A hardened steel plate with a series of holes of various sizes. Wire is drawn through the plate to reduce its thickness, or to change its shape. Draw plates are commonly available with round, square, or triangular holes.

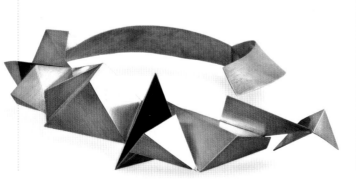

Electroforming The process of forming metal objects by using an electric current to deposit the metal in a mold. The mold must be coated with a substance that conducts electricity. Electroforming is sometimes used to reproduce antique pieces; the process is also used for creating new individual pieces, and for mass production.

Electroplating The process of depositing a layer of metal on an object by means of an electric current. Jewelry made from base metal is often electroplated with silver or gold to enhance its appearance. Items made from plastic or other nonmetallic substances can be electroplated if they are first coated with a substance that conducts electricity.

Electrum A naturally occurring pale yellow alloy of gold and silver. The proportions of the metals vary but this alloy usually contains more gold than silver.

Engraving The process of cutting away the surface of a substance, using a sharp steel tool called a graver. Lines are often engraved in a metal surface to form a decoration or inscription. Cameos and intaglios are made by engraving gemstones.

Etching The controlled corrosion of a surface with acid. In jewelry, the process is used to form surface decoration on metal: some parts of the surface are protected by an acid-resisting substance, while others are eaten away by the acid.

Exothermic A chemical reaction that gives off heat as a by-product.

Facet A flat surface ground on a cut gemstone.

Ferrous Containing iron.

Findings Mass-produced jewelry components, such as catches, joints, and clips, which are commonly used, even on handmade jewelry. When such components are made by hand, they are sometimes called fittings.

Firestain (Firescale) The black coating that forms on silver when it is heated. The coating consists of copper oxide and is formed by the copper in the impure silver combining with oxygen in the air.

Flux (1) A substance used in soldering to ensure that the solder flows. Any oxide present on the metal tends to prevent the solder from flowing. The flux is applied to the parts to be soldered and prevents air from reaching them. As a result, no oxide is formed, so the solder is able to flow and join the metal. Borax is the flux commonly used by jewelers.

Flux (2) A colorless transparent enamel, often used as a base layer to give applied colored enamels greater clarity, especially when enameling on copper.

Forging The process of hammering metal to change its shape.

Former A steel shape for supporting metal while it is being hammered. Formers are also known as mandrels.

Fretwork A sheet that has been pierced with holes or shapes to make an ornamental pattern.

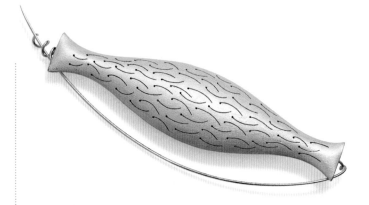

Fume cupboard A glass-fronted cupboard that has an extraction or air-filtration system inside, in which chemical processes such as etching are done.

Gallery (1) A wire fixed to the back of jewelry to raise the level of the metal so that there is sufficient clearance below for the stones.

Gallery (2) A mass-produced decorative metal strip, often with a series of elongated holes across the center, usually known as a "closed" gallery. Open galleries are made by cutting a closed gallery along the middle of the holes to produce a series of U-shapes on each piece. An open gallery can be used as a ready-made claw setting, with the arms of the "U"s forming the claws.

Gauge A standard unit of measurement of the thickness of sheet or the diameter of wire.

Gilding metal A gold-colored alloy consisting mainly of copper and zinc. It is used to make inexpensive jewelry and is usually gilded.

Gimp A coil of very fine wire used to protect the ends of threads on which beads or pearls are strung. The ends are passed through gimps so that they cannot wear away by rubbing on the catch of the jewelry. Also called French wire.

Girdle The widest circumference of a gemstone. The girdle forms the boundary between the crown (top) and the pavilion (base).

Grain (1) A unit of weight, common to both the Troy and Avoirdupois systems. Four grains are equal to one carat, the unit of weight for precious stones and pearls.

Grain (2) A tiny ball of metal (see granulation).

Granulation The decoration or texturing of a surface by the application of tiny balls (grains) of gold or silver. Various techniques have been developed for making and attaching the grains.

Hallmark A series of impressions made in an item of gold, silver, or platinum. The hallmark is an official guarantee of the fineness of the metal.

Intaglio An object with a hollowed-out design, the flat surround being the highest part. The opposite of a cameo, an intaglio is sometimes known as hollow relief. In jewelry, intaglio designs are usually made in gemstones and sometimes in metal.

Investment Fine-grade plaster used in the casting process.

Jig A tool used to form several items of identical shape.

Karat A measure of the fineness of gold or gold alloy. The number of karats is the number of parts by weight of pure gold in 24 parts of the metal. Pure gold is, therefore, described as 24 karat, and 14k gold is an alloy that contains 14 parts of pure gold in 24 parts of the alloy. In the United Kingdom, the spelling "carat" is used.

Malleability The property, usually of a metal, of being easily hammered, rolled, or pressed to shape without fracturing.

Mandrel *See* Former.

Marquise/Navette Any gemstone with a boat-shaped girdle. The curved sides meet at a point at each end of the stone.

Outwork Processes or special professional services that are performed by someone else, for example engraving and plating.

Pallions Small pieces of solder, taken from the French word for "flake."

Patina A surface finish that develops on metal or other material as a result of exposure to chemicals or handling.

Pickle A solution used during construction to clean flux and oxides from metal after heating—for example, after soldering. Pickle is also used to clean finished jewelry. Dilute sulfuric acid is often used as a pickle.

Piercing saw A saw with a blade narrow enough to be threaded through a drilled hole so that a pattern can be cut out from sheet metal or other material.

Planishing The process of hammering metal with a polished hammer to obtain an even surface.

Pleochroic A term used to describe a gemstone that appears to have two or more different colors when viewed from different directions.

Repoussé A relief design punched into thin metal from the back.

Rouge Jeweler's rouge is red iron oxide, a fine abrasive used for the final polishing stages of precious metals.

Schiller effect A sheen similar to iridescence, produced by the interference of light reflecting off internal layers within a gemstone.

Shank The part of a ring that passes around the finger.

Soldering The process of joining metal, using an alloy called solder. The solder is designed to melt at a temperature lower than the metal it is intended to join. The work and solder are heated until the solder melts. On cooling, it solidifies to form a firm joint. The terms easy, medium, and hard solder describe solders with progressively higher melting points. Thus, some joints can be made at a relatively low temperature without melting earlier joints made with a higher-melting-point solder.

Sprue The unwanted piece of metal attached to a casting and formed by the access channel in the mold.

Stamping The process of forming a pattern in sheet metal, using a punch bearing the complete design. The pattern is formed by a single blow and the process is suitable for mass production.

Swaging The process of making metal U-shaped by hammering it into a U-shaped groove in a metal block.

Tap A tool used for cutting a screw thread inside a hole.

Tang The end of a file, graver, or tool, which is fitted into a wooden handle.

Tempering The process of heating metal after hardening to reduce its brittleness.

Triblet A tapered steel rod on which rings are shaped.

Tripoli A coarse abrasive used in the first stages of polishing metal.

Upsetting A forging technique used to spread the end of a piece of rod.

Vulcanizing press A press used for compressing hot rubber to form molds for casting.

Work-hardening The hardening of a metal caused by hammering or bending, which often makes the metal too hard to work with until it has been softened by annealing.

SUPPLIERS AND SERVICES

U.S.A.
Tools
Allcraft Tool and Supply
666 Pacific Street
Brooklyn, NY 11207
Tel. (718) 789-2800

Anchor Tool and
Supply Company
PO Box 265
Chatham, NJ
Tel. (201) 887-8888

Armstrong Tool and
Supply Company
31747 West Eight Mile Road
Livonia MI 48152
Tel. (800) 446-9694
Fax (248) 474-2505
Web www.armstrongtool.com

Frei & Borel
PO Box 796
126 Second Street
Oakland, CA 94604
Tel. (510) 832-0355
Fax (800) 900-3734
Web www.ofrei.com

Indian Jeweler's Supply Company
601 E. Coal Avenue
Box 1774
Gallup, NM 87305-1774
Tel. (505) 722-4451
Fax (505) 722-4172
Web www.ijsinc.com

Metalliferous
34 West 46th Street
New York, NY 10036
Tel. (212) 944-0909
Fax (212) 944-0644
Web www.metalliferous.com

Myron Toback
25 West 47th Street
New York, NY 10036
Tel. (212) 398-8300
Fax (212) 869-0808
Web www.mjsa.polygon
.net/~ 10527

Paul Gesswein and Company, Inc.
255 Hancock Avenue
PO Box 3998
Bridgeport, CT 06605-0936
Tel. (203) 366-5400
Fax (203) 366-3953

Rio Grande
7500 Bluewater Road NW
Albuquerque, NM
Tel. (800) 545-6566
Fax (800) 965-2329
Web info@tbg.riogrande.com

Swest Inc.
11090 N. Stemmons Freeway
PO Box 59389
Dallas, TX 75229-1389
Tel. (214) 247-7744
Fax (214) 247-3507
Web www.swestinc.com

Precious metals
David H. Fell and Company
6009 Bandini Boulevard
City of Commerce, CA 90040
Tel/Fax (323) 722-6567
Web www.dhfco.com

T.B. Hagstoz and Son
709 Sansom Street
Philadelphia, PA 19106
Tel. (215) 922-1627
Fax (215) 922-7126
Web www.silversmithing.com/
hagstoz

Handy and Harman
1770 Kings Highway
Fairfield, CT 06430
Tel. (203) 259-8321
Fax (203) 259-8264
Web www.handyharmanproducts
.com

Hauser and Miller Company
10950 Lin-Valle Drive
St. Louis, MO 63123
Tel. (800) 462-7447
Fax (800) 535-3829
Web www.hauserandmiller.com

C.R. Hill Company
2734 West 11 Mile Road
Berkeley, MI 48072
Tel. (248) 543-1555
Fax (248) 543-9104
Web www.crhillcompany.com

Hoover and Strong
10700 Trade Road
Richmond, VA 23236
Fax (800) 616-9997
Web www.hooverandstrong.com

Belden Wire and Cable Company
PO Box 1327
350 NW N. Street
Richmond, IN 47374, 95352-3837
Tel. (765) 962-7561
Web www.belden.com

Base metals
NASCO
1524 Princeton Avenue
Modesto, CA 95352-3837
Tel. (209) 529-6957
Fax (209) 529-2239

Revere Copper Products
PO Box 300
Rome, NY 13442
Tel. (315) 338-2554
Fax (315) 338-2070
Web www.reverecopper.com

CANADA
Tools
Busy Bee Machine Tools
2251 Gladwin Crescent
Ottawa, ON K1B 4K9
Tel. (613) 526-4695
or 1909 Oxford Street East
London, ON N5V 2Z7
Tel. (519) 659-9868

Lacy and Co. Ltd
55 Queen Street East
Toronto, ON M5C 1R6
Tel. (416) 365-1375
Fax (416) 365-9909
Web www.lacytools.com

Precious metals
Imperial Smelting and Refining
Co. Ltd.
451 Denison
Markham, ON L3R 1B7
Tel. (905) 475-9566
Fax (905) 475-7479
Web www.imperialproducts.com

Johnson Matthey Ltd.
130 Gliddon Road
Brampton, ON L6W 3M8
Tel. (905) 453-6120
Fax (905) 454-6869
Web www.matthey.com

UNITED KINGDOM
Tools
Buck & Ryan
Victoria House
Southampton Row
London WC1B 4AR
Tel. (0207) 430 9898
Web www.buckandryan.co.uk

H.S. Walsh
234 Beckenham Road
Beckenham
Kent BR3 4TS
Tel. (0208) 778 7061
or 44 Hatton Garden
London EC1N 8ER
Tel. (0207) 242 3711
Web www.hswalsh.com

Enameling supplies
Vitrum Signum
Gresham Works
Mornington Road
North Chingford
London E4 7DR
Tel. (0208) 524 9546
Web www.vitrumsignum.com

Precious metals
Cookson Precious Metals Ltd.
49 Hatton Garden
London EC1N 8YS
Tel. (0845) 100 1122
Web www.cooksongold.com

Rashbel UK Ltd.
24–28 Hatton Wall
London EC1N 8JH
Tel. (0207) 831 5646
Web www.rashbel.com

Johnson Matthey Metals Ltd.
40–42 Hatton Garden
London EC1N 8EE
Tel. (0207) 269 8400
Web www.matthey.com

Base metals
FAYS Metals
Unit 3, 37 Colville Road
London W3 8BL
Tel. (0208) 993 8883

Scientific Wire Company
18 Raven Road
London E18 8HW
Web http://wires.co.uk

Gemstones
Capital Gems
30B Great Sutton Street
London EC1V 0DU
Tel. (0207) 253 3575
Web www.capitalgems.com

R. Holt & Co.
98 Hatton Garden
London EC1N 8NX
Tel. (0207) 405 5284
Web www.holtsgems.com

Levy Gems
Minerva House
26–27 Hatton Garden
London EC1N 8BR
Tel. (0207) 242 4547
Web www.levygems.com

A E Ward & Sons
8 Albemarle Way
London EC1V 4JB
Tel. (0207) 608 2703
Web www.aewgems.co.uk

Casting
West One Castings (gold, silver)
24 Hatton Garden
London EC1N 8BQ
Tel. (0207) 831 0542

Weston Beamor (platinum, fine casting)
3–8 Vyse Street
Birmingham B18 6LT
Tel. (0121) 236 3688
Web ww.westonbeamor.co.uk

Electroforming
Richard Fox
8–28 Milton Avenue
Croydon
Surrey CR0 2BP
Tel. (0208) 683 3331
Web www.foxsilver.net
Electroforming, plating, and polishing.

Water cutting
SCISS LTD.
Unit 9, Larkstore Park
Lodge Road, Staplehurst,
Kent TN12 0QY
Tel. (01580) 890582
Web www.sciss.co.uk/
Precision abrasive waterjet profile cutting.

Chemicals
Rose Chemicals
73 Englefield Road
London N1 4HD
Tel. (0207) 241 5100
Web www.rose-chemicals.co.uk/
Wide range of chemicals for etching and patination.

Other materials
4D Modelshop
The Arches
120 Leman Street
London E1 8EU
Tel. (0207) 264 1288
Web www.modelshop.co.uk
Model-making materials including plastics, metals, and silicone. Photoetching, base metal casting, and laser-cutting services.

Maplin Electronics Ltd
218 Tottenham Court Road
London W1T 7PX
Tel. (0207) 323 4411
Over 140 stores nationwide.
Web www.maplin.co.uk
Electronic components.

Pentonville Rubber
104–6 Pentonville Road
London N1 9JB
Tel. (0207) 837 7553
Web www.pentonvillerubber.co.uk
Rubber, latex, sheet, and wire.

Hamar Acrylic Fabrications Ltd.
238 Bethnal Green Road
London E2 0AA
Tel. (0207) 739 2907
Web www.hamaracrylic.co.uk
Acrylic stockist; laser-cutting service.

Alec Tiranti
27 Warren Street
London W1T 5NB
Tel. (0207) 380 0808
Web www.tiranti.co.uk
Sculptor's supplies, including resin, silicone, ceramic clays, and patination chemicals.

Barnett Lawson (Trimmings) Ltd.
16–17 Little Portland Street
London W1W 8NE
Tel. (0207) 636 8591
Web www.bltrimmings.com
Ribbons, buttons, feathers, and millinery supplies

Stuart R. Stevenson
68 Clerkenwell Road
London EC1M 5QA
Tel. (0207) 253 1693
Web www.stuartstevenson.co.uk
Artist supplies, including gold leaf, metallic powders, and varnishes.

Falkiner Fine Papers
76 Southampton Row
London WC1B 4AR
Tel. (0207) 831 1151
Web www.falkiners.com
Paper, bookbinding supplies, leather, and specialist adhesives.

GPS Agencies Ltd.
Unit 3–3a, Hambrook
Business Centre
Cheesmans Lane
Hambrook
West Sussex PO18 8XP
Tel. (0123) 457 4444
Web www.ivoryalternative.com
Imitation ivory, horn, ebony, shell, and marble.

ALMA
12–14 Greatorex Street
London E1 5NF
Tel. (0207) 377 0762
Fax (0207) 375 2471
Web www.almahome.co.uk/
almaleather.htm
Leather.

E-MAGNETS UK LTD.
Samson Works,
Blagden Street,
Sheffield, S2 5QT
Tel. (0114) 276 2264
Web http://e-magnetsuk.com/

INTAGLIO
9 Playhouse Court,
62 Southwark Bridge Road
London SE1 0AT
Tel. (0207) 928 2633
Web www.intaglioprintmaker.com/
Printmaking supplies, including PnP paper.

AUSTRALIA
Precious metals
A & E Metal Merchants
104 Bathurst Street, 5th floor
Sydney, NSW 2000
Tel. (029) 264 5211
Fax (029) 264 7370

Johnson Matthey (Australia) Ltd.
339 Settlement Road
Thomastown, VC 3074
Tel. (039) 465 2111
Web www.matthey.com

FURTHER READING

Books

Engraving on Precious Metals
Brittain, A. and Morton, P.
NAG Press, 1958.

Unclasped
Costin, Simon and Gilhooley, Derren
Black Dog Publishing, 2001.

Jeweller's Directory of Gemstones
Crowe, Judith
Firefly, 2006.

Electroforming
Curtis, Leslie
A & C Black, 2004.

A World of Rings: Africa, Asia, America
Cutsem, Anne van
Skira Editore S.p.A, 2000.

Secrets of Aromatic Jewellery
Dyett, Linda and Green, Anette
Flammarion, 1998.

Contemporary Japanese Jewellery
Fraser, Simon and Hida, Toyohiro
Merrell, 2001.

The Colouring, Bronzing and Patination of Metals
Hughes, Ricard and Rowe, Michael
Thames & Hudson, 1991.

Hydraulic Die Forming for Jewelers & Metalsmiths
Kingsley, Susan
20-Ton Press, 1993.

Adorn
Mansell, Amanda
Laurence King Publishing, 2008.

Enamels, Enameling, Enamelists
Matthews, G. L.
Krause Publications, 1984.

Boxes and Lockets
McCreight, Tim
A & C Black, 1999.

Metals Technic: A Collection of Techniques for Metalsmiths
McCreight, Tim (Ed.)
Brynmorgen Press, 1997.

Resin Jewellery
Murphy, Kathie
A & C Black, 2005.

The Art of Jewelry Design: From Idea to Reality
Olver, Elizabeth
North Light Books, 2002.

Jewels and Jewellery
Phillips, Clare
V & A Publications, 2008.

Jewellery in Europe and America
Turner, Ralph
Thames and Hudson, 1996.

Jewelry Concepts and Technology
Untracht, Oppi
Doubleday, 1982.

Traditional Jewellery of India
Untracht, Oppi
Thames and Hudson, 2008.

Magazines

Crafts
www.craftscouncil.org.uk/crafts/

Jewelry Artist
www.jewelryartistmagazine.com

Metalsmith (Society of North American Goldsmiths)
www.snagmetalsmith.org

Retail Jeweller
www.retail-jeweller.com

Schmuck Magazine
www.schmuckmagazin.de

Websites

Klimt02: International community for art jewelry and jewelry design
www.klimt02.net

Metalcyberspace: Information and resources
www.metalcyberspace.com

The Ganoksin Project: Archive of technical articles, and much more
www.ganoksin.com

The Goldsmiths' Company Directory
www.whoswhoingoldandsilver.com

GALLERIES, FAIRS, AND ORGANIZATIONS

GALLERIES

Contemporary Applied Arts Gallery, London, UK
www.caa.org.uk

Lesley Craze Gallery, London, UK
www.lesleycrazegallery.co.uk

The British Museum, London, UK
www.britishmuseum.org

William and Judith Bollinger Jewellery Gallery, Victoria and Albert Museum, London, UK
www.vam.ac.uk

Velvet Da Vinci Gallery San Francisco, USA
www.velvetdavinci.com

Ornamentum Gallery, Hudson, NY, USA
www.ornamentumgallery.com

The Scottish Gallery, Edinburgh, UK www.scottish-gallery.co.uk

Galerie Rob Koudijs, Amsterdam, Holland www.galerierobkoudijs.nl

Galerie Marzee, Nijmegen, Holland www.marzee.nl

e.g.etal Gallery, Melbourne, Australia www.egetal.com.au

Fingers, Auckland, New Zealand www.fingers.co.nz

Alternatives Gallery, Rome, Italy www.alternatives.it

Oona, Berlin, Germany www.oona-galerie.de

LOD, Stockholm, Sweden www.lod.nu

Deux Poissons, Tokyo, Japan www.deuxpoissons.com

Fairs

Inhorgenta, Munich, Germany www.inhorgenta.com

BaselWorld, Basel, Switzerland www.baselworld.com

Collect, Saatchi Gallery, London www.craftscouncil.org.uk/collect

Origin, Somerset House, London www.craftscouncil.org.uk/origin

Goldsmith's Fair, Goldsmith's Hall, London www.thegoldsmiths.co.uk/events

SOFA (Sculptural Objects & Functional Art), Chicago, New York, Santa Fe, USA www.sofaexpo.com

SIERRAD, Holland www.platformsieraad.nl

Organizations

Society of North American Goldsmiths www.snagmetalsmith.org

Hand Engravers Association of Great Britain www.handengravers.co.uk

Association For Contemporary Jewellery www.acj.org.uk

Crafts Council www.craftscouncil.org.uk/photostore

Craft Central www.craftcentral.org.uk

Ethical Metalsmiths www.ethicalmetalsmiths.org

Goldsmiths' Company www.thegoldsmiths.co.uk

Benchpeg newsletter www.benchpeg.com

Jewellery Association of Australia Ltd www.jaa.com.au

Society of Jewellery Historians www.societyofjewelleryhistorians.ac.uk

Guild of Enamellers www.guildofenamellers.org

The Institute of Professional Goldsmiths www.ipgold.org.uk

INDEX

CREDITS

The author would like to thank the following people for their invaluable contributions and expertise:

Melanie Eddy: Jewelry Making: A Brief History; Stringing Beads: text and demonstration.

Paul Wells, for the following demonstrations: Forging; Fold Forming; Anticlastic Raising; Chasing and Repoussé; Mokume Gane.

Campbell Muir: Grain setting demonstration.

Chris Howes: Lost wax casting.

The staff of the Jewelry Design Department at Central Saint Martins College of Art and Design for their help and support during this project, and the use of the workshops.

Cookson Precious Metals Ltd for providing images of tools and materials.

Cookson Precious Metals Ltd
59–83 Vittoria Street
Birmingham B1 3NZ
United Kingdom
0121 200 2120
www.cooksongold.com

Thank you to Deirdre O'Day for additional picture research and text on Jewelry Making: A Brief History.

The author and publisher can accept no liability for the use or misuse of any materials mentioned in this book. Always read product labels and take all necessary precautions.

Quarto would like to thank the following artists for kindly supplying images of their work for inclusion in this book:

Adrean Bloomard; Anne Morgan www.annemorgan. co.uk; Aiko Machida www.

aikomachida.com; Akiko Furuta akikofuruta@gmail.com; Alena Joy www.alenajoy.com; Alidra Alic André de la Porter www.alidraalic.com; Andrea Wagner www.andreawagner. nl; Anna Wales www.annawales. com ; Annette Petch www. annettepetchjewellery. co.uk; Ashley Heminway ajheminway@tiscali.co.uk; Bernadine Chelvanayagam www.craftcentral.org.uk/ bernadine-chelvanayagam; Chus Bures www.chusbures. com; Deukhee Ka ibbai1124@ hanmail.net; Daniela Dobesova www.danieladobesova. com; Emily Richardson www. emilyrichardson.me.uk; Erica Sharpe www.ericasharpe. co.uk; Fabrizio Tridenti www. fabriziotridenti.it; Felicity Peters www.felicitypeters.com; Felieke van der Leest www. feliekevanderleest.com photo: Eddo Hartmann; Frieda Munro; Georgie Dighero; Gilly Langton; Hannah Louise Lamb www. itchyfingers.org; Harriete Estel Berman www.Harriete-Estel-Berman.info ; Il Jung Lee www. iljunglee.com; Inni Pärnänen www.inni.fi; Janis Kerman www. janiskermandesign.com; Jennaca Leigh Davies www.jennaca.com; Jessica de Lotz jessicadelotz. wordpress.com; Joanne Haywood www.joannehaywood. co.uk; Karin Kato karinkato411@ hotmail.com; Kathryn Marchbank www.designnation.co.uk; Kaz Robertson kazrobertson. blogspot.com; Kelvin J Birk www.kelvinbirk.com; Laura Bamber www.laurabamber. com; Laura Jayne Strand www. laurajaynestrand.com; Lesley Strickland www.lesley-strickland. co.uk; Lina Peterson www. linapeterson.com; Linnie McLarty www.linniemclarty. com; Lucy Sarneel l.sarneel@ planet.nl; Margareth Sandström www.sandstrom-dewit. se; Meghan O'Rourke www.

CREDITS (CONTINUED)

meghanorourkejewellery.com; Melanie Eddy www.melanieeddy.co.uk; Mette Klarskov www.metteklarskovlarsen.com; Michelle Xianon Ni; Midori Saito www.midorisaito.com; Nelli Tanner, photo: Heidi Asplun; Ornella Iannuzzi www.ornella-iannuzzi.com; Pamela Deans; Paul Wells ; Peter de Wit www.sandstrom-dewit.se; Phoebe Porter www.phoebeporter.com.au; Ramon Puig Cuyas www.galerie-biro.de; Rebecca Hannon photo: Jeremy Tressler www.rebeccahannonjewelry.com; Rinaldo Alvarez www.rinaldoalvarez.es; Royston

Upson; Rui Kikuchi www.rubikus.net; Ruth Anthony www.ruthanthonydesigns.com; Salima Thakker www.salimathakker.com; Scott Millar www.scottandrewmillar.com; Sean O'connell www.oneorangedot.com; Serena Park www.serenapark.com; Shelby Ferris Fitzpatrick www.shelbyfitzpatrick.com; Sonja Seidl www.sonjaseidl.com; Stacey Whale www.staceywhale.com; Susan May www.susanmay.org; Takafumi Inuzuka www.uni-t-design.com; Victoria Dicks; Victoria Marie Coleman www.victoriacolemandesign.com;

Yeonkyung Kim studioaura@naver.com

Alamy: pages 14t; 15t; 16. Wartski: page 22. V&A: pages 17; 19; 21. Wendy Ramshaw/V&A Images, Victoria and Albert Museum: page 23.

We would also like to thank Benchpeg www.benchpeg.com Treasure www.treasureuk.com The Goldsmith's Company www.thegoldsmiths.co.uk Damson www.damsonjewellery.co.uk

All other images are the copyright of Quarto Publishing plc. While every effort has been made to credit contributors, Quarto would like to apologize should there have been any omissions or errors—and would be pleased to make the appropriate correction for future editions of the book.

Author's website www.anastasiayoung.co.uk

BOOKS AND MAGAZINES FROM INTERWEAVE